VISUAL ETHICS

Visual Ethics addresses the need for critical thinking and ethical behavior among professionals responsible for visual messages in photography and photojournalism, film, and digital media. From the author of *Photojournalism: An Ethical Approach*, published more than 20 years ago, this book goes beyond photojournalism ethics. It discusses crucial contemporary concerns, including persuasion, stereotyping, global perspectives, graphic design decisions, multimedia production, social media, and more. Written for an ever-growing discipline, authors Paul Martin Lester, Stephanie A. Martin, and Martin Smith-Rodden give serious ethical consideration to the complex field of visual communication.

Paul Martin Lester is a Clinical Professor for the School of Arts, Technology, and Emerging Communication at the University of Texas at Dallas. He received a Bachelor of Journalism from the University of Texas at Austin, an M.A. from the University of Minnesota, and a Ph.D. from Indiana University. He is the author or editor of several books that include: *Visual Communication: Images with Messages, Seventh Edition* (2017), *Digital Innovations for Mass Communications: Engaging the User* (2014), *Images that Injure: Pictorial Stereotypes in the Media, Third Edition* with Susan Ross (2011), *Visual Journalism: A Guide for New Media Professionals* with Christopher Harris (2002), *Desktop Computing Workbook: A Guide for Using 15 Programs in Macintosh and Windows Formats* (1996) and *Photojournalism: An Ethical Approach* (1991). From 2006 until 2011 he was editor of the *Visual Communication Quarterly*, a publication of the Visual Communication Division of the Association for Educators in Journalism and Mass Communication (AEJMC) published by Taylor and Francis. From 2011 until 2015 he was editor of the AEJMC publication *Journalism and Communication Monographs* published by Sage. He also co-wrote a monthly column, "Ethics Matters" for *News Photographer* magazine for the National Press Photographers Association (NPPA).

Stephanie A. Martin is an Assistant Professor of political communication in the Division of Corporate Communication and Public Affairs at Southern Methodist University. She is editor of *Columns to Characters: The Presidency and the Press Enter the Digital Age* (Texas A&M Press). Her work has also appeared in *Rhetoric & Public Affairs* and *Visual Communication Quarterly*, as well as in book chapters in several edited volumes. Martin's research centers on public rhetoric, particularly with regard to the American presidency, popular conservative movements, and rights to dissent in the public sphere. She has also written about hate speech and the ethics of silencing. Martin holds a Ph.D. in Communication from the University of California, San Diego and an M.A. in Journalism from the S.I. Newhouse School of Public Communication at Syracuse University. Her expert commentary has been featured in the national media, including *NPR*, the *Christian Science Monitor*, the *Congressional Quarterly Researcher*, and the *Orange County Register*.

Martin Smith-Rodden is an Assistant Professor for Journalism and the coordinator of the Photojournalism Sequence at Ball State University, located in Muncie, Indiana. He holds a PhD in Applied Psychological Science and a Master of Science in Experimental Psychology from Old Dominion University (Norfolk, VA). For more than three decades he's been a photojournalist, photo editor and team leader, as well as being a cognitive psychologist. He's worked in the Baltimore/Washington, San Antonio (Texas) and Norfolk (Virginia) metro areas. In 2011 he was named Photo Editor of the Year by the National Press Photographers Association's Best of Photojournalism competition. He was also Region 3 (mid-Atlantic) Photographer of the Year in 1996.

VISUAL ETHICS

A Guide for Photographers, Journalists, and Filmmakers

Paul Martin Lester
with Stephanie A. Martin and Martin Smith-Rodden

Routledge
Taylor & Francis Group

NEW YORK AND LONDON

First published 2018
by Routledge
711 Third Avenue, New York, NY 10017

and by Routledge
2 Park Square, Milton Park, Abingdon, Oxon OX14 4RN

Routledge is an imprint of the Taylor & Francis Group, an informa business

Library of Congress Cataloging in Publication Data
A catalog record has been requested for this book

ISBN: 978-1-138-21049-3 (hbk)
ISBN: 978-1-138-21050-9 (pbk)
ISBN: 978-1-315-45513-6 (ebk)

Typeset in Bembo
by Taylor & Francis Books

CONTENTS

Conclusion: Let Empathy Be Your Guide **125**

FOREWORD

Paul Martin Lester

Visual ethics is, of course, the reason why this book was written, but its hidden agenda is more complex. Although the ethical issues related to collecting, processing, and presenting visual messages in all manner of media and a seemingly unlimited number of purposes is important and, quite frankly, overdue, the actual purpose of this work is to teach critical thinking. Through practice using the 10-step Systematic Ethical Analysis (SEA) for how to best analyze ethical slights of the past and present, you should learn how to respond in positive ways to dilemmas presented to you in the future – both professional and personal. Your goal with the SEA is to move from a gut-feeling, highly individualized, short-term, and subjective reaction to a rational, collective, long-term, and less subjective outcome (I won't write "objective" for obvious reasons after you read Chapter 3). That way, you should come to the conclusion that any dilemma does not have one correct and one wrong solution. The SEA is designed to get you neck-deep in the murky waters of a tricky situation and realize that there are several types of boats – from a homemade raft to a Viking River Cruise ship (notice: A blatant plug) – that will get you safely to shore. (How's that for a salient metaphor?) In other words, there are many viable and positive alternatives to a dilemma that can be imagined after some careful consideration and a little creativity.

The chapters include discussions on important media issues from advertising to virtual reality. The main topics addressed in this book include credibility, objectivity, role-related responsibilities, values, loyalties, etiquette, empathy, and yes, ethics. Interviews with professionals conducted and written by Dr. Martin Smith-Rodden can be found in Appendix A. Those of you who are observant should, I trust, notice that it seems odd that a book that starts with "visual" does not have a single published illustration. Arguably, ethics is a subject that relies more on words than images. And yet, there are more than 300 illustrations described by words. At the end of each chapter are the sources that provide examples, additional context, and information. These images – still and moving – should be of interest to anyone committed to visual communication. This book also includes case studies where you can practice using the SEA (with the SEA form found in Appendix B, completed analyses and case studies using the SEA in Appendix C) and annotated sources that provide academic perspectives both written by Dr. Stephanie A. Martin.

Finally, it should be clear that the study of ethics is a highly personal exercise. Thinking about what others did wrong and determining alternatives that should be taken inevitably

leads to you questioning and considering your own past actions both positive and negative. To that end, you will no doubt notice that the style of writing is perhaps a bit more informal than other textbooks. There are personal pronouns, contractions, cuss words, and parenthetical phrases – all elements that I caution my students to avoid in their term papers. Simply put, if you find yourself in one of my classes, you will know that this book's tone matches my conversational style. Reading this book, then, should feel like a conversation. I hope someday we get a chance to make that happen.

Online only, please.

PREFACE

Welcome to Your Personal Ethical Journey

It was the type of assignment that makes cynical reporters and photojournalists outwardly groan: Go to the airport and meet 80-year-old twin brothers – one local and the other flying in from Ireland. They hadn't seen each other in more than 40 years.

There were many reasons for not wanting to go on the job. Most reasons come down to the greatest detriment a journalist can exhibit – previsualization. To cement the buzzkill while driving to the airport, Jack, the reporter and I discussed what we would experience at the reunion – a long wait at the gate (note: This anecdote happened before the airport restrictions mandated by 9/11 in 2001), an excited family, the ancient brothers seeing each other and giving a quick hug, and inarticulate or clichéd explanations of how it all felt to them. As a photojournalist with my role-related responsibility to make sure I visually recorded the reunion, I was sure that I wouldn't be able to sum up the situation in a single frame because the lighting at the airport would be poor and there would be too many friends and family members crowded around the two men to get a clear and clean composition. Terrible quotes and awful photographs – a challenge for both of us. Jack and I couldn't wait to get what we needed and get out so we could go to our favorite restaurant for dinner.

Sure enough, the reunion ended up just as we had imagined. But the unexpected occurrence at the airport haunts me to this day. Consequently, I always start a mass media ethics class I teach with the story and what I consider to be one of the most unethical actions I ever took.

At the airport, I stood in front of a roped area next to the local brother and his family. I wore my usual array of cameras for this situation – one around my neck with a 35mm lens and an electronic flash attached and another with an 85mm lens hanging off my right shoulder. My left shoulder carried my camera bag. I looked like a badass photojournalist ready for anything. But I wasn't ready for what happened next.

After about 30 minutes, the plane taxied to the gate. Well-dressed first class passengers walked past my vantage point. I knew it would be several minutes before the brother would wobble out of the gangway so I was relaxed. But then I caught sight of someone famous.

Inexplicitly walking toward me was the actress Faye Dunaway ("Faye Dunaway," 2017).

Before her airplane trip, she was in three critically acclaimed and internationally influential motion pictures. She starred in *Bonnie and Clyde* and *Chinatown* and was honored with Academy Award Best Actress nominations for both roles. For *Network* she won an Oscar for

her performance. She was a big, worldwide star (let's not think about her colossal gaffe during the 2017 Academy Award ceremony).

She was about 20 feet from me when our eyes briefly met and I could tell she noticed my cameras. I was a bit stunned at seeing such a famous person unexpectedly but I was snapped out of my awe by an agonizing scream she directed at me. She turned toward a wall, hid her face, and sobbed uncontrollably. It was awful. I wanted to go to her and let her know I wasn't there to photograph her, but I froze. Incredibly, the departing passengers didn't seem to notice this distraught woman on the side as they moved quickly past her. Several moments passed. Most of the passengers were off the plane. Dunaway remained against the wall with her hands on her cheeks. No one went to her to ask if she needed help including myself. She then suddenly became erect, wiped her face, and started to walk toward me. Without thinking I picked up the camera with the flash around my neck. As she walked past she covered her face with a hand.

I took a picture (Lester, 2017).

This book details historic and current ethical dilemmas in various media and for numerous purposes and includes as its base a ten-point systematic ethical analysis (SEA) that should help guide whether actions should be considered ethical. The SEA is largely a product of what has been called the "ethics mantra" which states: Do your job and don't cause unjustified harm. The mantra should then be combined with an understanding of six moral philosophies – the categorical imperative, utilitarianism, the golden mean, the golden rule, the veil of ignorance, and hedonism. With both the mantra and the philosophies, I failed.

It wasn't my job to document Faye Dunaway's visit. In fact, it should have been no concern to anyone. Plus, by taking a harshly intrusive flash picture I caused emotional harm to the actress. Furthermore, the use of the six philosophies substantiates the conclusion that my behavior was reprehensible.

The **categorical imperative** stresses a rule that should not be violated. Professionally, anything newsworthy is part of my role-related responsibility as a photojournalist. A categorical imperative demands that it should be photographed. However, there was nothing newsworthy about Dunaway's arrival at the airport.

Utilitarianism emphasizes an educational reason for performing some task that may help others. Perhaps there is a slight justification when utilizing this philosophy because although Dunaway's privacy was violated and she was harmed, the fact that the picture and its story exists acts as an aid for an ethical discussion. Such a rationalization might be acceptable if I were thinking that way at the time. I wasn't.

The philosophy of compromise, one that is often a solution for many ethical dilemmas, is the **golden mean**. Instead of impulsively pressing the shutter button, I might have first explained to her the situation and asked her if I could take a photograph. She would have said no, of course, but I would feel better about myself.

The next two philosophies of the six used in this book encourage you to consider those in the picture and those who view the image.

The **golden rule**, the oldest of any of the philosophies mentioned and the **veil of ignorance**, the most recent one, both encourage you to put yourself in someone else's position or situation. Ask: Would *you* want to be photographed in such a manner given a similar situation and do you think someone needs to see it? No and no.

Finally, and saving the worst for last, is **hedonism**. Perhaps not surprisingly, this philosophy is another ancient way of describing a common human behavior. Anytime you perform an action based on purely personal motivations – to win favor from another, to win a contest, to earn some monetary advantage, and so on – you invoke a hedonistic attitude. I took Faye Dunaway's picture simply because I could. I misused my power as a journalist and a casual

observer in order to satisfy my own momentary and fleeting desire for attention. My ego got in the way of my better judgment.

My excuses? I was inexperienced, egotistical, and untrained. Although my major in college was photojournalism, I had been a newspaper photographer for less than two years. Although I had photographed indicted persons paraded in handcuffs known as "perp walks" for the benefit of the media by police personnel, I never encountered a famous person so distressed about me performing my professional duty. I was even a bit offended that she became so upset over me while I was doing my job. Because I was 20-something with a good paying job and a privileged position I thought I could do no wrong. My attitude at the time was that anyone on the other side of my lens was fair game for my photographic prowess. I was the hunter and everyone else the prey. Besides, there were awards to win and raises to be earned. I couldn't stop to think about the repercussions of my actions.

But perhaps the most telling excuse was that during my time as a student, I never took an ethics course. I only had classes that taught me how to use the equipment and techniques necessary to become a professional photographer. As I recall, ethical considerations were never emphasized in any of the instruction. I also completed liberal studies classes necessary to graduate, but I didn't take a single course on philosophy or ethics. In addition, after being hired, there were no opportunities for learning about ethics. The one exception were annual "Short Courses" sponsored by the National Press Photographers Association (NPPA) that in one day presented visual reporters and their work in a format that inspired storytelling techniques and respect for those within the frames, but without any organized presentation or discussion on ethical issues and analysis (NPPA, 2017).

The good news – this memory of the brothers' reunion and Ms. Dunaway's surprising reaction started me on a path of learning and writing about ethical behavior with this textbook being the latest installment of my journey – an after-the-fact utilitarian justification. By the way, if you know Faye Dunaway or how to contact her, let me know. I would love to apologize.

Visual Ethics is Your Personal Journey

Ethics has personal and professional components. Visual communicators must juggle positive personal values with unique role-related responsibilities. As a journalist or documentary image-maker, you are a surrogate for the public. You are often the only witness to an event, the only recorder for history, the calm and cool explainer to others, as well as the educator and explainer. As a designer, editor, filmmaker, or advertising and public relations professional, you are also a persuader, a propagandist, and an entertainer. How can you possibly be expected to be objective and subjective, impassive and emotional, uninvolved and engaged given the physical constraints, technological changes, and sociological pressures the mass communications profession offers?

Ethics.

The key to produce work that aids the common good and satisfies your need for storytelling is a continual, inquisitive, and consistent path toward ethical behavior. Consequently, an exploration of ethical behavior is a personal, emotional, and intellectual journey. It is the outcome of an open, questioning mind that desires progressive development. The quest toward ethical behavior also requires an understanding of your own values and loyalties that can cause conflicts between how you actually behave and how you should behave. And when you make an error in judgment, it takes a humble heart to learn from the experience and do better.

This book is dedicated to the notion that being an ethical visual communicator not only makes you a better person but also creates opportunities and storylines that you might have

overlooked in the past. As such, your personal growth, your career, and your profession can only be enhanced by focusing inward and outward.

Visual Ethics is inspired by an important work, *Photojournalism: An Ethical Approach* (Lester, 1991) that was published more than 25 years ago. In that work, philosophies, techniques, and issues important to the photojournalism profession were featured in chapters that emphasized three major concerns: Victims of violence, rights to privacy, and subject and image manipulations. Needless to mention, much has changed in the field of visual communication since *An Ethical Approach*. Hence, the main motivation for this book. *Visual Ethics* acknowledges a need for critical thinking and ethical behavior among those responsible for visual messages in all areas of mass communications while acknowledging the personal decisions and experiences that make us empathetic personas and dedicated professionals.

The main difference between *An Ethical Approach* and this book is that it goes beyond photojournalism ethics to include the professions and techniques of documentary and advocacy reportage, citizen journalism and activism, advertising and public relations, typography, graphic design, informational graphics, cartoons, motion pictures, television, computers, the web, augmented reality, games, immersive storytelling, social media, story selection, and editing. It should be obvious that in today's complex media environment propelled by technological advances made possible by the web and the development of apps, visual communication is a field that requires serious contemplation and a guide that showcases the best practices possible.

This book offers many examples produced by working professionals that may or may not be directly related to your present interests. No matter. You will learn from all of the varied perspectives. This work also includes intellectual discussions that illuminate technical considerations and philosophical justifications, opportunities to discover your own values and conflicts, and perhaps even a few inconsistent and confusing viewpoints. The goal of *Visual Ethics* is to challenge your own opinions about what is and is not ethical behavior within a wide variety of visual communication presentations. Consequently, the journey you've started by reading this preface may be a tough slog. It is never easy to look deeply into yourself and bring to light the motivations for your actions. In addition to that daunting task there is another idea you must accept – your ethical exploration should never end. Being ethical in your personal and professional lives means constantly evaluating yourself for as long as you live. Luckily, it's not as difficult as you might think. That's because the most important trait that you should already possess is having a concept of empathy. As you continue with your life and career and all the decisions and actions yet to come, if you simply and honestly consider what someone else thinks and feels as a result of your actions, in other words, if you are an empathetic person, you will more likely be an ethical visual communicator.

References

"*Bonnie and Clyde*, (1967), We Rob Banks Scene." (2015). YouTube. Accessed June 28, 2017.

"Faye Dunaway." (2017). Internet Movie Database. Accessed June 28, 2017 from https://www.youtube.com/watch?v=2GM0LKQ-ml0 and http://www.imdb.com/name/nm0001159/?ref_=nv_sr_1.

Lester, P. (1991). *Photojournalism: An ethical approach*. Accessed June 28, 2017 from http://paulmartinlester.info/writings/pjethics.html.

Lester, P. (2017). Accessed June 28, 2017 from http://paulmartinlester.info/dunaway.jpg.

NPPA. (2017). Accessed June 28, 2017 from https://nppa.org/.

ACKNOWLEDGMENTS

This book would not be possible without the love from xtine, Allison, Parker, and Martin, the support from Martin and Sam – Los Tres Martins (we're working on a logo), professionals who contributed their expertise and time for insightful interviews – Jim Collins, Sarah Hill, Kenny Irby, Stephen Katz, Lisa Lange, Nick Oza, Denis Paguin, Emmanuelle Saliba, Judy Walgren, the anonymous reviewers, and the ever patient, yet persistent professionals of Focal Press/Routledge who include William Burch, Alison Jones, and Judith Newlin. Any ethical growth I have made in my life is because of them.

Any transgressions along my journey are my own damned fault.

Stephanie thanks first Paul Martin Lester for conceiving this project and leading it through to completion. We are three Martin writers, but he is the lead and his ethics are beyond question. Thanks, too, to his wonderful family – xtine, Allison, Parker, and Martin – for sharing Paul with us. I'm grateful as well to my wonderful division at SMU who never fail to extend me the time and space I need to write and think and who insist that our work be both ethical and good.

On a personal note, special thanks to Ivan Butterfield (and Marge!) who taught me everything I know about photography, to my parents who taught me to ask hard questions and look for good in the world, to Stefanie Barraco Zmich who is never far from my mind when I'm thinking about ethics and the First Amendment (she knows why), to my wonderful Paco, who makes being the partner of an academic seem like an easy gig (which it is not!), and to Niles and Tate who are the world – the whole, wide world – to me.

Martin celebrates his better half Pamela and his direct descendants Wilson and Katherine with his contributions to this book.

1

ETHICAL ISSUES AND ANALYTICAL PROCEDURES

Whenever I'm asked what I teach and I mention mass media ethics, the reaction is almost always a cynical smirk with a comment such as, "Well, that must keep you busy." The implication being, of course, that the media is so unethical that I can't possibly discuss all of the publicized and controversial dilemmas that mass media professionals are accused of in sixteen weeks. The general characterization is unfair and rises to the level of a stereotype when critics, mostly political candidates and their supporters, label journalists as the "lamestream media" and a presidential candidate calls a reporter a "sleaze" and complains about libelous and dishonest stories. Nevertheless, it is difficult at times to defend some questionable and cringe-worthy actions reported in the media.

To name a few recent media examples from advertising, entertainment, journalism, and public relations sources: Pop star Meghan Trainor removed a music video in which the producers digitally slimmed her waist without, as she claims, her approval (Turner, 2016). KTLA Los Angeles meteorologist Liberté Chan was offered a sweater during a live report to cover her bare shoulders (Politi, 2016). A Planned Parenthood employee discussed fetal remains in a hidden and edited video ("Investigative footage," 2017). The actor Sean Penn interviewed the (then) fugitive Joaquin "Shorty" Guzman for *Rolling Stone* magazine (Penn, 2016). Alison Parker and Adam Ward were killed during a live television broadcast (McLaughlin and Shocichet, 2015). Beyoncé's album "Lemonade" featured her husband Jay-Z's marital infidelities (Pareles, 2016). TMZ paid for recordings that featured former owner of the Los Angeles Clippers Donald Sterling stating racist opinions to his friend, V. Stiviano ("Clippers owner," n.d.). A Twitter user posted personal information about several prominent Chinese citizens (Forsythe, 2016). A Sky News reporter looked through damaged luggage from Malaysian Airlines flight 17 shot down over the Ukraine to learn a victim's name before family members could be notified (Brown, 2014). NBC anchor Brian Williams was removed from his prestigious position after he admitted he exaggerated his war coverage experiences (Byers, 2015). The website Gawker aired film of the former wrestler Hulk Hogan having sex; he was later awarded $115 million for the privacy breach through a lawsuit financed by the billionaire Peter Thiel ("Hulk Hogan," n.d.). "Saturday Night Live" produced a parody of a Toyota Camry commercial of a father leaving his daughter at an airport to join ISIS and not the Army as in the car advertisement ("Father daughter ad," 2015). Apple CEO Tim Cook refused to help the FBI by cracking open an

iPhone used by a mass killer ("Apple CEO," 2016). As Sonny and Cher once sang, "The beat goes on."

However, not all questionable actions rise to the level of unethical behavior. How do you know what is and is not ethical? As you will learn in this chapter, you should only come to a conclusion about an action after a careful and systematic consideration of the issues involved. In other words, you should not use an initial gut reaction to determine your response. Before you learn the systematic ethical analysis (SEA) procedure used in this book, you must first understand the definition of ethics.

What is Ethics?

Ethics is the study of how people *actually* behave and how they *should* behave toward other persons, sentient beings (animals that can feel pain or discomfort), and systems (academic, business, economic, environmental, governmental, and so on). Simply noting the questionable behavior as in the examples above is a not too illuminating form of ethics named descriptive. It is all well and good to call out behaviors that you suspect to be unethical, but such labeling doesn't advance the field and definitely doesn't lead to better behavior. It is another form of ethics – normative – that helps us all progress. After a deliberate process such as the SEA, normative ethics concludes how individuals should have performed. With normative ethics credible alternatives are offered to guide others in what should have been done so they might do the right thing.

Many seem to confuse the concept of morals and ethics. Although interconnected, their differences are important and should be understood. Knowing what is right, good, and acceptable and what is wrong, bad, and unacceptable is being moral. Morality, then, is concerned with judgment while ethics is concerned with behavior. The concepts are interconnected because the actions we take should be based on what we think is correct. We are taught the difference between right and wrong and how we should act given a unique set of circumstances throughout our lives by friends, caregivers, role-models, educational opportunities, as well as the millions of tiny and significant everyday and life-changing and affirming experiences that fill our minds with memories, questions, and solutions. Another crucial educator in our quest toward moral development and ethical behavior is the media, which is why the study and practice of mass communications is so vital.

The approximately 2,500-year history of philosophical thinking concerned with ethical behavior can be summed in one sentence introduced in the preface, the ethics mantra:

Do your job and don't cause unjustified harm.

As long as you attempt or accomplish the unique role-related responsibilities that define your position, whether personal or professional, and any injury you may cause to another while performing those duties can be justified, you are most likely acting ethically.

We all demonstrate diverse and often complex jobs or roles throughout our personal and professional lives. We may be children, friends, students, caregivers, parents, consumers, teachers, office workers, creators, managers, and so on. Each role signifies a complex interrelated structure composed of responsibilities that define that position. A friend, for example, initiates contact, cares for another, offers advice, is reliable and consistent. An instructor writes a syllabus, meets with a class, gives lectures, and assesses assignments. However, a friend might also give critical advice or reveal a secret that may be tough to hear while an instructor might give tough exams, assign 20-page term papers, write critical remarks about a student's work, and

give a less than favorable grade. Friends and instructors sometimes cause harm. However, there is no ethical slight if that harm can be justified. A friend cares and speaks the truth. A teacher is concerned that you understand the material conveyed during lectures and grades work with competence and objectivity. Any harm, hurt feelings or a "C" in the class, is therefore justified.

Five Areas of Ethical Concern

As mentioned in the preface (what, you didn't read it?), the inspiration for this book in your hands is one published in 1990, *Photojournalism: An Ethical Approach*. In the earlier work, three major concerns for visual communicators were stressed – victims of violence, rights to privacy, and subject and image manipulations. This book adds two more concerns to the list – persuasion and stereotypes.

Victims of Violence. After a gruesome image of dead or grieving victims of a tragic event is presented to the public in either the print or screen media, many viewers are often repulsed and offended by the picture. Nevertheless, violence and tragedy are staples of American journalism. "If it bleeds, it leads" is a popular, unspoken sentiment in many newsrooms. The reason for this obvious incongruity is that a majority of viewers are attracted and intrigued by such stories. Photojournalists who win Pulitzer Prizes and other international competitions are almost always witnessing excruciatingly painful human tragedies that nevertheless get published or broadcast. It is as if viewers want to see violent pictures, but through gaps in the fingers in front of their face. Not surprisingly, most letters to editors, news directors, and website managers from concerned members of the public have to do with violent images than any other visual communication concern.

But not all violent images come from tragic news stories. In 2017 comedian Kathy Griffin, known for her caustic comments to reporter Anderson Cooper on New Year's Eve television specials, was photographed by Tyler Shields, a former professional inline skater, looking at the camera, unsmiling, and holding a gruesome bloody head of a realistic likeness of President Trump ("Kathy Griffin," 2017). In a tweet Cooper wrote, "For the record, I am appalled by the photo shoot Kathy Griffin took part in. It is clearly disgusting and completely inappropriate." Griffin in a video tweet said, "I beg for your forgiveness. I went too far. I made a mistake and I was wrong." Griffin was fired from her 10-year gig at CNN and lost product endorsement deals and bookings. Shields told a TMZ reporter, "You make art, you gotta stand by it. I can't censor myself." File this tale in the "What Did You Expect?" folder.

Rights to Privacy. Ordinary citizens or celebrities who are suddenly thrust in front of the unblinking lens of a camera because of a connection to some sensational news story almost always voice privacy concerns. Seldom do you hear viewers complain about violating someone else's right to privacy. Courts in America have consistently maintained that privacy rights differ between private and public persons. Private citizens have much more strictly enforced rights to their own privacy than celebrities who often ask for media attention. Not surprisingly, celebrities bitterly complain when they are the subject of relentless media attention because of some controversial allegation. For private or public citizens, perhaps the most stressful news story is the funeral of a loved one. Sometimes a person's privacy is more important than getting a story. Besides ethical considerations related to privacy, legal issues or torts should be a part of the calculus of whether an image should be taken, obtained, or made public ("The privacy torts," 2002). The legal scholar William Prosser wrote in 1960 of four torts that define the legal concept of privacy: Intrusion upon seclusion or solitude, public disclosure of embarrassing private facts, publicity which places a person in a false light in the

public eye, and appropriation of a name or likeness. As a rule to guide you, ethics should always trump legal considerations. Rather than die from the flames and smoke filling the floors of the World Trade Center on 9/11, about 200 of the trapped victims decided to end their lives by jumping out of windows ("9/11 jumpers," 2017). "Jumpers" was the name given to them by the New York City medical examiner who ruled that they did not commit suicide, but were victims of a homicide. Although many visual reporters fulfilled their role-related responsibility (a categorical imperative philosophy) and photographed the jumpers, most news entities did not show the images to the public. Nevertheless, many can be found on YouTube with warnings (a golden mean perspective) about "graphic content," "viewer discretion is advised," and "not for children." *9/11: The Falling Man* is a documentary film based on Associated Press photographer Richard Drew's photograph of a man falling from the north tower (*9/11: The Falling Man*, 2006). It is a thorough and ethical investigation into the probable identity of the victim.

Subject, Image, and Context Manipulations. Deception has been a part of photography since it was first invented. Stage-managing, the arrangement of objects and persons within a frame as if they were props for a theatrical presentation, is probably ethically acceptable with photographic portraits, advertising set-ups, media and photo op events, and fictionalized motion picture and television productions. However, when stage-managing is used in news photography or documentary films, the practice is often criticized. One of the most recent blatantly unethical examples of stage-managing came after the Brussels terrorist attacks in 2016 when footage from a Fox News report clearly revealed photojournalist Khaled Al Sabbah directing a young girl near a memorial to the victims (Jamieson, 2016). Fortunately, it is rare for a visual reporter to manipulate a story so blatantly, but photographers often stage-manage a scene unwillingly. Alex Cooke writing for Fstoppers reports that anthropologist and photojournalist Ruben Salvadori produced a short film that revealed how "the presence of a myriad of photographers with large cameras tends to encourage an exaggeration of normal behavior that lends the drama they seek" (Cooke, 2016). Even during violent clashes with military personnel, as those covered by Salvadori in East Jerusalem, there are lulls in the action that aren't necessarily photogenic or news-worthy. However, with 20 photojournalists pointing their cameras at protesters, many times a tacit agreement of action will be induced. Visual reporters working on news events should never alter the actions of those around them either through direct or implied consent. That injunction is a categorical imperative and a role-related responsibility.

Image manipulations through digital technology are relatively easy to accomplish, hard to detect, and perhaps more alarming, often alter the original image so that checking the authenticity of the picture is impossible. Some critics have predicted that in a few years, images – whether still or moving – will not be allowed in trials as physical evidence because of the threat to their veracity created by digital alterations. Cameras and the images they produce are naively thought by many to never lie. But because humans operate the machine, technical, composition, and content manipulations are unavoidable. Computer technology did not start the decline in the credibility of pictures, but it has hastened it.

Persuasion. The Dean of a school of communication once told me that "All communication is persuasion." Whether that statement is literally true is up to you to decide, but in many situations – convincing a friend to see a certain movie or eat at a particular restaurant to attempting to convince your professor to give you a higher grade on your essay or your boss to give you a raise – we all use persuasion in our daily lives. Media personnel use factual information, seemingly credible sources, and emotional appeals to educate a reader or viewer about a particular situation, to change a person's mind on a topic of concern, and to promote

a desired behavior or action. As we become dependent on visual messages to communicate complex ideas, information relies on the emotional appeal inherent in visual presentations. And because the fields of advertising, public relations, and journalism can often be used by savvy practitioners, the blurring between corporate, governmental, and editorial interests for persuasive purposes is one of the most pressing concerns of media critics today.

Writing for *The New Yorker* magazine, Alexandra Schwartz reviewed an exhibit, "Crime Stories: Photography and Foul Play" that was shown at the Metropolitan Museum of Art in 2016 with the headline, "The Long Collusion of Photography and Crime" (Schwartz, 2016). Pictures dating from the 1800s revealed police officials showing off their caught criminals, wanted posters, executions, crimes in progress, sympathetic portraits of killers, and victims of murder. Schwartz noted that the exhibit raised ethical issues related to the "American attraction to criminal glamour, and our queasy, not always critical fascination with looking at violence – are the right ones to ask during the current vogue for 'true crime,' that funny phrase we use for stories told in public about terrible things others suffer privately." The show makes clear that photographers are often, perhaps unknowingly, used by others to forward a persuasive agenda imposed by authority figures, social critics, and commercial entities.

Visual journalists often want their viewers to care for the sources of their stories. Motion picture and television producers want you to enjoy a picture or program so you will tell your friends to see the presentation. In addition, politicians employ a public relations staff to put a positive "spin" on a situation and to set up media events and photo ops that show their candidate or government official in the best light possible.

With so much expertise in the White House, it is surprising when a seemingly controlled event is marred by insensitivity or incompetence. Philip Bump of *The Washington Post* reported on a photo op that went awry for the Trump Administration when senior advisor Kellyanne Conway was pictured with her feet on a couch in the Oval Office looking through her smartphone while a group of educators from traditionally African American universities and colleges posed with the president (Bump, 2017). Conway was accused of being a distraction when the focus of the event should have been on the leaders' visit. As Bump concluded,

> Events like this are the lowest-hanging fruit for a politician. Come in, listen for a bit, take a photo, move on. It's rarely the case that such events create new policy, but it's probably even rarer that they end up creating a media firestorm. It's like the Trump team stepped up to the plate in a game of tee-ball, and somehow ended up spraining an ankle while hitting into a double play.

Persuasion often is a double-edged sword.

Stereotyping. African Americans are criminals. European Americans are racists. Mexicans are rapists and drug dealers. Native Americans are alcoholics. Gays are effeminate. Lesbians wear short hair. Transgender persons are pedophiles. Those who use wheelchairs are helpless. Older adults need constant care. Homeless people are drug addicts. Sensational politicians, inexperienced individuals in interviews and on social media, and images presented in the media perpetuate these prevalent stereotypes. For example, it is easier and quicker for a visual communicator to take a picture of an angry African American during a riot than to take the time to explore in words and pictures the underlying social problems that are responsible for the civil disturbance. Stereotypical portrayals of ethnic, gender, physical characteristics, sexual orientation, and job-related cultural groups are a result of communications professionals being

lazy, ignorant, or racist. As with the printing term from which the word comes, to stereotype is a shorthand way to describe a person with collective, rather than unique characteristics. Visual stereotypes are easily found in all manner of media, but not easily defended.

Gap is a clothing company headquartered in San Francisco that has been in business for more than 45 years and with more than 3,500 stores worldwide. And yet, in 2016 a seemingly innocent advertisement that showed two young models wearing snappy Gap clothing revealed the gap between gender portrayals. As described by Madeline Farber of *Fortune*, the ad sparked a firestorm of outrage on social media sites (Farber, 2016). The diptych featured a full-length image of a smiling boy pulling apart a collared shirt and jacket to show off a blue tee-shirt with the famous tongue-sticking-out head shot of Albert Einstein and the copy, "THE LITTLE SCHOLAR Your future starts here. Shirts + graphic tees = genius idea." Originally, the scientist's name on the shirt was misspelled as "Einstien," but was corrected after the typo was made known. The girl's portrait showed her as passive, arms at her side, and looking up. She wore silver animal ears on her head and a sweater that featured the letter G in pink. The picture was cropped at her waist. Her ad's copy read, "THE SOCIAL BUTTERFLY. Chambray skirts + logo sweaters are the talk of the playground." Comments from Twitter users included: "My daughter & son both love to have genius ideas – please don't limit them." A Gap spokesperson wrote, "we did not intend to offend anyone." For many of the unethical deeds performed by persons described in this book, innocence is often used as a defense when the hedonism philosophy is employed.

Regardless of the technology employed and the underlying purpose of the media message, the five concerns of violence, privacy, manipulations, persuasion, and stereotypes should be considered as you read through the subsequent chapters and carefully study the examples and case studies provided.

The Systematic Ethical Analysis (SEA)

The study of ethics has been improved and made easier to understand by orderly systems of analysis of particularly challenging case studies. Such procedures elevate the field of ethics past the banal descriptive level and toward the more illuminating and thoughtful normative goal. Remember, the end result of any SEA is to arrive at credible alternatives (the use of the plural is intentional – there is often more than one acceptable solution) given a set of facts that describe a particular ethical dilemma. The end result should be several reasonable solutions to a perplexing challenge.

The Ethics Unwrapped website sponsored by the McCombs School of Business at the University of Texas at Austin presents a two-step Systematic Moral Analysis (SMA) that has a goal to find alternatives that don't cause harm to other people (Elliott, 2017). This SMA is inspired by the work of the philosopher Bernard Gert who describes ten moral rules in *Common Morality: Deciding What to Do* that concentrate on actions that, when followed, minimize harm to yourself and others (Gert, 2004). His list of ten moral rules include seven negative requirements – do not kill, do not cause pain, do not disable, do not deprive someone of freedom, do not deprive someone of pleasure, do not deceive, and do not cheat – and three positive suggestions – keep your promises, obey the law, and do your duty. The two steps in the SMA, conceptualization and justification, are designed to help you understand who might be harmed and how that harm can be minimalized. For conceptualization, ask yourself who might be harmed and how is that harm administered by an action. For justification, does breaking a moral rule prevent a greater harm from occurring or does the harm you cause legitimately address a more significant harm that was

already caused? If an action causes the least harm to others, can withstand public scrutiny, and would be ethically permissible for anyone in a similar situation, it can be considered ethical.

The Swedish-born American philosopher Sissela Bok, one of the only persons whose parents are both Nobel Prize recipients, formulated a three-step SEA. Bok has written several books concerned with ethical behavior including *Mayhem: Violence as Public Entertainment* (1998) and *Lying: Moral Choice in Public and Private Life* (1999). Her deceptively simple solution to solving ethical dilemmas involves asking yourself how the facts of a case study make you feel, obtain assistance from experts in the field, and make your alternatives known to the public in order to refine your solution (Cohen, n.d.). Her SEA is an interesting combination of the personal and the community as she advocates an inner, self-awareness approach combined with an outward, public sharing of information.

Harvard professor of social ethics and theologian, Ralph B. Potter, Jr. developed a little more complex SEA that involved four steps popularly known as the "Potter's Box" (Christians et al., 2001). His procedure asks you to know all of the facts involved with a case study without any judgments or conclusions, identify the possible values of those involved based on an actor's personal and professional role-related responsibilities, consider philosophies such as Aristotle's golden mean, Immanuel Kant's categorical imperative, and John Stuart Mills' and Harriet Taylor's utilitarianism (don't panic – those philosophies and three others will be explained below). These philosophies can be employed to justify or criticize decisions made. Finally, Potter asks that you name the loyalties or allegiances that the actors of the dilemma may consider to be important. Unlike Bok's SEA, or the one used in this book, Potter's steps can be made in any order and repeated as the analysis becomes more thoughtful and sophisticated. In that way his "Box" becomes the "Potter's Circle." Potter's work is an important addition to the canon of ethical analysis with its emphasis on facts, values, philosophies, and loyalties, but the end result, although perhaps a satisfying intellectual experience, seldom leads to a definitive solution.

Many view the two-step SMA as described in the Ethics Unwrapped website, Bok's three-step approach, and Potter's Box/Circle, as insufficient for a thorough ethical analysis for use by professionals. Consequently, the ten-step SEA was developed to address the shortfalls in other analytical schemes and provides a clearer understanding of how to formulate credible alternatives to the actions presented by the facts of a case study.

The Ten-Step SEA

1. What are the three most significant facts of the case?

After a careful evaluation of all the known facts presented within a particular scenario, single out the top three facts that are the most important.

2. What are three facts you would like to know about the case?

You should have questions about the case study that are not answered by the facts presented. You may need to interview individuals, consult written records, explore the web, and so on to obtain a clearer idea of the facts and motivations of the actors involved with the case.

3. What is the ethical dilemma related to the case?

Most dilemmas come down to a conflict of interests between the various parties involved, but there may also be economic, privacy, and personal issues that motivate the dilemma.

4. Who are the moral agents and what are each person's specific role-related responsibilities (RRRs)?

A moral agent is any person or entity that can be held responsible for an action. Although it is rare to name a company as a moral agent, it does happen. During the Enron Corporation scandal of 2001, the auditing firm of Arthur Andersen, one of the largest in the world, was indicted by Federal prosecutors and found guilty. Children, prisoners, or anyone mentally incapacitated are often not considered moral agents because they often are not considered responsible for their actions. Defense lawyers often use a moral agent argument for clients involved in drinking-and-driving accidents. It rarely works. A clue in identifying RRRs is to note that they are always verbs.

5. Who are the stakeholders and what are each person's specific role-related responsibilities (RRRs)?

A stakeholder is anyone affected by a decision from a moral agent. It is important to note that a moral agent and a stakeholder cannot be the same person or entity.

6. What are the possible positive and negative values of all the moral agents and stakeholders named in Steps 4 and 5 and the two most opposite values from all the lists?

Values are general concepts (truthfulness, fairness, diversity, and so on) that correspond with the RRRs or attitudes of those involved.

7. What are the loyalties of the moral agents and stakeholders named in Steps 4 and 5 and the two most opposite loyalties from all the lists?

Loyalties are alliances based on promises to yourself or to others that come from reasonable expectations from their RRRs. Someone involved with a case might have loyalties to him or herself, to family members, to sources or clients, to an organization, or to a profession.

8. For each of the six moral philosophies used in this book describe either a justification or a criticism that can be applied to a moral agent or a stakeholder named in Steps 4 and 5 in the case study. In chronological order, the six philosophies are:

Golden rule. The golden rule, or the ethic of reciprocity, teaches persons to "love your neighbor as yourself." This theory has been attributed to ancient Greek philosophers such as Pittacus of Mytilene (died 568 BCE), considered one of the "Seven Sages of Greece," who wrote, "Do not to your neighbor what you would take ill from him;" Thales of Miletus (died 546 BCE), another Sage of Greece who said, "Avoid doing what you would blame others for doing;" and Epictetus (died 135 CE), a Stoic philosopher who wrote, "What thou avoidest suffering thyself seek not to impose on others." In fact, every major religion has some variable of the golden rule as a part of their scriptures and/or teachings. This philosophy holds that an individual should be as humane as possible and try not to harm others by insensitive actions (Puka, n.d.).

Hedonism. From the Greek word for pleasure, hedonism is closely related to the philosophies of nihilism and narcissism. A student of Socrates, Aristippus (who died in Athens in 356 BCE) founded this ethical philosophy on the basis of pleasure. Aristippus believed that people should "act to maximize pleasure now and not worry about the future." However, Aristippus referred to pleasures of the mind – intellectual pleasures – not physical sensations. He believed that people should fill their time with intellectual pursuits and use restraint and good judgment in their personal relationships. His phrase sums up the hedonistic philosophy: "I possess; I am not possessed." Unfortunately, modern usage of the philosophy ignores his original intent. The Renaissance playwright and poet Ben Jonson, a contemporary of William Shakespeare, once wrote one of the best summaries of the hedonistic philosophy, "Drink today, and drown all sorrow; You shall perhaps not do it tomorrow; Best, while you have it, use your breath; There is no drinking after death." Phrases such as "live for today" and "don't worry, be happy" currently express the hedonistic philosophy. If an opinion or action is based purely on a personal motivation – money, fame, relationships, and the like – the modern interpretation of hedonistic philosophy is at work. Not surprisingly, most unethical decisions are based on hedonistic inclinations while most actors who use the philosophy are loath to admit it (Weijers, n.d.).

Golden mean. Aristotle was born near the city Thessaloniki in 384 BCE. As his parents were wealthy, he studied at the Athens-based Academy led by the renowned Greek philosopher Plato, who was a student of Socrates – the SPA succession of Greek philosophical education – Socrates to Plato to Aristotle. After learning and teaching at the Academy for 20 years, Aristotle traveled throughout the region studying the biology and botany of his country. He was eventually hired as a tutor for Alexander the Great and two other kings of Greece, Ptolemy and Cassander. When he was about 50 years old he returned to Athens and began his own educational institution, the Lyceum, where he wrote an astounding number of books on diverse subjects that made breakthroughs in science, communications, politics, rhetoric, and ethics. He was the earliest known writer to describe the phenomenon of light noticed by a *camera obscura* that eventually led to a further understanding of how the eyes and the photographic medium work. Although the golden mean was originally a neo-Confucian concept first espoused by Zisi, the only grandson of the Chinese philosopher Confucius, Aristotle elaborated on it for Western readers in his book *Nicomachean Ethics*, named after his father. The golden mean philosophy refers to finding a middle ground or a compromise between two extreme points of view or actions. The middle way doesn't involve a precisely mathematical average but is an action that approximately fits that situation at that time. Generally speaking, most ethical dilemmas are solved with the golden mean approach ("Golden mean," 2007).

Categorical imperative. Immanuel Kant was born in Königsberg, the capital of Prussia (now Kaliningrad, Russia) in 1724. The fourth of 11 children, at an early age he showed intellectual promise and escaped his crowded household to attend a special school. At the age of 16 he graduated from the University of Königsberg, where he stayed and taught until his death. Kant never married and never traveled farther than 100 miles from his home during his lifetime. Thirteen years before his death in 1804, he published *Critique of Pure Reason*. It is considered one of the most important works in philosophical history. In it Kant established the concept of the categorical imperative. *Categorical* means unconditional, and *imperative* means that the concept should be employed without any question, extenuating circumstances, or exceptions. Right is right and must be done even under the most extreme conditions. Consistency is the key to the categorical imperative philosophy. Once a rule is established for a proposed action or idea, behavior and opinions must be consistently and always applied in

accordance with it. But for Kant, the right action must have a positive effect and not promote unjustified harm or evil. Nevertheless, the categorical imperative is a difficult mandate to apply (McCormick, n.d.).

Utilitarianism. The legal scholar and philosopher Jeremy Bentham developed his theory of utility, or the greatest happiness principle, from the work of Joseph Priestley, who is considered one of the most important philosophers and scientists of the eighteenth century. Bentham acknowledged Priestley as the architect of the idea that "the greatest happiness of the greatest number is the foundation of morals and legislation." John Stuart Mill was the son of the Scottish philosopher James Mill and was tutored for a time by Bentham. Mill along with his wife, Harriet Taylor, expanded on Priestley and Bentham's idea of utilitarianism by defining different kinds of happiness. For Mill and Taylor, intellectual happiness is more important than the physical kind. They also thought that there is a difference between happiness and contentment, which is culminated in Mill's phrase, "It is better to be a human being dissatisfied than a pig satisfied; better to be Socrates dissatisfied than a fool satisfied." In utilitarianism, various consequences of an act are imagined, and the outcome that helps the most people is usually the best choice under the circumstances. However, Mill and Taylor specified that each individual's moral and legal rights must be met before applying the utilitarian calculus. According to them, it is not acceptable to cause great harm to a few persons in order to bring about a little benefit to many. By the way, the reason history seldom acknowledges the important work of Harriet Taylor is that social customs of the day (and most saliently economic factors that influenced the publisher) denied Taylor her rightful place as an important contributor and co-author (Nathanson, n.d.).

Veil of ignorance. Articulated by the American philosopher John Rawls in his book *A Theory of Justice* in 1971, the veil of ignorance philosophy considers all people equal as if each member were wearing a cover so that such attributes as age, gender, and ethnicity could not be determined. Under such a rhetorical exercise, no one class of people would be entitled to advantages over any other. Imagining oneself without knowing the positions that one brings to a situation results in an attitude of respect for all involved. The phrase "walk a mile in someone's shoes" is a popular adaptation of the veil of ignorance philosophy. It is considered one answer to prejudice and discrimination. Rawls taught at Harvard University for almost 40 years. In 1999 he received the National Humanities Medal from President Bill Clinton, who said that he "helped a whole generation of learned Americans revive their faith in democracy itself." It is this philosophy that advocates the value of empathy that should be a prime motivating influence for mass communicators. A professional who exhibits empathy, as explained by John Rawls, is one who cares as much about others as she cares about herself ("Veil of ignorance," 2017).

9. What creative and/or credible alternatives could resolve the issue?

Many times, a far-fetched, creative, unrealistic, and even wacky idea will trigger a way of looking at a situation in a different way so that a credible alternative emerges. You should come up with two creative and at least two credible alternatives.

10. What would you do as a member of the media?

As advocated by Sissela Bok in her three-step SEA, this final step asks you to make known your personal reaction to the case study being analyzed. Pretend you are a specific media professional involved with the case. What action would you take and why?

The SEA. Nothing to it, right? There's an old joke that I shouldn't even mention because I'm sure you've heard it, but I don't care because I can't see your reaction. It starts with a flummoxed tourist lost in New York City on her way to a concert. She stops a fast-walking passerby on the sidewalk and asks, "How do you get to Carnegie Hall?" Without missing a beat, the hardened New Yorker answers, "Practice, practice, practice." How do you get comfortable in using the SEA to solve your ethical dilemmas whether you are home alone with plenty of time to think about each step, on location at an assignment when you need an immediate answer, or with a group of your co-workers waiting for your solution because they know you read this book? Okay, you've got it. The Canadian author and journalist Malcolm Gladwell (*The Tipping Point, Blink, What the Dog Saw*, and *David and Goliath*) famously introduced in his book *Outliers: The Story of Success* the concept of the 10,000-hour rule (2017). He asserts that if you practice anything – from playing the guitar to learning a philosophical approach – for 10,000 hours you will become a world-class practitioner or expert. To put it in perspective, if you worked on an activity for eight hours a day, six days a week (I assume you take Fridays off), for 50 weeks a year (again, I'm assuming you take a week off in August and in March), in a little more than four years you would be the master of your domain (a blatant "Seinfeld" reference). But let's get real. Eight hours a day? More realistically, if you practiced one hour a day three days a week for 30 weeks a year, you would achieve the goal of mastery in a mere 111 years. With this book you have the opportunity to become a visual ethics expert. At the end of each chapter there will be case studies in which you can practice with the SEA for as many hours as you choose.

SEA Analysis by Nikky Farinas

2016 Elections: False Balance

Brief Summary

This case study highlights the idea of a "false balance" in the media, during the presidential election campaign of 2016, in an article by Liz Spayd (2016), the former public editor for *The New York Times*. This method of journalism ensures that both candidates are portrayed in the same light. Fairness being the main priority and not truth. This type of "balanced" coverage equates something minor and major in order to give candidates the same amount of coverage. This type of journalism has been criticized because it "masquerades as rational thinking." For example, during the campaign people started to equate Hillary Clinton's use of private email servers with the charge that Russian officials hacked into American computers. This strive for "balance" urged journalists to prioritize equal coverage rather than reporting facts.

Step 1: Three Significant Facts

1. One interesting fact from this article is that this year's candidates had "the lowest approval ratings in history." Spayd (2016) argues that this may be why journalists are having such a hard time covering the election. "Journalists are accustomed to covering candidates who may be apples and oranges, but at least are still both fruits." This is significant because it becomes clear that we have never had a

candidate like Donald Trump. This election can serve as a learning experience for journalists and the media.

2. Spayd (2016) claims that a media who heavily favor one candidate is not the key to fair journalism. Rather, she claims that what is needed is more honesty and truthful reporting. No more striving for a "false balance," just reporting the absolute truth whether it's majority is good or bad for a candidate. It is important for journalists to understand that there is a solution to "false balance" in order for them to fix that problem.

3. Although Spayd (2016) targets journalism as a whole she does mention that "false balance" takes place mostly on "opinion pages and social media." This is significant considering the amount of people that use social media sites as their only source of news. If the only content being given to them contains the "false balance" style of writing, they mold their opinions based on a biased article.

Step 2: Facts to Know

1. Is there a punishment for publishing "false balanced" stories?

Although there is no punishment for publishing "false balanced" stories because it is not flat out lying about the candidates, but rather an exaggeration, there is also no punishment for publishing false news unless the news causes harm to someone or violates human rights ("False news", n.d.).

2. As mentioned earlier, most of the "false balanced" stories took place on social media platforms and opinion pages. What percentage of voters got their information off websites like Facebook?

According to Vox, around 44 percent of voters received their news from Facebook while 9 percent received their news from Twitter (Lee, 2016).

3. Why does it matter that these "false balanced" stories are published on Facebook, a social media platform and a news platform?

Things we see on social media can trigger our way of thinking. A "study found that 41 percent of young people between the ages of 15 and 25 had participated in some kind of political discussion or activity online" (Green, 2016). That's close to half of the percentage of young people voicing their opinions and obtaining information on social media platforms.

Step 3: The Ethical Dilemma

The issue here is that the story the journalists are trying to report ends up being manipulated. As they strive for "balance" between the candidates, "the press unfairly equates a minor failing of Hillary Clinton's to a major failing of Donald Trump's" (Shafer, 2016). Journalists strive to stay impartial during elections, however this method can be detrimental to people's way of thinking. This is important because "A balanced treatment of an unbalanced phenomenon distorts reality" (Vanden Heuvel, 2014). This sort of biased style of journalism can be especially detrimental during an election year which is when many journalists strive for an even more balanced style of writing that is unbiased. Bias promotes a group of people, person, or

idea which "is a violation of the principle of journalistic ethics" ("Journalists Ethics Code", n.d.). Bias and false balance "may prompt that news organization to right a wrong and take up an unpopular cause" (Dean, n.d.).

Step 4: Moral Agent and RRRs

Journalists. They report current and important events, assure the public that they are receiving all the facts accurately, report the story to the public, remain unbiased but truthful in all reporting.

Step 5: Stakeholders and their RRRs

The public. As citizens it is their duty to educate themselves on the two candidates which can be difficult when journalists are giving them "falsely balanced" stories, to vote and make a decision based on information they receive about the candidates.

The candidates. Aside from their own media they put out into the public, their public image relies heavily on journalists; it is their role to win over the people of America which is done mainly through their public image.

Step 6: Values

Reporters: Ethical, truthful, unethically striving for balance
The public: Impressionable, civic minded, logical
The candidates: Civic minded, ambitious, selfish
Most opposite values: Ethical vs. selfish

Step 7: Loyalties

Reporters: Themselves, the public, their employers
The public: Themselves, the candidates, their fellow Americans
The candidates: Themselves, their party, the public
Most opposite loyalties: Reporters vs. Candidates

Step 8: The Six Philosophies

Categorical imperative: The categorical imperative philosophy is not a set of rules that is given, but rather it is "supposed to provide a way for us to evaluate moral actions and to make moral judgments" (Pecorino, 2002). As global citizens there is a moral expectation that everybody adheres to the rules. As servants to the public, journalists have a greater expectation to follow this philosophy.

Utilitarianism: In the utilitarian world, their main concern is that we make choices in our lives that "maximize utility, i.e. the action or policy that produces the largest amount of good" (Nathanson, 2016). It is the journalists' main goal to do as much good in the world by providing the public with as much truth and current news that is happening in the world at that time.

Hedonism: The philosophy of hedonism is that "all pleasure is intrinsically good, and nothing but pleasure is intrinsically good" ("Hedonistic theories," 2009). It focuses on the idea that pleasure is the only thing that brings value into our lives and anything less has no value (Moore, 2004). Most journalists follow this philosophy to a certain degree. Otherwise,

"false balance" wouldn't exist. False balance strives to be equal to promote "fairness and equality" to these candidates, ideas that promote pleasure and goodness.

The golden rule: The golden rule is one that is known worldwide and valued in different traditions and philosophies. It appeals to need of humans to have fairness and goodness in their lives. "The Golden Rule also emphasizes values of mutuality, interdependence and reciprocity" ("Understanding the Golden Rule," 2016). Journalists follow this rules in their everyday practice, or else they wouldn't be in the career path they are on now. Journalists have a sort of "watchdog" protection over the public and this sense of duty to help the public, a sort of interdependence relationship.

The golden mean: Put plainly, the golden mean is the mean between two extremes. When you pick the mean, you are seen as acting morally ("Aristotle – The Golden Mean," 2016). The golden mean is what is suggested that journalists do in order to rid the journalism world of "false balance." Not to exaggerate the bad things candidates have done and not to hide the better aspects of the candidates either, but rather to report the story just as it is.

Veil of ignorance: The veil of ignorance is a philosophy in which people are not judged based their "personal characteristics and social and historical circumstances" (Freeman, 2014). Journalists invoke the veil of ignorance when they report their stories with complete truth and unbiasedness. However, this is the philosophy that tends to be forgotten once journalists start adhering to the idea of a "false balance."

Step 9: Creative and Credible Alternatives

Creative: Ban any journalist who functions under the "false balance" style of writing. Place the journalist on a "do not hire" or "do not publish" list. This would prevent them from having their "false balance" style of writing from being publishing. This ban would only last for 6 months before the journalist could have their work published again.

Creative: Have journalists pick a party to affiliate with and only write about that party's candidate. This would eliminate any need for the journalists to be "fair & balanced" when reporting about the election.

Credible: Journalists be made more aware about "false balance" therefore they can be more conscious of their writing style while covering the election. The more other journalists reprimand other journalists for this type of writing the more journalists will be aware that this style of writing is looked down upon.

Credible: Journalists make an effort to write better stories. Stories that don't strive to be "equal" but rather, truthful. It can also be an option that editors be in charge of assuring that stories with a "false balance" styles of articles are not published.

Step 10: What Would You Do as a Media Professional?

If I were a media professional, I would try and assure that stories are better written. I would encourage news directors and editors to be more alert to the stories they publish. This encourages more awareness and double-checking of the angles of how stories are being written and that they aim to be truthful and not only "fair."

Annotated Sources

Lester, P.M. (2010). "Ethics and images: Five major concerns," in *Journalism Ethics: A Philosophical Approach*, Christopher Meyers (Ed.). New York, NY: Oxford University Press, pp. 351–358.

In this piece, Paul Lester briefly defines visual ethics. He explains that while some people, perhaps especially reporters, think of news photography as easy, it is actually extremely powerful and more likely to be remembered by readers than are words. Moreover, because pictures tend to capture the shocking, the violent, and the strange with particular precision, photographers have a special duty to take ethics seriously in applying their craft.

Lester, P.M. (2015). "Ethical and legal issues of concern," in *Digital Innovations for Mass Communications: Engaging the User*. New York, NY: Routledge.

Here, Lester outlines the relationship between privacy and ethics, and notes that what photographers, reporters and others can do *legally* is often different – that is, more permissive – than what they should do *ethically*. Lester describes how digital media and the advance of smartphone technology make it easier than ever for citizens to invade one another's privacy rights, sometimes for newsworthy purposes, and oftentimes not. The essay concludes with an alphabetized list of ethical concerns and possible injuries students should think through in deciding whether an action they might take is justified, or not.

References

"9/11 jumpers." (February 12, 2017). YouTube. Accessed June 28, 2017 from https://www.youtube.com/watch?v=X1FwibQhZoI.

9/11: The Falling Man. (2006). Internet Movie Database. Accessed June 28, 2017 from http://www.imdb.com/title/tt0810746/.

"Apple CEO Tim Cook explains why he is refusing FBI demand." (February 24, 2016). BBC News. Accessed June 28, 2017 from http://www.bbc.com/news/av/world-us-canada-35655688/apple-ceo-tim-cook-explains-why-he-is-refusing-fbi-demand.

"Aristotle – The Golden Mean." (2016). Retrieved December 2, 2016 from http://faculty.bucks.edu/rogerst/jour275morals.htm.

Bok, S. (1998). *Mayhem: Violence as Public Entertainment*. New York: Basic Books.

Bok, S. (1999). *Lying: Moral Choice in Public and Private Life*. New York: Vintage.

Brown, S. (July 24, 2014). "Sky News apologizes after reporter rifles through MH17 victim's luggage." CNN. Accessed June 28, 2017 from http://www.cnn.com/2014/07/21/world/europe/malaysia-airlines-sky-news-apology/.

Bump, P. (February 28, 2017). "The Conway picture is only a small error in Trump's swing-and-a-miss black college event." *The Washington Post*. Accessed June 28, 2017 from https://www.washingtonpost.com/news/politics/wp/2017/02/28/the-conway-picture-is-only-a-small-error-in-trumps-swing-and-a-miss-black-college-event/?utm_term=.bf2b857cac92.

Byers, D. (February 13, 2015). "Brian Williams' alleged lies: A list." Politico. Accessed June 28, 2017 from http://www.politico.com/blogs/media/2015/02/brian-williams-alleged-lies-a-list-202585.

Christians, C., Fackler, M., and Rotzoll, K.B. (2001). *Media ethics: Cases and moral reasoning* (6th ed.). New York: Longman.

"Clippers owner Donald Sterling to GF – Don't bring black people to my games, including Magic Johnson." (n.d.). TMZ. Accessed June 28, 2017 from http://www.tmz.com/videos/0_wkuhmkt8/.

Cohen, J. (n.d.). "Bok's model." Washington State University. Accessed June 28, 2017 from http://dtc-wsuv.org/jcohen/tools-for-ethical-decision-making/boks-model.html.

Cooke, A. (July 25, 2016). "Fascinating video reveals the manufactured nature of some photojournalism." Fstoppers. Accessed June 28, 2017 from https://fstoppers.com/bts/fascinating-video-reveals-manufactured-nature-some-photojournalism-139573.

Dean, W. (n.d.). "Understanding bias – American Press Institute." Retrieved December 07, 2016, from https://www.americanpressinstitute.org/journalism-essentials/bias-objectivity/understanding-bias/.

Elliott, D. (2017). "Systematic moral analysis." Ethics Unwrapped. Accessed June 28, 2017 from http://ethicsunwrapped.utexas.edu/video/systematic-moral-analysis.

"False news." (n.d.). Retrieved December 2, 2016, from https://www.article19.org/pages/en/false-news.html.

Farber, M. (August 2, 2016). "People are outraged by this 'sexist' Gap ad." *Fortune*. Accessed June 28, 2017 from http://fortune.com/2016/08/02/gap-sexist-ad-controversy/.

"Father daughter ad." (Season 40, 2015). SNL. Accessed June 28, 2017 from http://www.nbc.com/saturday-night-live/video/father-daughter-ad/2850279?snl=1.

Forsythe, M. (May 12, 2016). "Personal data of prominent Chinese posted on Twitter." *The New York Times*. Accessed June 28, 2017 from https://www.nytimes.com/2016/05/13/world/asia/personal-data-of-prominent-chinese-posted-on-twitter.html.

Freeman, S. (September 19, 2014). "Original position." Retrieved December 2, 2016, from https://plato.stanford.edu/entries/original-position/.

Gert, B. (2004). *Common morality deciding what to do*. London: Oxford University Press.

Gladwell.com (2017). Accessed June 28, 2017 from http://gladwell.com/.

"Golden mean" (July 25, 2007). American Nihilist Underground Society. Accessed June 28, 2017 from http://www.anus.com/zine/articles/draugdur/golden_mean/.

Green, R. K. (November 16, 2016). "The game changer: Social media and the 2016 Presidential Election." *Huffington Post*. Accessed December 06, 2016, from http://www.huffingtonpost.com/r-kay-green/the-game-changer-social-m_b_8568432.html.

"Hedonistic theories." (November 1, 2009). Retrieved December 2, 2016, from http://philosophy.lander.edu/ethics/hedonism.html.

"Hulk Hogan sex tape!" (n.d.). TMZ. Accessed June 28, 2017 from http://www.tmz.com/videos/0_8w7zoron/.

"Investigative footage." (2017). The Center for Medical Progress. Accessed June 28, 2017 from http://www.centerformedicalprogress.org/cmp/investigative-footage/.

Jamieson, A. (March 25, 2016). "Staged picture from Brussels bombing prompts ethics debate." *The Guardian*. Accessed June 28, 2017 from https://www.theguardian.com/media/2016/mar/25/staged-photo-brussels-attack-memorial-ethical-debate-photographers.

Journalists Ethics Code. (n.d.). Accessed December 07, 2016, from http://ethicnet.uta.fi/belarus/journalists_ethics_code.

"Kathy Griffin beheads Trump in shocking photo shoot." (May 30, 2017). TMZ. Accessed June 28, 2017 from http://www.tmz.com/2017/05/30/kathy-griffin-beheads-donald-trump-photo-tyler-shields/.

Lee, T. B. (2016, November 16). "Facebook's fake news problem, explained." Accessed December 1, 2016, from https://www.vox.com/new-money/2016/11/16/13637310/facebook-fake-news-explained.

McCormick, M. (n.d.). "Immanuel Kant: Metaphysics." Internet Encyclopedia of Philosophy. Accessed June 28, 2017 from http://www.iep.utm.edu/kantmeta/.

McLaughlin, E.C. and Shoichet, C.E. (August 27, 2015). "Police: Bryce Williams fatally shoots self after killing journalists on air." CNN. Accessed June 28, 2017 from http://www.cnn.com/2015/08/26/us/virginia-shooting-wdbj/.

Moore, A. (April 20, 2004). "Hedonism." Retrieved October 4, 2016, from https://plato.stanford.edu/entries/hedonism/.

Nathanson, S. (n.d.). "Act and rule utilitarianism." Internet Encyclopedia of Philosophy. Accessed June 28, 2017 from http://www.iep.utm.edu/util-a-r/.

Nathanson, S. (2016). *Internet encyclopedia of philosophy*. Retrieved October 4, 2016, from http://www.iep.utm.edu/util-a-r/#H1.

Pareles, J. (April 24, 2016). "Review: Beyoncé makes 'Lemonade' out of marital strife." *The New York Times*. Accessed June 28, 2017 from https://www.nytimes.com/2016/04/25/arts/music/beyonce-lemonade.html?_r=0.

Pecorino, P. (2002). "Categorical imperative." Retrieved October 4, 2016, from http://www.qcc.cuny.edu/SocialSciences/ppecorino/MEDICAL_ETHICS_TEXT/Chapter_2_Ethical_Traditions/Categorical_Imperative.htm.

Penn, S. (January 9, 2016). "El Chapo speaks." *Rolling Stone*. Accessed June 28, 2017 from http://www.rollingstone.com/culture/features/el-chapo-speaks-20160109.

Politi, D. (May 15, 2016). "Reporter is forced to put on sweater live on air to cover up 'revealing' dress." Slate. Accessed June 28, 2017 from http://www.slate.com/blogs/the_slatest/2016/05/15/ktla_reporter_liberte_chan_forced_to_put_on_sweater_live_on_air.html.

Puka, B. (n.d.). "The Golden Rule." Internet Encyclopedia of Philosophy. Accessed June 28, 2017 from http://www.iep.utm.edu/goldrule/.

Schwartz, A. (April 9, 2016). "The long collusion of photography and crime." *The New Yorker*. Accessed June 28, 2017 from http://www.newyorker.com/culture/photo-booth/the-long-collusion-of-photography-and-crime.

Shafer, J. (September 13, 2016). The case against journalistic balance. Retrieved December 2, 2016, from http://www.politico.com/magazine/story/2016/09/journalism-balance-fairness-false-equivalence-hillary-clinton-donald-trump-2016-214242.

Spayd, L. (September 10, 2016). "The truth about 'false balance'." *The New York Times*. Retrieved December 1, 2016, from https://www.nytimes.com/2016/09/11/public-editor/the-truth-about-false-balance.html.

"The privacy torts: How U.S. state law quietly leads the way in privacy protection." (July, 2002). Privacilla.org. Accessed June 28, 2017 from http://www.privacilla.org/releases/Torts_Report.html.

Turner, C. (May 11, 2016). "Meghan Trainor pulls music video that digitally altered her waistline." *The Telegraph*. Accessed June 28, 2017 from http://www.telegraph.co.uk/news/2016/05/11/meghan-trainor-pulls-music-video-that-digitally-altered-her-wais/.

"Understanding the Golden Rule." (2016). Retrieved October 8, 2016, from https://www.scarboromissions.ca/golden-rule/understanding-the-golden-rule.

Vanden Heuvel, K. (July 15, 2014). "The distorting reality of 'false balance' in the media." *The Washington Post*. Retrieved December 1, 2016 from https://www.washingtonpost.com/opinions/katrina-vanden-heuvel-the-distorting-reality-of-false-balance-in-the-media/2014/07/14/6def5706-0b81-11e4-b8e5-d0de80767fc2_story.html?utm_term=.78e37d1e4d45.

"Veil of ignorance." (2017). Ethics Unwrapped. Accessed June 28, 2017 from http://ethicsunwrapped.utexas.edu/glossary/veil-of-ignorance.

Weijers, D. (n.d.). "Hedonism." Internet Encyclopedia of Philosophy. Accessed June 28, 2017 from http://www.iep.utm.edu/hedonism/.

2

VISUAL REPORTING

The night shift is a time when many of the most emotional and violent conflicts between residents of a city are displayed before the calm, objective lens of a camera's eye. Having worked this time period for a large metropolitan daily newspaper, I've seen the results from tragic killings, devastating car crashes, and the aftermath of murders. As a 24-year-old photojournalist without much experience in the world up to that time, I've witnessed and photographed the mangled sight of a young man's body laying on the ground after his life was cut short by a shotgun blast from a grocery store manager during a robbery attempt, the body of a man face down in the shallow water of a bayou next to his overturned sedan, and the lurid wail from a woman in police custody caught after she had plunged a knife into the chest of her lover. These memories will not pass as "tears in rain" as Rutger Hauer famously stated at the end of *Blade Runner*, but leave a psychic toll to this day (2012).

In all three situations, electronic flash pictures were taken at the scenes. These stark, hyper-focused, and high-contrast images shrouded by the night's inevitable darkness were never published. Because a photo editor declined to use them, they were eventually filed in a folder in the newspaper's repository, nicknamed, perhaps ironically yet somehow appropriately, "the morgue." It's a collection where few persons bother to look. In fact, it may be surprising to learn that most images recorded by a visual reporter are never seen by the public. What's more, I knew at the instant I took the photographs that my editor would not want to include them within the next day's record of newsworthy events. So why did I go to the trouble to take, edit, process, and put them on his desk?

Why should a photojournalist record images she knows will not be published or seen because of violent content?

A partial answer comes from understanding a visual reporter's chief role-related responsibility – to record images of newsworthy events. However, the end result of that task is not for the public's consumption, but for an editor to see them in order to satisfy her main duties – to make a decision to use the pictures and, if so, to decide how they will be used. As such, a visual reporter's primary client is not a news viewer or user, but a news editor.

For the photojournalist, Kant's categorical imperative is clearly a prominent philosophy when it comes to violent images. If pictures are not taken, a professional image maker runs the risk of not completing a vital role-related responsibility. Deciding a camera's perspective, the choice of lens, the proper shutter speed and exposure, and so on at a scene, selecting

which images best describe an event, processing the pictures for color balance, composition, continuity, and storytelling, and presenting selects to an editor are all a part of a visual journalist's job and justified as ethical by the categorical imperative philosophy. Another ethical motivation based on the categorical imperative is to document the event for historical purposes. The reasons publishers store images are that those pictured might be of interest to the publication and researchers at a future time and to graphic designers who might need the images for other publications. However, if a photojournalist's motivation in taking a picture is not to document events but to make money selling pictures, winning contests, or becoming famous, the hedonism, not the categorical imperative philosophy is invoked.

Praiseworthy visual reporters and editors communicate with each other to formulate reasons why the images should or should not be shown to the public. Again, the use of the categorical imperative philosophy by an editor invokes the rigid following of a journalistic rule – if a story is newsworthy, the visual news must be presented. There can be no exception. Fortunately, a more reasonable justification comes from the utilitarian philosophy. Viewers might be motivated to seek help if they are emotionally depressed after seeing those featured in the news. Although the publicizing of the images – whether still or moving – might not help the family and friends of the victims, a greater public is served by the possible lessons learned – a crucial test for the utilitarian philosophy. An editor might agree with a hedonistically motivated visual journalist and believe the pictures are Pulitzer Prize worthy and make them available for that reason. Such a decision is not necessarily unethical if paired with the categorical imperative and utilitarian philosophies.

Victims of Violence

Since the introduction of photography to the public in 1839 through the technical achievement accomplished by three French citizens, Louis-Jacques-Mandé Daguerre, Isidore Niépce, and with the inspired earlier work of his late father, Joseph Nicéphore Niépce, history is filled with images that appalled, enraged, educated, persuaded, or were unseen by viewers because of their gruesome content ("Isidore," n.d.).

The next year after the announcement of the daguerreotype process another Frenchman, Hippolyte Bayard was shown in a picture of what was considered (at the time) to be the first photograph of a body. The accompanying caption explained that after inventing his own photographic process that did not achieve the accolades or the lifetime pension offered by the French government to Daguerre and Niépce, Bayard committed suicide. The image reveals his corpse after it was retrieved from the Seine in Paris (Willette, 2015). Although Bayard's shirtless body lies in a peaceful repose with calm facial features and his hands lying casually on a blanket, you can imagine the shock it invoked if viewers thought it were true. It wasn't. The first picture of a cadaver was actually the first semi-nude, self-portrait, and set-up.

It didn't take long before serious photojournalists, in still and moving media, soon turned their cameras toward the unblinking gaze of those actually killed. Visual reporters have always been attracted to wars and other military conflicts because of their dramatic combination of peril and pathos. During the American Civil War, Mathew Brady hired some of the most famous names in photographic history – Alexander Gardner and Timothy H. Sullivan – to take pictures of military encampments and post-battle scenes ("Photography and the Civil War," 2017). Actual, fast-moving conflict was impossible to capture given the long shutter speed required of the wet-collodion process used during this time period. Subsequent pictures of distorted and decaying corpses were too gruesome for the public grown weary of the long war. Consequently, Brady went bankrupt when he couldn't sell them at his galleries. About

40 years later during the Spanish-American War, *Collier* magazine photojournalist Jimmy Hare "photographed swollen bodies with bones breaking through the skin" that were nevertheless published by William Randolph Hearst publications in order to enrage viewers to support the conflict (Mraz, 2017). About 40 years later, Hungarian war photographer Robert Capa captured a "moment-of-death" picture of a soldier during the Spanish Civil War hit in the head by a bullet, although some claim it was a set-up (Rohter, 2009). Nevertheless, it was shown in *Time* magazine and other publications. During World War II photographer George Strock took a picture of the bodies of U.S. servicemen face down on a beach that was initially censored by the government, but when released and published in *Life* magazine, was praised by viewers because, as one soldier wrote, it gave "real meaning to our struggle" (Dunlap, 2013). After images were released of Holocaust victims with their bodies stacked in gruesome piles, the world was educated to the banality of evil (Rosenberg, 2017). In 1963 Associated Press reporter Malcolm Browne won a Pulitzer Prize for a picture of the self-immolation of a Buddhist monk, Thích Quảng Đức protesting persecution by the South Vietnamese government (Witty, 2012). Five years later during the Vietnam War Eddie Adams captured the moment-of-death street execution of a Viet Cong prisoner and won a Pulitzer Prize ("Saigon execution," 2014). Is there a common link for these pictures spanning almost 100 years? In each case, a photojournalist had to be on the scene to actually take the picture. Lives were risked for the profession. Some lives were lost for the same reason.

During the Gulf War in 1991, Kenneth Jarecke photographed the remains of an Iraqi man burned alive while attempting to escape the cab of his truck (DeGhett, 2014). The horrific image was never widely published. For Jarecke, the understanding of his role-related responsibility combined with an assurance from the categorical imperative philosophy to take pictures that led him to the conclusion that "if I don't take pictures like these, people like my mom will think war is what they see in movies. It's what I came here to do. *It's what I have to do*" (a classic categorical imperative justification). James Gaines, the managing editor of *Life* magazine at the time declined to publish the image based on a golden rule justification of not adding grief when he explained, "We have a fairly substantial number of children who read *Life* magazine." However, Stella Kramer, a freelance photo editor for *Life* invoked the hedonism philosophy as the personal reason for Gaines' decision with Americans only tolerating a "good, clean war. So, that's why these issues are all basically just propaganda." She then added, "As far as Americans were concerned nobody ever died." Author Torie Rose DeGhett voiced a utilitarian, educational justification for printing the picture, "Photos like Jarecke's not only show that bombs drop on real people; they also make the public feel accountable." Besides pictures of those killed on military battlefields, other memorable images that show public deaths can either sensationalize or memorialize victims depending on your perspective.

American wars today are too often fought like cold, objective, video games with soundless explosions of colorless smoke, fire, debris, and death seen in third-person controlled detachment from military drone aircraft as their guided missiles complete a mission by soldiers thousands of miles from the battlefield. Is it Aristotle's golden mean that justifies the decision to avoid ground troops in favor of this monitor mayhem or is it hedonism is employed to criticize a strategy in which superior technology is used to kill from a screen's image outside Las Vegas with more innocent civilians as victims than actual enemy combatants? For the visual reporting profession a more fundamental question should be asked: Will camera-carrying drones replace photojournalists' boots on the ground?

In the web browser of your choice, use the keywords, "girl bomb Pulitzer" and you will find Nick Ut's black and white Pulitzer Prize photograph from the Vietnam War taken in

1972 ("Nick Ut," n.d.). Titled "The Terror of War," it shows 9-year-old Kim Phuc and other children running and screaming in agony after an accidental napalm bombing. You will also discover Massoud Hossaini's Pulitzer Prize winning haunting color image of Tarana Akbari crying amid the bloody bodies of about 70 persons killed from a suicide bomb attack in Kabul, Afghanistan in 2011 ("The Pulitzer Prizes," 2012). Hossaini, an Afghan photojournalist for the French picture agency AFP, upon learning of his win said that he hopes those who see the picture "don't forget the pain Afghanistan's people have in their life." Sadly, we learn of such bombings almost daily from news reports from the Middle East, but it takes a still image to rivet our attention and think of the human cost of war. For Hossaini, his hope that viewers always remember a child's pain is a utilitarian approach. For myself, Rawls' veil of ignorance and his call for empathy guides my reaction – I never want to see a loved one of mine with so many tears and so much blood. And yet, and this may be something you disagree with, even if Tarana were my daughter and those were my family members dead on the ground and I were an editor responsible for running the picture, I would have made the image public. I would have relied on my role-related responsibility and either the categorical imperative or utilitarianism philosophy to educate viewers in words and images the mission of journalism and the sometimes painful decisions that must be made by visual reporters and editors.

The history of images that show victims of violence continues beyond battlefield images and is unfortunately long and often questionable. A student of photojournalism ethics (or anyone reasonably proficient in conducting a web search) should have seen:

- Tom Howard's photograph of the execution of Ruth Snyder at Sing Sing Correctional Facility in 1928 with a camera secretly strapped to his leg to avoid detection that was printed large on the front page of the *New York Daily News* (Zhang, 2015),
- the stark pictures of organized crime murder victims by Arthur Fellig, known professionally as "Weegee," a pseudonym that referenced the popular Ouija fortune-telling game that Fellig used because of his seemingly uncanny luck to show up first at crime scenes. In reality, and as with any good journalist, he had many sources ("Gritty photographer," n.d.),
- Evelyn McHale's serene body lying on a limousine after she jumped from the Empire State Building respectfully composed by student photographer Robert Wiles in 1947 (Cosgrove, 2014),
- the horribly disfigured face of 14-year-old Emmett Till lying in a coffin murdered in Mississippi for allegedly flirting with a European American woman in 1955 who much later recanted her story (Merda, 2015),
- Bob Jackson's murder of Lee Harvey Oswald by Jack Ruby in 1963 (Meyer, 2016),
- Bill Eppridge's 1968 picture of Juan Romero, a busboy working at the Ambassador Hotel in Los Angeles, cradling the head of slain Robert F. Kennedy (Cosgrove, 2014),
- John Filo's 1970 image of Mary Ann Vecchio screaming for help over the bloody body of Jeffrey Miller at Kent State University (Zhang, 2012),
- John Harte's 1985 image of a grieving family over the drowned body of 5-year old Edward Romero (Harte, 2014),
- the 1993 heart-breaking Pulitzer Prize winning picture by Kevin Carter of a Sudanese child shadowed by a vulture (Neal, 2017),
- Kurt Cobain's autopsy photograph after his suicide in 1994 (Radar Staff, 2015),
- the grotesque close-up torso of Nikki Catsouras, 18, who died in a 2006 car crash after losing control of her father's Porsche 911 Carrera at more than 100 mph and hitting a concrete toll booth in Orange County, California (Bennett, 2009), and

- in 2015 the body of 3-year-old Aylan Kurdi face down on a Greek beach after an unsuccessful attempt to escape the violence in Syria taken by Associated Press photographer Nilüfer Demir (Hare, 2015).

Poynter Institute's Kelly McBride wrote that Demir's picture should be shown because of its political significance. She adds, "Sometimes it's gratuitous for the media to show images of death [a hedonistic critique]. But sometimes it's absolutely the most responsible thing journalists could do" [utilitarianism]. Humans find countless ways to die and photographers must be present to make records for history in order to promote the need for commerce but more importantly to satisfy their professional duty.

Rights to Privacy

After photography became a simple, hand-held operation due to the invention of roll film by George Eastman, the medium was expanded beyond the scope of chemists to include the general public. However, it should be noted that Eastman's camera cost about $25 in the 1880s. Adjusted for inflation it would cost more than $500 today – a hobby only the upper middle class at the time could afford. Nevertheless, the amateur boom included persons taking pictures of themselves, their friends and family, and significantly for this discussion, strangers. *The New York Times* "likened the snapshot craze with an outbreak of cholera that had become a national scourge." Vigilante associations were formed to protect the honor of unsuspecting women from photographers. After a man destroyed the camera of someone taking a picture of a woman, the jury would not convict him. In Victorian London a photographer had to obtain an official permit to take pictures in a park while the German government passed a statute prohibiting photography without permission from a person. The writer Bill Jay noted during this earlier time period, "As any impartial observer will admit, no aspect of a life was too private, no tragedy too harrowing, no sorrow too personal, no event too intimate to be witnessed and recorded by the ubiquitous photographer" (Featherstone, 1991). Those words easily apply to today's use of smartphones and our celebrity-centric world. Unfortunately, hedonism is a strong motivation on both sides of a lens.

In the United States with its First Amendment protections, no legislation ever required photographers to ask permission to take pictures of persons in public. When Farm Security Administration photographer Dorothea Lange in 1936 took pictures of Florence Thompson and three of her children in Nipomo, California with an image from the series considered to be one of the finest in the history of the medium, the so-called "Migrant Mother" close-up, Thompson bitterly complained for years that her privacy had been violated and that she deserved compensation ("Dorothea Lange's 'Migrant Mother,'" 2013). Likewise, Mary Ann Vecchio voiced the opinion that John Filo's photograph of her during the Kent State University tragedy ruined her life when it violated her privacy and was displayed throughout the world. In both cases Thompson and Vecchio would have little standing in the courts, as the situations were newsworthy and taken in public locations.

An important area of privacy law that is applicable to still and moving images has to do with the concept of unreasonable intrusion. Generally, anything that can be seen in plain, public view can be photographed. However, a visual reporter is not permitted to use technology that violates that mandate – cameras that are hidden, with long lenses, attached to drones or helicopters, and so on. Pictures in private places require permission. Well-known street photographer Philip-Lorca diCorcia in 2005 took a picture of Erno Nussenzweig as he walked through Times Square in New York City (Gefter, 2006). The image was later

exhibited in an art gallery and published in a book of photographs. Nussenzweig sued because he claimed his privacy was violated. He lost the case. If he had won, street photography as commonly practiced by amateurs, artists, and photojournalists would have been severely limited. Also, for paparazzi it is good news as well because taking pictures of celebrities remains permissible. Nevertheless, what is legal is not always ethical and sometimes a photographer acting unethically can also be legally liable.

The most recognized case of a photographer violating a person's privacy is that of freelance photographer Ron Galella who was admittedly obsessed with the former wife of President John Kennedy and wife of a Greek shipping magnate, Jacqueline Onassis ("Story behind," 2016). Galella was famous as one of the first paparazzo. *Time* magazine called him the "Godfather of the U.S. paparazzi culture." It is estimated that his personal photographic collection contains more than three million pictures of celebrities, with most of them despising him and his relentless endeavors. After Marlon Brando hit him in the face and broke his jaw, he wore a football helmet the next time. But Jackie O was his main fixation. From a judge's opinion in 1973, Galella

> came uncomfortably close in a powerboat to Mrs. Onassis swimming. He often jumped and postured around while taking pictures of her, notably at a theater opening but also on numerous other occasions. He followed a practice of bribing apartment house, restaurant, and nightclub doormen as well as romancing a house keeper to keep him advised of the movements of the family.

Galella even disguised himself as a Greek sailor and made pictures of Onassis sunbathing in the nude on the island of Scorpios. The pictures were later published in *Hustler* magazine. Galella claimed he was simply exercising his right as a journalist under the First Amendment. In two courtroom decisions (he simply ignored the first decision that ordered he stay at least 25 feet from Onassis), the court said he was guilty of "acts of extremely outrageous conduct." To avoid a possible 6-year prison term and a fine of $120,000 ($654,000 today), Galella signed an agreement to "never again aim a camera at Mrs. Onassis or her children." Hedonism? Indeed. Galella once admitted that he made about $20,000 ($109,000 today) a year on pictures of Onassis alone that he sold. In 2010 the documentary film, *Smash His Camera*, featured his life and career (2010).

During the 2016 presidential campaign, the Perry family and their friends experienced a sudden shock to their systems when their smiling faces from a family reunion inundated news and social media sites (Firozi, 2016). In an effort to gain credibility with African Americans, President Donald Trump while a Republican candidate, used the pleasant snapshot next to a headline that proclaimed, "American Families for Trump" in a retweet that included the picture to his followers. The Perrys thought, rightly so, that their privacy had been violated. Eddie Perry noted, "When I saw it, I immediately knew it was political propaganda. Why use it without asking for someone's permission?" he asked. Why? Because of the old adage (aren't they all old?), "It is far easier to ask for forgiveness than to ask for permission." Obviously, the Trump troopers didn't think they would be caught so no prior approval was contemplated. Still, within 30 minutes after its release, the source of the image was found. Try it yourself. Pretend you work for Trump and were asked to find a photograph of a smiling African American family. In Google type, "black family" and press the Images tab. You'll find it. Needless to add, no one from the Trump campaign apologized to the Perry family.

Nowhere is the word "privacy" mentioned in the US Constitution. However, the concept has long been established through numerous court proceedings and opinions. A photojournalist

should be aware of the privacy laws that apply to her jurisdiction, but also realize that cred-ibility, a highly prized value, might be lost if ordinary persons or famous persons going about everyday activities are unduly harassed with poor social etiquette, intrusive behavior, and telephoto lenses. Otherwise, permission to take pictures of strangers might become a legal requirement in the future.

Subject and Image Manipulations

As these examples will show, deception has too often been a factor in the production and evaluation of news photographs. Similar to a theatre director influencing actors and the set design of a production, stage-managing is a term used to describe a situation in which a subject and/or a photographer controls the actions and/or arranges objects and people within the frame. As stated, the first stage-managed picture was the self-portrait by Hippolyte Bayard. In the United States, one of the first examples comes from the American Civil War. A photographer under Mathew Brady's employ, Alexander Gardner made two photographs of the body of 18-year-old Pvt. Andrew Hoge of the 4th Virginia Infantry in Gettysburg (Griffin, 2008). In one, Hoge was shown as a dead sniper lying on his back, his face turned toward the camera, and his rifle propped up against one of the rocks. In the other, Hoge's body is in a different location. Author Susan Moeller wrote that during the Spanish-American War in Cuba bodies were moved for better compositions. Some creative photographers even re-enacted famous battle scenes in New Jersey backyards and bathtubs.

Arthur Rothstein, a documentary photographer for the Farm Security Administration (FSA) during the American Dust Bowl era, didn't move a body – he moved a sun-bleached steer skull to grassy and then parched land (Hirsch and Erf, n.d.). The portrait of Florence Thompson and her children is flawed because Dorothea Lange stage-managed Thompson and her children in order to get the iconic photograph, the "Migrant Mother." Many would say that Lange's categorical imperative handed down by Roy Stryker, head of the information division of the FSA, to make pictures that showed persons at their worst during the Great Depression excused Lange for setting-up the pictures she made. Perhaps. Certainly, the portrait would not be as powerful if it were not for the compositional and content considerations controlled by Lange.

Another famous picture clouded by controversy was the one taken by Associated Press photographer, Joe Rosenthal, at the summit of Mount Suribachi, a Japanese observation post on the island of Iwo Jima in 1945 (Masoner, 2016). Nevertheless, the picture was a photo op, a stage-managed recreation with a larger flag than the first one erected earlier. Still, watch the film of the flagpole being quickly lifted by the Marines and you should be impressed with Rosenthal's talent to capture the perfect moment even though he knew it was coming.

More times than is popularly realized, powerful individuals and celebrities control what photographers can and cannot take. If a rock star doesn't want a photojournalist in the dressing room before a performance, that's understandable, but when a government employee demands restrictions, the ethics become more problematic. Reported by photojournalists covering the White House, since Ronald Reagan was president, still photographers were not allowed to take pictures of live addresses to the nation because the noise of camera shutters is loud and distracting. Consequently, all the published historical photographs of a president talking to the public were reenactments. For example, when President Obama announced the death of Osama bin Laden in 2011, the Poynter Institute, a leader in journalism training and commentary, reported that a Reuters White House photographer Jason Reed told "how

the president made his speech to a single TV camera, then immediately after finishing, he pretended to speak for the still cameras." Reed explains,

> As President Obama continued his nine-minute address in front of just one main network camera, the photographers were held outside the room by staff and asked to remain completely silent. Once Obama was off the air, we were escorted in front of that tele-prompter and the President then re-enacted the walk-out and first 30 seconds of the statement for us.
>
> *(Zhang, 2011)*

Most newspapers printed the picture without explaining that the situation was a stage-managed, media event, photo op, set-up.

The Amsterdam-based organization, the World Press Photo Contest, one of the most prestigious in the world, was embroiled in a controversy in 2015 when it awarded and then rescinded its first place award to Italian photographer, Giovanni Troilo (Donadio, 2015). As reported by *The New York Times*,

> The controversy erupted [because of] a photo in which Mr. Troilo had photographed his cousin having sex with a woman in the back of a car, using a remote-control flash to illuminate the steamy back seat. By putting a flash in the car, critics had said, Mr. Troilo effectively staged the photo, violating the rules of the contest.

Michele McNally, a member of the contest's jury and the director of photography for *The New York Times* wrote an explanation that addressed the difference between stage-managed and news pictures, "a staged photograph is not acceptable in news pictures that are used to depict real situations and events. Portraiture and fashion and still lifes are of course produced and directed."

For the World Press Association, the definition is simple, "World Press Photo rules state, 'staging is defined as something that would not have happened without the photographer's involvement'" (Donadio, 2015). As with Dorothea Lange's news picture of Florence Thompson's situation, it is unethical for photojournalists to stage-manage a scene as if the persons pictured were models in a studio. After all, the contest is called World Press Photo, not World Art Photo.

Most email I receive about picture manipulations has to do with questions about the digital deceptions available through Photoshop software. However, the same effect can be achieved through analog, cut and paste techniques and have been throughout history. In 1857, only 18 years after photography was announced, artist Oscar Rejlander produced a documentary picture of a homeless boy tossing a chestnut in the air (da Cruz, 2013). However, stopping a moving object in mid-air was a technical feat impossible with the slow film and lenses in use at that time. Rejlander produced the effect through the use of a fine thread. In that same year, he also made the controversial, "The Two Ways of Life" (2014), an elaborate story of a young man's decision to follow good or evil. Thirty separate negatives were combined to produce the single image. A few years later, a popular close-up portrait of Abraham Lincoln seen on the $5 bill was cut and placed on a full-length portrait of Southern statesman, John Calhoun in order to make money after Lincoln's assassination ("Lincoln-Calhoun," 2014). Once again, hedonism is the primary philosophy at work.

The Lincoln/Calhoun reunification example starts an informative collection of manipulated images shown on a website maintained by Fourandsix (forensics) Technologies, Inc., a

company that authenticates pictures "for personal motivations or for legal verification." Included in the 200-plus slideshow are notable examples such as the 1982 treatment of Gordon Gahen's horizontal picture of the Great Pyramids of Giza digitally moved to fit the vertical cover format of *National Geographic* magazine ("Pyramids of Giza," n.d.), the 1994 darkening of OJ Simpson's face by artist Matt Mahurin for *Time* magazine ("O.J. Simpson cover," n.d.), the 2003 two-shot combination front page picture printed on the front page of the *Los Angeles Times* early during the Iraq War by Brian Walski (Van Riper, n.d.), *Charlotte Observer* photographer Patrick Schneider fired after continuing to make exposure and color control changes to images submitted for contests and publication (Winslow, 2006), a cropped and doctored image for a 2010 *The Economist* cover picture of President Obama seemingly alone and a bit clueless as to how to fix the catastrophic oil leak into the Gulf of Mexico ("Louisiana," n.d.), and a 2016 advertisement for Snickers candy bars in which 11 purposeful Photoshop errors are featured (Nudd, 2016).

A recent digital manipulation violation, dubbed plagiarism by the headline writer for PetaPixel, was performed by photographer Souvid Datta in 2017. One of the most revered and honored visual reporters in the history of the medium is the American documentarian Mary Ellen Mark (2017). Since her first published work in 1974, *Passport*, until her last, *Tiny: Streetwise Revisited* in 2015, she has produced 22 books. Mark's images have inspired and educated millions and are well known by her many fans and admirers. So, using a part of one of her pictures to add import to your own photograph is a dumb thing to do, right? One of Mark's most affecting books is the 1981 *Falkland Road: Prostitutes of Bombay: Photographs and Text*, a classic photojournalism effort concerned with the lives of sex workers in India. Michael Zhang writes that Datta combined part of a photograph from *Falkland Road* as a background element to his own picture (Zhang, 2017). Datta has won numerous awards and grants for his photography. Why make such a glaring ethical breach? Hedonism. With his reputation shattered, he has not responded to requests for interviews and has taken down his website and his Facebook and Twitter accounts.

One of the latest controversies involves a technique known by photographers for several years. High-dynamic range (HDR) imaging involves superimposing several images taken at different exposures in order to obtain a richly saturated picture. With software now available for smartphones, HDR is a popular Flickr group with more than 100,000 members sharing more than a million photographs ("Everyone's photos," n.d.). The technique is considered ethical for art and illustration photography, but for news pictures, not so much. In 2012 an HDR manipulated *Washington Post* frontpage picture taken by Bill O'Leary of an airplane flying over a bridge that a year earlier was the scene of a plane crash sparked considerable debate among the photojournalism community (Myers, 2012). Most critiques for the use of HDR technology come from the fact that the end result is a combination of at least three pictures. Former NPPA President and Ethics and Standards Committee Chair, John Long (2017) wrote,

> HDR images are multiple 'moments' that are combined, and this is not what the public expects from news photographs. News photographs are 'single' moments. And, while I love the images, I do not think they are appropriate for newspapers except as examples of artwork. They are not what the public understands to be documentary photographs, yet.

Dang. I wish he hadn't added that last, "yet." Yet, Long's learned opinion comes from his understanding of how ethical considerations change over time, cultures, and expectations. In

times past, it was perfectly fine to hang a chestnut. Today, a photojournalist would be figuratively hanged for a similar unethical act.

Seeing is believing? With manipulations of all sorts, just because you see something doesn't mean you should believe it's true. In fact, as a consumer of images, we should all be educated on the ways of visual persuasion and a bit cynical whenever we see, hear, or read any form of communication. BUT as a communications practitioner, you should also be keenly aware that your viewers and users are not as sophisticated as you in the ways visual messages can be manipulated. As such, your ethics should be beyond reproach.

See Appendix A for a professional's approach to visual reporting.

Case Studies

Case Study One

One of the most famous photos of all time is *Kissing the Sailor*, taken by Alfred Eisenstaedt on August 14, 1945. The photo purportedly captures a sailor kissing a nurse in Times Square, New York, just after news of Japan's surrender in World War II was announced. Most people have historically viewed the photo in a frame of celebratory fun. However, others contend that the photo is better viewed as having captured a kind of assault, as the nurse may have been grabbed and kissed against her will. Does it matter which interpretation is correct? What if the nurse was simply caught off guard, but didn't really feel offended? What if she didn't mind, but her identity was lost to history, or by the time her identity was rediscovered her memory of the day's events had changed? Whose ethics matter more – the original photographer's, the viewer's, or the publisher's (*Life* magazine).

Callahan, M. (June 17, 2012). "The true story behind the iconic V-J Day sailor and 'nurse' smooch." *New York Post*. Accessed June 28, 2017 from http://nypost.com/2012/06/17/the-true-story-behind-the-iconic-v-j-day-sailor-and-nurse-smooch/.

See Appendix B for the 10-Step Systematic Ethical Analysis Form.

Case Study Two

In 2013, Dashiell Bennett wrote in *The Atlantic* magazine that "New technology also means that anyone with a plane ticket and a phone can be a freelancer That means more competition for stories – and lower wages – but also more reporters who don't really know what they're doing." Bennett further suggested that "war tourism" has become a thing, where individuals vacation in conflict zones seeking thrills or quick fame without thinking through the consequences of their presence. What both of these phenomena have in common is the notion that fame and "the get" (especially the photo of "the get"!) are more important than the story itself. This, in turn, suggests that it is the reporter or storyteller – the one who dodged the bullets – who matters, not the people who suffer the conflict. How does this fact reestablish global power structures? What does it have to do with the visual ethics issues raised in this chapter? Do you think advancing technology will make it better or worse? Are there technological fixes that could improve the ethical quandaries?

Bennett, D. (July 10, 2013). "The life of a war correspondent is even worse than you think." *The Atlantic*. Accessed June 28, 2017 from https://www.theatlantic.com/international/archive/2013/07/life-war-correspondent/313463/.

See Appendix B for the 10-Step Systematic Ethical Analysis Form.

Case Study Three

Imagine your friend sends you a video text message of a drunk person falling out of a dorm window at your college, with the text next to it, "Hilarious! LOL!" How would you view and interpret this message? Now, imagine you got the same message from your sister, with the same message saying, "Uh – I see you had too much fun again last night." Now, imagine you got the same message yet again, this time from your grandmother, with the message, "Be careful!" How would not only the text of each of these messages, but also your relationship with each sender, influence how you interpreted the video *and* why you were being sent the link to watch? What does this tell you about the nature of objectivity? (Hint: the video hasn't changed, but its presentation to you has.) Are the senders biased? What is their motivation? Are their motivations the same? Are their relationships with you the same? Does it matter? What does this tell us about media, ethics, photography, videography, framing, and more?

See Appendix B for the 10-Step Systematic Ethical Analysis Form.

Annotated Sources

Bock, M.A. (2011). "You really, truly, have to 'be there': Video journalism as a social and material construction." *Journalism & Mass Communication Quarterly*, December, *88*, pp. 705–718.

Media convergence means that many news organizations must find new ways to transmit information. Many have turned to video journalism as an easy and cheap way to put stories out. In video journalism, often only one person goes out and does the work of shooting, writing, and editing a story. This article describes this process, and considers how the low resource model of video journalism shifts story narratives away from reporters and toward sources, a simultaneously positive and negative effect.

Brennen, B. (2010). "Photojournalism: Historical dimensions to contemporary debates", in *The Routledge Companion to News and Journalism*, Stuart Allan (Ed.). New York, NY: Taylor & Francis (Routledge), pp. 71–81.

Many people think photography is the ultimate form of "real" journalism. It goes beyond words to capture what really happened: You can't argue with a picture. But this has never been as true as people think – what is left out of the frame is sometimes as important as what is in it, for example. And, with digital technology, it is easier than ever to manipulate images and so change the nature of "truth." Even when these manipulations are not done for ethically sinister ends, they still complicate questions about how photojournalists must balance their ethical duties to professional objectivity – which is always already problematic – with the ways that digital technology allows for an emphasis on emotion in storytelling.

Lester, P.M. (2005). "On mentors, ethics, war, and hurricanes". *Visual Communication Quarterly*, pp. 136–145.

Ethical photojournalism emphasizes human stories, even when these human stories are difficult to grapple with. In fact, argues Paul Lester in this article, sometimes what makes a story or a photograph ethically necessary is precisely its difficulty: "A question that is truly ethical deserves a response that addresses the human cost," he writes. "Ethics can provide good reasons for publishing or airing images that readers and viewers find offensive. Sometimes the public simply needs this picture – to have unpleasant information provided to them visually." This is especially true, he continues, in the context of modern war in the United States, where the tendency is to publish pictures that celebrate American success and

downplay the foreign horrors, injuries and civilian deaths that American bombings leave behind. Leaving out these pictures constitute ethical failures of will and a privileging of the American ego over legitimate human suffering that needs to be seen.

Mäenpää, J. (2013). "Photojournalism and the notion of objectivity – The particularity of photography and its relationship with truthfulness", in *Past, Future and Change: Contemporary Analysis of Evolving Mediascapes*, Trivundža, I. T. et. al (Eds.). Založba: University of Ljubljana Press, pp. 123–133.

Objectivity is a necessarily tricky term. When it comes to creating news, including news photographs, most people think it means that there is, or there should be, a wholly forthright way to present the news, that is fair and honest, without slant or opinion from reporters. To present a story otherwise is to be biased – to know what the "real" truth is, but to decide to obscure it to tell the story in a particular way. However, objectivity is a social construction of truth – much like a written story *must be* written from a human point of view, so a photograph *must be* taken from a human's vantage point, as well. This requires framing, knowledge, perspective, and assumptions about truth, history, and what the story means. Objectivity is socially organized and defined. This doesn't make objectivity fake. Rather, the social nature of objectivity, complicates its meaning.

References

Bennett, J. (April 24, 2009). "One family's fight against grisly web photos." *Newsweek*. Accessed June 28, 2017 from http://www.newsweek.com/one-familys-fight-against-grisly-web-photos-77275.

"Blade Runner – final scene, 'Tears in Rain' monologue." (July 18, 2012). YouTube. Accessed June 28, 2017 from https://www.youtube.com/watch?v=NoAzpa1x7jU.

Cosgrove, B. (March 19, 2014). "'The most beautiful suicide': A violent death, an immortal photo." *Time*. Accessed June 28, 2017 from http://time.com/3456028/the-most-beautiful-suicide-a-violent-death-an-immortal-photo/.

Cosgrove, B. (May 15, 2014). "Behind the picture: RFK's assassination, Los Angeles, 1968." *Time*. Accessed June 28, 2017 from http://time.com/3879872/robert-kennedy-assassination-photographs-by-bill-eppridge-june-1968/.

da Cruz, P. (February 26, 2013). "Combination printing." Philippe da Cruz. Accessed June 28, 2017from http://philippe.dacruz.free.fr/index.php/Photographie/combination-printing/?lang=en#more-1216.

DeGhett, T.R. (August 8, 2014). "The war photo no one would publish." *The Atlantic*. Accessed June 28, 2017 from https://www.theatlantic.com/international/archive/2014/08/the-war-photo-no-one-would-publish/375762/.

Donadio, R. (March 4, 2015). "World Press Photo revokes prize." *The New York Times*. Accessed June 28, 2017 from https://www.nytimes.com/2015/03/05/arts/design/world-press-photo-revokes-prize.html.

"Dorothea Lange's 'Migrant Mother' photographs in the Farm Security Administration Collection: An overview." (January 24, 2013). The Library of Congress. Accessed June 28, 2017 from https://www.loc.gov/rr/print/list/128_migm.html.

Dunlap, D. W. (March 28, 2013). "Photo that was hard to get published, but even harder to get." *The New York Times*. Accessed June 28, 2017 from https://lens.blogs.nytimes.com/2013/03/28/a-photo-that-was-hard-to-get-published-but-even-harder-to-get/.

"Everyone's photos." (n.d.). Flickr. Accessed June 28, 2017 from https://www.flickr.com/search?text=hdr&structured=yes.

Featherstone, D. (Ed.). (1991). *Observations: Essays on documentary photography*. New York: Friends of Photography.

Firozi, P. (June 4, 2016). "Trump shared a photo of a black family, but they don't support him." The Hill. Accessed June 28, 2017 from http://thehill.com/blogs/ballot-box/presidential-races/282234-trump-shared-a-photo-of-a-black-family-on-the-trump-train.

Gefter, P. (March 17, 2006). "Street photography: A right or invasion?" *The New York Times.* Accessed June 28, 2017 from http://www.nytimes.com/2006/03/17/arts/street-photography-a-right-or- invasion.html.

Griffin, J.C. (2008). *A pictorial history of the Confederacy.* New York: McFarland, p. 110.

"Gritty photographer Weegee captures New York's sordid and crime-ridden streets after dark." (n.d.). *New York Daily News.* Accessed June 28, 2017 from http://www.nydailynews.com/news/shocking-photos-famed-crime-photographer-weegee-gallery-1.1282477.

Hare, K. (September 3, 2015). "Front page of the day: 'Somebody's child'." Poynter. Accessed June 28, 2017 from https://www.poynter.org/2015/front-page-of-the-day-somebodys-child-warning-dis turbing-image/371092/.

Harte, J. (December 10, 2014). "The Hart Park drowning photo." John Harte Photo. Accessed June 28, 2017 from https://johnhartephoto.wordpress.com/2014/12/10/the-hart-park-drowning-photo/.

Hirsch, R. and Erf, G. (n.d.). "Perceiving photographic truth." *Photovision.* Accessed June 28, 2017 from http://www.photovisionmagazine.com/articles/iopv2n6.html.

"Isidore Niépce and Daguerre." (n.d.). Maison Nicéphore Niépce. Accessed June 28, 2017 from http://www.photo-museum.org/isidore-niepce-daguerre/.

"Lincoln-Calhoun composite." (2014). Iconic Photos. Accessed June 28, 2017 from https://iconicp hotos.org/2010/04/24/lincoln-calhoun-composite/.

Long, J. (2017). "Is it journalism or is it art?" NPPA. Accessed June 28, 2017 from https://nppa.org/pa ge/9341.

"Louisiana, United States." (n.d.) Altered Images BDC. Accessed June 28, 2017 from http://www.alteredimagesbdc.org/the-economist/.

"Mary Ellen Mark." (2017). Accessed June 28, 2017 from http://www.maryellenmark.com/.

Masoner, L. (December 7, 2016). "About 'flag raising over Iwo Jima' by Joe Rosenthal." The Spruce. Accessed June 28, 2017 from https://www.thespruce.com/controversy-iwo-jima-flag-photograp h-2688403.

Merda, C. (August 28, 2015). "Photos: Emmett Till's death – and a gruesome picture – sparked a movement." *National Sun Times.* Accessed June 28, 2017 from http://national.suntimes.com/national-world-news/7/72/1726997/gallery-emmett-tills-death-gruesome-photo-sparked-movement/.

Meyer, J.P. (April 29, 2016). "Bob Jackson's iconic photo of Ruby shooting Oswald still resonates." *The Denver Post.* Accessed June 28, 2017 from http://www.denverpost.com/2013/11/22/bob-jacksons-i conic-photo-of-ruby-shooting-oswald-still-resonates/.

Mraz, J. (2017). "Fellows find: Jimmy Hare photography collection reveals early photojournalism history." Harry Random Center. Accessed June 28, 2017 from https://blog.hrc.utexas.edu/2013/12/ 19/fellows-find-jimmy-hare/.

Myers, S. (January 14, 2012). "Washington Post raises eyebrows, questions with 'composite' photo on front page." Poynter. Accessed June 28, 2017 from https://www.poynter.org/2012/washington-p ost-raises-eyebrows-with-composite-photo-on-front-page/159412/.

Neal, L.M. (May 17, 2017). "How photojournalism killed Kevin Carter." ATI. Accessed June 28, 2017 from http://all-that-is-interesting.com/kevin-carter.

"Nick Ut." (n.d.). World Press Photo. Accessed June 28, 2017 from https://www.worldpressphoto. org/people/nick-ut.

Nudd, T. (February 17, 2016). "Fail on the back of SI's swimsuit issue." *AdWeek.* Accessed June 28, 2017 from http://www.alteredimagesbdc.org/the-economist/.

"O.J. Simpson cover, Matt Mahurin." (n.d.). Iconic Photos. Accessed June 28, 2017 from https://ico nicphotos.org/2013/07/21/o-j-simpson-cover-matt-mahurin/.

"Photography and the Civil War." (2017). Civil War Trust. Accessed June 28, 2017 from https://www. civilwar.org/learn/articles/photography-and-civil-war.

"The Pulitzer Prizes." (2012). Pulitzer Organization. Accessed June 28, 2017 from http://www.pulitzer. org/winners/massoud-hossaini.

"Pyramids of Giza, Egypt." (n.d.). Altered Images BDC. Accessed June 28, 2017 from http://www. alteredimagesbdc.org/national-geographic/.

Radar Staff. (September 6, 2015). "His final moments! See Kurt Cobain's death scene in shocking never-seen-before photos." Radar. Accessed June 28, 2017 from http://radaronline.com/photos/ kurt-cobain-never-seen-before-death-scene-photos/.

Rohter, L. (August 17, 2009). "New doubts raised over famous war photo." *The New York Times*. Accessed June 28, 2017 from http://www.nytimes.com/2009/08/18/arts/design/18capa.html.

Rosenberg, J. (April 3, 2017). "Prisoners who were killed." ThoughtCo. Accessed June 28, 2017 from https://www.thoughtco.com/prisoners-who-were-killed-during-holocaust-1779701.

"Saigon execution: Murder of a Vietcong by Saigon police chief, 1968." (May 13, 2014). Rare Historical Photos. Accessed June 28, 2017 from http://rarehistoricalphotos.com/saigon-execution-1968/.

Smash His Camera (2010). Internet Movie Database. Accessed June 28, 2017 from http://www.imdb.com/title/tt1280015/.

"Story behind the most famous paparazzi photo ever." (September 9, 2016). *Time*. Accessed June 28, 2017 from http://time.com/4458511/paparazzi-jackie-kennedy-ron-galella/.

"The Two Ways of Life." (December 14, 2014). Codex 99. Accessed June 28, 2017 from http://www.codex99.com/photography/10.html.

Van Riper, F. (n.d.). "Manipulating truth, losing credibility." *The Washington Post*. Accessed June 28, 2017 from http://www.washingtonpost.com/wp-srv/photo/essays/vanRiper/030409.htm.

Willette, J. (January 2, 2015). "Hippolyte Bayard (1801–1887)." Art History Unstuffed. Accessed June 28, 2017 from http://arthistoryunstuffed.com/hipployte-bayard-1801-1887/.

Winslow, D. R. (August 2, 2006). "A question of truth: Photojournalism and visual ethics." NPPA. Accessed June 28, 2017 from https://nppa.org/news/2160.

Witty, P. (August 28, 2012). "Malcom Browne: The story behind the burning monk." *Time*. Accessed June 28, 2017 from http://time.com/3791176/malcolm-browne-the-story-behind-the-burning-monk/.

Zhang, M. (April 11, 2015). "The first photo of an execution by electric chair." PetaPixel. Accessed June 28, 2017 from https://petapixel.com/2015/04/11/the-first-photo-of-an-execution-by-electric-chair/.

Zhang, M. (August 29, 2012). "The Kent State massacre photo and the case of the missing pole." PetaPixel. Accessed June 28, 2017 from https://petapixel.com/2012/08/29/the-kent-state-massacre-photo-and-the-case-of-the-missing-pole/.

Zhang, M. (May 3, 2017). "Photographer Souvid Datta appears to have plagiarized Mary Ellen Mark." PetaPixel. Accessed June 28, 2017 from https://petapixel.com/2017/05/03/photographer-souvid-datta-appears-plagiarized-mary-ellen-mark/.

Zhang, M. (May 5, 2011). "Obama reenactment of bin Laden speech for press photos stirs controversy." PetaPixel. Accessed June 28, 2017 from https://petapixel.com/2011/05/05/obama-reenactment-of-bin-laden-speech-for-photos-stirs-controversy/.

3

DOCUMENTARY AND ADVOCACY

Followers of some of the oldest religions on this planet have told variations of this parable. It goes something like this:

> Six persons are blindfolded and led into a large room that has, without their knowledge, an elephant. Each one is then asked to describe a different part of the animal by what they can feel. One puts his hands around a leg and proclaims that it is a support column for a balcony. Another feels the tail and is sure the object is a rope. After touching the elephant's trunk someone else is sure that it is the limb of a tree. A fourth person feels its ear and is positive the thing in question is a hand fan. Hands on the beast's belly feel like a ceiling to another. And finally, the person who grabs a tusk is positive the object is some kind of solid pipe. (With my luck, I would put my hands in a big pile of its excrement and conclude that whatever it is, I want to get the hell out of the room.)

Each of the six thought the conclusion was correct based on a limited examination. The parable is typically used to illustrate how a limited perspective based on a subjective experience can be distorted. It is used to teach the lesson that false conclusions are often reached when there are few data points and little communication between participants. It is also the perfect story to illustrate documentary work and the concept of objectivity.

As reported in the prestigious *Columbia Journalism Review* by writer Brent Cunningham, Michael Bugeja, director and professor of the Greenlee School of Journalism at Iowa State University said, "Objectivity is seeing the world as it is, not how you wish it were" (Cunningham, 2003). Nothing to it, right? To be a successful visual communicator simply turn off any preconceived notions of how you think people, places, and things around you are and view scenes within your visual array with the cold metal hardness of a camera. Then, record those actions with the aloof, unblinking eye of a lens and interpret those stories with the detached calmness of a memory card. That procedure is fine for a security camera fastened to a corner of a store's ceiling or a GoPro attached to yet another annoying buzzing drone, but the obvious truth is that as people, we filter everything we experience through our previous interactions whether they are successes, failures, or somewhere in-between. As a result, our predetermined mindset, that we might not be fully aware of, often leads us to make conclusions, which are often wrong, and engage in stereotyping, that is often harmful.

Rejoice and celebrate that we are humans and not machines. But where does that leave the concept of objectivity? Hopefully, it goes in the trash bin where it has always belonged. We have never been objective, it is impossible to be objective, and no matter how hard we try and are aware of our shortfalls in this area, we will never be totally objective. No wonder that in 1996 the Society of Professional Journalists (SPJ) acknowledged this dilemma and dropped "objectivity" from its ethics code ("SPJ Code of Ethics," 2014). Perhaps that's because for all the talk about the need for reporters with words and pictures to be impartial, detached, unbiased, unprejudiced, and dispassionate (can you tell I love using my *Thesaurus*?), the concept is simply not possible.

Journalism Values

In 2002 Patrick Lee Plaisance and Elizabeth A. Skewes (2003) asked 600 newspaper reporters and editors to rank 24 values (they couldn't find one more?) collected from previous studies. They did not have "Objective" as a choice. The researchers analyzed 352 returned surveys and determined that the value "Honest (sincere, truthful)" was Number One. Second place was "fair (treating others as you want to be treated)" (notice the golden rule in practice) while the bronze medal went to "responsible (dependable, reliable)." In case you're interested, "Clean (neat, tidy)" was the catfish of the list (you know, because catfish are bottom feeders). Interestingly, "accuracy" was not included as a choice. Perhaps the authors thought that the concept was professionally problematic. You might use accurate quotes from a newsmaker, moral agent, or stakeholder, but find out later that the source was misleading you or even lying. Similarly, a visual reporter might accurately record a scene, but the truth might be something completely different. And so I must (seemingly) digress.

Way back when, I was a student photojournalist working for my university's newspaper. My assignment was to take pictures of a protest rally in front of the governor's mansion. Forgive me, but over the years I've forgotten the reason for the demonstration. When I arrived at the fancy house surrounded by an elaborate and imposing metal fence at the appointed time, I was disappointed to see few at the scene who were enthused, energetic, and therefore, visually interesting about this important issue. My problem was that I had pre-visualized the situation and thought there would be hundreds of livid, screaming, demonstrators on both sides of the issue with many carrying signs and police and state police officials busy keeping the two groups separated. Imagine any area near where Donald Trump speaks. However, my frustration at not getting a good picture for my portfolio did not prevent me from continuing with my role-related responsibility of bringing back to my picture editor something useful for the next day's paper. Finally, the organizers decided that those in attendance would be the total number of participants for that day and commenced the protest. It consisted of about ten students, three with signs, walking up and then back in front of the main gate. I do remember that I had no doubt at the time that this group wasn't going to change the world as we know it. And so, I had two choices. I could use a wide-angle lens and from a high perspective several feet away from the walkers and take a picture that featured the sad, ineffective turnout or I could use a telephoto lens, again from several feet away, and take a close-up frame of a particularly emotional and vocal protestor carrying a sign along with other compatriots filling out the tight composition. In one, the viewer would know how few showed up. In the other, the viewer would have no visual idea (the low number might still be reported in the story or caption) how many attended the rally. Which perspective do you think I chose (descriptive ethics)? What do you think I should have done (normative ethics)?

Back to the topic. The list of 24 values provided by Plaisance and Skewes in their research article should be cherished and fostered as character traits regardless of someone's profession

or situation: Aboveboard, Ambitious, Broadminded, Capable, Cheerful, Civic-minded, Clean, Courageous, Empathetic, Fair, Forgiving, Helpful, Honest, Imaginative, Independent, Intellectual, Just, Logical, Loving, Minimizing Harm, Obedient, Polite, Responsible, and Self-controlled. It's a good list to keep in mind, even though I have always had trouble with being obedient. Regardless, I'm pleased that empathetic made the list because of the obvious Rawls' connection.

Four of the values included with the survey have similar traits that can be related to being neutral in the treatment and coverage of stories and their sources. These are fair, independent, just, and logical.

The well-known slogan for Fox News is simply "Fair & Balanced." Introduced in 1996 by founder Roger Ailes, the organization took an ethics hit after Ailes and popular "Factor" host Bill O'Reilly were forced to resign after several women employees complained that the two were the least fair of them all. The Fox News saying was conceived from the perception by some that other print and broadcast media outlets, particularly *The New York Times, The Washington Post,* MSNBC, and on occasion, CNN, emphasize a liberal agenda. Fox News leans to the right in its coverage and commentaries to even the political playing field. Understand the Fox News' position: Those responsible for the news justify their biased and unbalanced story selections and presentations in order to correct their perception of biased and unbalanced reporting by other media outlets. This hedonism-inspired argument shows the thinness of an ethical tightrope. In 2017 Fox News changed the motto to "Most Watched. Most Trusted." Stay tuned, or not.

One of the most dangerous myths that comes from this illusion of balance is that opposing sides of an argument should always be represented when reporting a story. Think of the main cause for global climate change and the possible link between vaccinations and autism as two controversial storylines made more newsworthy by spokespersons with agendas both pro- and anti-scientific. An old-school, journalism, objective reporting procedure would be to interview and photograph two persons with opposing opinions. Pat yourself on your pre-1990s back as your role-related responsibility would be satisfied. However, would the harm caused by delivering misleading information to the public be justified by an insistence on such fair and balanced coverage?

The Myth of Objectivity

Where the issue of objectivity is most interesting is in a discussion of photojournalism and documentary photographers and filmmakers. Photojournalists for paper and online news entities almost always make visual messages intended to be single-picture records of that day's news, sports, features, and so on. Visual reporters also spend from a few days to several months to produce picture stories that sometimes contain as many as 25 images with stories and captions and/or videos with interviews, wild sound, and music. Whether for a 20-minute assignment or a 20-week project, balanced reporting should be the norm as no stage-managing or content manipulations of any kind are ethically permitted. Documentary photographers and filmmakers work exclusively on long-form, multi-image and/or multi-scene presentations for websites, books, television, or motion picture screens. A key to the difference with photojournalists is that they often are visual reporters with few ties to news organizations or journalism schools. Photojournalists and documentary image-makers select the same types of stories, they use the same procedures to cover their subjects through in-depth ways, they use similar equipment to produce still and moving images with audio, and they both devote a great deal of time to produce quality work.

The last factor – time – is critical in this discussion of objectivity. With daily assignments, there is not much time to find, take, and deliver images to an editor. Consequently, objectivity is easier to master. But when there is no time limit for a story, complications can ensue. If a project takes several months or years to produce, for example, an emotional bond forms

between the documentarian and the story's source that often makes objectivity impossible. Human emotions should trump robotic actions.

Nevertheless, when either forced to complete an assignment in a matter of minutes or given the luxury of an open-ended deadline, objectivity is a myth that sounds good on paper but in reality impossible to achieve. As Julianne Newton (2000) wrote in her classic work, *The Burden of Visual Truth: The Role of Photojournalism in Mediating Reality*, subconscious and willful aesthetic, technical, and content-driven decisions made by an image-maker dictate the end result. Every choice one can imagine made by a visual communicator is based on subjectivity. Visual reporters often fool themselves, their editors, their subjects, and their viewers into thinking that they are objective and careful recorders of reality. The truth is, as always, difficult to determine because an image in a frame is a fabrication created from multivariate decisions based on previous experiences, current mood, political attitude, cultural background, expectations, technical knowledge, and ethical sensitivity.

The deuce you say. When you take pictures you make truthful, accurate, complete, and timely recordings of what occurred in front of my camera without embellishment, enhancement, and manipulation of any kind. Good for you. However, my argument is that such documents are not only philosophically impossible, but also physiologically unfeasible. If you don't believe my take on the subjectivity of objectivity (and why should you, really?), then take the words of British theoretical physicist and cosmologist Stephen Hawking (2010) who wrote with the help of Leonard Mlodinow, an American physicist, *The Grand Design*. According to the two scientists and philosophers, classical science gave us the notion that there is an actual world outside of our own perceptions. That's an easy concept to accept, right? As I sit in a café writing these words I see the capital letters on my computer's keyboard, feel the soft cushion on the couch I'm sitting on, hear two women discussing the benefits and costs of Buda Juice, and I smell chicken tortilla soup simmering on a burner in the kitchen. All of this sensual information is happening outside of me, right? Wrong. As the Scottish philosopher David Hume noted, "Although we have no rational grounds for believing in an objective reality, we also have no choice but to act as if it is true" (Morris, 2013). Of course, we think what we sense is real, but Hawking and Mlodinow (2010, p. 46) put the concept into sharper focus when they write:

> There is no way to remove the observer – us – from our perception of the world, which is created through our sensory processing and through the way we think and reason. Our perception is not direct, but rather is shaped by a kind of lens, the interpretive structure of our human brains.

In other words, we are the observer *and* the observed. This relationship between the reality perceived in the outside world and the reality generated within our minds is the same – the literal definition of subjectivity. A better argument against objectivity could not be made.

However, a speech to the Investigative Reporters and Editors (IRE) conference in 1995 by the learned educator and author Philip Meyer comes close (Meyer, 1995). He stated:

> Objectivity, as defined by the knee-jerk, absolutist school of media ethics, means standing so far from the community that you see all events and all viewpoints as equally distant and important – or unimportant. It is implemented by giving equal weight to all viewpoints and assertions – or, if not, all an interesting variety within a socially acceptable spectrum. The result is a laying out of facts in a sterile, noncommittal manner, and then standing back to 'let the reader decide' which view is true.

Nevertheless, Meyer cautions,

> When you start caring about how public debate goes, even if you don't prefer a particular outcome, you start making subjective decisions about what to focus on and when. Journalistic passivity is abandoned. One solution is to draw a line somewhere on the slippery slope, be subjective up to that point, and then stop.

For Meyer, data-driven, scientific, journalism methods combined with the passion to tell stories as exhibited by citizen journalists is the future for the profession and a hedge against subjectivity that degrades into outright manipulation (see Chapter 4).

Admire, emulate, and tell others documentary failures and successes you have seen. You can learn as much from examples from those who have slid down the metaphorical slippery slope as you can from notable successes. Take the time to view the first stage-managed, naïve, and exceedingly dull documentaries from the French brother team of Auguste and Louis Lumière, the first to think of showing movies within a theater, in such literal titles as *Workers Leaving the Lumière Factory* and *Fishing for Goldfish* ("Pioneers," n.d.); the imperfect first try at documenting Native Americans in Alaska by the American filmmaker Robert Flaherty in *Nanook of the North* (1922), brilliantly parodied by writers Fred Armisen, Bill Hader, Seth Meyers, and Rhys Thomas in *Kunuk Uncovered* for the "Documentary Now!" (2015) television series; the picture stories of much too happy natives and locals within the pages of early *National Geographic*, *Picture Post*, and *Life* magazines; and the work of the Farm Security Administration photographers ("Photographers of the FSA," n.d.), some of the most revered names in photographic history that included Walker Evans, Dorothea Lange, Russell Lee, Carl Mydans, and Arthur Rothstein to produce propagandistic images in order to assist those most affected by the Great Depression.

For critically acclaimed documentaries produced by award-winning visual journalists, study the winners of the category in various photojournalism contests – Alexia Foundation, Best of Photojournalism, Pictures of the Year International, World Press Photo, and many others. Study the methods, pacing, and techniques of documentary films that have emotionally moved, profoundly educated, and spurred change among viewers. For example, watch anything produced by Les Blank (2012), Barbara Kopple (n.d.), Albert and David Maysles ("Films," n.d.), Errol Morris (n.d.), and Frederick Wiseman (2017). Study the way complex stories are told in the work of director Gabriela Cowperthwaite of *Blackfish* (2013), in Davis Guggenheim's *An Inconvenient Truth* (2006) and its follow-up, *An Inconvenient Sequel: Truth to Power* (2017) directed by Bonni Cohen and Jon Shenk, in Lauren Greenfield's *The Queen of Versailles* (2013), in Werner Herzog's *Cave of Forgotten Dreams* (2013), and in Louie Psihoyos' *The Cove* (n.d.). You should also watch, listen, and recommend to your friends documentary films and miniseries as presented on Showtime, HBO, other cable channels and sources. For example, the Peabody Award winning podcast, "Serial," (2017) an offshoot of Ira Glass' "This American Life" radio show co-created by Sarah Koenig and Julie Snyder, is a clinic in how to conduct complex investigative journalism pieces with positive results. Andrew Jarecki's "The Jinx," (2017) a six-part series on HBO about the life and crimes of real estate heir Robert Durst is a workshop in how to conduct interviews. Appreciate the editing expertise evident in Brett Morgen's *Kurt Cobain: Montage of Heck* (2017). Marvel in the brilliant work of director and producer Ezra Edelman for ESPN Films in his five-part, 8-hour documentary miniseries, "O.J. Made in America" (n.d.). Compare it with FX Networks' "The People v. O.J. Simpson: American Crime Story" (2017) with actors playing key roles. Although both works are well produced, the Edelman effort, using interviews from actual participants and news footage at the time, feels more authentic.

The above suggestions for further viewing come from sensitive and thoughtful photo-journalists and filmmakers who acknowledge their biases – their inherent subjectivity with their subjects – but manage, despite the flaws in capturing reality, to produce work that make a difference.

So where does that leave you? What should you do to control your own biases when on an assignment? How do you remain fair and balanced? What can you do to combat your subconscious and conscious subjectivity?

A story told about G. Gordon Liddy, the morally bankrupt chief operative of President Nixon's White House Plumbers unit that broke into the Democratic National Committee headquarters in 1972 located in the Watergate building, involves him holding a hand over a candle flame until the flesh on his palm burns in order to prove his toughness. When asked how he did it, he answered, "The trick is not minding." The original quote actually comes from the 1962 epic, *Lawrence of Arabia* when Lawrence, played by Peter O'Toole performs the same "trick" over a lit match and says, "The trick is not minding that it hurts" ("The trick is ...," 2007). Simply put, no matter how high you regard the golden rule philosophy or how much empathy you feel related to the veil of ignorance philosophy, it is impossible to rid yourself of your biases, prejudices, and sympathies. So, don't mind.

Use your moral sense to know the difference between right and wrong and act to produce work that punishes the wrong and elevates the right (but perhaps not necessarily in the political meaning of the word). Be subjective. Care. Don't be a robotic camera stuck up on a selfie stick. And by all means, do your best. Here's a secret about the conclusion for every case study described in this book – do your best. That's all you can do. As stated previously and more succinctly: Do your job and do not cause unjustified harm. And if sometimes you err because you're human, try not to mind too much if your hand gets singed.

By the way, for the governor's mansion assignment, I turned in both versions to my editor – a wide-angle shot that showed how few protesters were at the scene and a telephoto frame that zeroed-in on one person holding a sign. After a brief discussion, it was decided that both pictures would be used.

See Appendix A for a professional's approach to documentary and advocacy.

Case Studies

Case Study One

Michael Moore is one of the most controversial documentary filmmakers of the twentieth and twenty-first centuries. Among his most controversial films is *Bowling for Columbine*, which explores the lead up and events surrounding the 1999 school shooting at Columbine High School. The film won the 2003 Academy Award for Best Documentary-Feature. Fans of the film contend that it nicely portrays how a "gun culture" in the United States that celebrates gun ownership and easy gun access leads to more violence and criminal activity than is true of other Western democracies where these kinds of gun practices are not the norm. Critics contend that Moore manipulated both facts and – even worse – images to make an untruthful argument about gun safety. The problem *is not* guns, but bad people, they said, and Moore's film unfairly framed the National Rifle Association (NRA), its leader Charlton Heston, and other individuals associated with the pro-gun movement.

Documentary films are both films in the regular sense, and arguments for a particular point of view. What is the obligation of filmmakers to fairly present all sides of an issue? How

much editing is too much? Is it enough to simply tell the other side: Find someone to make a movie for you?

Farber, S. (2002). "Michael Moore's 'Bowling for Columbine.'" *Documentary Magazine*. Accessed June 28, 2017 from http://www.documentary.org/magazine/michael-moores-bowling-columbine-2002.

See Appendix B for the 10-Step Systematic Ethical Analysis Form.

Case Study Two

Public relations professionals are allowed to "fix" quotes for the people they work for, to make them sound smarter, pithier, or more articulate than they might really be. Imagine now that you're working as a public relations person for a company, and your CEO goes on a safari, and his jeep accidentally runs over a giraffe. He has video of his voyage, and he's very excited to post some of the footage, but he asks you to leave out any mention of his mishap, and to edit out the part where the jeep hits the animal (he was driving). But you know this is the part people will be most interested in – after all, he wasn't supposed to be behind the wheel. He wasn't licensed to drive in that country.

See Appendix B for the 10-Step Systematic Ethical Analysis Form.

Case Study Three

In the middle of the 1990s, some producers at ABC News got a tip about possible unsanitary food handling practices at Food Lion, a national grocery store chain. Thinking that they probably wouldn't be allowed to bring their cameras inside the store to investigate, the producers decided to go undercover as employees. They made up fake resumes and got themselves hired in the meat department of a local Food Lion store.

Using hidden cameras, these producers captured evidence of bad behavior on the part of the supermarket, including repackaging and reselling meat past its "sell-by" date. This footage was subsequently aired on the ABC newsmagazine program "PrimeTime Live." Soon thereafter, Food Lion sued ABC for both fraud and trespass, eventually winning jury verdicts on both counts.

Rasmussen, K. (2012). "The landmark Food Lion case." Reporters Committee for Freedom of the Press. Accessed June 28, 2007 from https://www.rcfp.org/browse-media-law-resources/news-media-law/news-media-and-law-spring-2012/landmark-food-lion-case.

See Appendix B for the 10-Step Systematic Ethical Analysis Form.

Annotated Sources

Constantine, G. (2016). "Nowhere people: Exposing a portrait of the world's stateless people". TEDxEastEnd. Accessed June 28, 2017 from https://www.youtube.com/watch?v=u9DD6MZj5Z4.

Greg Constantine is a photojournalist who exudes empathy for the people he photographs in troubled and impoverished locations around the world. Listening to his passionate speech should convince you of his sincerity and commitment.

Freeman, C. (2012). "Fishing for animal rights in The Cove: A holistic approach to animal advocacy documentaries". *Journal for Critical Animal Studies, 10*(1), 104–118.

This article explores how documentary works to argue *for* something – in this case, to encourage viewers to take seriously animal rights. The writer of the essay, Carrie Packwood Freeman, takes the documentary film *The Cove* as her point of departure. *The Cove* won the 2009 Academy Award for Best Documentary, Feature Film, for its portrayal of dolphins and the need to protect their lives, habitats, and freedoms. Freeman argues the film can also be read as an argument for applying these same ethical values to creatures across the animal kingdom.

Kristine, L. (2013). "Shine a light on modern day slavery". TEDxOrangeCoast. Accessed June 28, 2017 from https://www.youtube.com/watch?v=KMLoxLUPWhw.

Lisa Kristine is billed on her website as an "international humanitarian photographer." Her portraits of persons trapped by modern-day slavery are stunning, insightful, and technically brilliant. But does her website, although informational, look too much like she is trying too hard to profit from the misery of others?

Rose, G. (2014). "On the relation between 'visual research methods' and contemporary visual culture". *The Sociological Review, 62*(1), 24–46.

As with text, images work to create shared meaning. This feature results in visual research methods that cannot merely be applied in social science. They are performances that help create the very worlds they study and explore. As such, photographs are not merely examples of objective evidence waiting for researchers to discover and endow with cultural significance, but are communicative tools that are open to interpretation.

References

"Barbara Kopple." (n.d.). Cabin Creek Films. Accessed June 28, 2017 from http://www.cabincreekfilm s.com/barbara_kopple.html.

Blackfish. (2013). Dogwoof. Accessed June 28, 2017 from http://www.blackfishmovie.com/.

Cave of Forgotten Dreams. (2013). IFC Films. Accessed June 28, 2017 from http://www.ifcfilms.com/films/ cave-of-forgotten-dreams.

The Cove. (n.d.). Oceanic Preservation Society. Accessed June 28, 2017 from http://www.thecovem ovie.com/.

Cunningham, B. (August 2003). "Re-thinking objectivity." *Columbia Journalism Review*. Accessed June 28, 2017 from http://archives.cjr.org/feature/rethinking_objectivity.php.

"Documentary Now!" (August 27, 2015). Internet Movie Database. Accessed June 29, 2017 from http://www.imdb.com/title/tt4823560/.

"Errol Morris." (n.d.). Errol Morris. Accessed June 28, 2017 from http://www.errolmorris.com/film. html.

"Films." (n.d.). Maysles Films, Inc. Accessed June 28, 2017 from http://mayslesfilms.com/films/.

"Frederick Wiseman." (2017). Zipporah Films, Inc. Accessed June 28, 2017 from http://www.zippora h.com/.

Hawking, S. and Mlodinow, L. (2012). *The Grand Design*. New York: Bantam.

An Inconvenient Sequel: Truth to Power. (2017). Internet Movie Database. Accessed June 28, 2017 from http://www.imdb.com/title/tt6322922/.

An Inconvenient Truth. (2006). Internet Movie Database. Accessed September 13, 2017 from http:// www.imdb.com/title/tt0497116/?ref_=nv_sr_4.

"The Jinx: The life and deaths of Robert Durst." (2017). HBO. Accessed June 28, 2017 from http:// www.hbo.com/the-jinx-the-life-and-deaths-of-robert-durst.

Kurt Cobain: Montage of Heck. (2017). HBO. Accessed June 28, 2017 from http://www.hbo.com/ documentaries/kurt-cobain-montage-of-heck.

"Les Blank films." (2012). Les Blank Films. Accessed June 28, 2017 from http://lesblank.com/.

Meyer, P. (1995). "Public journalism and the problem of objectivity." University of North Carolina. Accessed June 28, 2017 from http://www.unc.edu/~pmeyer/ire95pj.htm.

Morris, T. (2013). "David Hume's life and works." The Hume Society. Accessed June 28, 2017 from http://www.humesociety.org/about/HumeBiography.asp.

"Nanook of the North (1922)." (December 16, 2012). YouTube. Accessed June 28, 2017 from https://www.youtube.com/watch?v=m4kOIzMqso0.

Newton, J. (2000). *The burden of visual truth: The role of photojournalism in mediating reality*. New York: Routledge.

"O.J. Made in America." (n.d.). ESPN. Accessed June 28, 2017 from http://www.espn.com/30for30/ojsimpsonmadeinamerica/.

"The People v. O.J. Simpson: American Crime Story. " (2017). FXNow. Accessed June 28, 2017 from http://www.fxnetworks.com/shows/american-crime-story.

"Photographers of the FSA: Selected portraits." (n.d.). The Library of Congress. Accessed June 28, 2017 from http://www.loc.gov/pictures/collection/fsa/sampler.html.

"Pioneers, The Lumière brothers." (n.d.). EarlyCinema.com. Accessed June 28, 2017 from http://www.earlycinema.com/pioneers/lumiere_bio.html.

Plaisance, P.L. and Skewes, E.A. (2003). "Personal and professional dimensions of news work: Exploring the link between journalist' values and roles." *Journalism & Mass Communication Quarterly*, 80(4), 833–848.

The Queen of Versailles. (2013). Magnolia Pictures. Accessed June 28, 2017 from http://www.magpictures.com/thequeenofversailles/.

"Serial." (2017). Serial. Accessed June 28, 2017 from https://serialpodcast.org/.

"SPJ code of ethics." (September 6, 2014). SPH.org. Accessed June 28, 2017 from https://www.spj.org/ethicscode.asp.

"The trick is …" (2007). YouTube. Accessed June 28, 2017 from https://www.youtube.com/watch?v=BYNElueJj_w.

4

CITIZEN JOURNALISM

Two citizen journalists – before social media they were called amateur photographers – stood a few feet apart and took essentially the same picture. One was disgraced. The other won a Pulitzer Prize. Such starts a cautionary tale on citizen journalism and credibility.

According to Jay Rosen, media critic, author, and educator, citizen journalists are "the people formerly known as the audience." With hundreds of millions of easily pocketed and retrievable camera phones bought every year by consumers throughout the world that provide internet access to social media for quick and convenient uploads that bypass traditional print and broadcast outlets, creators and the audience are one. We are the media. Nevertheless, because an event is recorded does not necessarily make it journalism.

The citizen visual reporter and the visual account documented, user-generated content (UGC), must have credibility. A disciple of the Chinese philosopher Confucius asked the master, "I've heard that credibility is the cardinal principle of conducting oneself in society. Is that true?" Confucius answered, "How can one be acceptable without being trustworthy? It is like a carriage without a yoke. How can one move forward? Without credibility, one has no restraint." Not surprisingly, Confucius was an early advocate of the golden rule philosophy. He was also apparently opposed to hitching a ride on a passing ox cart.

Howard Chapnick (1996), author of *Truth Needs No Ally: Inside Photojournalism* and long-time head of the prestigious Black Star picture agency cautioned, "Credibility gives [visual reporters] the right to call photography a profession rather than a business. Not maintaining that credibility diminishes journalistic impact and self-respect, and the importance of photography as communication."

In a story that reveals its tone with the headline, "Real TV news stars rush to prostitute themselves on 'House of Cards,'" Michael Hiltzik of the *Los Angeles Times* condemns the practice of actual journalists appearing in the Washington-based political drama on Netflix (Hiltzik, 2014). Reporters from "60 Minutes," ABC, Al Jazeera America, CNN, Fox, NBC, and *The New York Times* have portrayed themselves on the show. For Hiltzik the issue is about credibility. "Losing your credibility is a high price to pay just for the sake of swanking around as yourself for a Hollywood soap opera," he writes. "The loss of credibility for the news shows that employ people willing to turn themselves into live-action cartoons is even worse."

A lack of credibility is often associated with the hedonism philosophy. Hedonism is an often-derided philosophy for a person to possess, almost always deserving of consternation.

Who wants to defend another whose behavior is based solely on an individual's sense of entitlement? Any visual reporter who performs an action to increase personal wealth, status, or standing rather than for professional reasons reduces credibility and is considered an example of hedonism.

Awards Signify Credibility

A man who hoped his philanthropy would counteract criticisms of his hedonistically inspired publishing decisions and lack of credibility established the Pulitzer Prize, one of the most prestigious awards given each year since 1917 for literary and journalistic excellence. In his will, the Hungarian-born Joseph Pulitzer provided $250,000 (almost $5 million today) to Columbia University to inaugurate a journalism school and to fund the Prize (Topping, 2017). He had many professional sins he wanted to atone. One of the most egregious was his circulation war with another hedonistic newspaper publisher of his day, William Randolph Hearst (Wierichs, n.d.). In order to sell more papers, attract advertisers, and promote their political agendas, the two sensationalized stories with frighteningly, large headlines, gaudy illustrations, stereotypical cartoons, faked interviews, and fake news. Their exaggeration of a minor conflict in Cuba between Spain and the United States so inflamed the will of the American public that it was blamed for the Spanish-American War in 1898. In addition, their outrageous, ego-driven, back-and-forth bidding war for the cartoonist Richard Outcault's "The Yellow Kid," the most popular cartoon of the day, led to the derogatory term for unethical behavior, yellow journalism ("The Yellow Kid," n.d.). At least for Pulitzer, his legacy is repaired through his eponymous Prize. For Hearst, his is forever tarnished by his unrepentant actions and opinions and Orson Welles' motion picture, *Citizen Kane*, a harsh view of the life of Hearst, considered one of the best films ever produced (Dirks, 2017). The stories of Pulitzer and Hearst prove that bad business decisions can be ruinous to one's reputation and counters the argument that bad publicity is a positive outcome from controversy.

On April 19, 1995 at 9:02 on a bright, blue, cloudless Wednesday morning, a truck bomb loaded with about two tons of explosives detonated next to the Alfred P. Murrah Federal Building in downtown Oklahoma City. This surprise attack remains the worst case of domestic terrorism in American history. The blast destroyed or damaged more than 300 buildings, crushed 80 automobiles, caused ruin in excess of $650 million (more than $1 billion today), injured more than 680 persons, and resulted in 168 deaths that included 19 children. One of the most memorable killed that day was one-year-old Baylee Almon, seen gently cradled by the bare hands of firefighter Chris Fields in photographs taken by Lester "Bob" LaRue and Charles H. Porter IV. The bloodstained child held calmly and caringly elicits sorrow, solemnity, and a visual comparison to the Pietà, the work by the fifteenth-century Renaissance sculptor Michelangelo Buonarroti. Wednesday's child is full of woe (Eversley, 2015).

As reported on the website Famous Picture Collection, Bob LaRue, 57, was a safety coordinator for the Oklahoma Natural Gas Company when he heard the explosion ("Oklahoma City bombing," 2013). He assumed it was a gas leak. He raced to his car to retrieve a company camera kept under a seat and made several frames of the scene. After his film was developed, he got a call from a photo clerk that an editor for *Newsweek* magazine wanted to see his negatives. He was paid $14,000 (about $21,000 today) from the magazine with more money sent to him by other media entities.

Charles Porter was a 26-year-old loan officer for Liberty Bancorp in a building nearby with dreams of being more than a credit analyzer. With a keen interest in photography, he earned a little extra money taking pictures at weddings, the Bullnanza Rodeo, and for the

University of Oklahoma's athletic department. While working at his desk he heard what he later called a sonic boom and immediately ran to his car to retrieve his camera. He took a few pictures of damaged buildings, debris, and rescue workers while not thinking too much about what he had recorded. As he usually did, he later took his film to be developed at his local Walmart. As reported by Ben Crandell (2016), Porter described the reaction of the women in the photo department to his prints. "They were looking over my shoulder, and they started crying. [One] said, 'Oh, honey, what have you got? What did you take a picture of?' And that's when I kind of went, 'Wait a minute. Hold on. I might have something here.'"

What Porter had was a photograph he sold to the Associated Press that ran in newspapers across the globe and filled the cover of *Time* magazine. The next year he won the Pulitzer Prize for Spot News Photography, a rare feat for anyone, but especially rare for an amateur photographer.

The first amateur photographer to win a Pulitzer Prize was Arnold Hardy, a 24-year-old graduate student at Georgia Tech in Atlanta ("Amateur who took Pulitzer," 2007). Getting home after a late-night date on December 7, 1946, Hardy heard a fire engine's siren. After a call to the station he learned the location of the fire, the Winecoff Hotel with 240 registered guests. When he arrived the hotel was engulfed in flames. His son, Glen, later told a reporter for the *Atlanta Journal-Constitution*, "He stood on the sidewalk and watched people plummet to their deaths." In the darkness and confusion of the situation he took four pictures using the flashbulb technology of the day. His final image forever froze Daisy McCumber, a 41-year-old Atlanta secretary. Miraculously, she survived the 11-storey fall. One hundred and nineteen died in the catastrophe, at that time the deadliest hotel fire in US history. Hardy sold his photograph to the Associated Press for $300 (about $3,700 today) and was published in newspapers throughout the nation. The next year, he won the Pulitzer Prize. As a utilitarian plus, his photograph led to changes in building fire codes across the country. In true amateur photography tradition, Hardy turned down a job with the AP and started a company that produced X-ray equipment. "The only pictures I've taken since then," he admitted, "have been of family and on vacations."

In 1954 another amateur won the coveted prize. Virginia Schau was a housewife from North Sacramento on a holiday with her husband near Redding, California. She happened upon the rescue of two men stuck in the cab of a semitrailer that teetered over the edge of a bridge that spanned the Pit River, a tributary of the Sacramento (Dhaliwal, 2013). As reported by Frank Van Riper, Schau's husband and a passerby lowered a rope to the men who screamed for help. During the successful rescue attempt, Schau's father reminded her of the *Sacramento Bee*'s photography contest. She ran to her car and retrieved her simple Kodak Brownie camera to take the picture. She won the $10 first place award (about $100 today) from the *Bee* and the next year the Pulitzer.

The third amateur to win a Pulitzer sold furniture in St. Louis. In 1989 Ron Olshwanger enjoyed taking pictures of fires so much he installed a police scanner in his car to arrive at burning infernos (Holland, 2008). Moments after he arrived at a house fire, he photographed firefighter Adam Long giving mouth-to-mouth resuscitation to two-year-old Patricia Pettus outside a burning house. Unfortunately, the child died from her injuries. Editors at the *St. Louis Post-Dispatch* paid Olshwanger $200 (about $400 today) and ran the picture on the front page. After he won the Pulitzer, he gave his cash award to the Pettus family. As another utilitarian philosophy bonus, the tragedy publicized the need for smoke detectors in homes.

Hardy, Schau, and Olshwanger all had one trait in common with professional photojournalists. Except for the sale of the image to a news organization and the $10,000 cash award from the Pulitzer Prize Board (worth today about $100,000, $90,000, and $20,000

respectively), none of them actively attempted to cash in on the picture's notoriety by endorsing cheesy product tie-ins.

LaRue's photograph taken on that fateful day is seldom seen, won no prizes, and remains a source of frustration for the citizen journalist all because he approved the use of the image on T-shirts, posters, and other memorabilia. After Baylee's mother, Aren publicly condemned the use of her daughter's image for tacky self promotions, executives of LaRue's gas company told him to stop selling the image because of the negative publicity and on the grounds that it wasn't his to sell. He used the company's camera and film. After LaRue refused to stop profiting from the picture, he was fired after 30 years on the job. He eventually lost a legal battle with the company over the copyright. It is estimated that he earned about $40,000 ($60,000 today). He gave some of the money to charities, but the majority of the earnings paid his legal fees. The controversy and questions about his credibility propelled Bob LaRue into the back pages of history and nullified a fine photographic effort.

Although Charles Porter also allowed his photograph to be used for memorabilia companies, particularly Precious Moments, known as a manufacturer of overly sentimental dolls, jewelry, and figurines, perhaps because of his more modest personality, his reputation remained intact. Writer Anthony Feinstein (2016) reports that today Porter is a physical therapist living in Texas. His Pulitzer trophy rests in a glass cabinet next to his family's fine china. In an interview he admitted, "Don't mistake for one second that I think that I am any kind of professional photographer. I was in the right place at the right time, and I was prepared and equipped to take advantage of that opportunity" (Crandell, 2016). A clearer definition of a bystander photographer could not be better stated.

Still photographers, then, have been recognized by major photographic award organizations with most rules for entries simply stating that the pictures be published. For those who use moving images as the medium of choice, honors are bestowed by the Heywood Broun Award, the Emmy Awards, the Edward R. Murrow Awards, the National Press Photographers Association, the Peabody Awards, the George Polk Award, among others.

However, despite the fact that citizens with camera phones have provided valuable moving image accounts during such news events as Iran's Green Movement, the Arab Spring, the Occupy movement, highly controversial police shootings, and countless other stories, award competitions, for the most part, do not recognize their achievements. And yet, over the years there have been extraordinary recordings made by average citizens that have changed the course of history.

For moving images, one of the most famous citizen journalists is considered to be Abraham Zapruder, a dress manufacturer with an interest in filmmaking. He used a Bell & Howell film camera loaded with 8mm Kodachrome II film to record in silence the assassination of President John Kennedy in Dallas. The footage has been called the most important 26 seconds in film history ("Zapruder film," 2011). The morning following the tragedy, Zapruder agree to let *Life* magazine publish frames from his film for a fee of $150,000 (the equivalent of $1,185,000 today). Although Zapruder died in 1970, his family retained the copyright of the film until 1999 when it was donated to the Sixth Floor Museum housed within the Texas School Book Depository from where Lee Oswald shot President Kennedy. The short film is available for viewing on the museum's website and elsewhere. An interesting contrast to the violent message of the Zapruder film is the remix by artist Josh Azzarella (Azzarella, 2005). After the presidential party passes by the street sign, a smiling Kennedy continues on his journey without incident.

In 1991 George Holliday, a 31-year-old plumber stepped out onto the second floor balcony of his apartment and used a newly purchased camcorder to videotape the beating of motorist

Rodney King by members of the Los Angeles Police Department. The tape has been called one of the most significant pieces of video ever recorded after it was shown throughout the world (Troy, 2016). When four police officers were acquitted in a criminal case against them the next year, the film was cited as one of the factors that caused the worst rioting in US history with 55 persons killed, more than 2,000 injured, and more than $1 billion ($1.7 billion today) in property damage. Nevertheless, the prestigious Peabody Award was given to KTLA-TV that first aired the footage and not to Holliday. Years later as reported by Erik Ortiz, Holliday urged citizen journalists "to stand up and record when they see something wrong – as long as they know that what they're putting out there reflects the truth."

Still images and video from bystanders were used by news agencies to help tell the complicated story of the destruction caused during 9/11 and the airplane attacks on the World Trade Center in New York City in 2001. Most of the amateur visual reporters were unrecognized and unknown to the general public. However, with the internet, and social media sites such as Facebook, Twitter, and Instagram along with websites such as the CitizenTube channel on YouTube, CopBlock (2017), and Photography Is Not A Crime (2017), amateur videos are easily uploaded and viewed by millions with those who recorded news events made public.

Although *The Washington Post* reported that police are responsible for 995 shooting deaths of suspects in 2015, few are recorded on camera. The exceptions stand out. Ramsey Orta, 24, filmed police give an illegal chokehold to Eric Garner (2014) that caused his death in 2014. The next year Kevin Moore, 30, recorded the arrest of Freddie Gray in Baltimore who later died in police custody.

In 2015 Feidin Santana, 23, a barber from the Dominican Republic filmed the fatal shooting in the back of Walter Scott by Officer Michael Slager in North Charleston, South Carolina ("Walter Scott shooting," n.d.). After Santana visited the home of Scott family members, he gave a copy of the video to the family. Concerning the decision to hand over the video, an action that a professional journalist would almost never do, Santana noted that the family was highly emotional and he thought about his position and their situation. "If I had a family member that it happened to, I would want to know the truth." His action was based on the veil of ignorance philosophy of feeling empathy for another. Slager was later indicted by state and federal authorities. The jury in the state trial was unable to reach a verdict and a mistrial was declared. A retrial of the charges is expected. Nevertheless, Slager pled guilty in the federal civil rights case.

In July 2016 two homemade videos of police shootings in as many days made the national news. In Baton Rouge, 37-year-old Alton Sterling was shot and killed after a struggle with police officers ("New video released," 2016). A friend of Sterling's and owner of a convenience store where the event took place, Abdullah Muflahi, filmed the incident. The entire footage was shown on the website *The Daily Beast*. Arthur Reed, a Black Lives Matters activist who heard about the arrest on a police radio scanner and arrived at the store also made a video of the shooting through a car's window. The next day in a suburb outside St. Paul, Lavish "Diamond" Reynolds sat in the driver's side of a car next to her fiancé, Philando Castile who was shot four times by a police officer. He later died from his wounds. Reynolds' four-year old daughter sat in the back seat. Reynolds used Facebook Live, a video-streaming service for smartphones, to broadcast the ordeal ("Lavish Diamond Reynolds," 2016). Her voice-over narration as she talked with the officer was extraordinary, as most bystander clips do not include detailed commentary. In 2017 a jury found the police officer Jeronimo Yanez who killed Castile not guilty on all counts.

The rash of publicized police shootings allegedly inspired a mentally ill Afghanistan War veteran a day later to ambush police officers after a peaceful protest march had ended in downtown Dallas, killing five and wounding seven. News coverage of that story combined footage taken by journalists with professional television equipment and citizens with camera phones. Video from Sidney Johnson, an intern with Central Track, a Dallas-based web publication showed police cars, downed officers, frightened passersby, the sound of gunshots, and someone yelling from inside a parking garage, "There are four cops down. There's a sniper from up here somewhere" ("Exclusive video," 2016). And then, "Holy shit." Another eyewitness with a camera, Randy Biart made his video available to the Associated Press and other news sources. His video is much more graphic ("Eyewitness video," 2016). From the roof of a building it shows a shootout with police officers with shots from the assailant hitting DART officer Brent Thompson multiple times from behind at point-blank range killing him. A voice is heard to say, "He's down. Oh, [expletive deleted]. There's more of them." Both videos are compelling visual documents, but the uncut, raw, and emotional voice-overs are typically not part of an edited newscast. None of the citizen journalists was cited for recognition by any award-granting television organization.

The reason still images win prizes for journalism excellence and bystander videos do not is because the expectation for a single image is lower than for a video. All that is needed for a single photograph taken by an amateur to be considered for a journalism prize is for the photographer to be able to provide basic caption information – the who, what, when, and where questions answered – and for it to be published by a news entity. However, for a video to be considered by an award-granting institution, it must be edited and produced into a package – it cannot simply be raw footage. To win a television award it must have a story arc that moves from a beginning to an end with compelling pictures, insightful interviews, wild sound, informative voice-overs, and so on. That's the difference between still and moving image citizen journalism – although a dramatic storyline is always a vital component, it is the telling that is praised in moving presentations.

Nevertheless, that categorical imperative might be softening. The one rare exception when unedited video won a major journalism award was in 2010 when a George Polk Award was given to an anonymous camera phone operator that showed the death of Neda Agha-Soltan (Daragahi, 2009), a young music student during an Iranian election protest. The curator of the Polk awards, John Darnton explained the organization's controversial decision with, "This award celebrates the fact that, in today's world, a brave bystander with a cell phone camera can use video sharing and social networking sites to deliver the news." Benny Evangelista (2010) reported that a Polk Award given to an anonymous bystander with a camera phone bothered Bill Kovach, a long-time journalist and chairman of the Committee of Concerned Journalists, an organization dedicated to the future of the profession based at the University of Missouri School of Journalism. Kovach thought that viewers might too easily accept such reports by amateurs "at face value" when they should be skeptical if a report does not come from a traditional news agency. "Professional journalists are trained to adhere to values that give their reports credibility," Kovach said. "But citizen journalists, especially if they are unnamed, may not have the same drive to try to help you decide whether or not it's worthy of belief and that's what journalism is designed to do." However, he did admit that "The new technology has created the opportunity for us to have a direct relationship with people in the community and begin to draw them into [the journalism] process, make them smarter consumers of it and also make them potential producers of it whenever they are where the action is." NBC's Tom Brokaw could not credit the citizen journalist during the ceremony because it was not known who took or uploaded the video.

Professionalism Typifies Credibility

Whether a seasoned professional visual reporter who works for a well-known media entity to a teenager with a camera phone who happens to be at the scene of a dramatic news event, the line between the two citizen journalists – for both groups can be classified as such – becomes more gray and fuzzy as handy technology, the employment of social media, and the public's acceptance of unverified visual reports are more commonplace. Journalism calls itself a profession because most of its members graduated from academic institutions, belong to organizations that promote the latest practices along with ethical behavior, keep up with trade journals and other publications specific to the field, attend conferences that provide inspirational stories, images, and workshops, and engage in active self-criticism when controversial actions are analyzed.

Telling a story in one picture or through thousands in a video takes a professional attitude that comes from intuition, keen observation of previous examples, and practice with a variety of stories and experiences. Graduating from an accredited journalism school that teaches the fundamental skills, critiques the work you produce, and challenges your personal ethics is a plus. In other words, you should not be called a citizen journalist simply because you captured moving images – you should be called, however, a citizen – a thoughtful, caring, and committed citizen that should be commended for risking your career, reputation, freedom, and even your life to record the actions of others you think are improper or illegal. As instances of questionable, violent, and illegal behavior are reported, citizens should record and make public their smartphone video so that the civic spotlight illuminates the darkest corners of maliciousness. Without citizen recordings, it is unlikely we would have heard of Rodney King, Freddie Gray, Walter Scott, Alton Sterling, Philando Castile, and many others. Nevertheless, a conclusion should not necessarily be made simply from a compelling and emotional video. Conclusions should be drawn after a gathering of all facts, explanations, the motives of those involved, and after a period of introspection. Journalism provides a procedure for that process and credibility is earned by thoughtful, thorough, and timely reporting.

Nevertheless, journalism and the world's citizens need your homemade, eyewitness, and bystander videos. By all means, keep making recordings and keep making them available to journalism organizations and on social media. But please, please, do us all a favor and turn your smartphone sideways for a horizontal picture.

An editor or a news director has a difficult choice. Just because a bystander video on first viewing is presumably significant or contains uncommon subject matter doesn't mean that it should immediately be available for downloads from a website or aired on television. However, the pressure to do so is compounded after the clip has been shown on several social media sites. If already widely distributed, the argument goes, why not show it? A mass audience media entity demands an editing process in which professional discretion evaluates the credibility of the source, the news value and facts of the content, and the potential for causing more harm to participants and viewers than illuminating the incident. If carefully vetted and if warnings about gruesome content are given as part of a journalism package, chances are the ethics mantra has been satisfied: Do your job and don't cause unjustified harm. Your actions can be considered ethical if your role-related responsibilities are met and any harm the presentation may cause can be clearly and understandably defended. In that way, professionalism and more importantly, credibility, is maintained.

See Appendix A for a professional's approach to citizen journalism.

Case Studies

Case Study One

One of the most war-torn regions in the world is Syria. The conflict, which began in 2010, forced tens of millions of people from their homes, creating a humanitarian and refugee crisis. Many of those affected were children. Much of the reporting of the story focused on the refugee crisis – the difficult journey displaced Syrian citizens faced; and the sometimes less than welcoming greeting these individuals received upon arrival in Europe or the United States. And, no doubt, these are important stories.

However, also important are the stories of the people who have not left Syria but, instead, have stayed. However, few who live there have the training to do this. To try to fill this void, Syrian native Zaina Erhaim returned home in 2013 to train fellow citizens in the craft. She was sponsored by the Institute of War and Peace reporting. Erhaim trained more than 100 citizen journalists, one-third of whom were women who had never done anything like reporting before. Not only does this bring a unique perspective, but gives these women a chance to use their voice in a way that had never been possible before.

Ciobanu, M. (October 15, 2015). "Citizen journalists in Syria 'start writing history.'" Journalism. Accessed June 29, 2017 from https://www.journalism.co.uk/news/writing-history-training-citizen-journalists-in-syria-/s2/a574666/.

See Appendix B for the 10-Step Systematic Ethical Analysis Form.

Case Study Two

Almost everyone is familiar with *Wikipedia*, the online encyclopedia that lets users write and edit content in a collaborative fashion. Not as many people, however, are as familiar with *Wikinews*. *Wikinews* is a sister site to *Wikipedia*, but rather than creating content about historical events or scientific terms, for example, the idea is to create news stories. However, like *Wikipedia, Wikinews* operates under the value that stories should be written from a "neutral" viewpoint, and not from one which means to advocate particular perspectives or agitate for change.

One of the first major events that writers used *Wikinews* to cover was Hurricane Katrina in 2005. However, by in large, the site had a relatively low number of stories appear (during the first 20 days after the storm there were only 6, written collectively by 51 different people), and many were edited a significant number of times. This made reporting slow. As a result, even where *Wikinews* writers were trying to do good – say, by coming to agreement about how to best use language that would counter racial bias in reporting – the slow process meant that by the time stories were posted they did little good because they no longer had much news value.

"Category: New Orleans disaster." (2017). Accessed June 29, 2017 from https://en.wiki news.org/wiki/Category:New_Orleans_Disaster.

See Appendix B for the 10-Step Systematic Ethical Analysis Form.

Case Study Three

Cell phone cameras have become one of the most important tools for raising awareness of police tactics, aggression and over-aggression and, even, police abuse against African American citizens. Recordings of police encounters with black citizens become proof when

wrongdoing occurs, and they also act as catalysts for spurring protests and demanding that action be taken against offending officers, or to ensure better treatment against citizens of color in the future. In a way, the recordings show that anyone with a camera can be a journalist.

However, even as more activists and minority citizens take on this role, some in the police feel threatened by the ubiquitous presence of cameras. This creates even more tension between these citizens and law enforcement, and deepens the sense of distrust. Some police officers even suggest such photography and recording should be illegal. But this violates the First Amendment.

Gillmor, D. (August 16, 2014). "Ferguson's citizen journalists revealed the value of an undeniable video." *The Guardian*. Accessed June 29, 2017 from https://www.theguardian.com/commentisfree/2014/aug/16/fergusons-citizen-journalists-video.

See Appendix B for the 10-Step Systematic Ethical Analysis Form.

Annotated Sources

Ahva, L. and Hellman, M. (2015). "Citizen eyewitness images and audience engagement in crisis coverage". *International Communication Gazette, 77*(7), 668–681.

Amateur (nonprofessional) photographs have proliferated with the advance of digital technology, and are now widely available for use in news coverage of events and crises happening far away.

Bock, M.A. "Little brother is watching: Citizen video journalists and witness narratives", in *Citizen Journalism Global Perspectives*, Vol. 2, Elinar Thorsen and Stuart Allan (Eds.). New York, NY: Peter Lang.

With the relatively recent explosion of cameras hiding in most everyone's pockets, there has been a compounded increase in the amount of citizen videography used in breaking news. The cell phone camera and the occurrence of the everyday journalist has led to a new way of capturing minute-by-minute accounts of breaking news as it unfolds.

Cummins, R.G. and Chamber, T. (2011). "How production value impacts perceived technical quality, credibility, and economic value of video news". *Journalism & Mass Communication Quarterly*, pp. 737–752.

Consumers are apt at recognizing differences in production quality, but do not attribute production quality to a comparable increase in economic value. In other words, viewers are unwilling to pay for the higher quality content that they prefer. Several factors including video resolution, aspect ratio, audio quality, and shot stability play into determining production value, but the relative importance of each of these factors requires more study.

Firmstone, J. and Coleman, S. (2014). "The changing role of the local news media in enabling citizens to engage in local democracies". *Journalism Practice, 8*(5), 596–606.

The role of communication between local government and local citizens is in a transitional period. Traditional media members tend to view their relationship with local government as a co-dependent one, and the traditional media views the move toward citizen media as a trend, not something more serious.

Mythen, G. (2008). "Citizen journalism and the transformation of news". *Journal of Risk Research, 13*(1), 45–58.

Understanding there are inherent caveats associated with the quality of citizen journalism, Mythen finds that it is fair to conclude that citizen journalism can increase the amount of news for the public, and that the increase could raise the quality of the news when it improves upon already gathered news. He finds the greatest question to be the balance of speed of reporting in citizen journalism and the quality of the journalism which is being practiced.

References

"995 people shot dead by police in 2015." (n.d.). *The Washington Post*. Accessed September 14, 2015 from https://www.washingtonpost.com/graphics/national/police-shootings/.

"Amateur who took Pulitzer-winning Winecoff fire photo dies." (December 7, 2007). *Ledger-Enquirer*. Accessed June 28, 2017 from https://web.archive.org/web/20071221085402/http://www.ledger-enquirer.com/251/story/194225.html.

Azzarella, J. (2005). "Untitled #7 (16mm)." Vimeo. Accessed June 28, 2017 from https://vimeo.com/21680441.

Chapnick, H. (1996). *Truth needs no ally*. Columbia, MO: University of Missouri Press.

"CopBlock." (2017). CopBlock. Accessed June 28, 2017 from https://www.copblock.org/.

Crandell, B. (May 13, 2016). "Unlikely Pulitzer winner Charles Porter IV to speak in West Palm Beach." SouthFlorida.com. Accessed September 13, 2017 from http://www.southflorida.com/theater-and-arts/sf-charles-porter-iv-pulitzer-palm-beach-photographic-centre-20160513-story.html.

Daragahi, B. (June 23, 2009). "Neda an international martyr." SFGate. Accessed June 28, 2017 from http://www.sfgate.com/politics/article/Neda-an-international-martyr-3294784.php.

Dhaliwal, R. (June 12, 2013). "Rescue on Pit River bridge." *The Guardian*. https://www.theguardian.com/artanddesign/picture/2013/jun/12/rescue-on-pit-river-bridge-photography.

Dirks, T. (2017). "Citizen Kane (1941)." AMC Filmsite. Accessed June 28, 2017 by http://www.filmsite.org/citi.html.

Evangelista, B. (February 20, 2010). "Amateur video wins prestigious journalism award." SFGate. Accessed June 28, 2017 from http://www.sfgate.com/business/article/Amateur-video-wins-prestigious-journalism-award-3198685.php.

Eversley, M. (April 19, 2015). "Iconic Oklahoma City photo caused twists and turns." *USA Today*. Accessed June 28, 2017 from https://www.usatoday.com/story/news/2015/04/18/oklahoma-city-photo/25957831/.

"Exclusive video from the downtown Dallas shooting on 7/7/16." (July 7, 2016). Central Track. Accessed June 28, 2017 from https://www.youtube.com/watch?v=DAzy37yzodk.

"Eyewitness video: Dallas gunman shoots police office." (July 8, 2016). *The Washington Post*. Accessed June 28, 2017 from https://www.washingtonpost.com/video/national/eyewitness-video-dallas-gunman-shoots-police-officer/2016/07/08/78648854-452d-11e6-a76d-3550dba926ac_video.html.

Feinstein, A. (February 3, 2016). "The accidental photographer." *The Globe and Mail* (Canada), p. A6.

Garner, E. (December 4, 2014). "'I can't breathe': Eric Garner put in chokehold by NYPD office – video." *The Guardian*. Accessed June 28, 2017 from https://www.theguardian.com/us-news/video/2014/dec/04/i-cant-breathe-eric-garner-chokehold-death-video.

Hiltzik, M. (2014). "Real TV news stars rush to prostitute themselves on 'House of Cards.'" *Los Angeles Times*. Accessed June 28, 2017 from http://articles.latimes.com/2014/mar/24/business/la-fi-mh-tv-journalists-20140324.

Holland, E. (December 30, 2008). "From 2008: Finding meaning in fire – and photo." *St. Louis Post-Dispatch*. Accessed June 28, 2017 from http://www.stltoday.com/from-finding-meaning-in-fire-and-photo/article_719a7fdb-d96c-56e9-b721-91e9e7b60429.html.

"Lavish Diamond Reynolds recorded her boyfriend Philando Castle being shot by police (footage)." (July 7, 2016). YouTube. Accessed June 28, 2017 from https://www.youtube.com/watch?v=BKUvRMckJkM.

"New video released of Alton Sterling shooting." (July 6, 2016). CBS News. Accessed June 28, 2017 from https://www.youtube.com/watch?v=pdGXhSQvTKc.

"Oklahoma City bombing." (May 14, 2013). Famous Picture Collection. Accessed September 13, 2017 from http://www.famouspictures.org/oklahoma-city-bombing/.

Ortiz, E. (July 9, 2015). "George Holliday, who taped Rodney King beating, urges others to share videos." NBCNews. Retrieved from https://www.nbcnews.com/nightly-news/george-holliday-who-taped-rodney-king-beating-urges-others-share-n372551.

"PINAC be the media." (2017). Photography is not a Crime. Accessed June 28, 2017 from http://photographyisnotacrime.com/.

Topping, S. (2017). "Biography of Joseph Pulitzer." The Pulitzer Prizes. Accessed June 28, 2017 from http://www.pulitzer.org/page/biography-joseph-pulitzer.

Troy, G. (March 3, 2016). "Filming Rodney King's beating ruined his life." Daily Beast. Accessed June 28, 2017 from http://www.thedailybeast.com/filming-rodney-kings-beating-ruined-his-life.

"Walter Scott shooting." (n.d.). Vimeo. Accessed June 28, 2017 from https://vimeo.com/124336782.

Wierichs, J. (n.d.). "William Randolph Hearst." The Spanish American War Centennial Website. Accessed June 28, 2017 from http://www.spanamwar.com/Hearst.htm.

"The Yellow Kid." (n.d.). The Ohio State University. Accessed June 28, 2017 from https://cartoons.osu.edu/digital_albums/yellowkid/.

"Zapruder film slow motion." (October 1, 2011). YouTube. Accessed June 28, 2017 from https://www.youtube.com/watch?v=iU83R7rpXQY.

5

ADVERTISING AND PUBLIC RELATIONS

My grandfather and father both worked for newspapers in Texas. My dad once told me he'd cut his throat if I ever became a journalist. And after I told him I planned to do just that, he sliced his neck, but he was shaving at the time (ba–dum–dum, cshh). Turns out, neither of them were what I would consider journalists. My grandfather worked in public relations and my father in advertising.

My "Grandpop" started as a legitimate journalist. He was on the scene in 1947 reporting on a story that at the time was considered the deadliest industrial accident in history (the worst accident remains the Union Carbide catastrophe when in 1984 its pesticide plant in Bhopal, India discharged about 40 tons of deadly gas into the air and killed 4,000). Nicknamed the "Texas City disaster," almost 600 persons were killed and 1,000 buildings destroyed after the SS Grandcamp that was docked at the Galveston Bay caught fire and created a chain-reaction of devastating blasts. The ship carried more than 2,000 tons of ammonium nitrate fertilizer. As a comparison, the Oklahoma City blast in 1995 was a result of about two tons of the volatile material ("1947 Texas City," 2017).

A few years later Grandpop was named Oil Editor of the Houston newspaper, a prestigious position, especially for a Texas publication at that time. When I was 15 years old, we had a serious talk in his home office. He told me that part of his job for the newspaper was to review new gasoline blends from oil companies. After he received notice of a new formula, he would drive to a refinery and get his car filled up and then write about the fuel as if it were a new entree introduced at a fancy restaurant. Framed on a wall of his office was a column he wrote that concentrated on a new gas from ExxonMobil, known at the time as Enco, Esso, or Humble depending on where you lived. The company already had a tiger as its mascot, but my grandfather wrote that its gasoline was like "putting a tiger in your tank." Company executives obviously liked the line and used it as their slogan. Grandpop pointed to the column and said with a tinge of frustration, "And would you believe it, they never gave me a dime." Still, getting your tank filled up with gasoline and joy riding through town so you can give a favorable review of a company's product is a nice perk, although a gallon of gas in 1959 only cost 18 cents (about $1.50 today), but it is not journalism. It's akin to writing a restaurant, performance, or movie review. Of course, there are reporting techniques and styles that come to play, but for the most part his columns were simply examples of positive publicity for the oil companies.

My father, with the small scar on his throat, was more firmly anchored in the field of strategic communication. He worked in the advertising department of a Dallas newspaper as a copywriter. As with most publications, it produced special sections on any number of subjects that often looked like journalism, but were in reality cleverly disguised promotional pieces. My dad wrote glowing tributes of products, services, and locations to accompany photographs in 4-to-8-page inserts about motorcycles, restaurants, and cabins on the lake. He once proudly exclaimed to me what he thought was his finest tag line for a product, "What's brand new and millions of years old?" When I went blank, he laughed loudly, slapped me on the back, and shouted, "Peat moss." He taught me that with enough passion just about anything could get you excited. Still, I don't think of peat moss that much today.

Even though I didn't consider my Grandpop and dad to be journalists, they taught me the importance to define a task and complete it by a deadline and what to look for when evaluating commercials. Early on I remember my father pointing to the television screen and announcing, "That's a good ad." He knew from experience. After his newspaper job, he worked for a large advertising agency and then formed his own company that produced both public relations and advertising campaigns – a practice that is *de rigueur* today.

My ancestors never learned ethical behavior in a college class – in fact, they never went to college. What they learned about their professional role-related responsibilities came from on-the-job experiences, from their workmates, through judgment that comes from common sense, and, perhaps most importantly, from making mistakes. You, on the other hand, have a distinct advantage as you pursue your career. Whether as a separate college class concentrated on mass media ethics, discussions within a general communications course, or through your own interests, readings, and testimonials provided by an organization, you have the opportunity to learn from the errors of others and the praises heaped upon those who do the right thing. A key in knowing the difference when confronted with an ethical dilemma is being clear about the values you should be emulating in order to behave in a morally praiseworthy way.

Values Exemplified: The TARES Test

In 2001 academics Sherry Baker and David L. Martinson (2001) wrote an important article in the *Journal of Mass Media Ethics*, "The TARES Test: Five Principles for Ethical Persuasion." For the two researchers, there is a clear difference between professional persuasion in which almost any action is justified that adds to a company's ledger sheet or improves its image and ethical persuasion that relies on moral development and acceptable ethical behavior. A hedonistic reliance on professional persuasion results in a visual message that is designed to simply grab your attention, promote the sale of a product or a way of thinking, and does so by exploiting cultural values. This type of persuasion does not elevate viewers to be better citizens and discriminate consumers. On the other hand, ethical persuasion may also use the methodologies and technologies common with all modern media practices, but its end result is to create empathy, understanding, and commonness among diverse cultural groups, a veil of ignorance, golden rule, and utilitarian perspective.

To differentiate between professional and ethical persuasion, Baker and Martinson devised a five-part test with the awkward acronym, TARES. The test should not be thought of as only appropriate for the public relations and advertising professionals, but can be employed to evaluate any visual message described in this book. The five principles for evaluation of a presentation are that the message in words, images, and context should be **T**ruthful, the spokesperson or source of the message should be credible or **A**uthentic, the message should **R**espect its audience by creating work that maximizes the worth and dignity of individual

members, the message should also be **E**quitable, or deemed as fair and impartial as possible, and finally, promote **S**ocial responsibility among its citizens to make the world better.

Truthful, authentic, respectful, equitable, and socially responsible are important principles in a professional and a personal life. Imagine being dishonest, false, irreverent, unfair, and indifferent to consequences to someone you work with or a family member or friend. You probably wouldn't work long at a firm or have a friendship for long if that truth came out. The five TARES principles, or values, are significant, but they are by no means the only ones you should consider.

The authors identify several sources of additional value-evaluating schemes from individuals and organizations. In his writings journalism professor and ethics author Ed Lambeth "identified for the ethical practice of journalism the principles of truth telling, justice, freedom, humaneness, and stewardship" (Baker and Martinson, 2001, p. 158) The Code of Ethics of the Society of Professional Journalists (SPJ) "discusses the principles of truth, minimizing harm, independence, and accountability." The Member Code of Ethics of the Public Relations Society of America (PRSA) "discusses the principles of advocacy, honesty, expertise, independence, loyalty, and fairness." The Credo for Ethical Communication put forth by the National Communication Association (NCA) "lists the principles of human worth and dignity, truthfulness, fairness, responsibility, personal integrity, and respect for self and others." The International Association of Business Communicators (IABC) "articulates the principles of human rights, rule of law, sensitivity to cultural norms, truthfulness, accuracy, fairness, respect, and mutual understanding." They even quote the Pontifical Council for Social Communications and its "proposed three moral principles for the ethical practice of advertising: truthfulness, dignity of the human person, and social responsibility." You should also review the 24 values newsroom reporters identified in a survey conducted by Patrick Lee Plaisance and Elizabeth A. Skewes in Chapter 3.

In the end, all of these above-mentioned values, as well as the difficult-to-admit negative or opposite values, are internalized in whole or cherry picked individually to help us navigate this so-called life. For Baker and Martinson, each of the five principles deserves further explanations:

Truthfulness: As stated in the article, "People rely on information from others to make their choices in life, large or small. Lies distort this information." They manipulate the choices of the deceived and lead a viewer to false conclusions.

> To persuade others through deceptive messages is harmful and undermines trust. Truthfulness in the TARES Test is a broader standard than literal truth. It is possible to deceive without literally lying. The Principle of Truthfulness requires the persuader's intention not to deceive. It is an intention to provide others with the truthful information they legitimately need to make good decisions about their lives.

That is the hallmark of this part of the TARES test.

Communication without truthfulness is not persuasion. It is propaganda. If someone is swayed through false claims and deception, the victory over that individual is pyrrhic, short-term, and ultimately, unsatisfying. Why? It's because truth always finds a way to be told.

Authenticity: The authors offer several values associated with this principle including integrity, personal virtue, sincerity, genuineness, loyalty, and independence.

Once again, a personal and a professional sense of credibility is a major part of authenticity. Ideally, the two personas – your private and public lives – should have consistent values to promote maximum credibility and authenticity.

Respect: This value, according to the authors,

> requires that [visual communicators] regard other human beings as worthy of dignity, that they not violate their rights, interests, and well-being for raw self-interest or purely client-serving purposes. It assumes that no professional persuasion effort is justified if it demonstrates disrespect for those to whom it is directed. This principle requires further that people should be treated in such a way that they are able to make autonomous and rational choices about how to conduct and arrange their lives according to their own priorities, and that this autonomy should be respected.

If you have trouble feeling respect for yourself, your peers, your colleagues, your job, your present situation, and so on, you will have a difficult time creating work that is meaningful.

Equity: Creators of visual messages should, according to the academics, "consider if both the content and the execution of the persuasive appeal are fair" and if the persuasive message has been employed without unjust manipulation.

> Appeals that are deceptive in any way clearly fall outside of the fairness requirement. Vulnerable audiences must not be unfairly targeted. Persuasive claims should not be made beyond an audience member's ability to understand both the context and underlying motivations and claims of the persuader.

Being fair and impartial is a direct link to John Rawls' veil of ignorance philosophy, as the authors rightly note. As noted by Baker and Martinson, "The veil of ignorance requires professional communicators to step conceptually out of their roles as powerful disseminators of persuasive promotional messages and to evaluate the equity of the appeal from the per-spective of the weaker parties." With the use of smartphones and fact-checking websites, it is easier for a media consumer to determine if a message's content is fair and impartial. The trouble is, most of us either have our minds made up and ignore the appeal (I will never be persuaded to use Crest toothpaste – I am a Colgate man) or don't have the time or the will to discover if a presentation is equitable or not (I have never had a cavity and I don't want to take a chance by switching). However, there is another motivation that undermines this principle (and the others for that matter). This condition is summed in three letters, Meh. Most of us simply don't care.

Social Responsibility: Professional communicators should, according to the authors, be "sensitive to and concerned about the wider public interest or common good." Media operatives who act in "harmony with this principle would not promote products, causes, or ideas that they know to be harmful to individuals or to society and will consider contributing their time and talents to promoting products, causes, and ideas that clearly will result in a positive contribution to the common good and to the community" of all.

The late great graphic designer Saul Bass, who redefined the art of motion picture title credits, created some of the best known logos for international companies, and was an Academy Award winning filmmaker, refused to work with products that he thought were harmful. His position was admirable as he cared more for the common good than fattening his bank account. However, given his preeminent position in the field and his years of service to the profession, his choice, although admired, should be discounted. A more respected position should be someone working at her first job confronting the dilemma whether to work on an advertising or public relations campaign for a product or service that goes against her moral values and rejects the assignment. It takes courage to risk your new career and

adhere to your values while choosing loyalty to your profession over your own or your family's welfare. And when confronted by your decision to just say no, always try to employ at least one philosophy that clearly articulates the justification behind your negative reaction and the reason for your decision not to participate. If you do, chances are your workmates will admire your position and your boss will give you three weeks' severance pay instead of only two.

Advertising Stereotypes

In the stylish, yet critically panned film, *The Neon Demon* directed by Denmark-born Nicolas Winding Refn, Elle Fanning plays Jesse who is caught within the dystopia world of modeling (*The Neon Demon*, 2016). She's 16 years old, moves from Georgia to Los Angeles to become famous and admits, "I can't sing. I can't dance, I can't write." Luckily, she considers herself pretty and says, "I can make money off pretty." She soon learns that pretty isn't enough to be successful in a world populated by jealous models, exploitive managers, and, naturally, a scary photographer. However, in the world of commercial advertising, pretty almost always trumps intelligence, integrity, and sincerity.

Unfortunately, given the corporate pressures to always increase the bottom line, older adults, who should know better, have for decades practiced the same hedonistic philosophy. The list of companies that have created campaigns, often called "shock advertising" that produce a firestorm of negative publicity is long, relentless, and a bit depressing. The "shock" experienced by viewers and explained by reporters in news articles and screen reports offer free publicity. If not an ancient proverb, it is at least a commonly held view by perhaps many teenagers who know that they shouldn't do something, but because of their youth and hormones, can't resist: It is much easier to ask for forgiveness than to ask for permission.

The shock is almost always not based on the copy of those ads, but by the art. Shocking images are necessary, it is argued, because of the ubiquitous prevalence of smartphones. In our fast-paced and easily distracted society, companies must compete for our attention. We live in an attention culture where those wanting to see products and ideas must use any trick available to rivet our eyeballs on what is considered new. These attention-inducing visual messages are designed to implant the company's brand or logo into your long-term memory. However, in truth, using controversy as an attention tactic is not that new.

Consequently, clothing retailers engaged in highly competitive and cutthroat business practices often seek free publicity, even if it is negative, to sell their products. Calvin Klein in the 1980s used the young model Brooke Shields (2017 [1981]) and later teenagers in sexual situations. Candies posed former *Playboy* model Jennifer McCarthy on a toilet ("The evolution of footwear," 2015). Christian Dior had multiple Addict cosmetic campaigns that posed women with desperate expressions and poses. Abercrombie & Fitch for its Christmas catalog showed young persons enjoying orgies. The California-based hamburger chain Carl's Jr. is often criticized for its woman-as-object commercials (Davies, 2013). The list of women using their looks to promote burgers is long: Paris Hilton, Kate Upton, Nina Agdal, Katherine Webb, Emily Ratajkowski, and Charlotte McKinney. Men don't eat cheeseburgers? The prevalence of sexy, buxom women in print advertisements and on web and television commercials is a common cultural trope used by advertisers to gain attention, increase market share, and target a male demographic that doesn't mind the overt sexism. Even executives for the conservative company JC Penney were caught red-faced after its ad agency produced a web-based commercial touting the speed in which two young lovers can take off and put on their Penney clothing ("Speed dressing," 2008).

The Greek philosopher Aristotle proposed three factors that are needed in order to persuade another person to your point of view ("Ethos, pathos & logos," n.d.). The three, updated for today's professionals, are: *Logos*, the argument must make logical sense to the recipient; *ethos*, the person making the argument or the context in which it is presented must have credibility; and *pathos*, the argument should be accompanied with emotional stories, testimonials, and images. Persuasion and its much maligned cousin propaganda is either an overt or a covert technique in almost all areas of visual communication. When the persuasion is clear and explicit as with most advertising messages, public relations appeals, graphic design and informational graphics presentations, and documentary works viewed in movie theaters, on television, or through the web, the methods employed are usually considered acceptable. However, when shocking visual messages and digital manipulation techniques are used to grab a viewer's attention and portray a cultural group in a stereotypical way, the examples can be considered unethical. For example, with names such as "advertorials" and "infomercials," advertisers mimic the production cues of print and screen journalists to persuade an unsuspecting viewer to purchase a product. With full-page ads in newspapers and magazines that resemble news-editorial pages and 30-minute commercials that look like talk shows, corporate executives rely on the credibility of the media to fool its audience of trusting viewers. Most consumers of the media can easily tell the difference between an advertisement and a news story. But sometimes the distinction is so subtle, only highly observant viewers can tell the difference.

The Italian clothing company, Benetton has often smudged the line between journalism, advertising and public relations in numerous campaigns ("Benetton ad stereotypes," 2017). Consequently, few companies have had to use the forgiveness defense as often as Benetton. Conceived and produced by art director Oliviero Toscani, early print advertisements showed models from different races all symbolically emphasizing racial harmony and equivalence. Images showed a woman breast-feeds a baby, children look at the camera while their similarly colored tongues stick out, and two children sit side-by-side on matching toilets. But the need for more publicity and sales induced more daring visual messages that replaced feel-good studio shots with horses fucking, and a priest and nun kissing. After much public condemnation, Toscani switched from studio set-ups to using actual news photographs he found printed in the media. Young children working in a brick factory, a car on fire, refugees escaping on an overly crowded ship, and HIV/AIDS patient David Kirby and his family on his deathbed. Originally taken by a student photographer and published in *Life* magazine, the Kirby photograph unleashed a worldwide critical firestorm aimed at Benetton, but not toward the photojournalist or the Kirby family. But it was a $20 million advertising campaign launched in an issue of *Talk* magazine in January 2000 that caused Benetton to rethink the philosophy behind shock advertising and using previously published news pictures. *Talk* contained a 96-page booklet entitled "We, on Death Row." With the bright green Benetton logo interspersed on several pages, photographer Oliviero Toscani posed 26 death row inmates from across the United States like models. None wore Benetton clothing. Toscani was forced to resign, Sears canceled a lucrative deal, and Benetton officials apologized and vowed never to upset the public again. Riiiight.

Public Relations Manipulations

Perhaps not surprisingly, politicians and their publicity handlers are the most common abusers of unethical visual messaging (Ralph, 2013). Politicians have readily embraced what has been called a photographic opportunity, shortened to "photo op." Also known as a media event,

the photo op is a stage-managed, highly manipulated still or moving image. A successful photo op appears to look real but is actually a contrived fiction in which the source, his or her handlers, and sometimes the photographers themselves orchestrate the timing, location, subject, props (telephone, pen and paper, podium, and so on), lighting, foreground and background elements (banners, signs, supporters, and so on), and sometimes even the selection and placement of the photographers covering the "event." Although traditionally the photo op is thought of as a way to get positive publicity for a politician, the photographic genre can include all types of so-called media or pseudo-events, from owners celebrating their store openings to portraits of corporate leaders in their offices. As the author and political commentator George F. Will wrote, "A photo opportunity, properly understood, is someone doing something solely for the purpose of being seen to do it. The hope is that those who see the resulting pictures will not see the elements of calculation (not to say cunning) that are behind the artifice" (Lester, 2009).

Northwestern University professor of communications Robert Hariman wrote, "American politics has always been media intensive and defined in part by its visual arts." As President Herbert Hoover, one of the first politicians to actively use publicity as a tool, once remarked, "Candidates for office cannot escape the ubiquitous photographer." Consequently, a politician's public image is a vital commodity similar to a product's design, logo, and packaging. As such, anyone involved in securing votes from the public must be careful about the pictures the public sees by the media. The photo op was institutionalized by the administration of Franklin Delano Roosevelt after his press secretary, Stephen Early, a United Press International (UPI) and AP reporter, allowed photographers to take pictures of the president, but asked them not to show that the polio-stricken Roosevelt used a wheelchair. For the most part, that prohibition was honored. In truth, politicians long before Roosevelt used photography to aid themselves and their causes during catastrophes. In addition, ministers, military leaders, and relief workers have also used reporters and their images to their advantage during catastrophic times.

But sometimes the best intentions from publicists go awry. As reported in a previous book I wrote (Lester, 2009), *On Floods and Photo Ops: How Herbert Hoover and George W. Bush Exploited Catastrophes*, during the aftermath of Hurricane Katrina in 2005, President George W. Bush and his image handlers were criticized for several photo ops. The president was persuaded to fly over the stricken region to see the devastation for himself. With the president sitting at a window, Karl Rove, Bush's Senior Advisor and Deputy Chief of Staff for Policy, beckoned writers and photographers to come to the front of the aircraft to witness Bush's concern as the luxury jet flew low over the devastated city of New Orleans and the Gulf Coast. After the picture was displayed on newspaper front pages across the country, former White House press secretary Scott McClellan later wrote that the photograph "was quite an object lesson in the supreme power of images in today's visually oriented world." Douglas Brinkley, author of *The Great Deluge: Hurricane Katrina, New Orleans, and the Mississippi Gulf Coast*, wrote, "It was obviously intended as a photo op, a depiction of the President as a compassionate man, connecting to the tragic region. It backfired." Howard Fineman of *Newsweek* reported, "Republican strategists privately call[ed] the resulting image – Bush as a tourist, seemingly powerless as he peered down at the chaos." Pollster John Zogby called it "the wrong visual … emblematic of a failing presidency."

Another goof from the Bush Administration became one of the most infamous photo ops ever devised. On March 20, 2003, the invasion of Iraq, code-named "Operation Iraqi Freedom," began. Less than two months later, Baghdad had fallen, President Saddam Hussein was in hiding and Osama bin Laden, the Al-Qaeda leader believed responsible for the 9/11 attacks, was on the run. In May, President George W. Bush planned to announce on the USS

Abraham Lincoln docked outside San Diego that the military effort in Iraq was achieved. "Mission Accomplished" was the visual message printed on a sign hung on the carrier during a speech to the nation. It was a phrase that would not only ironically define the Iraqi War but the historical legacy of the failed Bush administration. And although the line was removed from Bush's speech, the large sign behind him that used the phrase tarnished his presidential legacy. Bob Bergen, a research fellow for the Canadian Defense and Foreign Affairs Institute in Calgary, summed up the banner, "Many people look back at that day and declare it a public relations disaster, a major misfiring of the vaunted White House spin machine. The mission in Iraq has not been accomplished, combat operations are far from over." Of course, in today's political environment with President Trump (is he still president?) and his administration creating public relations gaffes on an hourly basis, the faults of the Bush Administration seem quaint by comparison (Lester, 2009, p. 62).

Back to TARES

Not surprisingly, most advertisements, including presidential political spots, fail the TARES test while most public service announcements (PSAs) pass. Truthful, authentic, respectful, equitable, and socially responsible presentations unfortunately are not values that correspond with the profit motives of most clothing, cosmetic, and fast food executives. Nevertheless, there are plenty of examples produced by organizations that have no trouble passing the TARES test. The best place to find ethical stand-outs is from organizations that give awards for PSAs. One of the most prestigious prizes given to outstanding advertising work in print and screen media is the CLIO Awards. Cited for outstanding achievement was August Lang & Husak agency's campaign created for the American Academy of Orthopaedic Surgeons and devoted to the perils of distracted driving in a heart-breaking reverse film technique that reveals a mother preoccupied by her son's green frog toy, BBDO's collaboration with the organization Autism Speaks to promote research on the condition, and J. Walter Thompson's campaign to help free Burma's estimated 2,100 political prisoners that teamed with Human Rights Watch to create

> an interactive installation at Grand Central Station. Consisting of hundreds of prison cells, a closer look reveals that the cell bars are actually ink pens. Visitors could remove the pens to symbolically free the innocent prisoners and then use the pen to sign a petition calling for their release.

When the best minds from advertising and public relations professionals are charged with the task, they often produce powerful combinations of words and images that help us become aware and care about our health, our fellow citizens, and our planet. In that sense, they are illustrations of the best that John Rawls' veil of ignorance philosophy has to offer. When an advertisement, whether for commercial or persuasive motivations, makes us empathize with another, we are made more whole, more human.

See Appendix A for a professional's approach to advertising and public relations.

Case Studies

Case Study One

One of the worst environmental catastrophes ever was the 2010 oil spill that happened in the Gulf of Mexico when a British Petroleum oil rig exploded and then caught on fire. The rig

had been drilling for oil about 41 miles off of the Louisiana coastline when the accident happened, killing eleven people and injuring another 17. The ruptured pipe was 10,000 feet below the water's surface, and was not sealed for nearly three months. It devastated the sea life in the Gulf, wrecking the tourism coastline economies of Alabama, Louisiana and Texas for several years, as "eyeless shrimp and infant dolphins washed ashore, and oil balls appeared along 650 miles" of beach.

As bad as the spill was, most public relations professionals thought the BP response was equally abhorrent. In the spill's early days, company executives issued evasive and ineffective apologies. Later, the company tried to downplay the scale of the disaster, and seemed to send a message that the problem was an American mistrust of business, rather than a valid concern over environmental catastrophe. For some, this was made all the worse when BP ran an ad campaign a year later showcasing clean beaches and safe-to-eat seafood that made it seem like the effects of the spill were long gone.

Warner, J. (June 18, 2010). "The Gulf of Mexico oil spill is bad, but BP's PR is even worse." *The Telegraph*. Accessed June 29, 2017 from http://www.telegraph.co.uk/finance/newsbysector/energy/oilandgas/7839136/The-Gulf-of-Mexico-oil-spill-is-bad-but-BPs-PR-is-even-worse.html.

See Appendix B for the 10-Step Systematic Ethical Analysis Form.

Case Study Two

In spring 2017, Pepsi created a public relations nightmare for itself when it released a web-based video advertisement starring Kendall Jenner. In this "short film," Jenner bids her modeling job adieu as she joins a protest march and creates a bridge of understanding between dissidents and skeptical police by giving a cop a Pepsi. Hugs and cheering ensue all around.

The ad was criticized for making light of real issues – as though social justice could be made easy if only those calling for it had remembered to bring along fizzy soft drinks. One of the final scenes in the commercial compared unfavorably with an actual news photograph taken by Jonathan Bachman of a Baton Rouge protester. Within 48 hours of its posting to the web, the video had already gotten 1.6 million views on YouTube, as it was passed around via both Twitter and Facebook. On YouTube, it got five times as many down votes as up votes. So, in a way, the ad did spur community and a sense of social engagement, perhaps just not in the way Pepsi intended.

Watercutter, A. (April 5, 2017). "Pepsi's Kendall Jenner ad was so awful it did the impossible: It united the internet." *Wired*. Accessed June 29, 2017 from https://www.wired.com/2017/04/pepsi-ad-internet-response/.

Appelbaum, Y. (July 10, 2016). "A single photo from Baton Rouge that's hard to forget." *The Atlantic*. Accessed June 29, 2017 from https://www.theatlantic.com/notes/2016/07/a-single-photo-that-captures-race-and-policing-in-america/490664/.

See Appendix B for the 10-Step Systematic Ethical Analysis Form.

Case Study Three

Dove's Real Beauty Campaign has both its champions and its critics. The campaign claims that its goal is to expand the conversation about what makes a woman beautiful or, more specifically, to celebrate all women as beautiful: whatever their age, shape, color, ability, hairstyle, or any other thing. Those who like the campaign say it celebrates "real" women

and "diverse" women as they really are, for all that they are. Those who oppose it counter that the very existence of women's beauty products – which is what Dove is selling – proves there is no way out of the beauty matrix. Moreover, they say, while the ad campaign portends to celebrate all women, there is still only a very small subset represented.

Stampler, L. (April 22, 2013). "Why people hate Dove's 'Real Beauty Sketches' video." *Business Insider.* Accessed June 29, 2017 from http://www.businessinsider.com/why-people-hate-doves-real-beauty-ad-2013-4.

Bahadur, N. (January 21, 2014). "Dove 'Real Beauty' campaign turns 10: How a brand tried to change the conversation about female beauty." *Huffington Post.* Accessed June 29, 2017 from http://www.huffingtonpost.com/2014/01/21/dove-real-beauty-campaign-turns-10_n_4575940.html.

See Appendix B for the 10-Step Systematic Ethical Analysis Form.

Annotated Sources

Fredriksson, M. and Johansson, B. (2014). "The dynamics of professional identity." *Journalism Practice, 8*(5), 585–595.

This article explores why journalists view public relations as a threat to journalism. The authors explore this phenomenon from the viewpoint of the professional identity of a journalist and analyze journalistic ideology, organizational belonging and social position. They find that, in general, journalists fear the loss of trustworthiness when a journalist transitions into a public relations position. Other factors such as age, time spent as a journalist and place of employment play a role.

Lee, S.T. and Cheng, I. (2012). "Ethics management in public relations: Practitioner conceptualizations of ethical leadership, knowledge, training and compliance." *Journal of Mass Media Ethics, 27*(2), 80–96.

Lee and Cheng explore how ethics plays into job training and job practice for public relations officials. Their study found that there is not much formally presented to public relations staffers, and that while good ethical decisions are not celebrated, poor ethical decision making is punished. For many public relations officials, their ethics were not taught in the workplace but were learned through personal experiences and their upbringing.

Page, J.T. (2006). "Myth & photography in advertising a semiotic analysis." *Visual Communication Quarterly, 13*(2), 90–109.

In this study, the author examines several Kohler advertisements. She finds that the advertisements use female models as a singular means to their sexuality in concert with a surrealist depiction of the appliances to sell them as desirable and self-constituting. The author notes that it is acceptable to use women in images in a way that would never be acceptable in writing.

Zayer, L.T. and Coleman, C.A. (2015). "Advertising professionals' perceptions of the impact of gender portrayals on men and women: A question of ethics?" *Journal of Advertising, 44*(3), 1–12.

A study on the perceptions of male and female advertising professionals of the influence of different portrayals of men and women in advertising. The authors found that advertisers generally believe their depictions of men and women should follow the "traditional"

archetype of men and women. Zayer and Coleman suggest that if a culture wants to move in a direction of being more open and accepting of gender outside the hegemonic definition, that we should look to our advertising as being a prime means to achieve that end.

References

"1947 Texas City disaster." (2017). Texas City Library. Accessed June 29, 2017 from http://www.texascity-library.org/disaster/first.php.

"Ann Landers." (2017). Biography. Accessed June 29, 2017 from https://www.biography.com/people/ann-landers-9372525.

Baker, S. and Martinson, D.L. (2001). "The TARES test: Five principles for ethical persuasion." *Journal of Mass Media Ethics*, 16(2&3), 148–175.

"Benetton ad stereotypes." (2017). Google Images. Accessed June 29, 2017 from https://www.google.com/search?q=benetton+ad+stereotypes&source=lnms&tbm=isch&sa=X&ved=0ahUKEwijvc_Dy4zUAhULwVQKHWUeAHoQ_AUICigB&biw=948&bih=748.

"Brooke Shields in the Calvin Klein Jeans commercial 1981." (2017 [1981]). YouTube. Accessed June 29, 2017 from https://www.youtube.com/watch?v=YK2VZgJ4AoM.

Davies, M. (March 13, 2013). "Put it in my mouth: A history of disgusting Carl's Jr. ads." Jezebel. Accessed June 29, 2017 from http://jezebel.com/5990397/put-it-in-my-mouth-a-history-of-disgusting-carls-jr-ads.

"Ethos, pathos & logos." (n.d.). European Rhetoric. Accessed June 29, 2017 from http://www.european-rhetoric.com/ethos-pathos-logos-modes-persuasion-aristotle/.

"The evolution of footwear marketing." (May 10, 2015). Footwear News. Accessed June 29, 2017 from https://www.pinterest.com/pin/529524868668777379/.

Lester, P.M. (2009). *On floods and photo ops: How Herbert Hoover and George W. Bush exploited catastrophes*. Jackson, MS: University Press of Mississippi.

The Neon Demon. (2016). Rotten Tomatoes. Accessed June 29, 2017 from https://www.rottentomatoes.com/m/the_neon_demon/.

Ralph, E.F. (November 15, 2013). "Photo oops: History's worst political photo ops." *Politico Magazine*. Accessed June 29, 2017 from http://www.politico.com/magazine/gallery/2013/11/photo-oops-historys-worst-political-photo-ops-000157?slide=0.

"Speed dressing: The controversial fake ad." (July 8, 2008). YouTube. Accessed June 29, 2017 from https://www.youtube.com/watch?v=UjQzD6mx4g8.

6

TYPOGRAPHY AND GRAPHIC DESIGN

Archeologists in the year 2520 uncovering the buried ruins of a major city in the world will no doubt find text on billboards, storefronts, and traffic signs in the languages we know and use today. These words however will probably not be understood by 26th Century scientists because languages of today will eventually become obsolete and forgotten. Luckily, there will be an energetic and tenacious researcher with a well-used digging tool who will find along the viaducts and abandoned highways in the old cities evidence of writing that will be instantly recognized and easily read. For amid the buried rubble of civilizations long past will be elaborated and brightly colored signs and symbols created by graffiti artists that will last through the millennia. This often scoffed and criminalized form of visual communication will in the future become the one, universally accepted language. Therefore, the future of mass communications will not rely on the preservation of pens, paper, computers, smartphones, or satellites. In the vast future, we will understand ancient civilizations because of compressed paint in spray cans.

(Lester, 2017, pp. 459–460)

Imagine you have invented a device that will in all likelihood make you wealthy beyond your imagination and most probably will change the world (no, it's not a version of Pokémon Go).

Unfortunately, for several years you had to borrow a tremendous sum of money from several individuals to pay for basic research, numerous and expensive experiments, costly materials, fabricated and untested equipment, a support staff, your workshop and living expenses, and even a herd of cattle. Understandably, you didn't want word leaked of your creation so you only gave the moneylenders just enough information to convince them to give you the funds you desperately needed. However, obtaining feasible results took much longer than you anticipated. Consequently, your supporters became nervous that you wouldn't pay back your loans. Without a viable timeline for the introduction of the invention you called the "secret art," you were sued for failure to keep up with your interest payments. Ironically, just when you were about to make your creation known with plans for sales, a foreclosure hearing concluded that you must surrender your products and all of the contents of your workshop to your chief investor. Devastated and defeated, you never recovered from your loss.

The man who won the lawsuit didn't prosper much better. After he took possession of your invention, he took credit for its creation, and attempted to sell it throughout Europe. Fatefully, during his travels that took him to Paris, he caught the bubonic plague and died. Nevertheless, a once trusted assistant and his grandsons successfully made the invention

known and contributed to the success of one of the most important technological advances that benefited and heralded the modern world.

But alas, you died practically penniless and worse, your achievement was largely unrecognized outside the town where you lived. As another insult, no one thought to paint a portrait of you during your lifetime. After you died, your body was buried in a cemetery next to a church that were all later destroyed. You only became famous for your influence on history many years after your death. After his success with *Hamilton*, perhaps Lin-Manual Miranda's next project should be a musical based on this convoluted tale.

Johannes Gutenberg and the Birth of Typography

The story of the birth of typography includes Johannes Gutenberg's unique personality, his invention of the mechanical moveable typeface press, Johann Fust's foreclosure proceedings that resulted in his award of the device and the finished books, and Peter Schoeffer's partnership with Gutenberg and later with his father-in-law Fust that resulted in their printing logo included in the finished pieces without mention of Gutenberg's contribution ("Johannes Gutenberg," 2016). This cautionary tale in the field of visual ethics is particularly associated with conflicts of loyalties.

Associations or relationships that are based on promises to yourself, other persons, organizations, companies, countries, and concepts are considered loyalties. As such, they are intricate and intimate components of what makes you, you. In many ways the role-related responsibilities, whether in personal or professional settings, that make your "job" requirements unique are closely associated with the loyalties you treasure. If your responsibilities are mainly to yourself, family members, and co-workers, you are likely more loyal to those individuals especially if part of your role demands that they rely on you for financial support. Consequently, you may hesitate to quit a job you don't like or complain to a superior if you notice bad behavior. However, if your role requires you to act ethically in a work situation, your loyalty probably leans more toward your profession. You may then be compelled to become a whistleblower and notify the media of your company's unethical behavior despite the harm it may cause to your income. Of course, loyalty also has a dark side. You can be loyal to a cause that promotes awful behavior. Wars have been fought and millions of lives lost by those who with unflinching loyalty have followed leaders with evil intent. The keys in understanding the difference between praise-worthy and blame-worthy behavior is knowing fully your role-related responsibilities for a specific situation and how those commitments form loyalties that contribute positively to your own and society's development.

Loyalty to oneself, a highly hedonistic approach, rules the actions of those thus described. For Gutenberg, his loyalty to himself led him to only work toward his dream to retire in financial comfort. He was not interested in changing the world with his printing press innovation. If he had been in a more sharing and egalitarian mindset, he would have let others know from the beginning the details of his operation. He would have had to borrow less money, he would have completed the task faster, and he would have had Fust, an able businessperson, to help him sell his printed materials to more quickly pay for his condo on the south of France. Fust had an opportunity to do the right thing, but as he was loyal to himself, he decided to lend Gutenberg an impossible amount of money to repay, won a probably pre-planned foreclosure case, and put his name on the books Gutenberg worked so hard to produce ("The Gutenberg Bible," n.d.). Fust's only saving grace is that he was also loyal to his family. Peter Schoeffer was the able assistant who learned the printing process from Gutenberg and who mostly likely was the graphic designer responsible for the look of the pages that included the typeface, column configurations, and ornate enlarged letters and border artwork. He married Fust's only daughter Christina and was most loyal to his family.

Their sons, John and Peter continued in the family's printing business with Peter's younger son, Ivo heading the third generation of printers.

Calligraphy and typography are closely related – they both are letter-based artwork. For calligraphy, artists draw letters with styluses and brushes on clay tablets, papyrus scrolls, and paper books ("History of printing," 2017). At least 4,000 years ago, Sumerian scribes lived in the fertile crescent of the Middle East. Over many generations they developed the first written language, cuneiform letters pushed into soft clay with a stylus. Ancient Egyptians configured paper-like papyrus reeds to write their hand-printed letters. Millennia later monastery scribes tediously copied manuscripts by hand while civilizations throughout the world produced aesthetically pleasing illustrated manuscripts that were one of the first examples to combine words and images into a single presentation.

As opposed to calligraphy, typography is the art of selecting and arranging letters that are produced mechanically or digitally for print or screened media. Attempts throughout history and by several cultures used such materials as clay, wood, and metal to aid printing on a variety of substrates. In China, the Song dynasty, around the year 1,000CE, used clay while the choice for the Qing dynasty was wood for constructing letterforms for printing. About 200 years later bronze metal printing was introduced in Korea and adopted in China about 250 years later (remember: before Gutenberg's press news on innovations traveled more slowly). The challenge with Asian typography is their alphabet contains thousands of letters. Until the written language was simplified in modern times, a commercial printing press was not practical. Therefore, typography as a profession did not begin until the widespread use of Gutenberg's invention reserved for languages with alphabets of less than 50 letters.

Inspiration vs. Appropriation

Gaining inspiration from an artist's creation should be encouraged. We should all, within the constraints or freedoms that come from our own brand of creativity called individual style, attempt as much as possible to get inspired by others. It is one of the chief reasons art is made available for public viewing. I am convinced that a 6 × 4-foot finger painting on white butcher paper made by my then 3-year-old twin boys hanging on a wall of their playroom was inspired after a visit to a Jackson Pollock exhibit at a museum. However, taking credit for another person's work is wrong. Such a practice is not only unethical; it can also be deemed illegal. It is clear that Fust had every right to sue Gutenberg for nonpayment and to accept as remuneration his books and printing materials, but Fust and Schoeffer unethically took credit for the invention of the commercial printing press and the books that were produced. In so doing, they committed an egregious offense – intellectual property theft. As it turns out, such thefts are all too common in the typography and graphic design professions.

For more than 30 years, Steven Heller was the editor of U&lc (Upper and lowercase) magazine, dedicated to the typographical profession. He is also responsible for numerous books on typography and graphic design. When Heller (2005) admits to unethical behavior, all practitioners should take notice. In his article, "Typographica Mea Culpa, Unethical Downloading" for the Typotheque type foundry website, Heller confesses to a common practice by designers: Paying for the use of a typeface, but then sharing it without permission to others. He writes,

> Through ignorance or malice, or the malice that comes from voluntary ignorance, many designers that I know simply ignore type licenses and, therefore, cavalierly trade or transfer entire fonts to fellow designers, service bureaus, mechanical artists, printers, lovers, or in-laws. The digital age has made this easy, but as I realized it does not make it right. Illicit type sharing betrays an honor system that can only work if we are all honorable.

He speculates that a justification for this activity might be because type is not viewed as equivalent to images. "As fundamental as it is to visual communication," he writes,

> type is not considered sacrosanct in the same way as, say, a photograph or illustration. The principle of 'one-time usage' or 'one-person licensee' seems foreign when it comes to type. Yet it should not take a lot of additional soul-searching to conclude that violating the 'industry standard' licensing agreement is also unfair to the people who have worked hard to make the type that we all use.

He concludes his article with,

> For years I have allowed designers working for me to infringe the agreement that I have failed to read. Forget about legality, without adherence to the fundamental principal, we place our colleagues in financial jeopardy and we become much less ethical in the bargain.

After careful consideration, Heller changed his loyalties from himself, his workmates, and his friends to those who created the original work and, perhaps more importantly, to his profession. Such is the power that comes from a personal, ethical analysis.

Another ethical issue that involves typography is a bit more sinister – psychological manipulation. In 1994, the Microsoft Corporation released one of the most ridiculed typefaces ever devised, Comic Sans (Johnston, 2013). With its breezy, fun, and informal style, designer Vincent Connare intended the typeface to be used to convey information to children. Controversy erupted when it was used by careless designers for serious subjects such as "a Dutch war memorial, printed advice for rape victims, blog posts by a law firm, and for résumés." Using a light-hearted visual message for a dreadfully serious subject can be judged unethical, but also in poor taste, or an example of bad etiquette.

But it gets worse. Several researchers have discovered that you can actually manipulate persons through the use of typeface choices. Documentary filmmaker Errol Morris (2015) reported that the use of Comic Sans "makes readers slightly less likely to believe that a statement they are reading is true" than the same statements presented in more formal typefaces. Furthermore, a study based on one conducted by Carnegie Mellon University researchers concluded that a survey that asks for personal, even embarrassing information from users will more likely get honest answers if the typeface is Comic Sans. John Timmer for the Ars Technica website writes, "In short, an unprofessional-looking interface seemed to loosen participants up in the same manner that approaching a question indirectly did" (Hill, 2010). The next time you are asked to complete an online survey, take notice of the typeface used before you commit yourself. If the pollsters' loyalties don't match your own, you may be susceptible to manipulation.

Combining pictures and words on substrates from stone to monitors defines the field of graphic design. Although typefaces are highly symbolic line drawings with emotional impact, typography describes their singular use in layouts. Graphic design uses typography and images in static and dynamic displays for maximum visual impact. When cave artists painted or scratched on cave walls or rock outcroppings animal representations and the united them with enigmatic and mostly undefined symbols, graphic design was born. Much later, the Egyptians produced illustrated manuscripts and wall decorations that combined their hieroglyphic writing system with illustrations. The *Book of the Dead* (2300–1200 BCE) contains excellent examples of illustrated scrolls (Mark, 2016). In ancient Greece, the founder of the Academy

in Athens and one of the most important figures in Western philosophical thought, Plato and the writer, architect, and engineer Marcus Vitruvius Pollio expressed a "dynamic symmetry" composed of natural shapes found in the world: the square, the triangle, and the circle that inspired design concepts in print, clothing, and architecture (Mark, 2009 and Cartwright, 2015). With technological advances in the nineteenth century such as lithography, faster printing presses, photography, and halftone printing, the time was right for graphic design to be considered a vital element in the communication of visual ideas. Designers influenced by movements such as art nouveau, dada, art deco, de stijl, bauhaus, pop art, punk, new wave, hip-hop, and others, elevated design into a respected art form through book and magazine covers, posters, cartoons, music, fashion, furniture, architecture, and films. Nevertheless, these art movements are not without their ethical dilemmas. Art nouveau designers were accused of copying the flowing style of ancient Asian pieces as seen on vases and wall hangings. Dada, de stijl, and punk artists dared to break the established rules of aesthetic values and angered the establishment. The art deco, bauhaus, and new wave movements were criticized for their tame, commercial-centric designs. Pop artists were viewed as aesthetically flippant and socially sarcastic. Finally, hip-hop artists endured disapproval by those who disliked the emphasis on graffiti and charges of vandalism. Reviewers with loyalties to traditional art movements and their subjects prevented them from seeing the value in new works. Over time, of course, criticisms and those who make them are forgotten while the work endures.

Sometimes ethical issues are common to both typography and graphic design. One point of intersection was discussed in the Gutenberg case study – intellectual property theft or its more socially acceptable cousin, the concept of fair representation. Either one involves not giving credit for a design when credit is due. South Carolinian graphic designer and so-called "street artist" Shepard Fairey borrows from popular cultural images and phrases for his reconstituted art ("Obey Giant," 2017). His sticker artwork, "Andre the Giant Has a Posse" was taken from a newspaper picture of the wrestler whose given name was André René Roussimoff (you might know him as an actor in one of my favorite movies, *The Princess Bride*). After a sports branding company complained about the use of its trademark, Fairey simply used Andre's face with and without the slogan "Obey" that came from slogans on billboards as seen in John Carpenter's motion picture *They Live*. Consequently, Fairey's lucrative clothing line was begun. Remixing and repackaging can be ethically defended when any harm to the original work is minimal. However, when the person who created the baseline work is significantly harmed financially, the use cannot be justified.

In 2008, Fairey made a poster that featured a head-and-shoulders portrait of Barack Obama over the word "HOPE" from a photograph taken by Associated Press (AP) photographer Manny Garcia in 2004. Garcia believed he should have been compensated for the work, whereas Fairey argued that the appropriation is a form of "fair use." Although Fairey and the AP settled out of court, in 2012 the illustrator pleaded guilty in a New York court to one count of criminal contempt as he destroyed evidence in the case. He was sentenced to 300 hours of community service, fined $25,000, and placed on probation for two years ("Shepard Fairey," 2012).

Independent artists with unique ideas need to be vigilant and have good lawyers. The Spanish fashion chain Zara, the clothing companies Forever 21, Rue 21, and Gucci, and Snapchat were caught copying design ideas from other graphic designers. Zara plagiarized the work of Los Angeles based artist Tuesday Bassen (Evans, 2016). Bewilderingly, Zara's response to Bassen's claim of infringement was to dismiss it because the number of emails she received about the intellectual property theft was miniscule compared with the millions of visitors who frequent the clothing company's website. In two other cases, Izza Sofia (2017b)

writing for Design Taxi, a blog that specializes in graphic design issues and examples, reported that the 21s stole a design by the Mexican-born, Los Angeles-based independent artist, Ilse Valfre. "The alleged copies being sold by Forever 21 and Rue 21 appear much too similar to be coincidental. Valfre is currently pursuing legal action with regards to the designs in question," writes Sofia. In 2017 the international clothing giant Gucci was accused of stealing artist Stuart Smythe's serpent logo he created for his CLVL Apparel Co. label in 2014 (Sofia, 2017). Smythe wrote on Instagram that Gucci "copied not only the combination of elements together that create this logo, but when I overlay my snake illustration on top of the copy, the scales even line up perfectly." A California-based graphic designer, Sara M. Lyons discovered that Snapchat, in a Geofilter image, closely copied one of her illustrations because of alert fans that know her style (Sofia, 2017a). Lyons explained, "I might not have noticed it on my own because I don't use Snapchat every day, but I'm fortunate to have lots of friends and followers who recognize my work." To its credit, a spokesperson for Snapchat admitted that the designs were similar and "it was removed this morning."

Because of the ethical violation of ripping off independent artists, New York illustrator Adam J. Kurtz listed stolen designs from different artists and the opportunity to support each designer by buying the original art on the website Shop Art Theft ("Hold Zara accountable," 2017). Loyalty to a company's bottom line is often at odds with an artist's need to be fairly compensated for original art. A graphic designer or a company who reproduces wholesale someone else's work without credit or compensation is acting unethically and courting legal problems. Designers should be inspired by other work, but not copy it.

Balancing Loyalties

A typographer and a graphic designer must balance three conflicting approaches – utilitarianism, hedonism, and the golden mean. The philosophy of utilitarianism stresses the educational benefits of a publication. A design should be readable, legible, and useful. Being too loyal to yourself and concentrating on the hedonism philosophy may lead to designs that attract attention only for the purpose of satisfying commercial interests, shocking viewers, or expressing a personal statement. Graphic artist Milton Glaser, responsible for the design of *New York* magazine and the "I [HEART] NY" logo, among others, warns, "There's a tremendous amount of garbage being produced under the heading of new and innovative typographical forms" (Lester, 2013). Despite the criticism of typefaces being designed solely for the amusement of a particular graphic artist, the prevalent use of typographical computer programs produces ways of thinking about the use of type never before imagined.

Glaser could be referring to graphic designer David Carson (2017), for many years the innovative art director for *Ray Gun* magazine. He has been called the founder of grunge typography because of his non-traditional displays of text on a page that includes lines of type that overlap, columns of varying lengths on the same page, and an interview with the musician Brian Ferry he considered so boring that he set the text in the symbol set known as Zapf Dingbats. Jonathan Hoefler, who created typefaces for *Sports Illustrated* and other magazines, likes "unusual fonts that challenge typographical assumptions After all, design is about breaking the rules. Rule-breakers become rulers" ("Fonts by Hoefler," 2017).

The graphic designer Saul Bass, who created such designs as the AT&T logo to the opening title credits for Martin Scorsese's movie *Casino*, would probably concur with Hoefler ("The Saul Bass poster," 2017). "Sometimes," Bass said, "we design for our peers and not to solve communications problems." Between the two extremes expressed by Glaser on the side of readability and Hoefler and Bass who stress innovation is the golden mean approach,

which advocates design decisions based on a "middle way" between the two display styles. To achieve Aristotle's golden mean philosophy, then, a designer must reach a difficult compromise by juggling the purpose of the piece, the need for it to be noticed, the intended audience, the idea that it should be pleasing to look at, and the desire to create a unique style. The world is certainly large enough to support both dynamic, cacophonous displays and quiet, traditional typographical presentations. However, innovation seldom comes from designers who follow this compromising approach. Sensitive to conflicting ethical philosophies is one of the reasons that the field of design is challenging and rewarding. Whichever path you decide, make sure your loyalties are solid and easily articulated when the inevitable critic questions your intentions.

No other statement acknowledges the complexity of a profession than an established code of ethics. Author Paul Nini (2017) consolidated statements from the International Council of Societies of Industrial Design and the International Association of Business Communicators into five responsibilities. According to the organizations, a designer should know the needs and concerns of audience members and clients, never confuse or mislead a viewer, treat all, especially members of vulnerable communities with dignity and respect, promote the well-being of the general public, and maintain credibility by open communication in times of misunderstandings. As you should note, the values expressed by the trade groups are audience-centric – they recognize how trust links the designer, the design, and the consumers. Lamenting the fact that the connection between a design and the audience is seldom stressed in educational environments, Milton Glaser said,

> Because design is linked to art, it is often taught as a means of expressing yourself. So you see with students, particularly young people, they come out with no idea that there is an audience. The first thing I try to teach them in class is you start with the audience. If you don't know who you're talking to, you can't talk to anybody.

Regardless of the field of visual communication you eventually enter, loyalty to your audience should be of primary concern. If you always consider your audience, your choices, whether based on your personal vision or inspired from the work by someone you admire, will more likely be effective, admired, and ethical.

Case Studies

Case Study One

Every spring young boys and girls take to their local baseball and softball diamonds to "play ball!" Many of them do so sporting jerseys with names like, "Yankees," "Rangers," "Padres," and "Red Sox," monikers of Major League Baseball Teams. They are allowed to do so because, as the official web site of Little League Baseball explains, "Major League Baseball has never restricted any Little League teams from calling themselves 'Mets,' 'Yankees,' 'Cardinals,' 'Angels,' or any of its other trademarked names." This is by agreement with Little League. However, and this is the catch, teams who use major league names must also,

> note that unauthorized use of any trademark, including those belonging to Major League Baseball, may result in civil liability by the manufacturer of items bearing those trademarks. So, even though a local Little League that uses shirts with unauthorized Major League Baseball trademarks will not be held liable, it is likely that the business that provided the shirts would be.

What does this mean? It means that if a team decided to call itself the Angels, for example, after the Anaheim Angels, it couldn't just use any Angels logo, but would have to exactly match the colors and writing of the team from California. If it didn't do so, and Major League Baseball found out, they could sue – not necessarily the kids and their parents, but the printer who sold them the shirts. So what seems on the surface like a nice deal for everyone, might really be called a closed deal between Little League and the Major Leagues, and the only way Tommy can play on a team called the Tigers (his favorite animal, not necessarily the club from Detroit) is if he joins a league that pays dues to the national Little League office.

"Use of third party trademark names and logos." (2017). Little League Baseball. Accessed June 29, 2017 from http://www.littleleague.org/learn/rules/positionstatements/UsingTrademarkedNamesLogos.htm.

See Appendix B for the 10-Step Systematic Ethical Analysis Form.

Case Study Two

Some fonts are meant to do more than simply communicate words, but show the power of symbols. In April 2017, NYC Pride, New York's LGBT Film and Media Art Organization's NewFest and marketing firm Ogilvy & Mather released a special font to celebrate Gilbert Baker, the designer of the rainbow flag. Baker had recently died. In creating the font, the designers hoped to honor Gilbert's many contributions to the LGBTQ community as both an artist and activist.

Robertson, M. (April 26, 2017). "New font celebrates Gilbert Baker, designer of rainbow flag." *SFGate*. Accessed June 29, 2017 from http://www.sfgate.com/local/article/New-font-celebrates-Gilbert-Baker-designer-of-11099049.php.

See Appendix B for the 10-Step Systematic Ethical Analysis Form.

Case Study Three

In April 2017, Khloe Kardashian was sued for a copyright violation for having posted a photo to her Instagram account of … Khloe Kardashian! The lawsuit was brought by Xposure Photos, a U.K.-based photo agency. The picture was taken by one of their photographers, Manuel Munoz, and showed Kardashian and one of her sisters going out for dinner. Munoz had licensed the shot to the newspaper *The Daily Mail* – but not to Kardashian. As such, argued Xposure, Kardashian had no right to use it without paying for it, even though she was the subject of the photo. Xposure claimed Kardashian's use was infringement, and asked for damages of at least $25,000. Kardashian, on the other hand, might claim that Xposure is appropriating her likeness for profit, and that she has every right to use photos of herself on her own Instagram account.

Gardner, E. (April 26, 2017). "Khloe Kardashian sued for posting a photo of Khloe Kardashian on Instagram." *The Hollywood Reporter*. Accessed June 29, 2017 from http://www.hollywoodreporter.com/thr-esq/khloe-kardashian-sued-posting-a-photo-khloe-kardashian-instagram-997650.

See Appendix B for the 10-Step Systematic Ethical Analysis Form.

Annotated Sources

Nini, P. (2004). *In Search of Ethics in Graphic Design*. AIGA.

There is a lack of established professional guidelines for ethics in the field of graphic design. The author argues if graphic designers put themselves last and put the audience first, an

ethical model might follow. In following this guideline, the author lays out six points titled "The Designer's Responsibility to Audience Members and Users."

Typeright. (2013). *The TypeRight Guide to Ethical Type Design.* Accessed June 29, 2017 from http://www.typeright.org/getd_print.html.

TypeRight is a website whose mission statement is "to promote typefaces as creative works and to advocate their legal protection as intellectual property." This page lays out the history of type face design, the state of the typeface design industry, the role of the designer, and legal information on copyright. The role of the designer includes, but is not limited to, originality, respect for others work, and "remixing" other type faces.

References

Cartwright, M. (April 22, 2015). "Vitruvius." Ancient History Encyclopedia. Accessed June 29, 2017 from http://www.ancient.eu/Vitruvius/.

"David Carson Design." (2017). Accessed June 29, 2017 from http://www.davidcarsondesign.com/.

Evans, D. (July 29, 2016). "Talking with Tuesday Bassen about her David vs. Goliath battle against Zara." The Cut. Accessed June 29, 2017 from https://www.thecut.com/2016/07/tuesday-bassen-on-her-work-being-copied-by-zara.html.

"Fonts by Hoefler & Co." (2017). Accessed June 29, 2017 from https://www.typography.com/.

"The Gutenberg Bible." (n.d.). Harry Ransom Center. Accessed June 29, 2017 from http://www.hrc.utexas.edu/exhibitions/permanent/gutenbergbible/.

Heller, S. (March 5, 2005). "Typographica mea culpa, unethical downloading." Typotheque. Accessed June 29, 2017 from https://www.typotheque.com/articles/typographica_mea_culpa_unethical_downloading.

Hill, K. (August 30, 2010). "Use Comic Sans to get people to reveal their most sensitive private information online." *Forbes.* Accessed June 29, 2017 from https://www.forbes.com/sites/kashmirhill/2010/08/30/use-comic-sans-to-get-people-to-reveal-their-most-sensitive-private-information-online/2/#40b2c2ab33be.

"History of printing timeline." (2017). American Printing History Association. Accessed June 29, 2017 from https://printinghistory.org/timeline/.

"Hold Zara accountable for art theft." (2017). Shop Art Theft. Accessed June 29, 2017 from http://shoparttheft.com/.

"Johannes Gutenberg." (2016). Biography. Accessed June 29, 2017 from https://www.biography.com/people/johannes-gutenberg-9323828.

Johnston, C. (June 20, 2013). "Hate Comic Sans? Blame this Microsoft virtual assistant." Ars Technica. Accessed June 29, 2017 from https://arstechnica.com/staff/2013/06/hate-comic-sans-blame-this-microsoft-virtual-assistant/.

Lester, P.M. (2013). *Visual communication images with messages,* 6th edition. Boston, MA: Cengage Learning, p. 172.

Mark, J.J. (March 24, 2016). "Egyptian Book of the Dead." Ancient History Encyclopedia. Accessed June 29, 2017 from http://www.ancient.eu/Egyptian_Book_of_the_Dead/.

Mark, J.J. (September 2, 2009). "Plato." Ancient History Encyclopedia. Accessed June 29, 2017 from http://www.ancient.eu/plato/.

Morris, E. (May 18, 2015). "How typography shapes our perception of truth." Co.Design. Accessed June 29, 2017 from https://www.fastcodesign.com/3046365/errol-morris-how-typography-shapes-our-perception-of-truth.

Nini, P. (2017). "Paul J. Nini." The Ohio State University. Accessed June 29, 2017 from https://design.osu.edu/people/nini.1.

"Obey Giant/The art of Shepard Fairey." (2017). Obey Giant. Accessed June 29, 2017 from https://obeygiant.com/.

"The Saul Bass poster archive." (2017). Accessed June 29, 2017 from http://www.saulbassposterarchive.com/.

"Shepard Fairey, creator of Barack Obama 'Hope' poster, admits destroying evidence." (February 25, 2012). *The Telegraph.* Accessed June 29, 2017 from http://www.telegraph.co.uk/news/worldnews/barackobama/9105364/Shepard-Fairey-creator-of-Barack-Obama-Hope-poster-admits-destroying-evidence.html.

Sofia, I. (June 23, 2017). "Gucci under fire for ripping off two artists' designs in its latest collection." Design Taxi. Accessed June 29, 2017 from http://designtaxi.com/news/393825/Gucci-Under-Fire-For-Ripping-Off-Two-Artists-Designs-In-Its-Latest-Collection/?utm_source=DT_Newsletter&utm_medium=DT_Newsletter&utm_campaign=DT_Newsletter_23062017&utm_term=DT_Newsletter_23062017&utm_content=DT_Newsletter_23062017.

Sofia, I. (a). (June 5, 2017). "Snapchat accused of ripping off an artist's design for one of its filters." Design Taxi. Accessed June 29, 2017 from http://designtaxi.com/news/393423/Snapchat-Accused-Of-Ripping-Off-An-Artist-s-Design-For-One-Of-Its-Filters/?utm_source=DT_Newsletter&utm_medium=DT_Newsletter&utm_campaign=DT_Newsletter_05062017&utm_term=DT_Newsletter_05062017&utm_content=DT_Newsletter_05062017.

Sofia, I. (b). (June 2, 2017). "Forever 21 is under fire for copying iPhone case design from indie brand." Design Taxi. Accessed June 29, 2017 from http://designtaxi.com/news/393396/Forever-21-Is-Under-Fire-For-Copying-iPhone-Case-Design-From-Indie-Brand/?utm_source=DT_Newsletter&utm_medium=DT_Newsletter&utm_campaign=DT_Newsletter_02062017&utm_term=DT_Newsletter_02062017&utm_content=DT_Newsletter_02062017.

7

INFORMATIONAL GRAPHICS AND CARTOONS

While a student at the Academy of Fine Arts in Lodz, Poland, graphic designer Paul Marcinkowski created a striking infographic that explained several ideas about tattoos with the information seemingly inked on a young man's neck, chest, and arms ("Tattoo infographic," n.d.). Detailed on the upper chest and within an outline of a map of the U.S. is the fact that 45 million Americans have tattoos. Down the right arm are percentages that represent the number of tattoos a typical person displays. For example, 18 percent have three or more (I only have one). Near the stomach in a blackletter typeface within four strands of ribbons are three reasons why many regret getting a tattoo after the fact – the personal name, the way it looks, and thinking that the concept was juvenile. A fourth reason should have been added – misspellings – in at least two occasions Marcinkowski left out the second "o" in tattooing for the realistic simulation. Oops.

A more famous graphic designer, Stefan Sagmeister (2017) famously did one better when he produced a poster for his lecture – a type of infographic – by having one of his interns carve the details of his presentation into his skin with an X-ACTO knife. In the painful-to-look-at-photograph of this effort, Sagmeister holds a carton of adhesive bandages. As my five-year-old boys say, "Owwie."

Infographics is a portmanteau, a combination of the words information and graphics that describes an ancient form of communication that some say goes all the way back to cave drawings from about 30,000 years ago. Some animal drawings were found to have gouges chipped near vital organs. Perhaps the images of bison, deer, and horses not only beautified the walls or gave power to the hunters, but also acted as diagrams and used for target practice (Stromberg, 2012).

Infographics (often called data visualization) either convert numbers into pictures, as with charts and maps, or use words and concepts to create readable alignments or fact-based utilitarian-based pictures. In combination with sophisticated data mining and interactive techniques, advanced drawing tools, and satellite data downloads, infographics are considered to be one of the most informative and ubiquitous forms for sharing statistical and non-statistical information. Not surprisingly, we are all exposed to thousands of infographics a day shown through print and screen media for news, educational, and persuasive purposes.

Cartoons are another prehistoric presentation in which advocates track its roots to cave walls. They come in two main flavors – single- and multi-frame. Their historic reach spans

from exaggerated caricatures of persons and animals on rocks to the latest computer-generated, performance-capture animated motion pictures. Cartoons also include such diverse forms as humorous and editorial efforts, comic strips and books, and sophisticated fictional and nonfictional books.

If you're not convinced that serious subjects can be conveyed through the cartoon medium, you should take a look at Eisner Award winners in the reality-based category. Will Eisner (2017) was a groundbreaking American cartoonist who contributed early to the comic book industry, advocated the term "graphic novel" to describe a medium for long-form stories, and provided educational impetus for the study of cartoons as a serious academic field. Previous Eisner winners include the funny and poignant personal memoir *Fun Home* by Alison Bechdel (2017) that was adapted into a Broadway musical, *Green River Killer: A True Detective Story*, a gritty and often scary account of a serial murderer's background and rampage by Jeff Jensen and Jonathan Case (2011), and the 2016 winner *March: Book 2*, part of a trilogy written by John Lewis and Andrew Aydin (2016) with drawings by Nate Powell hint at the variety of the medium. In the *March* books, U.S. Congressman Lewis details his journey from his humble upbringing to become a leader in the civil rights movement.

Despite such successes, many in the media harbor biases against cartoons as conveyors of serious subject matter. One often-lamented example is the decline of editorial cartoons in newspapers by staff artists. However, in combination with infographics, cartoons are gaining respect as those involved with declining print interests (e.g. newspapers) switch to online presentations and search for ways to improve viewership.

The innovative Korean video artist, Nam June Paik once exclaimed, "Paper is dead, except for toilet paper." Whew. As a pioneer and advocate of video art and who was one of the first to use the term, the "electronic superhighway" in 1974, Paik had a unique and perhaps biased perspective on the future of paper (Reed, n.d.). Other futurists, media critics, and technological advocates also predict the downfall of paper as a substrate for news because of increased costs, lower advertising revenues, and indifference among potential subscribers (AKA Millennials, but not you, right?). For example, after graduating from college with a journalism degree, I was hired as a photojournalist for the *Times-Picayune* newspaper in New Orleans. I was 24 years old, single, and living in the French Quarter, but that's a subject for an altogether different ethics book. Named after a French coin worth about a nickel, *The Picayune* began in 1837. In 1914 it merged with the *Times-Democrat*. After I had left to attend graduate school, the newspaper won a Pulitzer Prize for its coverage during the 2005 Hurricane Katrina disaster ("Timeline," 2017). The staff's editorial success, however, couldn't stave off the inevitable economic catastrophe common with many print newspapers that resulted in severe cutbacks on personnel, resources, and circulation, switched to online-exclusive reports, or quit production completely. In 2015, the owner of the *Times-Picayune* announced that the paper would only be printed for home delivery on Wednesday, Friday, and Sunday with smaller sections printed on the other days. In an unusual move, but perhaps prescient in terms of the reality of the situation, it was decided that news stories would be first made available on the online version to web, smartphone, and tablet users and then published in print for everyone else.

The newspaper industry around the world has suffered a similar fate. Major chains and individual papers have gone bankrupt, long-time established news operations have quit production, and many others have decided upon a golden mean compromise and converted to either online hybrids as with *The Times-Picayune* or have become web-only publications. New owners with promised deep pockets haven't been able to help that much. A deal with Mexican business person Carlos Slim couldn't aid *The New York Times* that much, News

Corp. head Rupert Murdoch delayed plans to expand the newsroom of the *Wall Street Journal* after buying it, and the founder of Amazon.com, Jeff Bezos bought the struggling *Washington Post*. Nevertheless, the investigative reporting of the Trump Administration by these newspaper reporters speaks to the vital need for unbiased journalism. Still, the owners of these publications would like to have more readers. However, circulation is increasing for newspapers in Asia, Latin America, and the Middle East where the tradition of receiving news via print is stronger. Concurrently, traditional television viewing and radio listening are on the decline, as online access becomes more of a staple in a person's media life.

An apocalyptic blog aptly named "Newspaper Death Watch" (2016) maintained by Paul Gillin keeps a running total on failed papers along with other uplifting stories. Analysts with the Future Exploration Network (2017) predict that "newspapers in the U.S. will become insignificant by 2017 and the rest of the world by 2040" while academics at USC's Annenberg School for Communication and Journalism in the Center of the Digital Future predict that most U.S. newspapers will be gone in five years ("Is America at a digital," 2011). Yikes, but a bit premature, don't you think?

But I disagree. I'm putting my money on Nam June Paik. News*PAPER* may be dead along with Paik since 2006, but newspapers will survive through online technologies that include modern versions of infographics and cartoon. There might even be a new word for the combination – infotoons.

And even if you are or not particularly interested in journalism as a career, you should be aware of ways to recruit and keep engaged users regardless of the medium, the type of message (hopefully ethical), and your professional field. The use of infographics, cartoons, and infotoons (that word is growing on me) as described in this chapter are only one tool of the many described in this book.

Ethics and Infographics

As with any form of visual communication, ethical behavior can sometimes be a challenge when hedonism trumps all other philosophies. If an infographic designer intentionally produces a misleading piece because of some personal, political, or economic motivation, that creator has committed the worse violation in mass communications – an ethically prohibited action that produces harm that cannot be justified. However, many times, errors are introduced due to a lack of experience, ignorance, or of not receiving proper training. For example, it is a rare employee who has taken a statistics or data mining class. Consequently, few individuals are knowledgeable enough about all the components required of a complex infographic to know when it is inaccurate or misleading. One of the reasons several team members – reporter, statistician, coder, illustrator, and editor – are used to create a multifaceted infographic is to avoid criticisms. But if working solo because of budget cutbacks, the support staff might be nonexistent. As such, these mistakes should not necessarily be considered unethical, but can be classified simply as errors in poor judgment. If such problems are quickly admitted and corrected, there is little harm. If the error is unnoticed or ignored, we're back to thinking of the designer as unethical. Always admit mistakes and fix them as soon as possible – one of those kindergarten lessons we all have violated and should have learned.

Edward Tufte (2017) advocates education and gives workshops around the world to help infographic producers. He has been a consultant for the visual display of empirical data for such corporations as CBS, NBC, *Newsweek, The New York Times*, the Census Bureau, and IBM. His self-published books *The Visual Display of Quantitative Information, Envisioning*

Information, Visual Explanations, and *Beautiful Evidence* were instant classics because of the combination of useful information and pleasing graphic design presentations.

For Tufte, a high-quality infographic should have an important message to communicate, convey information in a clear, precise, and efficient manner, never insult the intelligence of readers or viewers, and always tell the truth. Tufte argues for a conservative approach in which the presentation is never more important than the story. "Ideally," he admits, "the design should disappear in favor of the information."

Charts should accurately reflect the numbers they portray. For example, dollar amounts over many years should be adjusted for inflation and monetary values of different currencies should be translated into one currency value. Because images generally have a greater emotional impact than words, the potential to mislead with visual messages is higher. Inappropriate symbols used to illustrate an infographic can be confusing. A serious subject, for example, demands serious visual representation and not cartoon characters. Such graphic devices may attract attention, but the risk is that the audience will be offended – an example of poor etiquette.

Although computers have greatly aided the production of infographics, the technology also makes easy the inclusion of decorative devices that distract the reader from the chart's message. Three-dimensional drop shadows, colored backgrounds, icons, illustrations, gratuitous interactivity, and unnecessary audio cues may catch the reader's eye and ear but not engage the brain. Tufte notes the trend in television and computer presentations in which the numbers get lost in animated, colorful effects. Weather maps for television and newspapers sometimes are so crowded with cute illustrations that their informational content is lost. Designers should avoid the temptation to base designs solely on aesthetic or entertainment criteria, a hedonistic approach. They miss an opportunity to educate a viewer, a utilitarian philosophical approach, whenever they rely on decorative tricks. At best, such gimmicks distract from the message, and at worst they give wrong information. Tufte said it best: "Consumers of graphics are often more intelligent about the information at hand than those who fabricate the data decoration. And, no matter what, the operating moral premise of information design should be that our readers are alert and caring; they may be busy, eager to get on with it, but they are not stupid. Disrespect for the audience will leak through, damaging communication." Treat your audience with empathy and respect, as John Rawls advocates in his veil of ignorance philosophy, and your work will elevate others.

As reported by Renee Shur (2011), graphic designers, Juan Antonio Giner of England and Alberto Cairo of Brazil were so upset about misleading infographics that they came up with a statement of principles. They concluded that infographics should be based on reliable and factual information, give credit to sources, avoid gratuitous design bling, and should be considered on the same level as any journalism piece. Educator and designer Cairo on his blog, "The Functional Art" is in agreement with Edward Tufte when he elaborates that a designer of visualizations (another term for infographics) should "create graphics that are intended to bring attention to relevant matters [and] are built in ways that enable comprehension." Creating utilitarian and thoughtful designs requires a seriousness of purpose that should match the import of the content.

Author and designer Drew Skau (2017) reminds us to be careful about design choices such as the use of colors that have close to the same degree of brightness and thus are difficult to decipher for those with color deficiencies. Although considered more of a question of etiquette than ethics, "chartjunk," a Tufte term for over-the-top design frills employed to catch a viewer's attention without offering substantial and sustaining data, has been called data porn by infographics innovator Jonathan Harris. Along with Sep Kamvar, Harris is the author of *We Feel Fine: An Almanac of Human Emotion* (2009), a fascinating collection "that contains

photographs from more than 1,000 individual bloggers, thousands of statistical computations, hundreds of infographics, dozens of back stories and in-depth profiles, and countless insights into the extraordinary lives of ordinary people." Harris writes,

> The problem with data porn and infographics is that if the underlying data is not beautiful and interesting, any kind of aesthetic fanciness you apply to that data will not help. It's like taking a really, really boring person and having her wear designer clothing and lots of makeup. They're still a really, really boring person. A similar thing is true with data and a huge percentage of the data art now in infographics is boring.

His critique reminds me of a maxim I say to my beginning photojournalism students, "If a scene looks boring through your camera's viewfinder, it will look boring printed out or projected on the big screen in the classroom."

One of the most influential infographics innovators Nigel Holmes would agree more with Harris than Tufte when he states,

> I have tried to make reading and understanding graphics a pleasurable experience instead of homework. If I can raise a smile, I'll be halfway to helping readers *see* what I'm trying to explain. Many academics and data visualizers hate this approach. They insist on 'just the facts.' Any deviation from or addition to the facts is wrong, wrong, just plain *wrong!* They even invent pseudo-scientific theories that sound important: 'optimal data-ink-ratio,' and 'chartjunk'
>
> (Grimwade, 2016)

Holmes is known for creating aesthetically pleasing designs that attract the eye and the mind – a combination of the golden rule and utilitarian philosophies.

Writing in the *Journal of Business Communication*, Donna Kienzler (1997) notes that perhaps a solution to inappropriate and sensational visual designs is to emphasize personal accountability. She asks of designers, "What are possible consequences of their communication? How would they like to be the recipient of the communication? What would the world be like if everyone used the techniques in their communication?" Once again, Rawls' veil of ignorance philosophy that stresses personal empathy is evoked. However, she also reminds us of Immanuel Kant's categorical imperative philosophy with its emphasis on universality and treating others with respect and not simply as a means toward a desired outcome. "When applied to visuals," she writes, "this theory asks what [infographics] would be like if everyone constructed visuals in a particular way, and if a particular visual uses people as a means to someone else's end." With Rawls, Kant, and Mill and Taylor's utilitarianism emphasis on the greater good, Kienzler asks, "Does the visual actually do what it seems to promise to do? Is it truthful, or better – does it avoid implying lies? Does it avoid exploiting or cheating its audience? Does it avoid causing pain or suffering to members of its audience? Is it helpful? Where appropriate, does it clarify text? Does it avoid depriving others of a full understanding?" Apart from a graphic critique of an infographic, or any form of visual communication, Kienzler emphasizes an analysis based on philosophical justifications. Nice.

Ethics and Cartoons

On the surface, infographics and cartoons seem to be distinct forms of visual communication most often discussed in separate articles and textbook chapters. But conceptually, they should

solve the same challenge in storytelling – how to transform passive, casual viewers into thoughtful, engaged users (which should be a goal of all media producers). As such, the best examples both use words and pictures within carefully considered contexts to explain, illuminate, and inspire. The worst instances, however, too often are based on the hedonistic philosophy and are criticized for their marketing techniques, stereotyping of individuals, and presenting purposeful inappropriate sexual, violent, and political themes.

Product tie-ins probably began with Richard Outcault's popular newspaper cartoon character, "The Yellow Kid," introduced in 1895 (Lester, 2017, p. 288). The *Kid* showed up in advertisements and on promotional pieces such as buttons, metal cracker boxes, and hand fans. Walt Disney gave up illustrating his motion pictures himself to organize and manage the lucrative product lines inspired by his company's characters. Matt Groening's *The Simpsons* (2017) is one of the most successful modern-day examples of marketing with stuffed dolls, DVDs, and a theme park ride. With a popular movie, every animation studio makes an enormous profit on international ticket sales, video rentals, sound track albums, and product licensing agreements. At the same time, Saturday morning television programs and motion picture characters frequently appear in advertisements promoting everything from dolls to bicycles. Animated cartoons are often the most colorful forms of entertainment, with their characters attracting the eyes of young and old. Brightly colored characters sitting on toy store shelves that look exactly like their animated equivalents also elicit pleading requests to a parent or guardian. Children are particularly vulnerable to such persuasive commercial techniques, but adults also are easily manipulated.

As with most other types of visual messages, too often cartoonists resort to stereotypes. For example, African Americans had to endure extremely offensive racist stereotypes in Bugs Bunny cartoons in the 1940s from *Looney Tunes* and *Merrie Melodies*, distributed by Warner Bros. After media mogul Ted Turner, the founder of CNN purchased the Warner Bros. collection, he vowed to never show the 11 most racist cartoons on television, although they can be found on YouTube (Slotnik, 2008).

Confusing the issue are overtly sexual, violent, and political messages conveyed through the cartoon medium that are designed to create controversy. Perhaps the leader in the most offended category is *South Park* created by Trey Parker and Matt Stone, now in its sixteenth season on Comedy Central (Maglio, 2015). Its homemade, paper cut-out look perhaps buffers it against critics whom nevertheless cringe when the actress Sarah Jessica Parker is called a "transvestite donkey witch" or when the word *feces* is used 162 times in a fifth-season episode.

Meanwhile, technological and aesthetic innovations have brought a level of realism to violent animated video games to the point that media critics have taken notice (Painter, 2017). When the object of a cartoon-based game is to "kill" as many other characters as possible, children and others learn that conflicts are easily resolved, not through compromise in a golden mean tradition, but through direct, violent action – a hedonistic approach. After two young men killed 13 people and themselves at a Littleton, Colorado high school in 1999, it was discovered they obsessively played two "first-person shooter" video games, *Doom* and *Quake*. Consequently, Disney banished all violent video games from its theme parks and hotels.

Political cartoons filled with emotionally symbolic visual messages can spark great controversy in the name of freedom of the press, but at the cost of communicating religious intolerance and sarcasm. In September 2005 after the Danish newspaper *Jyllands-Posten* printed 12 cartoons with most depicting the Islamic prophet Muhammad in satirical or silly ways, many in the Muslim world organized protests, with some that turned violent (McGraw and

Warner, 2012). In 2011 the office of the French satirical weekly newspaper *Charlie Hebdo* was bombed after it published a satirical issue with Muhammad as the guest editor (Taibi, 2015). Fortunately, no one was injured. *Hebdo* became well known for its cover cartoons depicting religious leaders in sexually compromising and controversial situations. After one too many Muhammad depictions, considered a blasphemy by many, in 2015 two armed men burst into the editorial office of the newspaper and opened fire killing 12 and wounding 11 others.

For an editorial cartoon, one of the most despised forms of visual messages by politicians, most critics agree with author Allison Anderson that there are two essential components that should be conveyed to justify the work as ethical (Rubens, 1987). First, the piece should have at its core a truthful fact about the person and/or situation under review. Pulitzer Prize winner Gary Trudeau in his "Doonesbury" comic strip, often considered an editorial cartoon, once linked the entertainer Frank Sinatra with several organized crime figures who included Tommy 'Fatso' Marson, Don Carlo Gambino, Richard 'Nerves' Fusco, Jimmy 'The Weasel' Fratianno, Joseph Gambino, and Greg De Palma. Some newspaper editors decided to run the strips as Trudeau intended, others slightly edited the content, some added an article that explained the historical references in the cartoon, while a few decided not to run the series (Randolph, 1985). In 2016 Trudeau released a collection that covered 30 years of cartoons that featured Donald Trump titled, *Yuge 30 Years of Doonesbury on Trump.*

The second essential element acknowledges that a cartoon can show an exaggerated and unflattering caricature of its subject, express sarcasm, irony, parody, and disgust, and be offensive in its display and message. However, all of these elements should be clearly articulated and justified. After *Hustler* magazine publisher Larry Flynt printed a cartoon of the religious leader, and later disgraced, Jerry Falwell having sex for the first time with his mother in an outhouse, a court awarded him $100,000 ("The infamous Jerry Falwell," 2004). The ethics mantra is evoked: Do your job and don't cause unjustified harm. The job of many cartoonists is to make the powerful and hypocritical uncomfortable, but if a drawing is outlandish and untrue, the harm it causes cannot be justified and is considered unethical, regardless of First Amendment privileges.

There is a concern that with realistic presentations from designers inspired by advances in video game and virtual reality technology, infographics and cartoons used for actual news events may be too close to actually being at a scene and be upsetting for many. ABC News produce computer-generated mannequin-like infofilms called "Virtual Views." These quickly produced displays can be made viewer-ready in a matter of hours for television and web news shows. Companies such as Z-Axis Corporation in Denver and Decisionquest in Torrance, California, produce courtroom graphics in still and animated platforms. In 2009 Next Media Animation, a Taiwanese creative house created an animated report of the golfer Tiger Woods crashing his car and having problems with his marriage with a video game aesthetic that was more amusing than disturbing (Hu, 2014). During the first OJ Simpson trial in 1995, Failure Analysis, Inc., created a realistic animated diagram based on an interpretation of evidence collected after the murders of Nicole Simpson and Ron Goldman for the software distribution and technical information company CNet ("OJ Simpson trial video," 2011). Although the jury never saw the video, it was shown on national television on the tabloid journalism show "Hard Copy." Its viewing has been described as gruesome, controversial, and misleading by those who have seen it.

After the horrific carnage in the Pulse nightclub in Orlando in 2016, infographics designers for the *Tampa Bay Times* created an interactive reenactment of the timeline of the tragedy with accurate architectural renderings. As a user clicks on areas of the diagram, stories from victims are presented. Interestingly, there are no cartoon representations of those killed or

injured – only a few head-and-shoulder portraits, short descriptions, and quotations that accompany the overhead views of the inside of the club. There were 17 staff writers, information from CNN reports, three researchers, and one computer-assistant reporting specialist used in the piece. A link at the end takes viewers to a complete overview of the news story (see Chapter 11 for more details).

The virtual reality storyteller and leader in the field, Nonny de la Peña, created one of the first news experiments that attracted attention in the industry. Funded by USC's Annenberg School for Communication and Journalism and its MxR interaction lab, it was based on actual video footage, but with animated, cartoon avatars. "Hunger in Los Angeles" gave users with a virtual reality headset the opportunity to experience waiting in a church-sponsored food line and reacting to a man going into a diabetic seizure (Newman, 2012). Author Bryan Bishop described the experience. "As I took the headset off I was quiet; shaken," Bishop wrote. "I asked de la Peña about the diabetic man's fate, and she assured me that he had survived the attack. I was frankly surprised at how much I actually *cared*" (see Chapter 9 for more details).

The future for infographics and cartoons for use in storytelling may be the infotoon. The books by David Macaulay (2017), *Cathedral* and *The Way Things Work* detail the mechanisms of simple tools to complex machines in a clear, diagrammatic style that is both entertaining and educational. In *99 Ways to Tell a Story: Exercises in Style* Matt Madden (2005) brilliantly demonstrates how a simple account can be told with cartoons in almost any style imaginable. The work includes a political cartoon and an infographic chart. Steven Heller summed up the work with, "Its very subject is the language, style and rhetoric of comics and visual storytelling." There seems to be nothing that cannot be communicated through creative collaborations and technological advances that connect users with stories in never before fundamental ways. However, creators need to be mindful that their presentations primarily come from motivations that illuminate, educate, and inspire rather than from profit that seeks to sensationalize, stereotype, and commodify.

Simply put, avoid works that are needlessly and unjustifiably insensitive and vacuous. Remember the mantra: Do your job and don't cause unjustified harm. In other words, be ethical and etiquettable (another new word).

Case Studies

Case Study One

South Park, the Comedy Central cartoon series, made its name dragooning and satirizing everyone and everything. In 2010, during its fourteenth season and for its 200th episode, series' creators Matt Stone and Trey Parker made an especially controversial episode when they parodied the Muslim Prophet Muhammad – and earned, in return, a threatening message from an Islamic group based in New York City, and censoring from its home network.

In the episode, Muhammad was confined first to a U-Haul trailer and then to a bear suit, as Stone and Parker tried to be mindful that the Muslim faith prohibits depictions of the high prophet. Even so, many thought the cartoon went too far. The next week, when Stone and Parker *seemed* to again be depicting Muhammad (although this time it turned out to be Santa Claus in the bear suit), he was hidden under a CENSORED graphic and his lines were all bleeped out. However, Comedy Central thought this was not enough – or was still a kind of "making fun" – and so they added other bleeps to the program.

Itzkoff, D. (April 23, 2010). "'South Park' episode altered after Muslim group's warning." *The New York Times*, p. 3.
 See Appendix B for the 10-Step Systematic Ethical Analysis Form.

Case Study Two

You probably know from your college classes how boring it gets to listen to lectures and slides shows all the time. Imagine what would happen if your professors stopped lecturing, flipped the conversation around, and got all the ideas from you – the students. That's what one chief marketing officer did at one of the world's largest branding firms, much to his employees' delight.

James Thompson said he counted every single presentation slide he was shown during his first two months working for the guitar accessory company, Diageo and the number astounded him: nearly 12,000. He said something had to give, because with all those slides, only one person was ever talking. So, while he didn't ban presentations all together, he did make them far more infrequent. He wanted meetings to be conversations, not presentations; ideas, not sales pitches. He said the approach worked. Where before Diageo had struggled to attract top talent, now people are excited to work there. And sales are growing, where before they had been in decline.

Schultz, E.J. (November 16, 2016). "A ban on PowerPoint? How Diageo changed its culture." *Advertising Age*. Accessed June 29, 2017 from http://adage.com/article/cmo-stra tegy/powerpoint-ban-diageo-changed-culture/306739/.
 See Appendix B for the 10-Step Systematic Ethical Analysis Form.

Case Study Three

One thing that toy makers have to think about is the many different kinds of children who will want to use their games, including those with different kinds of abilities. One of the most popular toys for children of all ages are Lego blocks. But building Lego sets requires being able to follow – and so read and *see* – directions. This means that blind children might feel excluded from playing with the blocks. Two especially enterprising kids took up this challenge – one with eyesight and one without – and created instructions for individuals who are either blind or seeing impaired. The two developed 23 (and counting!) sets of directions for Legos that used sequential, written instruction instead of pictures and blueprints, including Hogwarts Castle, a Ferris Wheel, and an Arctic Snowmobile. The text instructions are available via download, and work with a screen reader.

Cushman, C. (June 19, 2016). "Building with Legos using accessible instructions." Perkins School for the Blind. Accessed June 29, 2017 from http://www.perkinselearning.org/accessi ble-science/activities/building-legos-using-accessible-instructions.
 See Appendix B for the 10-Step Systematic Ethical Analysis Form.

Annotated Sources

Murtha, J. (May 6, 2016). "Why the controversy over an Iowa cartoonist is no laughing matter." *Columbia Journalism Review*. Accessed June 29, 2017 from https://www.cjr.org/a nalysis/cartoonist.php.

After publishing an unflattering, but truthful, cartoon making fun of corporate farming CEOs, an Iowa based cartoonist lost his job of 22 years. This article explores why it matters that the cartoonist Rick Friday was fired when advertisers who supported his small publication companies pulled their money from his former employer's small newspaper, and why even small incidents like this shrink everyone's right to a free and robust press.

Robison, W., Boisjoly, R., Hoeker, D., and Young, S. (2002). "Representation and misrepresentation: Tufte and the Morton Thiokol Engineers on the Challenger." *Science and Engineering Ethics*, 8, 59–81.

When the engineers at Morton Thiokol recommended that NASA not launch Challenger because the temperatures were outside the range that they had had successes in in testing, there were questions raised if they should have done more and pushed harder, or if they had, in fact, met their ethical duty to raise a red flag. The problem here was that after an initial rejection of approval to launch the shuttle, Morton Thiokol changed their decision and instructed NASA to go ahead with the launch. The authors argue that because the engineers did not have all the data they needed to make a decision, they should not be held morally accountable.

Rubens, P. (1987). "The cartoon and ethics: Their role in technical information." *IEEE Transactions on Professional Communication, 30*(3), pp. 196–201.

Rubens writes on the ethical implications of using cartoons in technical writing. He suggests that artists should use cartoons to promote audience identification, remember to consider the cultural implication and to support a specific task. He argues that cartoons, if used improperly, can manipulate the audience in ethically unacceptable manners.

Tufte, E. (n.d.). "The cognitive style of PowerPoint: Pitching out corrupts within." 2nd edition. Accessed June 29, 2017 from https://www.edwardtufte.com/tufte/books_pp.

This is a long form outline of what to do and what to avoid when creating and delivering a PowerPoint presentation. It touches on wide ranging issues from the "physically thick and intellectually thin" printed presentations to the destruction of conversation thanks to PowerPoint's presenter-oriented design.

References

"Alison Bechdel." (2017). Dykes To Watch Out For. Accessed June 29, 2017 from http://dykestowatchoutfor.com/.

Cairo, A. (2017). "The Functional Art." Accessed September 19, 2017 from http://www.thefunctionalart.com/.

"The Emily Post Institute." (2017). Accessed June 29, 2017 from http://emilypost.com/.

"Future Exploration Network." (2017). Accessed June 29, 2017 from http://futureexploration.net/.

Grimwade, J. (October 3, 2016). "Nigel Holmes on humor." Infographics for the People. Accessed June 29, 2017 from http://www.johngrimwade.com/blog/2016/10/03/nigel-holmes-on-humor/.

Harris, J. and Kamvar, S. (2009). *We feel fine: An almanac of human emotion*. New York: Scribner.

Hu, E. (January 27, 2014). "For Taiwanese news animators, funny videos are serious work." All Tech Considered. Accessed June 29, 2017 from http://www.npr.org/sections/alltechconsidered/2014/01/27/267018900/for-taiwanese-news-animators-funny-videos-are-serious-work.

"The infamous Jerry Falwell/Hustler magazine ad." (September 23, 2004). College Humor. Accessed June 29, 2017 from http://www.collegehumor.com/post/51885/this-is-so-funny.

"Is America at a digital turning point?" (December 14, 2011). USC Annenberg School for Communication and Journalism. Accessed June 29, 2017 from http://annenberg.usc.edu/news/faculty-research/america-digital-turning-point.

Jensen, J. and Case, J. (2011). *Green River killer: A true detective story.* New York: Dark Horse.

Kienzler, D.S. (April 1997). "Visual ethics." *The Journal of Business Communication*, 34(2).

Lester, P.M. (2017). *Visual communication images with messages*, 7th edition. Dallas, TX: WritingForTextbooks.

Lewis, J. and Aydin, A. (2016). *March (Trilogy slipcase set).* New York: Top Shelf Productions.

Macaulay, D. (2017). "The way things work now." Houghton Mifflin Harcourt. Accessed June 29, 2017 from http://hmhbooks.com/davidmacaulay/.

Madden, M. (2005). *99 ways to tell a story: Exercises in style.* New York: Chamberlain Bros.

Maglio, T. (July 8, 2015). "'South Park' renewed for 3 more seasons." The Wrap. Accessed June 29, 2017 from http://www.thewrap.com/south-park-scores-3-season-renewal-set-to-top-300-episodes/.

McGraw, P. and Warner, J. (November 25, 2012). "The Danish cartoon crisis of 2005 and 2006: 10 things you didn't know about the original Muhammad controversy." *Huffpost.* Accessed June 29, 2017 from http://www.huffingtonpost.com/peter-mcgraw-and-joel-warner/muhammad-cartoons_ b_1907545.html.

Newman, B.A. (October 28, 2012). "Hunger in Los Angeles." YouTube. Accessed June 29, 2017 from https://www.youtube.com/watch?v=wvXPP_0Ofzc.

"Newspaper Death Watch." (2016). Accessed June 29, 2017 from http://newspaperdeathwatch.com/.

"OJ Simpson trial animation." (2011). YouTube. Accessed June 29, 2017 from https://www.youtube. com/watch?v=8zt4anqnJoc.

Painter, L. (January 4, 2017). "11 best first-person shooter games 2017." TechAdvisor. Accessed June 29, 2017 from http://www.techadvisor.co.uk/buying-advice/game/11-best-first-person-shooter- games-2017-best-fps-games-from-doom-csgo-3648797/.

Randolph, E. (June 10, 1985). "The perils of Trudeau; 'Doonesbury' pulled over Sinatra spoof." *The Washington Post*, p. B1.

Reed, J. (n.d.). "Nam June Paik: The artist who invented video art." National Endowment for the Arts. Accessed June 29, 2017 from https://www.arts.gov/photos/nam-june-paik-artist-who-invented- video-art.

Rubens, P. (September 1987). "The cartoon and ethics: Their role in technical information." ResearchGate. Accessed June 29, 2017 from https://www.researchgate.net/publication/260693991_ The_cartoon_and_ethics_Their_role_in_technical_information.

Shur, R. (2011). "Ethical standards for infographics." Occasional Planet. Accessed June 29, 2017 from http://occasionalplanet.org/2011/11/10/ethical-standards-for-infographics/.

"The Simpsons." (2017). Everything Simpson. Accessed June 29, 2017 from http://www.simpsons world.com/.

Skau, D. (2017). "Drew Skau blog." Accessed June 29, 2017 from https://visual.ly/blog/author/ drew/page/3/.

Slotnik, D.E. (April 28, 2008). "Cartoons of a racist past lurk on YouTube." *The New York Times.* Accessed June 29, 2017 from https://kathmanduk2.wordpress.com/2008/04/28/cartoons-of-a-ra cist-past-continue-to-lurk-on-youtube/.

"Stefan Sagmeister." (2017). Museum of Modern Art. Accessed June 29, 2017 from https://www. moma.org/collection/works/102915.

Stromberg, J. (December 5, 2012). "Cavemen were much better at illustrating animals than artists today." Smithsonian. Accessed June 29, 2017 from http://www.smithsonianmag.com/science-na ture/cavemen-were-much-better-at-illustrating-animals-than-artists-today-153292919/.

Taibi, C. (January 7, 2015). "These are the Charlie Hebdo cartoons that terrorists thought were worth killing over." Huffpost. Accessed June 29, 2017 from http://www.huffingtonpost.com/2015/01/07/ charlie-hebdo-cartoons-paris-french-newspaper-shooting_n_6429552.html.

"Tattoo infographic by Paul Marcinkowski." (n.d.). Design Boom. Accessed June 29, 2017 from http:// www.designboom.com/design/tattoo-infographic-by-paul-marcinkowski/.

"Timeline: Breaking news as it happened, August 29, 2005." (2017). Nola. Accessed June 29, 2017 from http://www.nola.com/katrina/.

Tufte, E. (2017). "The work of Edward Tufte and Graphic Press." Accessed June 29, 2017 from https:// www.edwardtufte.com/tufte/.

"Will Eisner." (2017). WillEisner.com. Accessed June 29, 2017 from http://www.willeisner.com/.

8

SCREENED MEDIA

I was six years old living with my family in Tulsa, Oklahoma when I was invited on a date with my parents.

I never found out why they took a boy so young to a downtown theater for an evening showing of the classic motion picture *Ben-Hur*. I must give them credit for the overly optimistic and risky decision to bring me along. I won't take my kids to a movie until they're at least 10. But perhaps a babysitter cancelled at the last moment or there was nothing good on TV. Let's check. In 1959 American television viewers had three options – what was showing on ABC, CBS, or NBC. If my mom and dad had stayed home on Saturday night they could have watched such classics as "Bonanza," "Leave It To Beaver," or "The Lawrence Welk Show." Somehow they passed on those viewing choices and decided to get off the couch, get dressed up, and make their son watch a three-and-a-half-hour movie. Insane.

Their decision to take me along changed my life in a deeply, fundamental way.

Prescient motion picture studio heads, producers, and theater owners knew that the medium had to keep up with technological advances and the approaching interest-sucking tsunami, television. After the public was introduced to "talking pictures" with the embarrassing and culturally insensitive *The Jazz Singer* in 1927, Dorothy's sensual overload walk on the yellow brick road in 1939's *The Wizard of Oz*, a film as huge as the story it told in the 1953 religious classic *The Robe*, and James Cameron's illusionary depth perspective and performance capture megahit *Avatar* in 2009, audiences craved more movies with sound, color, wide screens, and 3-D. The technological felines were out of the paper or plastic bag waiting for someone to make the ultimate cat video. And all this to prove to theatergoers that those who created motion pictures could produce better entertainment options than what was on television. Was it successful? Ultimately, yes. Sort of. Although television beat motion pictures in almost every metric devised, it is television that is declining in viewer interest. Many are writing that the real technological tsunami is not motion picture innovations or bigger television sets, but the web. Because soon, television, just as with movie theaters, desktop computers, and news on paper will cease to exist. These media will be overtaken by the almost infinite possibilities available on the web. And as an aside, what will eventually replace the web? Smartphone apps. And what will replace apps? They will be swapped with augmented reality glasses. And where will glasses go? Gone to flowers every one. When will we ever learn?

After the severe restrictions imposed by the U.S. government on materials, equipment, and personnel reserved for the war effort in the 1940s, the next decade – dubbed "The Golden Age" for television – was a time when the movie industry was doing its best to convince parents to bring their baby boomers to a fictional story that told of power, greed, love, religion, redemption, chariots, and the pecs of Charlton Heston.

Jon Solomon (2001) in his book, *The Ancient World in the Cinema* noted that the studios spent an unheard amount of $14.7 million (about $121 million today) on an extensive marketing effort to promote *Ben-Hur* with tie-ins to "candy, tricycles in the shape of chariots, gowns, hair barrettes, items of jewelry, men's ties, bottles of perfume, 'Ben-Her' and 'Ben-His' towels, toy armor, helmets, swords, umbrellas, and hardback and paperback versions of the novel." The promotional campaign for the movie worked. According to the website Box Office Mojo, the domestic total gross figure for the 1959 version of *Ben-Hur* was $74 million. In today's dollars that amount represents $600 million – a smash by any calculus. By contrast, the 2016 remake only brought in about $20 million with a production budget of $100 million – a colossal box office fail.

Size Matters

Without question the signature scene in the movie, the one everyone who has seen it remembers, is the chariot race ("Ben-Hur," 2015). For a six-year-old, everything shown in the movie before the race is a colossal bore. Hours of unexplained and unintelligible talk, talk, talk with adults in funny costumes does not sit well with a kid. However, I was adequately compensated. My parents, bless their hearts, bought my proper behavior with big cups of soda, candy, and popcorn. It was like enjoying a bag of treats on Halloween without having to trudge around the neighborhood begging. Despite the dull show, I was content and, more importantly, quiet. And just before I was going to explode in rage, despite the perks at being stuck in this dark place, movie magic happened. I perked up. I paid attention. I watched the movie. And I have to believe that part of the appeal for me on that late Saturday night was the size of the screen. *Ben-Hur* was an epic appropriately shot in widescreen and given my small stature, the screen was enormous and consequently the characters, the carts, and the horses were Donald Trump Yuge. The dimensions of the screen transported me to Rome. I was in the arena among the crowds and the competitors. I even got a laugh from my fellow audience members when during a particularly action-packed scene I uncontrollably yelled out, "Go Ben, go." I became anxious when the "bad guy" (Messala played by Stephen Boyd) tried to destroy Ben's chariot, but overjoyed when the running horses trampled Messala and Ben won the race.

And then, calamity struck. [WARNING: Spoiler Alert.] After the race, Messala is carried off into a side room. As he screams in agony, a doctor tells him that the only way to save his life is to amputate his legs. He convinces the surgeon to wait until he sees Ben. He doesn't want his rival to see him without his legs. The screams, the grimacing, the blood, the candy, the popcorn, and the sugar drinks all combined to make me feel hot and dangerous. In a panic, I tried to stifle the natural urge to get relief, but once the feeling starts, not much can stop it. Sure enough, I couldn't hold it in any longer. I hurled a stream as straight and sure as any bullet out of a gun. All of that sweet gunk from my restless tummy splashed on the back of a woman sitting in front of me.

I still recall her surprised and anguished cry. Horrible.

Regrettably, I never had a conversation with my parents as to why they brought me along and if they regretted my extreme reaction to the bloody scene accompanied by the cries of a man about to lose his legs. But the experience has a positive spin – I am cautious what my young boys watch regardless of the media in play. Ethical behavior, then, is not a topic

reserved for professional dilemmas. Considering your ethical responses helps with personal predicaments as well. But you should know that by now.

I'm convinced that my six-year-old brain would not have been so involved with the story cast on my six-year-old retinas if not for the action projected on a gigantic screen. Since 1959 screens have grown larger in direct proportion to the public's interest in larger screens with today's IMAX screens as big as 40 feet wide and 32 feet tall. However, they are dwarfed next to the over-the-field monitor at the Dallas Cowboy stadium's 160 feet wide and 72 feet tall screen (Shorr-Parks, 2014). Early television and computer screens included 12-inch displays while today you can buy a 90-inch screen for either technology – if you have a room large enough.

But you should ask yourself, why all this discussion on vomit and screens?

Screen size is related to ethics. Since my Ben-Hur experience and as an adult, I have had to leave a theater and my friends behind because of gruesome scenes shown in such movies as *Bonnie and Clyde, Platoon, Dances with Wolves*, and *Reservoir Dogs*. However, I learned that if I watched these pictures on the smaller screen of a television set, I could make it through the movie without discomfort. Interestingly, as screens get larger for public showings in multiplex theaters and private media centers in two-story houses, the screens of computers shrink as we all get used to watching whatever disturbing content we want to – from beheadings to eyewitness videos – on our tablets and smartphones. Consequently, more of us are able to watch horrific content, whether fictional or actual because the screens are smaller. And that's an ethical issue. Small screens desensitize us to the violence around the world based on our sensational-seeking hedonistic nature.

Screen size matters probably as much as the content within the frames whether the silver substrate is bolted to a wall or held in your hand. If you think of motion pictures, television, computers, and the web as tools for presenting images on a screen, some pictures we simply watch and others we can manipulate and control, they nevertheless have similar technical and ethical considerations.

Violent content is ameliorated, made more sensual, and can affect a viewer in the long-term because of the size of a screen. Large displays especially combined with 3-D glasses propel a viewer into the action. Conversely, the same gruesome content is more easily digested visually when the monitor is smaller. And with that acceptance of the images there is a fear that repeated viewings will promote intolerance, callousness, dependence, and most troubling, indifference.

Motion Pictures. Offering the simplistic argument that the violence seen in motion pictures is responsible for all of the social problems in a society is always politically salient. Undeniably, action-adventure and horror movies are always popular genres and filled with violent acts. Think of *Clockwork Orange, Die Hard, Fight Club, The Passion of the Christ, Saw*, and *Scarface*. However, those mainstream releases pale when compared with independent efforts as reported by the website Bloody Disgusting (2017). Violence will always be a staple of American films because they are enormously popular. One of the main reasons that the number of movies with gruesome content has increased is the economic situation of the major studios. Studio executives need big blockbuster hits to maintain the economic health of their enterprises. And because about 80 percent of all movies shown in Europe are from the United States, executives have learned that these movies are trendy throughout the world because violence translates across cultures. Everyone understands a bullet in flight – no translation needed. For example, *Resident Evil: Afterlife* from the production companies Sony and Screen Gems earned $60 million in the U.S. and $236 million in foreign sales.

America has the First Amendment and a strong tradition of free speech. Ironically, movie studios don't make as much as they could on mayhem because governments of some conservative countries have banned violent (and overtly sexual) films. One golden mean

compromise offered by many was the Motion Picture Association of America (MPAA), originally founded in 1922 to oversee the economic health of the fledging industry. Soon, it became a tool to control the content of movies by imposing a production code that prohibited so-called indecent language and images as well as political speech. If a motion picture failed to get a seal of approval, the movie would be banned from American theaters. Criticism of the MPAA's rating system, first established in 1968, became more public after two movies were given different ratings. A ticket buyer must be 17 years old to see an R-rated movie without an adult while many theaters will not show them. *Bully* (2012), a documentary that follows five bullied children throughout a school year, was given an R rating because of its multiple use of the word "fuck" while *The Hunger Games* about teenagers who must kill to stay alive received a PG-13 designation (Zeitchik, 2012). Obviously, words are viewed as more dangerous than violence by the rating's board. However, after much publicity, Lee Hirsch, the director of *Bully* edited some of the obscenities and the rating was changed to PG-13 to get a wider audience. Hirsch said, "I think this [controversy] has given fuel to a conversation that's long overdue about the double standard when it comes to rating movies."

Television. As of this writing, television is still the most ubiquitous medium for mass communication, although the web is already challenging that distinction. Nevertheless, in one year, the average household will have a television set operating for almost 110 days continuously, or 30 percent of the time. No other medium can claim that percentage. Throughout television's history there have been atrocious acts broadcast live to unsuspecting viewers at home. For example, the killing of Lee Oswald was played live on early television ("Oswald shooting," 2010). The scene further traumatized the country after the President Kennedy assassination. School children watched the launch of the space shuttle Challenger live and saw it explode in 1986 because teacher Christa McAuliffe was on board ("Challenger disaster," 2007). Pennsylvania State Treasurer Budd Dwyer, convicted for bribery gave a live press conference in 1987 killed himself with a 357 magnum, long-barrel pistol that was shown to young viewers at home whose kids' program was interrupted by a news bulletin ("Budd Dwyer," 2017). George Holliday had recently purchased a video camera when he recorded the police beating of Rodney King in 1991 that was shown numerous times around the world (Troy, 2016). Seven years later on a Los Angeles freeway Daniel Jones set his parked truck on fire and then killed himself with a shotgun that was shown live ("Infamous California," n.d.). Before the twin towers of the World Trade Center fell because of the fires from the commercial airlines that slammed into them in 2001, about 200 persons jumped to their deaths out of smoke-filled windows with many seen in news reports ("9/11 jumpers," 2017). Video was widely distributed of deposed President of Iraq, Saddam Hussein was crudely hung by his neck after his conviction of crimes against humanity in 2006 ("Saddam Hussein," 2017). Beheading videos produced by terrorist groups are easily available for viewing on YouTube and other sources ("Beheadings," 2017). In 2015, a Roanoke, Virginia CBS television station aired a live broadcast of reporter Alison Parker and videographer Adam Ward conducting an interview when they were killed by a disgruntled former employee. He uploaded the first-person video that he took with his smartphone on Twitter and Facebook and highlighted a new and disturbing trend – the combination of video and social media. Further complicating the ethical dilemma of the reporter shootings was the frontpage coverage by the *New York Daily News*, not a publication known for its subtlety dating from the 1928 Ruth Snyder execution photograph ("Shocking slay of reporter," 2015). The newspaper ran a series of three framegrabs from the killer's smartphone that showed his arm extended, pointing his pistol at Parker, and her terrifying reaction. Readers were horrified by the images.

The reactions were best exemplified by the golden rule philosophy, the one that advocates not adding grief to others that is commonly cited along with hedonism by media critics including the general public, that the pictures were published to sensationalize the event and to make more money. However, Shane Ryan, a writer for the newspaper, defended the decision when he wrote, "Why am I glad that the images of Parker facing down the barrel of a gun made the front page? Because, sensational journalism aside, actually watching the sickening footage of a terrified young woman being murdered by a psychopath may actually get a point across (Ryan, 2015). Maybe it will stop the willful ignorance, and the ridiculous cycle of superficial recovery that ends with finding hope and meaning in something that is both hopeless and meaningless. Maybe it will wake us up to the pain that we cause each other, and the changes we desperately need to make." Stop, Shane. You lost me at "sensational journalism aside." Television and the print media combined to shock viewers. But for Ryan, the lessons learned from being confronted by violent visual news have a basis in utilitarianism, despite the difficult argument that hedonism is more likely the justification.

Hedonism rears its ugly head in other, less obvious ways. For example, a news story on ABC's "Good Morning America" used yellow police crime tape as a prop to imply that a reporter was at the scene of a crime ("ABC News busted," 2016). A wide-angle picture taken by someone from CNN (nice) clearly showed that the tape was tied to a piece of photographic equipment – not a usual police procedure. After being caught, the ABC News' Vice President of Communication wrote, "This action is completely unacceptable and fails to meet the standards of ABC News." You got that right. Those personnel at the scene should have known better, but hedonism clouded their judgment.

Computers. Probably no one who played the arcade game "Pac-Man" in the 1980s thought that the colorful, chomping, right angle controlled creature was actually eating the dots along the path or was consumed by other relentless foes. That's because the decade was a more innocent time when computer-generated graphics weren't as sophisticated and powerful as they are today. Try to find a copy of the first John Madden football game released in 1988 and compare the graphic appearance to the latest edition. Technical innovations of the 1990s changed video games as they became more sophisticated in their storylines, included more interactive features, and improved their realism ("The evolution of video," n.d.). Due to such games as "Street Fighter II" in 1991, "Doom" in 1993, and "Grand Theft Auto" in 1997, violent games were established as a popular and profitable staple of the industry. In fact, games are more popular than motion pictures. David Mullich (2015) for Quora reports that "worldwide box-office revenue for the film industry in 2013 was $35.9 billion" while the video game industry made $70.4 billion during the same period. Part of the popularity can be attributed to the introduction of interactive "shooter" games after social critics raised important concerns about children and others who become obsessed with video game playing. The most popular games reward a player for committing some kind of violent act that tacitly teach anyone under its influence that conflicts are easily resolved, not through compromise, but through direct, violent action. Violence has a higher potential for contributing to adverse personality disorders than do motion pictures or television because the user is actually responsible for the actions in the game, rather than being a passive viewer.

The Web. If, as predicted by most media experts, the web will eventually replace all other media including print, motion pictures, and television, violent visual messages will continue to be easily accessed through a few simple keystrokes. With such obvious website names as Best Gore (2017) and Rotten (n.d.), these sites cater to those who seek extremely violent

images from journalists, citizen eyewitnesses, and even murderers making video selfies, or vidsies, of their brutal acts as a form of entertainment. Mark Marek, the owner of the Canadian website, Best Gore, was arrested for violating an obscenity law in 2012 for hosting a video of a murder produced by the perpetrator. Regardless, the site's homepage warns that it makes available to those 18 years old and older, "beheadings, executions, suicides, murders, electrocution, stoning, torching, drowning, car crashes, motorcycle crashes, workplace accidents, sexual accidents, animal attacks" and, well you get the picture. Justification for these images is also detailed on the webpage as based on the categorical imperative – it is their self imposed duty to show images censors and "petty tyrants" don't want you to see – and utilitarian – users are educated by the content because "by not seeing things for yourself, you are opening the door to being lied to and persuaded in one direction or the other," and, of course, hedonism – with its array of explicit sexual advertisements. Best Gore and other similar websites are largely a repository for pictures taken from news stories around the world. Journalists and their employers need to take some responsibility allowing access to images that most of the public would not see.

For visual communicators, one of the most important issues is that of free speech versus governmental censorship. Social critics have sometimes described the web as a huge, unregulated book or DVD store in which children can suddenly wander into a back room where all the pornographic magazines and lewd materials are shelved and all they need for access in many cases is a promise that they are at least 18 years old. Obviously, parents need to be responsible for the materials their children watch. But in a public setting – as in a university or library – adults should be given the opportunity to view a wide variety of materials available on the web.

The web is also made more ethically challenging by small, ubiquitous, often unseen cameras that monitor our movements, help catch and convict criminals, and occasionally save lives and spur policy changes. They also record some of the darkest interactions between the powerful and the powerless. The *Mother Jones* website documents incidences with links to videos recorded by police dashboard and body cameras, store security cameras, and bystander smartphones of fatal shootings of suspects (Lee and Vicens, 2015). The list of those killed under the color of authority is long and keeps growing: James Boyd, Albuquerque, New Mexico; Richard Ramirez, Billings, Montana; Jason Harrison, Dallas, Texas; Eric Garner, Staten Island, New York; John Crawford III, Beavercreek, Ohio; Dillon Taylor, Salt Lake City, Utah; Anthony Lamar Smith and Kajieme Powell, St. Louis, Missouri; Tamir Rice, Cleveland, Ohio; Jerame Reid, Bridgeton, New Jersey; Antonio Zambrano-Montes, Pasco, Washington; Charly Keunang, Los Angeles, California; Phillip White, Vineland, New Jersey; and Walter Scott, North Charleston, South Carolina. If seen on television, the clips are typically edited to about a minute with most of the gruesome content removed. The web, however, allows for the playing of videos in their entirety with the user able to enlarge the images, repeat the presentation as many times as desired, and pass them along through email and social media. Some of the videos begin with a message that warns the viewer of gruesome and disturbing content – clearly, a golden mean, but ineffectual solution to the dilemma of showing scenes that may evoke objections.

When violent content can be easily found, downloaded, repeatedly played, and shared on intimate hand-held devices, the impact of the gruesome scenes is lowered to the point of indifference. Such a mental state is alarming enough for fictional works, but the trend today includes actual news events. In addition to violence, screen size matters for the other issues for visual communicators – privacy, manipulations, persuasion, and stereotypes. The same work shown on a 50-foot width screen within most multiplex theaters and on a 4-inch

smartphone display drastically affects a viewer's experience whether it is composed of images that show violent content, violate the rights of privacy of innocent victims, alter reality through stage managing or computer manipulation, attempt to persuade users toward a way of thinking or a product to be bought, or perpetuate harmful stereotypical representations.

A visual communicator needs to consider the needs of all possible users of the technologies of display. However, those needs should be balanced with what the public ought to know with what the public needs to know. A decision to show a potentially disturbing image should not necessarily be based on what the public wants to know.

Case Studies

Case Study One

One of the most controversial issues in the 2016 American presidential campaign was that of the border between the United States and Mexico. Republican nominee, and eventual winner, Donald J. Trump, portrayed the border as a space of lawlessness and danger, and promised to build a giant wall between the two countries. "Build that wall!" became a popular line associated with his campaign.

However, statistics show that in the years leading up to the 2016 election, undocumented immigration to the United States over the Mexican border had been declining, and that fewer undocumented immigrants commit crimes than most people think, or is true of the population-at-large. So why was it so easy for Trump to stoke fears about the border? One possibility is the typical portrayal of the border on television and in film. Hollywood westerns, for example, almost always portrayed the border area as a place of lawlessness and danger. However, some recent productions programs, like the television program "The Bridge" and the film *Sicario* – have tried to offer a more complex portrait, where zone between the two countries – and the states of northern Mexico and the American south – are shown to be full of contradictions, populated by individuals who sometimes make good choices, and sometimes don't.

Solórzano, F. (2017). "Trump's border, as seen on TV." *Americas Quarterly*. Accessed June 29, 2017 from http://www.americasquarterly.org/content/trumps-border-seen-tv.

See Appendix B for the 10-Step Systematic Ethical Analysis Form.

Case Study Two

One of the most infamous Nazi's ever to go on trial was Adolf Eichmann. Eichmann was a relatively low level Nazi officer whose main job had been to manage the logistics of organizing and then mass deporting Jewish citizens, first into ghettos and then, later, into concentration camps. Eichmann famously claimed that he was not really responsible for his actions, because he was simply following the orders of others. At his trial in Israel, however, he was found guilty of crimes against humanity and sentenced to death. Central to his conviction, of course, were photos and images of the holocaust atrocity, which worked against his claim that he had to do what he did. That is, in the case of the Nazi official, the pictures of genocide "unmasked" his administrative evil. What does this tell you about the importance of all war photography? Is there a possibility that even as it worked in this case, we must be careful not to discount other kinds of administrative evil that are less carefully set up or look less organized than was true in the Nazi case? Is there a possibility that photographs

can somehow "set" a standard of what evil looks like, and so desensitize viewers to other kinds of harm?

Hartouni, V. (2012). *Visualizing atrocity: Arendt, evil, and the optics of thoughtlessness*. New York: NYU Press.

See Appendix B for the 10-Step Systematic Ethical Analysis Form.

Case Study Three

Most people like the internet to be fast. They like using it to be easy. When reading internet web pages, most people only browse and skim – feeling like they're getting the content, without reading every single word. Usually, this is okay. However, in some instances this opens users up to "dark patterns," a kind of web interface that tricks individuals into doing things they might not otherwise do, like buying insurance, taking a gift card for a refund instead of actual money back, or signing up for newsletters or recurring emails.

Brignull, H. (n.d.). "Dark patterns." Accessed June 29, 2017 from https://darkpatterns.org/.

See Appendix B for the 10-Step Systematic Ethical Analysis Form.

Annotated Sources

Czarny, M.J., Faden, R.R., and Sugarman, J. (2012). "Bioethics and professionalism in popular medical dramas." *Journal of Medical Ethics, 36*, 203–206.

This study analyzed a season of "House M.D." and a season of "Grey's Anatomy" to look at the possible ethical issues in the presentation of the medical dramas. In the analysis of the 50 combined episodes, the authors found 179 instances of distinct bioethical issues. They also identified 396 instances of questionable professionalism. In so doing, the authors raised concerns about how television series might be diluting what viewers think are ethical behaviors on the part of doctors, or what comprises ethical behavior among professionals, in general, including themselves.

Hoffman, M.C. and Gajewski, M. (2012). "The ten masks of administrative evil." *Administrative Theory & Praxis, 3*(1), 125–132.

Here the author outlines 10 different "masks," or ways in which administrations avoid doing what they are either legally or ethically obligated to do. They also describe "administrative evil" as that avoidance of the obligation. These masks are euphemisms, compartmentalization, instrumental rationality, legalism, accountability structures, dehumanization, mission supremacy, ethical fading, moral invasion, and reward and punishment. They then show how these masks have been portrayed in films, and make the notion of "administrative evil" visible to audiences, possibly causing viewers to accept less than acceptable behavior in their own elected officials.

Woodbury, M. (1998). "Defining web ethics." *Science and Engineering Ethics, 4*(2), 203–212.

An exploration into the ethics of coding, browsers, and the larger web, this article looks at the complications of interactions between different cultures as they intersect online. The authors argue that the Internet should look to librarians to learn how to build a marketplace which is accessible to all people, and which considers takes into account the myriad needs of users and the obligations users and designers have for paying attention to various external constituencies.

References

"9/11 jumpers." (February 12, 2017). YouTube. Accessed June 29, 2017 from https://www.youtube.com/watch?v=X1FwibQhZoI.

"ABC News busted Faked crime scene for live shot." (November 4, 2016). TMZ. Accessed June 29, 2017 from http://www.tmz.com/2016/11/04/abc-news-linsey-davis-fake-crime-scene/.

"Beheadings." (2017). Google Video. Accessed June 29, 2017 from https://www.google.com/search?q=beheading&ie=utf-8&oe=utf-8#tbm=vid&q=beheadings.

"Ben-Hur – The chariot race (1959)." (January 8, 2015). MovieClips. Accessed June 29, 2017 from https://www.youtube.com/watch?v=frE9rXnaHpE.

"Best Gore." (2017). Accessed June 29, 2017 from http://www.bestgore.com/.

"Bloody Disgusting." (2017). Accessed June 29, 2017 from http://bloody-disgusting.com/.

"Budd Dwyer." (2017). Daily Motion. Accessed June 29, 2017 from http://www.dailymotion.com/video/x32el73_budd-dwyer_news.

"Challenger disaster live on CNN." (July 24, 2007). YouTube. Accessed June 29, 2017 from https://www.youtube.com/watch?v=j4JOjcDFtBE.

"The evolution of video game violence." (n.d.). NAG. Accessed June 29, 2017 from http://n4g.com/user/blogpost/abizzel1/526296.

"Infamous California freeway suicide." (n.d.). Live Leak. Accessed June 29, 2017 from https://www.liveleak.com/view?i=bdd_1243483147.

Lee, J. and Vicens, A.J. (May 20, 2015). "Here are 13 killings by police captured on video in the past year." Mother Jones. Accessed June 29, 2017 from http://www.motherjones.com/politics/2015/05/police-shootings-caught-on-tape-video/.

Mullich, D. (September 24, 2015). "Who makes more money: Hollywood or the video game industry?" Quora. Accessed June 29, 2017 from https://www.quora.com/Who-makes-more-money-Hollywood-or-the-video-game-industry.

"Oswald shooting." (September 27, 2010). Totally Amazing Videos. Accessed June 29, 2017 from https://www.youtube.com/watch?v=3n9VQ-dXrwQ.

"Rotten dot com." (n.d.). Accessed June 29, 2017 from http://rotten.com/.

Ryan, S. (August 28, 2015). "Roanoke shooting belongs on the front page, images and all." *New York Daily News*. Accessed June 29, 2017 from http://www.nydailynews.com/opinion/roanoke-shooting-belongs-front-page-images-article-1.2339835.

"Saddam Hussein execution full version." (2017). Daily Motion. Accessed June 29, 2017 from http://www.dailymotion.com/video/x3aaau_saddam-hussein-execution-full-versi_people.

"Shocking slay of reporter, cameraman." (August 27, 2015). *New York Daily News*. Accessed June 29, 2017 from http://assets.nydailynews.com/polopoly_fs/1.2339834.1440715422!/img/httpImage/image.jpg_gen/derivatives/article_750/paste27n-1-web.jpg.

Shorr-Parks, E. (November 27, 2014). "How big is the Dallas Cowboys' massive screen in AT&T Stadium?" NJ.Com. Accessed June 29, 2017 from http://www.nj.com/eagles/index.ssf/2014/11/how_big_is_the_dallas_cowboys_massive_screen_in_att_stadium.html.

Soloman, J. (2001). *The ancient world in the cinema*. New Haven, CT: Yale University Press.

Troy, G. (March 3, 2016). "Filming Rodney King's beating ruined his life." Daily Beast. Accessed June 29, 2017 from http://www.thedailybeast.com/filming-rodney-kings-beating-ruined-his-life.

Zeitchik, S. (March 28, 2012). "'The Hunger Games,' 'Bully' prompt MPAA ratings fight." *Los Angeles Times*. Accessed September 19, 2017 from https://www.deseretnews.com/article/765563935/The-Hunger-Games-Bully-prompt-MPAA-ratings-fight.html.

9

MIXED AND VIRTUAL REALITY

My 5-year-old twin boys call the virtual reality system we have at home, "Goggle Movies." Parker carefully slips the Oculus Rift (2017) headpiece over his ears, sits on the floor, and with a full-face grin attempts to grab a sea turtle that swims above him. Martin loses his patience and tries to grab the headset off his brother's head, eventually gets his turn, and prefers a roller coaster video where he can lie on the floor and toss and turn with the ride. Just as Baby Boomers grew up with television and the Millennials the web, my sons' generation (the Digitals?) will think nothing special of virtual reality news and entertainment programs that they watch while they sit spread out in comfy chairs in the back of their self-driving cars on the drive home.

In case you've spent the last year listening too much to your LP records in the comfort of your book-filled den, the technologies featured in this chapter are the NEXT BIG THINGS. There are two reasons why these content platforms have received so much publicity and why any current experiments and beta presentations will soon be thought of as quaint historical artifacts much as someone who holds a strip of 35mm negative film up to a light.

But before we get too far into immersive media, let's start this chapter with some reality reality (RR) because there is no technology that can match the immersive experience provided to you by your mind. If you ever find yourself with a few free hours in the quaint college town of Oxford in Great Britain, first off, consider yourself lucky. By luck or design, you have been blessed with the opportunity to explore a city that was established more than a thousand years ago. Walk to Broad Street and explore the Bodleian Library, one of the oldest and largest in Europe. Purchase a biography of an altogether strange fellow and typographer Eric Gill at Blackwell's Bookshop (and be sure to get the shopkeeper to stamp the store's logo on a page). Later at the King's Arms or The White Horse tavern, enjoy a pint of ale while you read.

Whatever you do, don't miss the stone steps between the sculpted heads of philosophers that lead to the entrance of the Museum of the History of Science ("Welcome to the museum," 2017). Perhaps you may say to yourself that the title is a bit pretentious, but that initial conclusion is only because you are reading these words and have not actually visited a place that exhibits scientific equipment from the Middle Ages to the 1900s. Erected in 1663 to hold a rich guy's vast collection, the building is the oldest content-specific museum in the world with about 20,000 objects. In a brightly lit room, jam-packed with wall hangings and

reverently displayed objects in tediously dusted glass cases infused with an odd smell reminiscent of a combination of ether and your grandma's house, an old-fashioned blackboard – the kind that was used when I was a young student and I would fight for a teacher's attention by volunteering to slap the chalk dust out of the erasers – leans against a wall. A blackboard? So what? Well, none other than Albert Einstein used that slate surface crowded with strange mathematical markings when he gave lectures at the University of Oxford in 1931. Just a few meters away in that same room and within a glass case is an exhibit that peaked my interest even more than a visual representation of Einstein's mind and relativity – the equipment, carrying case, and detailed recipe for the photographs produced by Charles Dodgson, also known as Lewis Carroll. Still think this museum's name is pretentious?

If you are not quite as fortunate to actually walk the streets of Oxford, or almost any other city in the world, no matter. Open up Google Earth, put on an HTC Vive (2017) virtual reality (VR) headset and experience the magic of immersive storytelling as stated by the public relations machine of the web browser, "Explore the world from totally new perspectives. Stroll the streets of Tokyo, soar over Yosemite, or teleport across the globe." Exciting stuff.

In truth, however, VR is not quite that real – yet. Although you can pretend to window shop along the old streets and sidewalks or even fly along the rooftops of Oxford like a tech-savvy Mary Poppins, you can't open any door and enter. Alas, in VR, the wooden portal for the Museum of the History of Science remains closed and its abundant exhibits are out of your visual grasp. Although you decide where you want to travel, the Google Earth version of VR is a passive experience. You are watching scenes as if inside an enhanced motion picture in which you can look side-to-side, behind, up, or down to get additional views through the array's 720-degree viewport (a combination of two circles – one horizontal and the other vertical). And while the feeling of control is enhanced by your decisions of where to soar and what to view, engagement is limited to admiring or critiquing the natural and architectural wonders depending on your point-of-view.

Virtual reality's sibling is known as augmented reality (AR) also known as mixed reality (MR). The best systems seamlessly combine elements of VR with your own environment. Think of the 2016 fad, Pokémon Go in which players walked to various locations to find and capture cartoon characters that showed up on a smartphone's screen (one user was hit by a car when she walked into traffic). Advertisers, publishers, gamers, and journalists print coded graphic designs that create 3D objects and films when viewed with a smartphone's app. For example, a special issue of *Esquire* magazine featured Robert Downey, Jr. on its cover touting its AR content ("Esquire's augmented reality," 2012). David Granger, Editor-in-Chief of *Esquire*, indicated that there were "70,000 downloads of the software to have the AR experience" representing about 10 percent of the magazine's circulation. In addition to the *Esquire* cover, 3D displays could also be found on the covers of *DE:BUG*, a German publication that specializes in technology culture and the American magazine *Popular Science*. Topps introduced AR baseball cards while the US Postal Service announced an application that let customers see if the contents to be shipped would fit within one of their flat rate boxes. Artist Lucas Blalock produced the first photography book that uses AR to enhance a viewer's experience in *Making Memeries*, a play on Richard Dawkins' word creation, the meme (Stam, 2016).

Although interesting, AR programs are still mainly used solely to attract attention. On occasion, AR content can be found in printed publications, as a part of arcade-style games, on business cards, and as thinly disguised sales gimmicks for shoppers with a smartphone. There should be no reason, other than a lack of creativity, that a newspaper or magazine page, a press release, an advertisement, or a website cannot include a 3D informational

graphic, an organization's director introducing a new service, a behind-the-scene look from a newly released motion picture, or an interactive map that pops up valuable information in the face of an engaged user.

The primary commercial VR systems available to the public are Google VR in cardboard and headset versions, Sony's PlayStation VR, codename "Project Morpheus" appropriately named after a character in *The Matrix*, Samsung Gear VR from the electronics giant and designed for the company's smartphones (best played near a smoke detector), HTC Vive, introduced by the Taiwanese electronics company HTC and the Valve Corporation, a video game developer, and the Oculus Rift, introduced by Palmer Luckey in 2011 (Vincent, 2017). In the tradition of computer innovators of the past, he made his prototype as an 18-year-old working out of his parents' garage in Long Beach, California. Luckey also received guidance and inspiration from Associate Professor Mark Bolas and his Mixed-Reality Lab at the University of Southern California's Institute for Creative Technologies and Nonny de la Peña (Richmond, 2017). More on her and her work a bit later. Three years after Luckey's breakthrough, Facebook bought his company for $2 billion. Lucky indeed. The PlayStation, Vive and Rift devices come with hand controllers that allow users to grab and move virtual objects seen through headsets. This additional feature is important as it clearly delineates the difference between watching and engaging. This hands-on feature separates static movies from real world interactive experiences.

Recent and new VR game titles that transport a user into a fantasy, digital world can communicate feelings of admiration, surprise, wonder, and curiosity – all vital components of the chief marketing element that keeps consumers and major corporations interested – magic. When viewing a well-designed VR world for the first time, the simplest description is often the best – it is a vivid, dream-like enchantment unlike any existing experience you might have without a headset.

Google "VR games" or link to vrgamesfor.com and you will discover a world of gaming that is perhaps unfamiliar, untried, and unnerving. Dan Griliopoulos of *Techradar*, "The source for tech buying advice" lists the best VR games currently available. "Elite: Dangerous," a massively multiplayer combat game, a frantic bomb-defusing challenge, "Keep Talking and Nobody Explodes," the blood-filled "Surgeon Simulator" (relax – the patients are space aliens), the dogfighting space adventure, "Eve: Valkyrie," the first-person shooters, "Half-Life 2" and "Shooting Showdown 2," and of course no list is complete without menacing, mindless zombies after your pretty face such as with "Dying Light," a sequel of the critically acclaimed "Dead Island" based on the same premise. Notice a pattern in these choices? Violence sells. It is a variation of the old journalism trope, "If it bleeds; it leads."

Not surprisingly, the porn industry has developed VR titles for obvious reasons. Google "VR porn" and then explain to your partner that you accessed the websites purely for research purposes. If you have the inclination, time, and funds, you can purchase a full-body "sex suit" and experience VR intercourse from a device developed by the Japanese company Tenga. Cleaning charges are extra (sorry). More insidious are titles that promote stereotypes, sexism, and misogyny. For example, Sean Buckley of engadget.com writes that "Dead or Alive Xtreme 3" rewards users for committing sexual assaults (Buckley, 2016). As reported by media critic Anita Sarkeesian, there are many other games that promote harmful female stereotypes and violence toward women ("Feminist Frequency," 2017). She became known after she criticized the gaming industry for its male-dominated storylines under the banner heading, "Gamergate" (Hathaway, 2014). Her feminist perspective on misogynistic games as expressed through her video blog and speeches, is an important voice that provides an ethical foundation for digital productions. This concern is amplified with immersive VR systems and

content. Amy Westervelt (2016) writing in *Elle* magazine understands that thoughtful creators should tread carefully in this medium because "VR experiences are so immersive that people often confuse virtual reality with actual reality." She also notes, "harassment in VR is far more traumatic than in other digital worlds" because of the unsettling combination of unfamiliar circumstances, often-powerless response capabilities, and a heightened realism.

Fortunately, not all the popular titles involve gore, guts, and grabs. "Everest VR" and "The Climb," simulate mountain ascents, "Lucky's Tale" is similar to a classic arcade game, "Shufflepuck Cantina Deluxe VR" and "Pool Nation VR" allow you to play like the analog classics, "Euro Truck Simulator 2" puts you in the cab of a, well, a cool Euro truck, "Minecraft VR" is based on the popular digger program, "Job Simulator" where you can elect to be an auto mechanic, a gourmet chef, office worker, or a store clerk, and, of course, all sorts of sports programming.

For augmented or mixed reality, the game changer was thought to be the Google Glass – the highly anticipated eyewear with see-through digital interfaces that blended with your location and marketed with a cute commercial of a guy learning to play a ukulele to impress a friend (Bhutto, 2012). Users accessed the internet and other features through voice commands. However, with concerns about privacy (hackers could steal passwords while facial recognition software could identify strangers on the street), health (eye strain and distracted walking and driving), and ethics (interviewees not knowing their words and actions were recorded by Glass journalists), the prototype was discontinued in 2015. Reportedly, the Google gang is working on an improved version. In the meantime, Microsoft, the operating system software company started by college dropouts Paul Allen and Bill Gates, has made a prototype currently named HoloLens. It's a pair of mixed reality smartglasses (a new word) with a holographic 2D or 3D platform for use with Windows. Through simple finger movements, users can manipulate and work on any file as well as watch movies and play games (Mackie, 2016).

The Future of News

It is quite possible that AR will eventually overtake VR, but in the meantime, virtual reality dominates news stories and the public's imagination. Media entities such as "Frontline," ABC, *The Los Angeles Times, USA Today, The New York Times, The Washington Post, The Des Moines Register, Time* magazine, VICE, the Verge, and Ryot, games from HTC Vive, Oculus Rift, and PlayStation VR, as well as educational institutions such as the Newhouse School at Syracuse University, Columbia University's Graduate School of Journalism, Stanford University's Virtual Human Interaction Lab, the Reynolds Journalism Institute at the University of Missouri School of Journalism, and the School of Cinematic Arts at the University of Southern California (USC) have created critically acclaimed VR motion pictures.

Most notably, "Harvest of Change" (n.d.) detailed life on a family farm in Iowa produced by staff members of the *Des Moines Register*. *The New York Times* distributed more than one million Google cardboard virtual reality viewers to subscribers and smartphone users to watch documentaries such as "Walking New York," a tour of the wonderfully crowded streets of my home town and "Seeking Pluto's Frigid Heart," a view of the dwarf planet from the New Horizons spacecraft. Film director Spike Jonze worked with the United Nations for a documentary titled "Clouds Over Sidra," that featured a 12-year-old Syrian girl's experience at a refugee camp in Jordan. Jonze, a creative director for VICE and Chris Milk, a digital artist teamed to produce "the first-ever virtual reality news broadcast" titled, "VICE News VR: Millions March," an eight-minute film that featured New York City protesters concerned with police violence (Gutelle, 2015). Ryot in conjunction with the news website *The Huffington Post* produced "Protect the Sacred" about the Standing Rock, North Dakota pipeline protest

in 2D, 3D, and anaglyph (blue and red filtered sunglasses) 720 degree versions. *The New York Times* was one of the first media entities to use virtual reality technology with a smartphone app to immerse viewers into news stories. In *The New York Times'* 11-minute film, "The Displaced" (2017), three children from South Sudan, the Ukraine, and Lebanon are "driven from their homes by war." The experience of riding a bicycle from the perspective of a child is exhilarating and emotionally connecting. Rawls' empathic philosophy, the veil of ignorance, is again evoked.

On the academic side, university programs have collaborated with VR startups and news organizations to train a new generation of immersive storytellers. From assignments offered within traditional photojournalism classes such as at the University of Texas at Dallas to entire courses concentrated on AR and VR production such as those offered at Syracuse University, students learn to use the technology to engage viewers as never before. As universities offer more immersive storytelling courses and deliver their graduates to industry innovators, additional uses for MR and VR will be discovered with users demanding more. In the end, it will be up to consumers to decide whether MR, VR, or a hybrid will ultimately be the favored platform for immersive storytelling.

However, the current interest by members of the academic and journalism professions to produce news-oriented VR programs would have been delayed several years if not for the efforts by an innovator dubbed the "Godmother of VR," Nonny de la Peña. As a former *Newsweek* reporter, de la Peña combined her journalism skills, interested in engaging technology, and dynamic personality while at the USC School of Cinematic Arts to produce some of the first animated VR programs based on actual events. Some of the presentations produced include "Hunger in LA," a short film that includes a man who has a diabetic seizure while he waits in a food line, a recreation of the 2012 Trayvon Martin shooting by George Zimmerman, "Project Syria," that puts viewers into an Aleppo street scene, and "Across the Line," an app that communicates the perspective of a woman seeking an abortion. de la Peña heads the Emblematic Group (2017), a VR production company she started. Palmer Luckey was one of her interns. Hello?

Whether you replay her 2015 TED talk, "The Future of News? Virtual Reality" or are lucky enough to see her in person, Nonny de la Peña inspires immersive media like no other advocate ("The future of news," 2015). She plainly states that VR "Creates a real sense of being present on the scene. It puts the audience in a place where they can experience the sights, sounds and even emotions as events unfold. This is unlike any other medium."

The fact that VR is unlike any other medium might help explain the fact that you have read about 2,500 words explaining what it is. Such a background with examples is not necessary for photography, motion pictures, television, and the web. So, with a better understanding of what immersive storytelling is, attention can now be drawn to the real point of this chapter and this book – what should be the ethical procedures for using this technology?

An obvious hint can be found in de la Peña's quotation about VR. Yes, you experience the sights. And yes, you experience the sounds. But more significantly, you experience emotions. For example, she reports that users of one of her avatar-based head-mounted display movies, "Hunger in LA" left some weeping because they were moved by what they experienced and were powerless to actually help the situation. Passiveness can be extremely upsetting for many users familiar with interactive gaming systems and the control that is possible.

In the 2014 documentary *Life Itself* about the influence of *Chicago Sun-Times* cinema critic Roger Ebert, he famously said that film is a machine that generates empathy. If that is true, and I have no reason to doubt the concept that John Rawls would have no doubt supported, then a VR system in which the user has the illusion of actually being surrounded by the persons and events that compose a news story or social problem, is a machine that generates

empathy on crack. In other words, being surprised how a machine can make you care is powerful and should be carefully considered by creators. We all have been raised differently with a staggering variety of experiences that make each one of us unique. Some can handle intense VR experiences while others get nauseous and alarmed by the powerful visual messages.

Ethical Considerations

One of the first to write about the ethics of VR was Tom Kent (2015), the Standards Editor for the Associated Press and an instructor at Columbia University. In his article, "An Ethical Reality Check for Virtual Reality Journalism" published in 2015 in the online publication, Medium, Kent lists several factors for maintaining ethical standards. His primary basis that starts a discussion about VR ethics is that "Viewers need to know how VR producers expect their work to be perceived, what's been done to guarantee authenticity and what part of a production may be, frankly, supposition." The role-related responsibility of a VR producer should be to communicate full disclosure to a user about any potentially upsetting content. That duty is at the center of ethical VR production. This need for an honest admission of the nature and specifics of a presentation is unique to VR animations. The potential for harm is greater with VR than with traditional media. Vulnerable users may watch an intense experience that places them within a situation that triggers a suppressed memory. Imagine if there were visual reporters or citizen journalists with virtual reality cameras filming the aftermath of the terrorist bombing at an arena in Manchester, England in 2017. Watching the carnage though a head-mounted display might be too much to bare for most users.

There are also technical manipulations that are often employed by VR producers that are necessary to consider. For example, if cartoon avatars within a situation are based on still photographs and/or video as with the "Hunger in LA" presentation, and a user is allowed to walk around a scene, assumptions about the sides and backs of characters and objects need to be made by graphic artists since a 2D camera only recorded the event from one perspective. Tom Kent suggests that contrived graphic images remain out of focus with a note to users at the start of a program to inform them of the meaning of this technical contrivance.

Another challenge is the one-sided nature of news coverage. Should a VR package only show one view of a news event or should the user be allowed to see multiple angles and perspectives of a controversial story? Kent thinks users should be given the choice of several angles from different witnesses. However, this recommendation is a technical challenge during a spot news event, but perhaps necessary given the nature of the enhanced realism available by the technology.

Within a virtual world with a pair of goggles tightly strapped on your head and all traces of reality eliminated, it is perhaps easy to feel a part of a scene shown through high definition images and combined with the sounds associated with a story. However, whatever a user experiences is actually contrived by the creator of the piece and is a tightly controlled program. Consequently, there are details easily missed as you experience a new environment. Also, because the film is based on real events, some facts will not be shown. Once again, full disclosure is a solution. Users should be given all of the information related to an event before the headsets are mounted, sound clues or graphic symbols to make them aware of significant directions to view a scene, and as choices within a program, additional photographs, text, and videos provided to give a more complete understanding.

Kathleen Culver (2015), an associate professor for the University of Wisconsin-Madison School of Journalism and Mass Communication and associate director of the Center for Journalism Ethics is concerned about privacy and intellectual property issues when avatars and objects look too much like the real thing – a common criticism of Nonny de la Peña's

productions. Culver is also troubled about gruesome and frightening content that may have long-lasting effects on users. Feeling empathy toward users of VR devices is why de la Peña warns her viewers that the content may be upsetting. As Culver notes,

> The most important thing that we need to keep in mind with immersive and experiential media is that because people feel like they're somewhere else, you always need to keep the experience of the user as the most important ethical consideration.

Margaret Sullivan (2015), public editor of *The New York Times* wrote about VR ethics after her newspaper made "The Displaced" available with Google cardboard goggles. She reports one user's reaction as

> Five seconds into the film, I was struck by the immediacy – and the intimacy – of the images. These aren't computer-generated faces and landscapes; they're real people in real places, and I felt like I was standing there myself, not just observing from afar.

Once again, the realness of a VR experience is a response seldom felt with motion pictures, television, and the web regardless of how large a screen or with 3D glasses. The immediacy and the surrounding nature of the medium enhance the illusion of truth and not the suspension of disbelief. Therefore, creators, as never before, should be aware of empathic responses from users and the need to be as real as possible within the unreal world of virtual reality.

Traditional visual reporters often voice a common concern – will AR and VR immersive stories be considered on a par with video games? Will news reporting be turned into a superficial form of entertainment that excites the eyes but adds little to long-term understanding of an issue? No doubt early adopters of news oriented stereocards, 3D photographs viewed with a stereoscope during the turn of the previous century were equally educated and fascinated by scenes of devastation of the 1906 San Francisco earthquake and other significant events. Likewise, newsreel films shown in movie theaters, multi-page picture stories printed in *Life* magazine or in a reader's local newspaper, and motion picture, television, and cable channel documentaries have no doubt pleased and prodded patrons of these presentations. Entertainment has always been a part and a concern for the journalism profession. It seems certain that AR and VR will amplify the discussion. That's a good thing.

The major take-away for this chapter should be that immersive media are no longer in the fad stage of development but are fast becoming established mainstream methods of presentation for persuasive, entertainment, and journalism endeavors. As such, the rules for ethical behavior, although inspired from traditional news values, loyalties, and procedures, have yet to be written in full. Hopefully, you will be part of a team of communicators responsible for codifying the ethics of this powerful and little understood technology.

Case Studies

Case Study One

One of the most common, and most invisible, injuries soldiers face when they return from war is post-traumatic stress disorder, or PTSD. It is especially likely to strike individuals who witness symptoms include nightmares, insomnia, and feelings of isolation, irritability, and guilt. Individuals who witness sudden and unexpected traumatic events are, including those

that happen on battlefields, especially prone to developing PTSD. The condition is hard to treat, and even harder to get rid of. For soldiers with PTSD, it can be even harder because many believe that admitting they need help, counseling, or psychiatric intervention are signs of weakness.

In recent years, however, researchers have begun to use virtual reality (VR) technology to treat PTSD. Now, soldiers can safely re-expose themselves to their trauma, in order to re-live their memories and slowly discharge them of their power. The goal is to allow those who are struggling with the condition to find a way through it, rather than hiding it away because of stigma. The RAND Corporation, a global policy think tank, estimates that nearly half of all veterans with PTSD resist getting help, and that the military doesn't do enough to try to change this.

"How virtual reality is helping heal soldiers with PTSD." (April 3, 2017). NBC News. Accessed June 30, 2017 from https://www.nbcnews.com/mach/innovation/how-virtual-rea lity-helping-heal-soldiers-ptsd-n733816.

See Appendix B for the 10-Step Systematic Ethical Analysis Form.

Case Study Two

The chance to try VR is getting less expensive all the time, and so making it possible for journalists to make it a part of their story. With the advent of Google Cardboard, for example, individuals can get VR goggles for just a few dollars online or at their local drugstore. With this in mind, in 2016 *The Guardian* created a VR story called 6×9. The point of the story was to let viewers get a sense of what it felt like to be in prison, in solitary confinement, in a cell that was six feet wide by nine feet long. The hope was that those who took the time to look, would experience a sense of empathy that went beyond what is possible in more traditional media formats.

But this raises the question as to how much more advanced VR will have to get before this is really the case. As it is, one can look for a moment and see into the cell, maybe feel its presence for a moment, but then escape. Certainly, this is "virtual," but it is not "reality."

"How virtual reality is bringing journalism to life." (April 5, 2017). Media Update. Accessed June 30, 2017 from https://www.mediaupdate.co.za/media/133189/how-virtual-reality-is-bringing-journalism-to-life.

See Appendix B for the 10-Step Systematic Ethical Analysis Form.

Case Study Three

When it comes to VR, one thing many people worry about is the problem of moral panic. Moral panic happens when an idea of fear spreads through a society – a notion, for example, that something should be avoided because it is wrong. So, when it comes to VR, proponents worry that it will get a bad reputation because people will use it improperly – to have lifelike experiences sleeping with hookers, robbing banks, or engaging in mass shootings. If this happens, people will begin to see VR as a threat to society, rather than as something good, and so try to outlaw it. Then, a tool that could have led to solving complex and difficult problems will be lost. In response, VR proponents encourage developers to take a proactive approach that includes encouraging journalists to write stories about the possible good VR can do, alongside provocative stories about potential harms.

Scott, C. (April 5, 2017). "Why moral panic could be detrimental to the virtual reality industry." Journalism. Accessed June 30, 2017 from https://www.journalism.co.uk/news/why-publishers-of-virtual-reality-need-to-be-aware-of-moral-panic/s2/a702215/.

See Appendix B for the 10-Step Systematic Ethical Analysis Form.

Annotated Sources

de la Pena, N. et al. (2010). "Immersive journalism: Immersive virtual reality for the first-person experience of news." *Presence, 19*(4), 291–301.

This paper explores the new idea of virtual reality journalism where the audience can go inside a virtually reconstructed story to gain a first-person view of the details. It explores the ethics of virtual reality journalism and the current state of the technology, as well as the theoretical details backing up this concept. The authors argue virtual reality journalism offers a profound new way to understand the news and a new way to experience it.

Lorenzini, C. et al. (2015). "A Virtual Laboratory: An immersive VR experience to spread ancient libraries heritage." *Digital Heritage, 2*, 639–642.

To bring the resources of a library to the public, these researchers utilized immersive virtual reality in the form of a video game. The game was one where players did medical distillation in a medieval alchemy lab. This article outlines the tests of the game and the improvements made to make the game more appealing and fun for users. It details a new form of knowledge transmission through virtual reality that can be used with more traditional forms of learning environments, like museums.

Lugrin, J. et al. (2010). "Exploring the usability of immersive interactive storytelling." VRST '10: *Proceedings of the 17th ACM Symposium on Virtual Reality Software and Technology.* November.

The authors explore the feasibility of storytelling through virtual reality. They found that users could engage with their immersive narrative and were just as successful in completing the virtual reality narrative as they were with the traditional video game style narrative.

References

Bhutto, H. (May 7, 2012). "Google Glasses project." YouTube. Accessed June 30, 2017 from https://www.youtube.com/watch?v=JSnB06um5r4.

Buckley, S. (August 29, 2016). "'Dead or alive' VR is basically sexual assault, the game." Engadget. Accessed June 30, 2017 from https://www.engadget.com/2016/08/29/dead-or-alive-vr-is-basically-sexual-assault-the-game/.

Culver, K.B. (February 11, 2015). "Virtual journalism: Immersive approaches pose new questions." Center for Journalism Ethics. Accessed June 30, 2017 from https://ethics.journalism.wisc.edu/category/virtual-reality/.

"The Displaced." (2017). *The New York Times.* Accessed June 30, 2017 from https://www.nytimes.com/video/magazine/100000005005806/the-displaced.html.

"Emblematic Group website." (2017). Accessed June 30, 2017 from http://emblematicgroup.com/.

"Esquire's augmented reality issue: A tour." (March 27, 2012). YouTube. Accessed June 30, 2017 from https://www.youtube.com/watch?v=LGwHQwgBzSI.

"Feminist Frequency website." (2017). Accessed June 30, 2017 from https://feministfrequency.com/.

"The Future of news? Virtual reality." (May 2015). TED. Accessed June 30, 2017 from https://www.ted.com/talks/nonny_de_la_pena_the_future_of_news_virtual_reality.

Gutelle, S. (January 23, 2015). "Spike Jonze directs Vice's first ever virtual reality feature." Tube Filter. Accessed June 30, 2017 from http://www.tubefilter.com/2015/01/23/vice-news-vr-millions-march-spike-jonze/.

"Harvest of Change." (n.d.). *Des Moines Register.* Accessed June 30, 2017 from http://www.desmoines register.com/pages/interactives/harvest-of-change/.

Hathaway, J. (October 10, 2014). "What is Gamergate, and why? An explainer for non-geeks." Gawker. Accessed June 30, 2017 from http://gawker.com/what-is-gamergate-and-why-an-expla iner-for-non-geeks-1642909080.

"HTC Vive website." (2017). Accessed June 30, 2017 from https://www.vive.com/us/.

Kent, T. (August 31, 2015). "An ethical reality check for virtual reality journalism." Medium. Accessed June 30, 2017 from https://medium.com/@tjrkent/an-ethical-reality-check-for-virtual-reality-journalism-8e5230673507.

Mackie, J. (July 21, 2016). "Microsoft HoloLens review, mind blowing augmented reality!" Accessed June 30, 2017 from https://www.youtube.com/watch?v=ihKUoZxNClA.

"Oculus Rift website." (2017). Accessed June 30, 2017 from https://www.oculus.com/rift/.

Richmond, T. (2017). "Mixed reality." USC Institute for Creative Technologies. Accessed June 30, 2017 from http://ict.usc.edu/groups/mixed-reality/.

Stam, A. (October 30, 2016). "The world's first augmented reality photobook." Huck. Accessed June 30, 2017 from http://www.huckmagazine.com/art-and-culture/photography-2/worlds-first-augm ented-reality-photobook/.

Sullivan, M. (November 14, 2015). "The tricky terrain of virtual reality." *The New York Times.* Accessed June 30, 2017 from https://www.nytimes.com/2015/11/15/public-editor/new-york-times-virtua l-reality-margaret-sullivan-public-editor.html?_r=0.

Vincent, J. (May 5, 2017). "Palmer Luckey returns to public life sporting a new goatee." The Verge. Accessed June 30, 2017 from http://www.huckmagazine.com/art-and-culture/photography-2/ worlds-first-augmented-reality-photobook/.

"Welcome to the museum of the history of science." (2017). Museum of the History of Science. Accessed June 30, 2017 from http://www.mhs.ox.ac.uk/.

Westervelt, A. (June 22, 2016). "Will virtual reality be just another way to objectify women?" *Elle.* Accessed June 30, 2017 from http://www.elle.com/culture/a37146/will-virtual-reality-just-be-a nother-way-to-objectify-women/.

10

SOCIAL MEDIA

As opposed to my LinkedIn and Twitter accounts in which I accept all connections and followers, I have a cap on the number of "friends" I admit into my Facebook world – 100. Admittedly, it is an arbitrary number, but it allows me to make sure that whatever I share on the Book of Face gets to persons I know and trust. Those with thousands of friends astonish me. I find it difficult enough to keep track of the 100. Of course, if I ever took a picture, recorded a video, or wrote a comment that I want the social media world and not just my friends to know, I might consider using the status update menu choice of "Public" so that "anyone on or off Facebook" can see the post.

It is that simple act of clicking and sharing – to your friends and the world – that makes social media unique among other forms of communication that dates from when Sumerian scribes thousands of years ago pressed carefully conceived marks into moist clay. It is doubtful if more than five individuals saw a cuneiform account of a rich person's inventory of beer – one of the most common reports preserved through the millennia. Jump ahead to today and the mass distribution of messages by anyone with a smartphone, computer, a wifi connection (I'm currently writing this at a local Starbucks), and a free social media account has the unmistakable power to shape public opinions, affect business markets, and alter social customs and cultures. You might even be able to sway a presidential election with entries that contain alternative facts or fake news. Naaaaa. That could never happen.

However, are social media really new? Technologies have often been employed to promote political messages directly to the public by circumventing the usual mass communication media elite. In 1517, only about 70 years after Johannes Gutenberg's invention of the commercial printing press, Martin Luther supposedly hammered printed flyers on the wooden doors of religious institutions. He condemned the Church's pay-to-play practice of indulgences so that the wealthy could pay to enter Heaven despite their earthly sins. Ironically, it was the printing of indulgences using a moveable type press that paid for the construction and elaborate lifestyles of church officials. Despite Luther's efforts, it wasn't until 1967 when Pope Paul VI reformed the indulgence system ("How Luther went viral," 2011).

Viewed as an entertainment medium since its modern introduction within a Parisian theatre by Auguste and Louis Lumière in 1895, motion pictures were not thought of as persuasive tools until years later. As Secretary of Commerce in the 1920s Herbert Hoover was universally praised for bringing relief to victims after the devastating Mississippi River

flood of 1927 in which an area the size of South Carolina was destroyed by the rising water. After President Calvin Coolidge declined to run for a second term, Hoover, largely on the strength of his positive, mainstream media publicity decided he would aim for the position. His campaign for president was called "the first modern presidential race" as the relatively new medium of motion pictures was employed for the first time to promote a candidate. One 43-minute silent film, *Herbert Hoover: Master of Emergencies* (2014), was "played in communities across [the] country to remind voters of all that Hoover had done to make life better for those in need." The documentary, considered the first campaign film in U.S. history, featured Hoover's efforts to bring relief to the flood victims. Consequently, he handily defeated the Democratic candidate Al Smith by a landslide 58.2 percent of the popular vote and achieved 357 electoral votes more than Smith. However, his approval rating was short-lived. After America plunged in 1929 into the Great Depression and press reports correctly categorized him as an aloof and clueless leader, his reputation was forever sullied (Lester, 2009).

After the first American radio station, KDKA in Pittsburgh, Pennsylvania began its broadcasts in 1920, President Franklin Roosevelt in 1933 bypassed politicized newspapers largely owned by his opponents who controlled the slant of news stories and published critical editorial columns to speak directly through the radio medium to the American public in 30 occasional "fireside chats" ("The Fireside Chats," 2017). With his plain language and calm speaking style, Roosevelt convinced listeners that his controversial policies were best for the nation despite what they read in the Press with its biased reporting and fake news. Sound familiar? The Preservation Board of the Library of Congress noted that the recordings were "an influential series of radio broadcasts in which Roosevelt utilized the media to present his programs and ideas directly to the public and thereby redefined the relationship between the President and the American people."

Although the ability to send crude facsimile or "fax" messages predates telephone technology, it wasn't until the Xerox Corporation in 1964 introduced telephone-based fax machines that the communication device started to become commercially viable. About 20 years later, computer-based fax networks allowed internet-based connections for mass broadcasts, often known as "junk faxes" with the content the same as sales flyers left on a front door. However, politically savvy fax users also realized that substantial messages could be sent and received around the world. By 1989 the technology had advanced far enough so that student organizers used fax machines to communicate China's anti-democratic policies and gathering times for protests. The futurist David Houle (2009) notes that

> In offices near Tiananmen Square and in universities there were fax machines. Demonstrators used the technology to get the word out to the world. Much more importantly, the world responded, sending faxes by the hundreds, letting the demonstrators know that the whole world was watching.

As the Chinese government controlled traditional broadcast and print outlets, leaders failed to realize the impact of an analog print sending device connected to a landline telephone combined with activists who understood the power of crowdsourcing.

Another technology used to circumvent traditional media outlets was email. After World War II, a political "Cold War" between the United States and the Union of Soviet Socialist Republics commenced. Its most terrifying moment was the Cuban missile crisis of 1962 when it was discovered that the Soviet Union was storing nuclear weapons on the island nation 90 miles from Key West, Florida. Concerned that there might be a nuclear war in which major cities would be destroyed, the U.S. military started to consider alternative

communication methods ("The invention of the internet," 2017). With the help of the RAND Corporation, a governmental think tank, the Defense Department's Advanced Research Projects Agency (ARPA) started to discuss a communications network via computers. In 1969 the first email message was sent between researchers at UCLA and the Stanford Research Institute in Palo Alto using a computer network called the ARPANET. Detailed at the beginning of Werner Herzog's 2016 documentary film *Lo and Behold Reveries of the Connected World* (2016), UCLA Computer Science Professor Leonard Kleinrock wanted to send the message, "login," but was only able to enter the first two letters before the system crashed.

During the 1970s, powerful IBM and other mainframe computers were popular at government, business, and university research sites around the world. With all the activity generated by these machines, scientists soon realized that they needed communications links among these centers so that computer operators could transfer data and talk with each other electronically. Consequently, more and more computer users started using the ARPANET for work-related and personal messages. By 1983, the system had become so popular that it was divided into two – the original ARPANET for university use and MILNET for the military. When satellite links were added to the system, international communication became possible. ARPANET's name was changed to the International Network, or the internet (Lester, 2017). By far the most popular feature provided by this early version of the internet was email. In 1986 Eric Thomas (2017), an engineering student at a university in Paris, created software that automatically subscribed and maintained users for an electronic mailing list known as a "listserv." Soon, politicians, academics, marketing agents, and others used listservs for large-scale messaging in order to spark discussions on almost any topic and to influence public opinion and policy separate from the usual media routes – a digital version of fax messages.

In 1990, two Tims, Berners-Lee and Cailliau used a NeXT computer while working for the European Laboratory for Particle Physics (CERN) in Geneva, Switzerland ("History of the web," 2017). They developed a computer language called Hypertext Transfer Protocol (HTTP) that created files that could be accessed from the internet. In 1991 HTTP was used for the first browser that Berners-Lee called the WorldWideWeb. By 1993, interest in the internet expanded tremendously because of what was called its killer app – the Mosaic software program. Marc Andreesson and Eric Bina developed the browser while students at the University of Illinois and made accessing and downloading internet files that contained still and moving pictures with audio as simple as clicking a computer's mouse.

Given the history of attempts at social communication through the technology available at the time, it can be argued that our use of social media is revolutionary, not evolutionary. The way we use this communication technology and the messages' effect on worldwide culture is a logarithmic leap. The fact that someone with a computer, an account, and an opinion can mass communicate an idea and influence hundreds of thousands of others can be looked at as a gift or burden makes social media an unexpected byproduct of the technological transformation known as the internet and the web.

The Web and Social Revolution

With the web came the revolution in communication, as profound and prolific as the one started in the fifteenth century by Gutenberg – social media. As an introduction to this part of the chapter it is important to parse the two words in the title. "Social" relates to an informal gathering of like-minded individuals who are part of a particular group with cultural participation that might include persons by class, education, gender, ethnicity, interest, race, politics, religion, and/or others. "Media," the plural form of a particular "medium," is also a common

word that relates to print, broadcast, and screen forms of mass communication – such as magazines, movies, newspapers, radio, television, and computers. With traditional media outlets, the cost in time and money that it takes to have a major influence over the public's mind is enormous and largely prohibitive. However, when the terms social and media are combined with the web, the concept of individuals within a discrete group based on a particular cultural topic can have an unexpected impact on the rest of society simply because the barriers of mass distribution of a message are lifted – almost anyone with web access, a computer, and an opinion can become a social media star. Even a former reality television personality with a Twitter account, a penchant toward self-aggrandizing, and a habit of waking early in the morning pissed at his critics can upset the world's daily news cycle.

Many credit social media for propagating political information, demonstration times, and news reports about the Arab Spring democratic movement. Beginning in Tunisia in 2010, revolutionary spirit spread to several Maghreb and Middle East countries. Often dubbed the Twitter or Facebook Revolution because of the extensive use of those platforms to get the word out to supporters, other popular communications technologies available on smartphones, emails, and YouTube videos connected followers as well. Live television coverage by Al Jazeera and other networks of the large gathering and violence in Tahrir Square in Cairo and the Taksim Gezi Park in Istanbul also helped to inspire protesters. However, popular author Malcolm Gladwell discounted social media's role in these rebellions. He argued that a platform like Facebook is a low risk form of activism that allows users to voice their support without actually getting directly involved. In addition, instead of a top-down hierarchical process, social media spread messages laterally without a clear leader or method for achieving consensus when decisions were needed. As proof, as soon as there was a military crack-down on the protesters, the movement lost steam (Stepanova, 2011).

Nevertheless, as showed by the 2016 Black Lives Matter protests, the 2017 Women's Marches in Washington, DC and throughout the world, as well as demonstrations at several airports in response to President Trump's controversial executive order on Muslim immigration, the role of social media in organizing such public protests should not be denied or discounted.

The Rise of Fake News

Social media staples such as texting to friends, sharing pithy observations, updating a status, uploading a picture, and so on is almost always noncontroversial and ethical. Unfortunately, the 2016 presidential campaign demonstrated how fabricated posts easily manipulate the media and the public with President Trump repeatedly labeling traditional news sources, without evidence, as phony. However, many news reports *were* fabricated. Fake news accounts from some social media websites were comprised of fictionalized accounts and contained invented quotations, digitally altered photographs and video, and presented within a graphics layout made to appear credible. For hedonistic, attention-getting, and non-satiric purposes, these politically motivated producers created "news" in order to sway public opinion. What would motivate someone to go to the trouble to create a constant stream of fictitious stories? NPR reporter Laura Sydell tracked down a prolific fake news writer. He turned out to be Jestin Coler, a liberal Democrat from California (Pollak, 2016). Coler explained,

> The whole idea from the start was to build a site that could infiltrate the echo chambers of the alt-right, publish blatantly false or fictional stories, and then be able to publicly denounce those stories and point out the fact that they were fiction.

To be clear, fake news whether from established journalism entities or from the mind of an entrepreneur-minded blogster is wrong.

Picture and caption manipulations have a long history of contributing to the fake news genre. A 1928 campaign picture of Herbert Hoover and his running mate was faked because Hoover refused to pose with the vice-presidential candidate, Charles Curtis. *Life* magazine revealed a composite photograph, produced by a rival politician, of a Maryland Democrat running for office that looked like he was chatting with a Communist leader. The image was actually the result of two separate photographs. The image was widely distributed among the electorate. The Democrat lost the election. Truth was again a victim during a famous case of a man stuck in a cavern. Floyd Collins was a man who wanted to build his own amusement park ("The Floyd Collins tragedy," n.d.). In 1925, he became trapped while exploring Sand Cave a few miles from the famous, Mammoth Cave in rural Kentucky. For 17 days, rescue workers attempted to free Collins, but without success. He died from starvation. Fifty reporters on the scene turned Collins into a national martyr. More than 20,000 people from 16 states jammed into the area after reading the newspaper articles. In the 1951 movie originally titled, *Ace in the Hole*, subsequently changed to *The Big Carnival*, director Billy Wilder critically presented the side-show atmosphere surrounding the hole in the ground. Competition was intense among journalists on the scene to get interviews and pictures no other newspaper had. William Eckenberg, a photographer for *The New York Times*, learned that a farmer had a picture of Collins taken ten days earlier while inside another cave. Eckenberg found the picture, made a copy and sent it to New York. Many papers across the country used the picture. Fake news.

But what if the photograph or message I want to send to the world is not accurate, misleading, or worse, a known lie? How do ethical communicators respond to such behavior? Recent examples do not offer much consolation that this issue is easily resolved. Nevertheless, the correct ethical response to an unethical action is one of the most interesting aspects about studying ethics – what individual cultures and whole societies judge as positive or negative changes throughout time and because of technological innovations. In our attention culture sparked by the widespread use of smartphones with alerts that impel us to check compulsively our collection of social media apps, the fact that the image or story is true or false is less important than it gets us to view a page with advertisements.

We tend to forgive faked news images and stories if the purpose is largely for entertainment. One of the most infamous hoaxes was Orson Welles' "War of the Worlds" 1938 radio broadcast in which thousands of listeners believed Martians had landed in New Jersey ("Welles scares nation," 2017). The deception was enhanced by the use of reporting techniques popular at the time that were used to convince a naïve public of the veracity of the show. Although criticized, Welles apologized and was soon hired to direct one of the most acclaimed motion pictures in history – *Citizen Kane*. Another example are April Fool photographic fakes that were popular in many city and college newspapers. Curtis MacDougall (1958) in his book, *Hoaxes*, detailed several instances where newspapers published such images as giant sea creatures, Viking ships, and a man supposedly flying by his own lung power. The Reading, Pennsylvania *Eagle-Times* used double printing techniques to show the Concorde SST aircraft landing at the Reading airport, an oil tanker cruising down the Schuylkill River, and two children playing with a giant wishbone from a 750-pound turkey. And if you're of a certain age, you remember staying up late listening to radio programs that featured aural ("Number Nine" backwards) and visual evidence (the cover art for the album "Abbey Road") that the Beatles' Paul McCartney had died in a car crash (Yoakum, 2000). Eerie. If we didn't enjoy being fooled now and then, there wouldn't be novels, plays, movies, and television.

But some producers of website content have other motives than simply spreading joy. The McCartney death hoax is listed by *Time* magazine as one of the "world's most enduring conspiracy theories." The other nine mentioned on the website are the JFK assassination, the 9/11 cover-up, Area 51 and the aliens, secret societies that control the world, the moon landings, Jesus and Mary Magdalene, Holocaust revisionism, the CIA and AIDS, and the reptilian elite (this last one has to be true) ("Conspiracy theories," 2016). Other unproven theories include such diverse topics as water fluoridation, genetically modified crops, vaccines, and climate change. With sophisticated, graphically-rich websites, evidence in the form of still and moving images, testimonials from seemingly knowledgeable and credible experts, conspiracy bloggers have taken a page from Orson Welles' playbook – if the presentation seems authentic, it will be perceived as true ("The Conspiracy Blog," 2017). Propagators of these theories count on the fact that most users don't have the time to conduct the research in order to know for sure if the information found on the web is fact or fiction.

Conspiracy theories aside, instances of phony news reaching the social media mainstream are far too common and have become normative. One of the most egregious examples occurred in 2016. As Jodi Jacobson (2016) reported in Rewire, an online publication,

> During the [presidential] election, sites like True Pundit, State of the Nation, and the New Nationalist were responsible for creating vicious conspiracy theories, and releasing them to be picked up and amplified on Twitter, Facebook, Reddit, and other channels by the countless followers of these and other shadowy sites.

But which is worse: Creating a false account or passing it along?

A fictionalized story from True Pundit caught the attention of the traditional news media after the content was retweeted by retired Lt. General Michael Flynn, the first national security advisor for President Trump. Flynn resigned his position after it was discovered he misrepresented the subject of a telephone conversation with Russian Ambassador Sergey Kislyak to Vice President Pence. Nevertheless, Flynn's tweet content read:

> U decide – NYPD Blows Whistle on New Hillary Emails: Money Laundering, Sex Crimes w Children, etc… MUST READ! https://t.co/O0bVJT3QDr
> *(General Flynn (@GenFlynn) November 3, 2016)*

The weblink takes you to the True Pundit fake news site that details sexual allegations against Bill and Hillary Clinton supposedly being investigated by police officials. About a month later Edgar Welch armed with a loaded assault rifle, inspired by the phony information, entered Comet Ping Pong, a Washington DC pizza restaurant and fired shots in order, he thought, to save children that were inside and used as Hillary sex slaves. Luckily no one was hurt and he was arrested and later convicted and sentenced to four years in prison. Nevertheless, this incident should act as a cautionary tale about fake news accounts – there are many who read stories on blogs and retweeted on Twitter that believe the reports must be true because they fit their view of the world.

For visual communicators, fake news should be a major concern because images are often used to support biased and untrue views. Laura Mallonee (2016) writing for *Wired* magazine details several examples of photographic content manipulated by the words associated with them. During the 2016 presidential campaign, an image of tour buses in Austin shows that Democrats brought in protesters to a Trump rally in a fake Tweet while a picture of Hillary Clinton slipping on steps becomes evidence of her failing health in a Breitbart blog account. Months after the election Clinton revealed that one of the main reasons she lost was because of fake stories shared through Facebook that were provided by the Russian government in

collusion with Americans ("Hillary Clinton says," 2017). "The other side was using content," she said in a speech, "that was just flat-out false and delivering it in a very personalized way." Co-founder and CEO of Facebook, Mark Zuckerberg, in a story published in *The Telegraph* newspaper noted that he thought it was "'crazy' to think that fake news on the site had influenced the election in any way."

Full-frame and non-manipulated photographs should be considered ethically neutral if they are the product of a camera controlled by a visual reporter aware of her inherent biases. Cameras do not care what is recorded by their technology. However, it is the words associated with them through captions, articles, and the stories we make up about them in our minds that cause ethical dilemmas. Editors, reporters, social media managers, and readers should be more vigilant in their fact-checking skills so that fake news and "alternative facts" are exposed for what they are – lies. As a member of the general public one of the best sources to discover the truth about questionable stories and images is Snopes (2017). Known as the "Urban Legends Reference Pages," the website identifies facts from fiction in news accounts and popular myths as it debunks rumors and fake news reports. Begun in 1995 by David and Barbara Mikkelson and named after characters in William Faulkner stories, Snopes receives an estimated eight million visitors a month.

President Donald Trump's fascination with Twitter is well documented as he communicates to the public and sidesteps traditional media outlets to offer his opinions, often critical, of events and individuals during the 2016 campaign and throughout his reign ("Donald J. Trump," 2017). Many journalists decried his 140-character missives as uninformed at best and outright lies at worse. In 2017 bipartisan criticism was leveled against Trump for his personal attacks directed at MSNBC journalists ("Mika Brzezinski," 2017). To help readers who may question the veracity of Trump's farumps, *The Washington Post* created an add-on for web browsers called "RealDonaldContext" that "Adds context to Trump's not-quite-accurate tweets."

Other notable examples of fake news include Pope Francis' endorsement of candidate Trump, Hillary Clinton sold arms to ISIS terrorists, Queen Elizabeth invited President Trump to Buckingham Palace, and Trump's threat to deport *Hamilton* creator Lin-Manuel Miranda to Puerto Rico. Journalists sometimes make mistakes. That's why one of the most entertaining parts of a newspaper is the "Corrections" section. But making, admitting, and correcting an honest error and creating a false story in the hope of gaining eyeballs or hits to a blog to help sway an election are two fundamentally different actions. Unfortunately, as consumers of the media learn to use online tools so only stories that support a particular political stance are displayed, fact and fiction become inconsequential distinctions. For many, though, nothing the media reports is now trusted.

An editorial in *The Dallas Morning News* included a 5-point checklist that should be used to resist fake news items ("Tips for telling truth," 2016). According to the Texas journalists, before you share a juicy Tweet:

1. Make sure the source is credible,
2. Use snopes.com or politifact.com to check the facts,
3. Question if the information seems too unusual to be true,
4. Seek new sites for news, but always question their veracity, and
5. Conduct a critical analysis of every news story you read.

Concerns with Public Commentary

Unfortunately, fake news is not the only concern of social media. Examples of poor etiquette, unethical behavior, and illegal activities are almost the norm whenever users evoke a

hedonistic rather than a utilitarian, veil of ignorance, golden rule, or golden mean philosophy. When personal, economic, and/or political motivations dictate the content and tone of a message, intimidation and violent acts dominate critical discussions of the media.

Text messages have been known to cause harm and even death to others (O'Hara, 2017). Upset over the way journalist Kurt Eichenwald covered stories, ex-marine John Rivello sent a tweet that included a pulsating, epilepsy-inducing image that induced a seizure in Eichenwald. In 2017 a Texas grand jury labeled the GIF picture as a "deadly weapon" and indicted Rivello. Also in 2017 a Massachusetts judge found Michelle Carter guilty of involuntary manslaughter after text messages she sent to her former boyfriend convinced him to commit suicide. She was sentenced to 2.5 years in prison (Sanchez and Lance, 2017).

Since the early days of the web, media entities, in an effort to attract users to their online sites, provided ways for readers to express their comments about a particular story or topic. This noble and utilitarian feature was produced with good, yet naïve intentions. Many editors eventually shut down the service after comments and images from anonymous posters turned hateful. For example, many view the hard-hitting, investigative reporting online and television news service Vice (2017) as an example of the future of journalism. And yet editor-in-chief Jonathan Smith (2016) decided to remove the comment section from online stories because of their divisive content. "Too often they devolve into racist, misogynistic maelstroms," Smith admits, "where the loudest, most offensive, and stupidest opinions get pushed to the top and the more reasoned responses [are] drowned out in the noise." Perhaps a solution to bad behavior is to prevent it from happening, and yet such a drastic action seems antithetical to a philosophy that embraces a free exchange of opinions no matter how uninformed or cruel. A golden mean or middle way compromise might include a restriction in which commentators and image uploaders must employ their actual names. The vetting of user accounts to assure compliance is possible with advances in security software. Knowing that an inflammatory comment or image, whether still or moving can be traced to its source would be an incentive, perhaps, to play nice. And then I woke up.

One reaction to the darkest corners of social media is akin to the mood expressed by the shaky camera and black and white footage of a young camper trying to protect himself from an evil force by facing a rock wall in the penultimate scene of the 1999 horror film *The Blair Witch Project*. However, as a way to avoid controversial content, many view such a strategy as ineffective and simplistic. The list and description of all the gruesome images available through social media could fill several chapters in this book. Photographs of celebrity autopsies such as Kurt Cobain, suicide victims as with a close-up of Robin Williams' distorted face, a gruesome car accident victim described in Werner Herzog's *Lo and Behold*, and despicable videos that show beheadings, immolation, and torture are easily found on social media sites with a few well-chosen keywords. In fact, try this yourself. Type "beheadings, immolation, and torture" in Google and you will have the opportunity, as of this writing, to see more than 450,000 entries with the first four intriguing topics as "Islamic State Burns 4 Captives Alive," "Beheadings, Torture, Machine Gun Deaths," "Beheadings and Torture as Fresh Riots Break Out in Brazilian Prison," and "Afghan Woman's Beheading Latest in Alarming Trend."

But hey, it's the world we have inherited and inhabit. If you want to see the worst behavior humanity has to offer, be my guest. However, the ethical dilemma comes when the images show up without a warning about their content. Twitter offers a blanket warning for all who have an account: Beside the restriction that users "may not use pornographic or excessively violent media in your profile image or header image," anyone can post "inflammatory content" as long as the "graphic content" is marked as "sensitive media."

Furthermore, "When content crosses the line into gratuitous images of death, Twitter may ask that you remove the content out of respect for the deceased." Therefore, Twitter may or may not ban content that a reasonable person may find upsetting. As a golden mean solution, Twitter advises that a user simply "block and ignore" the offensive account. For Facebook, the warning procedure is a little different. Although the social media site bans material "shared for sadistic pleasure or to celebrate or glorify violence," news and documentary videos that depict gruesome content are included with the sentences, "Videos that contain graphic content can shock, offend and upset. Are you sure you want to see this?" Although Facebook allows members as young as 13 years old, the content of these videos are restricted to those who have self-identified as being at least 18. However, psychologist Dr. Arthur Cassidy (2017) evokes a categorical imperative perspective as he advocates a total ban on such videos. He reasons that resourceful younger users will find ways to circumvent such restrictions and that the watching of such material "has the potential to influence maladaptive behavior in those who might have the potential to become aggressors themselves." As with an electric light shining on a moonless night, the moth is compelled to pursue its destructive behavior.

Social media were originally created so that the public could easily share personal stories, opinions, and pictures and (let's get real) as a mechanism for corporations to gain marketing information about consumers so as to better sell their products and services. And as with all communication media (Alexander Bell never thought that telephone callers could capture Pokémon characters while being placed on Hold), the initial conception has morphed into an uncontrollable, unregulated, and uncomfortable collection of raves, rants, and rudeness. What is a grown-up to do? Simple. Do not contribute or share examples of bad behavior. Do not create or share unsubstantiated and questionable alternative facts in the form of art or copy regardless if produced for parodic or political reasons. And do not keep silent if you are offended by someone else's post. Simple? Kant's categorical imperative is never an easy philosophy to follow. Perhaps another perspective is required. Use the golden rule philosophy and treat others, as you would like to be treated. Simple.

Case Studies

Case Study One

In the 2016 American presidential election, many commentators suggested that candidate Donald Trump broke all the rules. Among his many purported innovations was his use of Twitter to reach voters – by the time he was inaugurated, Trump had more than 20 million followers, and many of his most controversial tweets were spread and debated by the mainstream media, as well. But on closer inspection, his Twitter following might not have been as large as it seemed. Closer analysis reveals that many of his followers are actually bots, spam accounts, and other dead accounts that don't actually correspond to real people. (In fairness, all celebrity accounts acquire these kinds of zombie-like followers.) Many others came from overseas, and may or may not have been valid. Of course, any U.S. president would likely develop an international following, although Trump often bragged that his followers were all voters, something that would not be possible for non-Americans. In all, it seems that Trump really had more like 3 million U.S. Twitter followers – far more than most people, but nowhere near 20 million.

Salkowitz, R. (January 17, 2017). "Trump's 20 million Twitter followers get smaller under the microscope." *Forbes*. Accessed June 30, 2017 from https://www.forbes.com/sites/robsa

lkowitz/2017/01/17/trumps-20-million-twitter-followers-get-smaller-under-the-microscope/
#1bb124c64407.

See Appendix B for the 10-Step Systematic Ethical Analysis Form.

Case Study Two

When it comes to news, what's most important? Getting the story to readers as quickly as possible, or making sure readers only read the story written by your own journalists? That's quickly becoming the question facing newsrooms around the world. The problem is this: When one reporter gets a scoop or writes an interesting story, the first thing she or he usually does is send out a tweet about the headline. The fastest way to share the story is to retweet the news. But that means sending readers or viewers to the competition, potentially losing audience. Because of this, some publications have begun to tell their reporters and writers they can only tweet about their own stories, or stories that support their own media sources. This was the approach of Sky News in Great Britain, who told its journalists to stick to their own beat, and only share their own stories or those of other Sky reporters.

Cellan-Jones, R. (February 2012). "Tweeting the news." BBC News. Accessed June 30, 2017 from http://www.bbc.com/news/technology-16946279.

See Appendix B for the 10-Step Systematic Ethical Analysis Form.

Case Study Three

It's easy to think that everybody gets their news online these days. Turn on the TV and you're sure to hear news about Twitter, Facebook, Instagram and other forms of social media. But read that last sentence again. How did it start? "Turn on your TV ..." A 2016 study published by the Pew Research Center found that 57 percent of American adults said they "often" get news from television, while only 38 percent said they "often" get news online (25 percent said radio and 20 percent said newspapers). But look behind those numbers and the story gets a bit more complicated. Older adults are the ones watching TV for news: 72 percent of those between 50 and 72 years old said they watched television for news; moving up to 85 percent of those over 65. For those under between 18 and 49, it was only 50 percent. Still, 50 percent is a lot of people. It reveals that there remains, even with the rise of mobile platforms, a large number of individuals who like to watch the news.

Mitchell, A., Gottfried, J., Barthel, M., and Shearer, E. (July 7, 2016). "The modern news consumer." Pew Research Center. Accessed June 30, 2017 from http://www.journalism. org/2016/07/07/pathways-to-news/.

See Appendix B for the 10-Step Systematic Ethical Analysis Form.

Annotated Sources

Dwyer, A. (2013). "'Twethics': A brief analysis of Twitter ethics in public relations."
 Commpro. Accessed June 30, 2017 from https://www.commpro.biz/twethics-a-brief-ana
 lysis-of-twitter-ethics-in-public-relations/.

Dwyer looks at the ethics of Twitter, and divides users into four groups: the paid tweeter, the company tweeter, the out-of-context tweeter, and the ghost-tweeter. She goes into depth on each one of these sub categories, questioning the ethical implications of each type. She ends with a short discussion on the importance of transparency in tweeting.

Hille, S. and Bakker, P. (2014). "Engaging the social news user." *Journalism Practice, 8*(5), 563–572.

Journalists can interact easily with their readers through comments on their articles. This study analyzed comments left on 62 Dutch newspapers and compared the comments left on the newspapers' Facebook pages with the comments left on the newspaper's webpage. They found fewer comments on Facebook pages, but they hypothesize that the lack of anonymity on Facebook is responsible for the higher quality of comments left.

Paulussen, S. and Raymond, A.H. (2014). "Social media references in newspapers." *Journalism Practice, 8*(5), 542–551.

Modern journalists use social media sites in their news coverage, and this essay examines the relationship between journalists and social media. Through monitoring print editions of two Flemish newspapers, the authors monitored how often Facebook, Twitter or YouTube was either mentioned ore cited as a source. They found that the use of social media is common, but it is not the dominant source of information for journalists.

Thériault, A. (2015). "The dubious ethics of Twitter mining." *The Establishment.* Accessed June 30, 2017 from https://theestablishment.co/the-dubious-ethics-of-twitter-mining-ce13e56e9fcb.

This author argues against media outlets using individual's tweets to publish stories. The author argues this allows the outlet to make a profit off the work of others, and simultaneously gives the user a huge amount of visibility.

References

"The Conspiracy blog." (2017). Accessed June 30, 2017 from http://theconspiracyblog.com/.

"Conspiracy theories." (2016). *Time.* Accessed June 30, 2017 from http://content.time.com/time/specials/packages/completelist/0,29569,1860871,00.html.

"Donald J. Trump." (2017). Twitter. Accessed June 30, 2017 from https://twitter.com/realDonaldTrump?ref_src=twsrc%5Egoogle%7Ctwcamp%5Eserp%7Ctwgr%5Eauthor.

"Dr. Arthur Cassidy website." (2017). Accessed June 30, 2017 from http://www.drarthurcassidy.com/.

"Eric Thomas." (2017). L-Soft. Accessed June 30, 2017 from http://www.lsoft.com/corporate/eric thomas.asp.

"The Fireside Chats." (2017). History. Accessed June 30, 2017 from http://www.history.com/topics/fireside-chats.

"The Floyd Collins tragedy." (n.d.). Iconic Photos. Accessed June 30, 2017 from https://iconicphotos.org/tag/bill-eckenberg/.

"Herbert Hoover: Master of Emergencies." (April 24, 2014). The Herbert Hoover National Historic Site. Accessed June 30, 2017 from https://www.youtube.com/watch?v=Awk6VH54Lac.

"Hillary Clinton says Facebook 'must prevent fake news from creating a new reality.'" (June 1, 2017). *The Telegraph.* Accessed June 30, 2017 from http://www.telegraph.co.uk/technology/2017/05/31/hillary-clinton-says-facebook-must-prevent-fake-news-creating/.

"History of the web." (2017). World Wide Web Foundation. Accessed June 30, 2017 from http://webfoundation.org/about/vision/history-of-the-web/.

Houle, D. (June 3, 2009). "Tiananmen Square and technology." David Houle. Accessed June 30, 2017 from https://davidhoule.com/evolutionshift-blog/technology/cell-phones/2009/06/03/tiananmen-square-and-technology.

"How Luther went viral." (December 17, 2011). *The Economist.* Accessed June 30, 2017 from http://www.economist.com/node/21541719.

"The invention of the internet." (2017). History. Accessed June 30, 2017 from http://www.history. com/topics/inventions/invention-of-the-internet.

Jacobson, J. (December 4, 2016). "Gunman acts on conspiracy perpetuated by Trump National Security Adviser Michael Flynn." Rewire. Accessed June 30, 2017 from https://rewire.news/article/2016/ 12/04/gunman-acts-conspiracy-perpetuated-trump-adviser-michael-flynn/.

Lester, P.M. (2009). *On floods and photo ops: How Herbert Hoover and George W. Bush exploited catastrophes.* Jackson, MS: University Press of Mississippi.

Lester, P.M. (2017). *Visual communication images with messages,* 7th edition. Dallas, TX: WritingForTextbooks.

Lo and Behold Reveries of the Connected World – Official trailer. (June 1, 2016). Magnolia Pictures. Accessed June 30, 2017 from https://www.youtube.com/watch?v=Zc1tZ8JsZvg.

MacDougall, C. (1958). *Hoaxes.* New York: Dover Publications.

Mallonee, L. (December 21, 2016). "How photos fuel the spread of fake news." *Wired.* Accessed June 30, 2017 from https://www.wired.com/2016/12/photos-fuel-spread-fake-news/.

"Mika Brzezinski and Joe Scarborough fire back at Trump over 'obsession.'" (June 30, 2017). *The Guardian.* Accessed June 30, 2017 from https://www.theguardian.com/us-news/2017/jun/30/mika -brzezinski-joe-scarborough-donald-trump.

"New bombshell: NYPD blows whistle on new Hillary emails: Money laundering, sex crimes with children, child exploration, pay to play, perjury." (November 2, 2016). True Pundit. Accessed September 19, 2017 from http://truepundit.com/breaking-bombshell-nypd-blows-whistle-on-new-hilla ry-emails-money-laundering-sex-crimes-with-children-child-exploitation-pay-to-play-perjury/.

O'Hara, E. (March 21, 2017). "Kurt Eichenwald case: Texas Grand Jury says GIF is a 'deadly weapon.'" NBC News. Accessed June 30, 2017 from http://www.nbcnews.com/news/us-news/kurt-eichenwa ld-case-texas-grand-jury-says-gif-deadly-weapon-n736316.

Pollak, J. (November 24, 2016). "NPR finds 'Godfather' of fake news is a liberal Democrat in California." Breitbart. Accessed June 30, 2017 from http://www.breitbart.com/big-journalism/2016/11/ 24/npr-finds-fake-news-company-run-liberal-democrat/.

Sanchez, R. and Lance, N. (June 17, 2017). "Judge finds Michelle Carter guilty of manslaughter in texting suicide case." CNN. Accessed June 30, 2017 from http://www.cnn.com/2017/06/16/us/m ichelle-carter-texting-case/index.html.

Smith, J. (December 20, 2016). "We're getting rid of comments on VICE.com." Vice. Accessed June 30, 2017 from https://www.vice.com/en_us/article/vvdjjy/were-getting-rid-of-comments-on-vice.

"Snopes website." (2017). Accessed June 30, 2017 from http://www.snopes.com/.

Stepanova, E. (May 2011). "The role of information communications in the 'Arab Spring.'" PONARS Eurasia, Memo No. 159.

"Tips for telling truth from fiction in this fake news mess we've found ourselves in." (November 21, 2016). *The Dallas Morning News.* Accessed June 30, 2017 from https://www.dallasnews.com/op inion/editorials/2016/11/21/fake-news-just-facebooks-problem-problem-tips-telling-truth-fiction.

"Vice website." (2017). Accessed June 30, 2017 from https://www.vice.com/en_us.

"Welles scares nation." (2017). History. Accessed June 30, 2017 from http://www.history.com/this-da y-in-history/welles-scares-nation.

Yoakum, J. (May/June 2000). "The man who killed Paul McCartney." Gadfly Online. Accessed June 30, 2017 from http://www.gadflyonline.com/home/archive/MayJune00/archive-mccartney.html.

11

EDITING CHALLENGES

On Easter Sunday, 2000, I was enjoying a fresh squeezed orange juice from a diner in downtown Berkeley. It was a typical California morning, clear cyan sky just starting to get hot. I used to tell my friends who lived in tornado and hurricane tormented states and worried that I lived in earthquake country that "the world might end, but at least it will be a sunny day." Well, the world didn't end that day, but one of the most notorious news stories for that year, was reported. Early the previous morning, 6-year-old Elián González was snatched from a home in south Florida by INS federal agents and returned to his father in Cuba (Zimmerman, 2017). Alan Diaz, working for the Associated Press, won a Pulitzer Prize for his picture of a terrified Elián taken by machine gun-toting agent Jim Goldman from his uncle's house.

Elián survived the nightmare crossing of the Florida Straits that killed his mother and 10 of the 12 other refugees on board their sinking boat only to become the centerpiece in a bitter battle between those who wanted him to remain in the United States with Miami relatives and those who wanted him returned to his father in Communist Cuba. Most non-Cubans, including the Clinton administration and the federal courts, believed the 6-year-old should be returned. On the other hand, most Cuban-Americans, including the actor Andy Garcia, the singer/entrepreneur Gloria Estefan and particularly the older, island-born generation of exiles, reflexively anti-Castro in all things, felt strongly that Elián should remain in the US.

Editors in print and screen media were faced with an ethical dilemma (*The Washington Post*, 2000). With such a complex and political story, should image choices and their positions emphasize the taking of Elián, the reunion of the boy with his father, or reflect a golden mean compromise?

Wendell Cochran (2000), a Freedom Forum Fellow analyzed front page newspaper coverage of the event collected by the Newseum, a Washington DC area museum devoted to journalism history and current practices provided by the Gannett newspaper chain. As Cochran reported,

> at 32 of the newspapers that the Newseum received for its front-pages display, the decision was made to run both the gun picture and the father–son reunion portrait. But at most papers, such as *The State* of Columbia, S.C., the picture of the gun-brandishing agent got by far the most space. Only a few papers, notably *The Washington Post* and the Newark *Star-Ledger*, ran the two images at nearly the same size. Six of the Newseum

papers ran the father-with-Elián picture but not the gun photo. Three of the newspapers ran the gun picture alone, but not the father–son picture, on page one.

The New York Times employed a creative alternative approach to Aristotle's golden mean philosophy when it

> ran the gun photo on page one in its early edition, but moved it inside for later runs, putting the father–son picture at the top of the page and also running the photo of the agent carrying Elián out of the house.

Finally, *El Nuevo Herald, The Miami Herald*'s Spanish-language daily exhibited the least objectivity that reflected the high emotions of their readers and the community when editors decided to produce an "extra" edition that featured Diaz's powerful photograph large with the headline, "¡Que Vergüenza!" or "HOW SHAMEFUL!" Although popular with the Cuban-American residents of Miami, this editorial decision was controversial among many staff members of the newspaper writes Bárbara Gutiérrez (2001), a former executive editor and reader representative for the Miami newspapers. Gutiérrez writes, "some observers in the *Herald* newsroom were appalled at its brazen editorial tone. They also questioned why *El Nuevo Herald* chose not to run columns by those who wanted the child to be returned to his father."

Editors had a difficult choice – emphasize the taking of Elián in a large photograph, as on the cover of *Newsweek* magazine; feature his reunion with his father, as on the *Time* cover, or try to balance the two storylines with images about the same size side-by-side, as on *The Washington Post* and *Los Angeles Times* front pages. Whichever choice is made, an editor should make a decision after a reasoned discussion with fellow journalists and not for sensational, economic, or political considerations.

Why End with Editing?

Editing concludes this book devoted to visual ethics because it is the most complex issue that visual communicators face. Regardless of whether the purpose and outcome of the visual presentation is for advertising, graphic design, informational graphics, journalism, motion pictures, public relations, television, and the web, editing involves the decision of the initial storyline and subject details, what equipment to use, how much time and funds should be devoted to the project, how the story or illustration will be recorded, the selection of audio and images, the piecing together of storytelling elements into a coherent account or design, how the resulting effort will be shown and with what media, who will be the audience for the display, and what, if any, will be a response if all of those decisions are criticized.

For example, photojournalists are often called upon to record the darkest moments in people's lives that include the most horrific visual messages one can imagine. Ordinarily, the first editing choice for a photographer arriving at such a scene would be whether to take or not take a picture. There are many reasons why a journalist would not take a photograph of a spot news story. One of the most humanitarian reasons would be if it were possible for the photographer to help those in need of immediate assistance. As long as it were possible for the journalist to help, knows how to help, and is not told to stay out of the way by rescue workers on the scene, it is a moral duty of that journalist to render aid. After such care is given, it is professionally acceptable to resume the role-related duties of a photographer and record the scene. Of course, a photographer might be sensitive to the anguish of the victim and decide not to record an image out of respect for privacy. There may be homeland

security restrictions imposed by a government. Another reason for not taking a picture might be if specifically asked to not make a recording. Although most news stories occur in full public view and it is legal to take such pictures in almost all cases, some photojournalists might respect the wish of the source and refrain from taking a picture. There may also be other reasons for not taking pictures: a camera might be defective, a memory card might be full, it might be too dark, bystanders might be in the way, and so on. However, technical problems, either from a broken camera or a lack of experience, are not considered part of an ethical dilemma's decision-making process. If after all the previous reasons are considered and a decision to take the photograph is made, the only actions available to the photojournalist after are whether to turn in the image to an editor or not.

In attempting to decide whether images should be made available to a media organization, a question should be asked: Does the action fulfill the journalist's role-related responsibility? A photojournalist is employed by a news organization for the specific purpose of providing facts in (mostly) a visual format (photojournalists are sometimes asked to provide caption information – names, titles, and sometimes observations and quotations). Not providing an image to an editor violates the contract the journalist has with the news entity. Therefore, the only possible action that fulfills the journalist's role-related responsibility is to give the picture to the editor.

From that point on, the ethical dilemma is lifted from the photojournalist and given to the editor who must decide whether to publish the picture and how it should be presented to the news organization's audience. In many enlightened news outlets when a potentially controversial picture is being considered, a visual reporter is asked to participate in a news-room discussion that might include other photographers, the principal reporter of the story and other journalists, and the editor-in-chief and publisher, if they are available. Regardless, the final decision to use the image is, in most cases, now up to the editor and not the pho-tographer. Therefore, the following steps apply to the editor.

An editor, then, has two choices: to publish the picture or not. Any decision to publish or not publish a picture should not be based only on the story of the day. Perhaps there is a larger context for this story that readers and users should know. Perhaps the picture involves a house on fire. In that case, it might be one of several recently started within the city limits. Fire and police officials might suspect an arsonist. Perhaps there is a problem with the electrical grid or natural gas lines within the city that are causing numerous fires. Perhaps no other photograph taken during previous fires were of high "decisive moment" quality as the imagined image. Perhaps children and others in the house were killed or seriously injured. Maybe with high winds the house set other homes in the neighborhood ablaze and caused millions of dollars in property damage. Suppose a mother left her children alone in the house and went next door to drink in the neighborhood bar. Maybe there was a domestic argument and the estranged father set the fire deliberately in a murder-suicide plot. With such larger contexts for a news story, an editor might be inclined to include this strong visual message along with a story on the front page. If the decision by the editor after consultation is to *not* publish the picture, the authors' qualms about the scenario – the mother's plight and the (assumed) negative reaction if she were to see her image published in the next day's news – are alleviated (although who can say that she would not react equally negatively to a story about the incident).

Photojournalist Lynsey Addario specializes in war and human rights photography in some of the most dangerous places in the world. She regularly works for *The New York Times* and *Time* magazine, among others. She has won a Pulitzer Prize and a MacArthur Fellowship "genius" award. Her book, *It's What I Do: A Photographer's Life of Love and War* was pub-lished in 2015. That same year she was interviewed for a Radiolab episode, "Sight Unseen"

(2015) about a decision she made with her editors at *Time* in 2009 to not publish photographs that showed the death of a US soldier in the Helmand Province of Afghanistan.

It's almost considered a journalist's maxim, but it's probably not written down anywhere, that you never ask permission from a source if you can take or publish a picture. Part of being a professional is that you develop a keen sense of news judgment, especially if the story involves government employees that conduct actions on behalf of its citizens.

Addario took photographs of an unsuccessful attempt by a US medevac team to save the life of Lance Corporal Jonathan Taylor. She knew the pictures were important for the public to see because they showed the ultimate sacrifice soldiers make. Nevertheless, as part of the condition of being an embedded journalist with the medical team, she needed permission from the dead soldier's family to publish the photographs. Having no alternative, she traveled to Florida to meet with Taylor's family where she had a heartfelt conversation, but permission was not granted. Still, Addario feels she did the right thing by respecting the family's wishes and not pushing for publication. Sometimes ethical behavior trumps a professional's role-related responsibility ("Afghanistan," 2016).

However, if the choice is made to publish an image, the editor must now decide *how* it should be presented. The editor has many choices. The image can be published:

- on the front page or cover,
- on an inside page,
- with only a caption,
- with a caption and a story,
- in color,
- in black and white,
- large,
- small,
- with other images in a picture spread,
- with an informational graphic or infotoon,
- with a detailed description of covering the story by the reporter and photographer,
- with a warning for readers that an inside page contains an image that might be upsetting to some readers,
- on a website, or
- to allow or disallow comments from others.

If this story were a "one-off" event, a tragedy, but not one within a more complicated context, an editor might be inclined to downplay the story graphically but still report it visually. The justification might be that the unusual nature of the strong photograph requires publication so that readers and viewers know in words and images the victim's pain and perhaps think of their loved ones (veil of ignorance) and make sure to check the smoke detectors in their own homes (utilitarianism). In that way, the aggregate good is served more by the publication of the image than without it. However, regardless of the best intentions by an editor, critics may complain if the footage was shot by a staff member, if the story is local in its origination, if the still or video is in color, if a viewer sees the image during the morning hours, if the image is shown on a front page or leads a newscast, if there was no context given for the picture or video either through copy or a voice-over, if the image shows people overcome with grief, if a victim's body is shown, if a body is clearly physically traumatized, if the victim is a child, and if nudity is involved. In fact, if five or more of these conditions apply, editors should prepare themselves for a reader/viewer firestorm. Editors should prepare notes for a column that justifies the decision to use the images.

As many letters to the editor and telephone transcripts as possible should be printed. Readers may not agree, but most will respect the decision if the response to the controversy is prompt and the justification is consistent.

The Ethics of Image Selection

In 2017 the social media platform Facebook struggled with a series of gruesome and unforeseen uses of what was thought to be an innocent and entertaining feature introduced to users ("Thai man," 2017). Facebook Live was meant to display birthdays, weddings, and walk in the woods (no double rainbows please) recorded by users wanting to share these moments with their friends. However, within a week, police reported that Steve Stephens killed a random man walking by his car on a Cleveland street and in Thailand, a man mad at his wife hanged their 11-month-old daughter and then killed himself. Both videos were posted live on Facebook. Words alone are disturbing enough as a Reuters' reporter describes the Thai murder, "The harrowing footage from Thailand showed Wuttisan Wongtalay tying a rope to his daughter Natalie's neck before dropping the child, dressed in a bright pink dress, from the rooftop of a deserted building in the seaside town of Phuket."

As a result of the controversy, CEO Mark Zuckerberg announced that the company would hire 3,000 employees in addition to the 4,500 already on staff to review the millions of videos uploaded daily by users – a daunting editing chore (Guynn, 2017). Previously, the company relied solely on its two billion members to report objectionable videos, but obviously, such a procedure depends on the kindness of strangers, a not altogether satisfying procedure.

The staff of the *Tampa Bay Times* created a three-dimensional interactive informational graphic to illustrate the mass shootings at the Pulse nightclub in Orlando ("Choice and chance," 2016). The images were based on the actual floor plan of the club and eye-witness and police reports. Titled, "Choice and chance," the tag line reads, "A gunman enters the Pulse nightclub. Those in his path have only a heartbeat to react." A computer user is meant to navigate through the infographic by clicking on areas within the cutaway structure where victims are identified with their pictures and text explains various scenarios. For example, above a blue-tinged representation of the club and next to a picture of a woman smiling, the copy reads, "On the dance floor, Brenda Marquez McCool tells her son: *Get down*. The shooter takes aim." After a double-click of a mouse, the copy changes to, "Her son lives." Another double-click and, "She dies" is added. Certainly gruesome mental images are invoked, but the newspaper was praised for its effort because the images shown of the Pulse were architectural renderings without audio effects and avatar-based victims shown shot by the killer as with most video games. Although the decision to not include life-like animated persons was largely based on economic and time constraints, the ultimate editing decisions resulted in a presentation that added to the body of knowledge about the tragedy without being sensational.

Tim Frances (n.d.) writing for the Ethical Journalism Network begins his piece with a strong statement:

> Image selection has always been a tricky ethical dilemma for journalists and editors, but in the last few weeks the complex issues arising from a number of high-profile cases have led to criticisms of the media from a wide variety of groups and commentators.

Frances concentrates on horrific video produced by a media savvy terrorist organization of the brutal murders of James Foley, Steven Sotloff, and David Haines. Frances writes of the decision to make the footage available through a website or screen capture still pictures moments before the killing by many print entities. Frances notes that

Journalists need to do more to avoid unwittingly contributing to the spread of objectionable content, and to think more carefully about the hidden messages that the images they publish may be sending and how it may affect the objectivity of a story.

He concludes that some stories with powerful and upsetting visuals should not be made available to the general public. "There are clear ethical lines that need to be drawn," Frances writes, "and should never be crossed."

Discretion is often in short supply by editors who are urged to produce viewers of sensational stories by economically-driven publishers and owners, to compete with other outlets no longer confined to cross-town rivals, and to fill the 24/7 news cycle in which the concept of a deadline is as dated as the smell of ink on your fingers after reading a printed newspaper.

Nevertheless, some stories are too important to leave up in a digital cloud without being seen by the ordinary public. In the case of military malfeasance, wrongful actions committed in the name of its citizens, that citizenry has the right and editors have the duty to show its leaders and others at its worse. Christopher Massie (2014) writing in the *Columbia Journalism Review* interviewed David Remnick, long-time editor of *The New Yorker* magazine after his decision to run photographs three weeks in a row of Iraqi prisoners tortured by American soldiers within the Abu Ghraib prison. Massie reported that Remnick knows he made the correct decision to devote that much space to the story that was accompanied by the words of Pulitzer Prize journalist Seymour Hersh. Admits Remnick, "If I have any regrets about it, it's that we didn't make the space to run more of them." For Massie, "History appears to have vindicated his decision. The Abu Ghraib photographs and the stories they illustrated became symbols of the corruption of the Bush administration's 'war on terror,' and contributed to the ongoing debate about America's use of torture."

When confronting situations and photographs of accident and tragedy victims, journalists are tom between the right to tell the story and the right NOT to tell the story. Arguments by well-meaning professional journalists can be made for and against the taking and publishing or the not taking and not publishing of almost any photograph. Curtis MacDougall (1971) in his visually graphic book, *News Pictures Fit to Print ... Or Are They?* argued that news pictures sometimes need to be offensive in order to better educate the public. He wrote, "If it were in the public interest to offend good taste, I would offend good taste." The problem comes, of course, when communicators disagree on what is in the public's interest.

A few years ago I was invited to Istanbul, Turkey to speak to a group of photojournalists during a conference concerned with ethical issues. Almost as soon as I arrived at my hotel a photographer gave me a copy of a local newspaper's coverage that featured a large, color photograph at the top of the page of a woman on her stomach killed by her husband (*Haber Turk*, 2011). A carving knife was still stuck in her bloody back. Needless to say, my time at the conference was dominated by the questions of whether the photographer should have taken the picture and if it was ethical to publish the gruesome image. I concluded that in America, a visual reporter probably would have taken the picture, but I couldn't imagine an editor using the image in a similar layout. At most, an editor inclined to use the photo would take a golden mean approach and use it on a website with a strong disclaimer about its content. As MacDougall points out, sometimes the public needs to be offended, but sometimes not.

The reason editing is the final chapter in this textbook is because the decisions made by a visual communication professional determine whether a still or moving image in print or for a screen resides on a cloud account or is actually seen by readers, viewers, and users. Such a decision should not be made quickly as most hedonistically-inspired judgments are criticized

for, but over time, with rationality, and in discussion with others. Considering the purpose and impact the images might have on the general public and particularly vulnerable populations should be one of the tools used toward ethical decision-making. Regardless of technology and intent – whether through a single photograph, an advertising campaign, a two-hour motion picture, or a two-minute virtual reality report for persuasive, entertainment, or educational reasons – society deserves judicious deliberation that hopefully guarantees that a presentation is not based solely on hedonistic motivations.

The challenge during this highly technical and political time is that anyone – everyone – can be thought of as an editor and make pictures, with little context and explanations, available to friends, family, and the world. From a kid pretending to be Luke Skywalker in his house to a gruesome murder shown live on Facebook, we live in an age of digital image freedom without restraint or ethical considerations. But that's a given. Live with it. Now what? Do what has always been done – edit yourself.

Choose carefully what you show and what you visually digest. And always consider the anonymous, faceless, and little understood other. Because in this day and time, there is no longer a separation between you and the media – we are all the media. As editors of what we produce and what we experience, how we use technology has always determined how cultures communicate values and how societies are judged by historians as positive or negative influences upon future generations.

See Appendix A for a professional's approach to editing challenges.

Case Studies

Case Study One

In 2015, judges disqualified 20 percent of the entries from the "World Press Photo Competition" due to concerns that the photos due to "excessive – and sometimes blatant – post-processing." For example, in studying the photos and comparing them with their original files, judges noticed that sometimes so much black toning had been used that entire objects disappeared from the frame. So while digital pictures are not film – they are data – the judges felt these photos had to be disqualified for dishonesty.

In response to the controversy, *The New York Times* ran an online discussion among judges and photographers (a *Times* editor had been chairwoman of the contest). Below are some of their thoughts. Which one resonates the most with you? What are the ethical considerations at stake?

Michele McNally, the director of photography and an assistant managing editor at *Times*, said,

> Once we saw the evidence, we were shocked. Many of the images we had to disqualify were pictures we all believed in and which we all might have published. But to blatantly add, move around or remove elements of a picture concerns us all, leaving many in the jury to feel we were being cheated, that they were being lied to.

Melissa Lyttle, president of the National Press Photographers Association and a contest judge explained,

> It's a dangerous and slippery slope to travel down when altered work is lauded, and other photojournalists see that as the ideal. It sets a bar that is unreal, unhealthy, and

unattainable … . It also reminds me of something I was told as a kid: lying is easy, telling the truth is the hard part.

"Debating the rules and ethics of digital photojournalism." (February 17, 2015). The New York Times Blogs.
See Appendix B for the 10-Step Systematic Ethical Analysis Form.

Case Study Two

Like almost everything in life, photography is subject to trends and fads; photographers do things one way this year, a different way next year. However, most people are not photographers, but individuals who hire photographers to capture their special events and lives for memory and safekeeping: weddings, births, graduations, important birthday parties, and more. People know that the pictures they get will capture the good and the bad – baby's sweet smile or the newly wedded couple's first kiss, alongside Uncle Johnny's awful blue tuxedo or that awkward seventh grade year when your sister had braces.
"Wedding photography editing trends." (April 13, 2017). Lydia Royce. Accessed June 30, 2017 from https://www.lydiaroyce.com/blog/wedding-photography-trends-2017.
See Appendix B for the 10-Step Systematic Ethical Analysis Form.

Case Study Three

Steve McCurry, who took one of the most famous photographs of all time, the Afghan Girl cover that appeared once on *National Geographic*, is famous for something else, too: faking content and manipulating his pictures. Many people became especially upset when they discovered this about McCurry precisely because he *is* so famous, and has taken photos that people credit with helping them to understand the world. They looked to his work as a way to help them see into places they would never go, and achieve insight about people they would never meet.

The controversy began when someone was looking at one of McCurry's photos on Instagram noticed an anomaly – a yellow sign post that appeared twice, and the second time it was bleeding into a passerby's leg. It had clearly been altered. An outcry ensued, because McCurry had never presented his pictures as being subject to digital altering. In response, McCurry explained that rather than being a strict photographer, he would define his work

> as visual storytelling, because the pictures have been shot in many places, for many reasons, and in many situations … My photography is my art, and it's gratifying when people enjoy and appreciate it. I have been fortunate to be able to share my work with people around the world.

In other words, he is not trying to be an objective journalist, but rather present a story with his own point of view, and this includes editing.
Letzter, Rafi. (May 21, 2016). "The 'Afghan Girl' photographer faked some of his photos. Does it matter?" Business Insider. Accessed June 30, 2017 from http://www.businessinsider.com/steve-mccurry-photo-editing-scandal-2016-5.
See Appendix B for the 10-Step Systematic Ethical Analysis Form.

Annotated Sources

Hogan, T. (n.d.). "Ethics and editing." *Photo Review, 50.* Accessed June 30, 2017 from http://www.photoreview.com.au/tips/editing/ethics-and-editing.

This article explores to what degree, and when, a photographer should reveal that he or she has edited a photograph. Hogan looks at different types of photographs, such as food and clothing (where editing is commonplace and therefore acceptable), scientific (where any editing must be revealed) and landscape (where the rules are murkier).

Irby, K. (2015). "Photojournalism ethics needs a re-examination." Poynter. Accessed June 30, 2017 from http://www.poynter.org/2015/photojournalism-ethics-needs-a-reexamination/325217/.

This article raises the point that the ethical standards for photo manipulation were established when photographs were processed in a physical darkroom. Now that most photographs are processed on powerful computers, Irby argues that is time for an update.

RTDNA. (2015). "Guidelines for ethical video and audio editing." RTDNA. Accessed June 30, 2017 from http://www.rtdna.org/content/guidelines_for_ethical_video_and_audio_editing.

The Radio Television Digital News Association lays out here four ethical guidelines to follow when editing audio and video. They are as follows. First, do not reconstitute the truth. Second, be judicious in your use of music and special sound effects. Third, use photographic and editing special effects sparingly and carefully. And finally, fourth, apply the same careful editing ethics standards to your newscast teases, promotions and headlines that you do for your news stories.

References

Addario, L. (2015). *It's what I do A photographer's life of love and war.* New York: Penguin Press.

"Afghanistan: The rescue brigade." (2016). *Time.* Accessed June 30, 2017 from http://content.time.com/time/photogallery/0,29307,1963443,00.html.

"Choice and chance." (June 20, 2016). *Tampa Bay Times.* Accessed June 30, 2017 from http://www.tampabay.com/projects/2016/breaking-news/orlando-nightclub-shooting/choice-chance-3d-map/#.

Cochran, W. (April 25, 2000). "Elián raid puts editors on tightrope." The Freedom Forum Online. Accessed June 30, 2017 from http://webapp1.dlib.indiana.edu/virtual_disk_library/index.cgi/4909942/FID2663/common/first%20amendment/www.freedomforum.org/news/2000/04/2000x04x25x07.asp.

Frances, T. (n.d.). "Images of journalism: Why ethics need to be part of the picture." Ethical Journalism News. Accessed June 30, 2017 from http://ethicaljournalismnetwork.org/images-of-journalism-why-ethics-need-to-be-part-of-the-picture.

Gutiérrez, B. (2001). "El Nuevo Herald provides a Latin American take on the news." Nieman Reports. Accessed June 30, 2017 from http://niemanreports.org/articles/el-nuevo-herald-provides-a-latin-american-take-on-the-news/.

Guynn, J. (April 18, 2017). "Zuckerberg: We're responsible for halting violent content on Facebook." *USA Today.* Accessed June 30, 2017 from https://www.usatoday.com/story/tech/news/2017/04/18/mark-zuckerberg-facebook-live-violent-content/100579530/.

"Haber Turk front page." (October 7, 2011). Accessed June 30, 2017 from http://paulmartinlester.info/Haber_Turk.jpg.

MacDougall, C.D. (1971). *News pictures fit to print ... or are they? Decision-making in photojournalism.* New York: Journalistic Services.

Massie, C. (August 22, 2014). "To publish or not: James Foley video spotlights media's tough call." *Columbia Journalism Review.* Accessed June 30, 2017 from http://archives.cjr.org/behind_the_news/to_publish_or_not_foley_video.php.

"Sight Unseen." (April 28, 2015). Radiolab. Accessed June 30, 2017 from http://www.radiolab.org/ story/sight-unseen/.

"Thai man broadcasts baby daughter's murder live on Facebook." (April 26, 2017). Reuters. Accessed June 30, 2017 from http://uk.reuters.com/article/uk-thailand-facebook-murder-idUKKBN17R1DE.

"The Washington Post front page." (April 23, 2000). "Raid reunites Elian and father." Accessed June 30, 2017 from https://img.washingtonpost.com/wp-apps/imrs.php?src=https://img.washingtonpost. com/news/morning-mix/wp-content/uploads/sites/21/2015/05/wapofront.jpg&w=480.

Zimmerman, A. (April 28, 2017). "The saga of Elián Gonzalez: A lost boy who was finally found." Daily Beast. Accessed June 30, 2017 from http://www.thedailybeast.com/the-saga-of-elian-gonzalez-a-lost-boy-who-was-finally-found.

CONCLUSION

Let Empathy Be Your Guide

In Rawls' thought experiment for his veil of ignorance philosophy, no one class of people is entitled to advantages over any other. Not knowing the demographic and cultural specifics of another should result in an attitude of mutual respect. Practically, the phrase "walk a mile in someone's shoes" is a popular adaptation of this philosophy.

American songwriter Joe South introduced the phrase to a popular audience with his 1970 hit, "Walk a Mile in My Shoes" later covered by such diverse singers as Bryan Ferry, Harry Belafonte, and Elvis Presley (Boyd, 2014). Although a simple sentiment plainly articulated, South's song speaks to how most confrontations and ethical dilemmas should be resolved – by reducing the self and considering the other. Although never mentioned, the song was popular because it expressed a value necessary in private and public interactions – empathy.

As with the tune, Rawls' work is considered an answer to prejudice and discrimination as it too is a call for empathy. Nevertheless, empathy is controversial. If you have too much of it, you might be patronizing toward those who need assistance and not regard another as an equal. But if you have too little, the stories told through the media regardless of production values and technologies may be viewed as merely objects for entertainment purposes. What is needed from visual producers are thoughtful and ethical productions so that presentations act as catalysts for empathetic understanding of complex social issues within a networked culture. If an ethic of empathy is considered, viewers and users will care about those they meet on the printed page or through head-mounted displays with the same level of concern as reporters and producers who research and make the presentations.

Empathy is a fairly new concept. It comes from the German, *Einfühlung* literally meaning "feeling in." In 1908 the English word, empathy, came from the Greek *pathos* for feeling, and *em* for in. Initially, "feeling in" was not thought of as a way to imagine being in another person's place. In the 1920s it was used to describe imagined feelings toward an inanimate object. A 1955 *Reader's Digest* magazine article defined it for the public as the "ability to appreciate the other person's feelings without yourself so emotionally involved that your judgment is affected" (Lanzoni, 2015).

Social psychologist Dan Batson (2011) identified eight aspects of empathy: "Knowing another's thoughts and feelings, imagining another's thoughts and feelings, adopting the posture of another, actually feeling as another does, imagining how one would feel

or think in another's place, feeling distress at another's suffering, feeling for another's suffering, and projecting oneself into another's situation." "Feeling in" is now legitimized.

Some social critics have noted that empathy has become the buzzword of the twenty-first century. It is the defining trait of our social and political evolution. Empathy may be to this century what "rights" was to the twentieth century, "equality" was to the nineteenth century, and common sense was to the eighteenth century.

As a word, a concept, and a goal, empathy is everywhere. New parents, college students, doctors in training, and employees of corporations learn of empathetic responses to produce personal, political, and social change. Organizations, such as the Roots of Empathy (n.d.) teach school children to have more of it. Much of this initiative for these programs is because of physical and cyber bullying. Political theory students study Franz de Waal's, *The Age of Empathy: Nature's Lessons for a Kinder Society* (2010). Author and political advisor, Jeremy Rifkin (2010) encourages empathy to improve our world through his writings and a TED talk. Empathy has entered the workplace with books such as Dev Patnaik's *Wired to Care: How Companies Prosper When They Create Wide-spread Empathy* (2009) that note how the value is good for business.

The link between fiction and empathy has been long established. In Harper Lee's classic novel *To Kill a Mockingbird* (1988) Atticus Finch says "You never really understand a person until you consider things from his point of view." Film critic Roger Ebert wrote that through motion pictures "We search for figures in the light whom we can anchor our empathy to, and swivel our lives accordingly" (Holmes, 2014). Quentin Tarantino explained the importance of empathy as a one-to-one, known personal experience (Ansen, 2003). "A beheading in a movie doesn't make me wince. But when somebody gets a paper cut in a movie, you go, 'Ooh!'" Mother Teresa put it in another, more thoughtful, way, "If I look at the mass, I will never act. If I look at the one, I will" (Slovic, 2007). Anecdotes or personal stories are inherently more persuasive than statistics.

In 1982 the video game company Electronic Arts (n.d.) started a revolution in game culture with its debut magazine advertisement that asked the intriguing question, "Can a computer make you cry?" The ad included a promise for the production of "Software worthy of the minds that use it." Thus began a quest to inculcate Rawls' concept of empathy – one of the most important emotions humans possess – into the world of gaming. EA Founder Trip Hawkins subsequently raised about 10 million dollars for the organization, "Teach Empathy Through Games" for 10-year-olds (Wan, 2014). In the game, "IF … The Emotional IQ Game," Hawkins explains,

> IF … which was inspired by the Kipling poem of the same name, takes place in a game universe where everything is connected through The Energy Field (so you really need empathy) and where rival dogs and cats are fighting over control but really need to understand and accept each other.

Sounds highly evolved. However, the EA (2017) games that sell the most do not necessarily teach empathy as with such titles as "Madden NFL 17," "EA Sports FIFA," "Ultimate Fighting Challenge," "Battlefield," and "Titan Fall." Nevertheless, Hawkins inspired others. Since 2004, "Games for Change" is an organization dedicated to promote social advancement through the use of video games. Its website lists numerous games that teach empathy and understanding. For example, in the newsgames category, players can imagine being Syrian refugees, help solve climate change, or be a reporter in Darfur.

In Nonny de la Peña's immersive storytelling virtual reality productions such as "Hunger in LA," "Project Syria," "Out of Exile," and "Kiya," you suspend your disbelief and become a passive witness of people's lives at a food bank, in Aleppo, intolerance that someone from the LGBTQ community faces, and a violent altercation between a woman and her ex-boyfriend, respectfully. But as well produced as these programs are, cartoon animations have a limited appeal. Some of the most powerful productions are live-action documentary portraits and stories. "After Solitary" is a man's downward spiral after being subjected to solitary confinement while in prison. This kind of immersive journalism is the future for the profession. There are hundreds of 360-degree virtual reality stories produced by such news organizations as Riot, Frontline, CNN, the *Los Angeles Times, The New York Times, The Guardian*, the Associated Press, ABC News, BBC One, the Huffington Post, and Buzzfeed. Plus, there are countless pieces produced by innovative amateurs and university students seen on YouTube.

As traditional print outlets gradually fade and become replaced by online media, many visual reporters and producers have found ways to tell insightful and moving stories through a combination of still and moving images, audio, and interactive features. Newspapers, magazines, and television stations throughout the world offer viewers a chance to test their level of empathy by the content presented. The National Press Photographers Association and other organizations reward creators with accolades for their efforts. One of the best showcases for high quality productions as well as offering opportunities to fine-tune the skills necessary to create work is the film, design, and educational studio MediaStorm founded by Brian Storm in 2005 ("MediaStorm," 2017). In-depth, long-term, and classic photo-journalistic documentary productions on serious social issues are the organization's hallmark. Emmy, Edward R. Murrow, and Alfred Dupont awards and nominations have been given to Storm's producers for such titles as "Marlboro Marine," "The Sandwich Generation," "Never Coming Home," and "Crisis Guide: Darfur."

In the end, do media productions, whether through traditional or emerging media, make a viewer and/or user more empathetic? When visual productions are most immersive, many think so. For example, as a tool in public relations, Cathe Neukum of the charity organization, International Rescue Committee believes virtual reality technology aids in education and leads to donations. "Four Walls: A Virtual Reality Experience" with Rashida Jones allows a user to be with a Syrian woman and her child in their refugee living space in Lebanon ("How virtual reality lets," 2016). Neukum says,

> We can't bring donors or people to the field, but we bring the field to donors and our constituents and our supporters. That's what's so great about VR, that's what makes it, I think, such an important tool for charities. The VR experience *puts you in the shoes of someone* who goes through a journey that ends in homelessness.

The description is the personification of the veil of ignorance philosophy.

Jeremy Bailenson, the founding director of Stanford University's Virtual Human Interaction Lab has been studying VR since its earliest iterations. He says there is increasing evidence that VR can be more effective than other media in evoking empathy (Novacic, 2015). But it has to be done right.

> What we know how to do well is to create these experiences that really leverage what's called embodied cognition, which is moving through a space, looking around, using your eyes, using your body to interact with the scene and that's what makes VR special.

However, using VR to promote empathy has its skeptics. Paul Bloom (2016), a Yale psychology professor and author of *Against Empathy: The Case for Rational Compassion*, thinks that if these kinds of VR experiences become common they will be no more effective than any other media.

> Feeling the suffering of other people is fatiguing. It leads to burnout. It leads to withdrawal. The best therapists, the best doctors, the best philanthropists are people who don't feel the suffering of others. It's just people who care about others and want to help, but do it joyously.

Bloom says he may be old school, but he thinks if you really want to get into the head of another human being and understand them, "try reading a good novel." Many advocates of immersive storytelling disagree with Bloom as they equate a good novel with a well-produced experience.

As a counter argument to Bloom, Professor of Psychology Richard Beck (2007) believes that empathy is the greatest virtue for humans. He writes,

> The only way to create a just and fair society is to imagine what it is like to be other people. What is it like to be poor with kids who need flu shots? What is it like to be born with a mental illness? Or prone to addiction? The list goes on and on. In the end our ability to create a just and fair society is directly tied to how fully we empathize with others. If we can't empathize with the poor or the mentally ill how could we possibly begin to know what they fairly and justly need and require to thrive and flourish.

He argues that empathy is a complicated topic that should be considered carefully by producers. He writes, "You can't just blandly say 'empathy' without some pragmatic considerations about how to implement it on a practical scale."

Professor of law and ethics and philosopher, Martha Nussbaum at the University of Chicago argues that immersive stories – whether from books or through head-mounted displays – have the potential to invoke empathetic responses (Conde, 2016). For Nussbaum, *schadenfreude*, feeling joy at someone else's pain – the opposite of empathy – is reduced by exemplary productions by those who understand that caring for others is a trait that needs to be carefully nurtured and practiced on a regular basis (Aviv, 2016).

Australian author Rachel Hennessy (2016) known for her novels, *The Quakers* and *The Heaven I Swallowed*, wrote,

> Creating empathy allows a user to enter the mind of someone whose situation is dissimilar to their own. It is one of the primary functions of storytelling. Through the simple act of *stepping into the shoes of another*, you the user, can experience a fundamental change in yourself *as a person*.
>
> *(Carson, 2017)*

Again, Rawls' veil of ignorance is referenced.

But of course, virtual reality productions are not the only sources for teaching empathetic responses because whether through film, television, photographs, or augmented devices and whether for entertainment, persuasive, or educational purposes, when technology is combined with compelling stories and have empathy as a guiding principle, the result is a visual ethic that is based on mutual respect between creator and consumer.

In the end, and in conclusion, a study of visual ethics teaches you to care about what you do, what you experience, and what you produce. Demonstrate that concern within every project you undertake. And if you can, and it is no small task, you can say you are on a personal path that leads to more thoughtful communications among producers and better understanding among users.

Be empathetic.

Be ethical.

Bye for now.

See Appendix A for a professional's approach to finding empathy.

References

Ansen, D. (October 12, 2003). "Pulp fiction." *Newsweek.* Accessed June 30, 2017 from http://www.newsweek.com/pulp-friction-138493.

Aviv, R. (July 25, 2016). "The philosopher of feelings." *The New Yorker.* Accessed June 30, 2017 from http://lithub.com/does-fiction-actually-make-us-more-empathetic/.

Batson, D. (2011). "These things called empathy," in *The social neuroscience of empathy.* Decety, J. and Ickes, W. (eds.). Cambridge, MA: MIT Press.

Beck, R. (October 1, 2007). "The greatest virtue, part 3: Empathy, the veil of ignorance, and justice." Experimental Theology. Accessed June 30, 2017 from http://experimentaltheology.blogspot.com/2007/10/greatest-virtue-part-3-empathy-veil-of.html.

Bloom, P. (2016). *Against empathy: The case for rational compassion.* New York: Ecco.

Boyd, G. (November 8, 2014). "Walk a mile in my shoes= Joe South." YouTube. Accessed June 30, 2017 from https://www.youtube.com/watch?v=th-epsY-7mA.

Carson, E. (2017). "Immersive journalism: What virtual reality means for the future of storytelling and empathy-casting." Tech Republic. Accessed June 30, 2017 from https://www.techrepublic.com/article/immersive-journalism-what-virtual-reality-means-for-the-future-of-storytelling-and-empathy-casting/.

Conde, M. (August 4, 2016). "Does fiction actually make us more empathetic?" Literary Hub. Accessed June 30, 2017 from http://lithub.com/does-fiction-actually-make-us-more-empathetic/.

de Waal, F. (2010). *The age of empathy: Nature's lessons for a kinder society.* New York: Broadway Books.

"EA website." (2017). Accessed June 30, 2017 from https://www.ea.com/.

"Electronic Arts advertisement." (n.d.). Accessed June 30, 2017 from https://storytron.files.wordpress.com/2009/02/can-a-computer-make-you-cry.jpg.

Hennessy, R. (October 7, 2016). "Can fiction still make a difference?" Literary Hub. Accessed June 30, 2017 from http://lithub.com/can-fiction-still-make-a-difference/.

Holmes, L. (July 3, 2014). "'A machine that generates empathy': Roger Ebert gets his own documentary." NPR. Accessed June 30, 2017 from http://www.npr.org/sections/monkeysee/2014/07/03/328230231/a-machine-that-generates-empathy-roger-ebert-gets-his-own-documentary.

"How virtual reality lets us see the Syrian refugee crisis with fresh eyes." (October 20,2016). Rescue.org. Accessed June 30, 2017 from https://www.rescue.org/article/how-virtual-reality-lets-us-see-syrian-refugee-crisis-fresh-eyes.

Lanzoni, S. (October 15, 2015). "A short history of empathy." *The Atlantic.* Accessed September 20, 2017 from https://www.theatlantic.com/health/archive/2015/10/a-short-history-of-empathy/409912/.

Lee, H. (1988 [1960]). *To kill a mockingbird.* New York: Grand Central Publishing.

"MediaStorm website." (2017). Accessed June 30, 2017 from https://mediastorm.com/.

Novacic, I. (June 18, 2015). "How might virtual reality change the world? Stanford lab peers into future." CBS News. Accessed June 30, 2017 from http://www.cbsnews.com/news/how-might-virtual-reality-change-the-world-stanford-lab-peers-into-future/.

Patnaik, D. (2009). *Wired to care: How companies prosper when they create wide-spread empathy.* New York: FT Press.

Rifkin, J. (August 2010). "The empathetic civilization." TED. Accessed June 30, 2017 from https://www.ted.com/talks/jeremy_rifkin_on_the_empathic_civilization.

"Roots of empathy website." (n.d.). Accessed June 30, 2017 from http://www.rootsofempathy.org/.

Slovic, P. (April 2007). "'If I look at the mass I will never act': Psychic numbing and genocide." *Judgment and Decision Making*, 2(2), 79–95. Accessed June 30, 2017 from http://journal.sjdm.org/7303a/jdm7303a.htm.

Wan, T. (February 26, 2014). "EA founder Trip Hawkins raises $6.5M to teach empathy through games." EdSurge. Accessed June 30, 2017 from https://www.edsurge.com/news/2014-02-26-ea-founder-trip-hawkins-raises-6-5m-to-teach-empathy-through-games.

APPENDIX A: INTERVIEWS WITH PROFESSIONALS

By Martin Smith-Rodden

Visual Reporting: An Interview with Denis Paquin

The choices of if, when, and how to publish violent news images have long been a foundational area of moral and ethical debate among professionals and gatekeepers in visual communication. Every once in a while, the arguments of how to handle such highly charged imagery are fueled by the appearance of a powerful news image, which energizes the discussion like a lightning rod. An indisputable example of such a photo is Turkey-based Associated Press (AP) staff photographer Burhan Özbilici's (2017) tragic series of photos from 2016, which depicts the assassination of Russia's Ambassador to Turkey, Andrey Karlov.

Özbilici captured the images near the end of his shift, when he stopped by an opening of a Russian photo exhibition in Ankara. Ambassador Karlov was making an appearance at the event and so Özbilici thought that Karlov's availability there would be a good opportunity to get some "filers," or archival headshots of notables and officials for use as file photos.

Russia's aggressive involvement in the lengthy and deadly Syrian civil war had complicated relations between Turkey and Russia, so he thought photos of the senior diplomat might be useful to have ready for upcoming stories.

When Özbilici arrived, the Ambassador began a low-key speech about his homeland. Suddenly a Turkish police officer who was quietly standing behind him leaped forward screaming and repeatedly shot Karlov in the back, shouting, "Don't forget Aleppo! Don't forget Syria!" as the diplomat fell to the floor mortally wounded. While the rest of the shocked attendees took cover, and recoiled from the shocking spectacle and gunfire, Özbilici remained and continued to photograph the assassin as he waved his gun, and shouted slogans at the onlookers, continuing to fire bullets into Karlov's motionless body on the floor. The gunman ordered everyone out of the room and was killed soon after, during the police response.

The riveting series of images of the grim and historic event captured the attention of the world and engrossed the photojournalism profession in discussions. Over time, the image of the shouting rogue policeman standing over the body in the gallery with his arm and gun pointed into the air was identified as a historic and iconic image. Also, it became symbolic of the risks and courageous duties incumbent on those in the profession (Özbilici, 2016).

"Photojournalism is a weird profession," said photojournalist Robert Scheer (2016). The Indianapolis-based photojournalist wrote about the photos in a discussion of "Why

Photojournalism Matters" and compared the work to iconic Pulitzer honored images and lauding Özbilici's composure while under fire. "Some days it's all ice cream socials and food shoots," continued Scheer. "But those of us who do this for any length of time eventually find ourselves running toward explosions or tear gas to get close to the scenes that most people run from."

A highly anticipated entry in the highest journalistic professional honors, Özbilici's images took Photo of the Year in World Press, but was passed over in the Pulitzer Prize competition. Even in the World Press, the philosophical split among photojournalists was evident. Stuart Franklin (2017), a venerable and respected photojournalist who served as the chair of the judging panel, wrote a lengthy opinion piece for *The Guardian* critical of the winning images, voicing sentiments consistent with the categorical imperative and saying Özbilici's photos, in effect, validated "the compact between martyrdom and publicity." In counterpoint, Franklin's peer and fellow judge Mary F. Calvert cited the ferociously honest nature of the images for their utilitarian value: "It was a very, very difficult decision, but in the end, we felt that the picture of the year was an explosive image that really spoke to the hatred of our times" (Khomami, 2017).

AP's Acting Director of Photography Denis Paquin concurs with a largely utilitarian evaluation of Özbilici's powerful images, taking polite but firm exception to Franklin's perspective: "Really, I think [Franklin's] forgotten what the award and what the contest stand for which is basically to honor the person who, you know, put him or herself in that kind of situation" ("Paquin appointed," 2010). Paquin explained,

> If you look at the entire sequence of the work he did. It wasn't a one-photo, 'that's my moment' and I ran away. He stayed there. You know, he basically was in the line of fire. The only thing he had to hide behind was a speaker stand. That's it. He was fairly exposed If the gunman that decided that Burhan was next, it would have been so. So, it's the presence of mind ... of doing his job.

In a discussion of the image's unique value and power, Paquin stressed other utilitarian perspectives, including the image's value as a historical artifact.

> It's not just about today and tomorrow – it's about the historical value of why we do what we do. And so, there was that aspect – how important it was to history The other aspect was how it really drove home yet again a great reminder of how powerful still photography remains, so it's not fleeting the way video is.

"You know, you're making constant judgments when you're in those kinds of positions," Paquin explained.

> And, for seasoned veterans, very, very few are going to run because you're doing your job anyway. So, that's why the reaction from the chair was a little unfounded. Because again, we're there to do a job. We're not thinking of promoting violence. There's always been these long discussions of 'does it lead to a copycat?' or 'Do people do it because they want publicity?' Those are not the kind of things that most photographers are thinking of when they're doing their jobs.

Paquin noted that deliberations of ethics and consequences do happen among editors and gatekeepers when they are about to distribute images or publish.

> You know it's a discussion that we have frequently in the newsroom. We had a lot of these discussions when ISIS was releasing their [beheading] videos, and when it came to how frequently or when are we going to release parts of their video

Paquin discusses some choices as if they are adopting a golden mean approach, where they strive to accurately depict the event, but come short of shocking the reader as well as appear to be an agent for the terrorists or playing into their agenda. Paquin says such decisions are typically made "on a case by case basis."

He continues about how AP forms their own publication standards:

> We weren't obviously going to do it every time, because then we would have looked like you know their mouthpiece – promoting their propaganda. And even when we did choose a still from it, it was usually a moment that was the furthest away from the horrific violence that ensued. So, there's a lot of discussion that goes on in those kind of circumstances, because we know what is being handed to us, so we know that they want a certain amount of publicity for it.

In addition to the historical value, another important consideration for Paquin is "the impact that a photo has on the viewer." The key to a powerful image is that it shows the necessary drama, and emotional content, but doesn't go as far to move the viewer toward total aversion, revulsion or sheer disgust. Paquin explains, "If you shock people to the point where they don't want to see an image, then you're not doing your job. Because you want people to spend time studying that photo ... looking at it ... learning from it"

> It's like reading a part of history or reading a book that you want to remember and you want to go back and study ... you know at first, you may not want to see it because you see it as a body on the ground. But you're going to want to go back and study what's in the photo itself. And that's where it's the information that you gather from it which is incredibly important.

Paquin drew comparisons to other historic and powerful images.

> How many people finally looked at Nick Ut's photo [of the children burned in an accidental napalm bombing during the Vietnam War]? So, you know, at first, it might have turned people off – and I'm certain it had nothing to do with nudity – but it had to do with the screaming face and how horrible it would have been ... but then you go back, and you start going beyond that person, and studying the landscape, and what's going on in that particular photo. You might even do research and find others because for me it's information that anyone who's curious wants to learn something from what we do.
>
> And again, we're at war, where there's civil strife, and we shoot pictures of dead bodies all the time ... and there's ways to do it. Again, if you shock your audience that they're so revolted that they're not going to look at that photo, then you're not doing your job. You really want to do it so that there's enough information that people want to go back and study the moment that you're trying to capture.

"I think it was a hell of a lot of front pages everywhere around the world," said Paquin about Özbilici's well-published images.

The amazing thing, too, is because he stayed, there were a variety of photos. If you didn't want to use that now-historic moment of the gunman standing yelling over the body, there were other images that people could use. So, I suspect that just about every newspaper in the world used something of Burhan's.

Paquin said that, if he were a photo editor at a news organization, he would have published the photo "definitely on the front page, as big as possible. Again – for maximum impact."

Despite the minor debate about the World Press Award outcome, Paquin sees value and some utility in the discussions these occurrences may bring.

I think it's a good discussion within our industry. And hopefully people don't place so much importance on who wins and who doesn't. I think you know it's a morale booster. If it's going to make people you know want to be out there. Winning awards isn't something that motivates – being good at what we do, being consistent at what we do, is.

According to Paquin the key lesson to remember in these discussions happen

when the photographers themselves explain what the process is – I think that it's valuable. You know, basically, whether 'it took me a month to do this project' and 'what it took to do this project,' or listening to Burhan and his emotions and what he was feeling when he shot those photos – I think those things are incredibly valuable.

Paquin reiterates, "I know I'm like a broken record when I'm talking about recording history, but it really is why you become a photojournalist."

References

"Burhan Ozbilici." (2017). World Press Photo. Accessed June 30, 2017 from https://www.worldpressp hoto.org/people/burhan-ozbilici.

Franklin, S. (February 13, 2017). "This image of terror should not be photo of the year – I voted against it." *The Guardian*. Accessed June 30, 2017 from https://www.theguardian.com/commentis free/2017/feb/13/world-press-photo-year-turkey-russian-assassination.

Khomami, N. (February 13, 2017). "Image of Turkish assassin wins 2017 World Press Photo award." *The Guardian*. Accessed June 30, 2017 from https://www.theguardian.com/media/2017/feb/13/ world-press-photo-award-2017-turkish-assassin.

Ozbilici, B. (December 20, 2016). "Witness to an assassination: AP photographer captures attack." AP News. Accessed June 30, 2017 from https://www.apnews.com/eadca282d5d341a79bb464bbadc4fa11.

"Paquin appointed AP deputy director of photography." (March 23, 2010). Boston.com. Accessed June 30, 2017 from http://archive.boston.com/news/nation/articles/2010/03/23/paquin_appointed_ap_ deputy_director_of_photography/.

Scheer, R. (December 20, 2016). "Scheer: Why photojournalism matters." *IndyStar*. Accessed June 30, 2017 from http://www.indystar.com/story/opinion/2016/12/20/scheer-photojournalism-matters/ 95666494/.

Documentary and Advocacy: Interviews with Nick Oza and Stephen Katz

The choice of whether to explicitly pursue advocacy through photojournalism continues to be a robust point of discussion and debate among professionals. Some photojournalists strive to avoid perceptions of advocacy in favor of the classic journalistic core values of objectivity

and impartiality. Others choose to embrace advocacy boldly. And many professionals fall somewhere in the middle.

Nick Oza (n.d.) has been a staff photojournalist at the *Arizona Republic* since 2006, where he has been drawn to stories about social topics such as refugees, immigration, child welfare, women's issues, mental health, and gang-related violence. Nick is a nationally and internationally recognized photojournalist, a four-time Arizona Photographer of the Year, and he was part of Knight-Ridder's Pulitzer Prize-winning team in 2006 for work documenting the effects of Hurricane Katrina.

Oza sees a fine line between activism and journalism but maintains that those in journalism have to be careful not to cross that line, "but still be the voice of a community." While Oza covers social issues with a sense of mission, he is careful to stay true to his espoused core values of journalistic objectivity.

One way to stay on the right side of that boundary is to be careful not to stray into any kind of participatory role with a subject. For instance, while doing a story on "Dreamers" – undocumented immigrants who came to the United States when they were minors – Oza was photographing a young woman who was stumped by the Byzantine task of filling out immigration paperwork for DACA (Deferred Action for Childhood Arrivals). When she asked Oza for assistance with completing the forms, he needed to restrain himself from his inclination toward helping her. "She had no clues how to even fill out the paperwork, and she was asking me 'Do you think I'll be able to get the help?'" He replied, "I'm not a lawyer … And there are many of you like this, and that's the story I want to tell. But you need an expert or a lawyer."

Oza says because he's careful with his boundaries, and honest about his process, people tend to trust him. When covering stories in Mexico and working with locals who were involved in drug or human trafficking, Oza has had to warn subjects of his photos about giving him their names. "People are trusting me and giving me their first name and last name." Oza recollected, "I told them 'There is a possibility your story can come out and your names in the story can jeopardize you. Are you going to be okay?'"

"As a human being you have to explain," Oza continued. "Those people have to live there – so we have to make them aware." "I'm going to be able to walk out when I'm finished, but something bad can happen to them." "These are the sensitive issues and you really have to be careful, as a journalist or a human being."

The genuine interest that Oza has for these populations facilitates his subject's sense of trust that they have in him. This, in turn, facilitates Oza's ability to be more effective in ways that a more detached photojournalist might not be. Oza's still connected with the marginalized populations that he reports on – and it helps facilitate his work through information, tips, and heads-up from the community that he's immersed in. "People can help you if they know what kind of work you're doing," says Oza.

Stephen Katz (n.d.) is more explicit and unflinching about his role as an advocate. "It's hard to avoid the word advocacy," he says. Katz has been a photojournalist at *The Virginian-Pilot* since 2004, where he came from working at the *Daily News* in Bangor, Maine, and *The Freelance Star* in Fredericksburg, VA. He regularly contributes pro bono work for various non-profits and NGOs (Non-Governmental Organizations). While he holds a Master's degree in Journalism (Temple University), he evolved into his life in journalism from spending some time as a social worker after earning a degree in anthropology (Dickinson College). Katz has been named "Photographer of the Year" by the National Press Photographers Association (2008), Northern Short Course (2008), Southern Short Course (2007), among his other regional, national, and international honors.

His grounding in a strong prosocial perspective makes Katz a vigorous and unapologetic advocate about, well, being an advocate. "I think there is an element of advocacy from the get-go in what we do, and I don't think that's anything to be ashamed of."

"Honestly, I think we're kidding ourselves if we don't think there is an element of advocacy in what we do as newspaper journalists," Katz said. "You know, we pursue stories that in and of themselves are advocating for certain communities or neighborhoods."

Katz gives an example on how local news organizations might cover local news:

> You know when the local football team goes to a bowl game, and we send a photographer and reporter down at the pep rally and all ... We are there for the team getting on the bus, and all the celebrations. But we don't have a photographer over photographing the other team in the same way.

Katz observes, "So how 'impartial' is that?"

> I think being an advocate doesn't necessarily mean you can't be objective. I don't think advocacy is a synonym for being subjective. I think they are two different things. I think it's a rich history of newspapers to be an advocate, frankly, for their community. The fourth estate is there to keep politicians, corporate executives, to keep the fat and powerful in check for the ordinary man on the street.

Not unlike Oza, Katz is unequivocal about the importance of establishing trust with those whose stories he tells.

> Subjects are true and honest and open when you're true and honest and open with them. That's when you know you're going to be telling the best stories or making the best images and you can't do that if you come into their home and you're completely mechanical.

Katz offered an example of some recent documentary work that focused on the victims and terrible legacy of Agent Orange. "You know I was teetering between being a photojournalist and being a champion for the cause," Katz recalled. "I pushed that story as far as we could go. There was something that was personal to me. And you know I pursued it with all the energy that I possibly could."

"And I'm not sorry for the way I worked that project," Katz reasoned.

> I think a lot of good came out of it. Nothing harmful came out of it. And you know, those people need a voice. That's what we offer. We often offer the common person – the man on the street – a voice. A mayor, or a senator, or politician, or a celebrity, or a wealthy businessman can have a press conference, and can say things that'll be picked up by media outlets. But there's really nobody but the journalists that are there to tell the stories of the people who don't have that privilege.
>
> You know that I advocate for every subject that I cover. I mean, why wouldn't I? I advocate. I advocate for my best images to run with each story. I advocate for as much space as we can on stories, so I'm clearly advocating for my own work. But that's not a photo – that's a person ... and that's a story that somebody has experienced. And so, again, for me photojournalism has very little to do with photography. Photojournalism is all about building a relationship with a subject. Witnessing what you know the aspect of

their life that we're covering. And then to share that, in an honest way, with people who consume our product. In some ways, it's very businesslike.

A place where Oza and Katz do find strong alignment is the importance they place on empathy as a photojournalist, as well as a strong sense of obligation and commitment to those whose lives they are documenting. Says Katz, "If you don't have empathy and compassion, I just I don't think you're going to make the same connection with readers as you could if you were a human first and a photographer second."

Oza admits that the immersion into the social problems he documents takes a toll on him. "You're a human being. With this type of subject matter, you really have to care about what you're doing – otherwise you cannot really cover it."

> I think you know, ethics-wise, in terms of manipulating photographs … changing or moving your subjects around … or being libellous … or changing reality … or editing pixels or content or erasing things – all that kind of stuff is ethically wrong. But showing compassion and showing empathy to your subject – I don't think that is a violation of any ethics policy.

Katz feels a strong sense of veneration to his stewardship role. "Always remember that it's a responsibility and a privilege that people give us to tell their stories and to be respectful and to be open and honest is the most important thing."

"Again, it's not lost on me that it's called 'taking a photograph,'" Katz observes.

> You know, we're taking something – and so we have to be willing to give as much as we take. And that's giving them the time … and them believing that I'm going to tell their story as honestly as I can… and that I'm sort of a conduit for getting their voice to be heard.

"I mean, it's an enormous responsibility that somebody shares with you their voice, their ideas, their opinion … and then we're responsible for sharing that with, you know, hundreds of thousands of people," says Katz.

"And we better be on the mark."

References

"Nick Oza website." (n.d.). Accessed June 30, 2017 from http://www.nickoza.com/index.
"Stephen M. Katz website." Accessed June 30, 2017 from http://stephenkatzphotography.com/splash.

Citizen Journalism: Interviews with Jim Collins and Emmanuelle Saliba

Jim Collins, Director of Photography at NBC News, and Emmanuelle Saliba, the Senior Editor for Social Newsgathering at NBC News, are two journalism professionals who have particular understanding of how citizen journalism and user-generated content (UGC) can contribute to storytelling. Collins (n.d.) had his origins in newspaper photo editing, and came to The Associated Press's New York headquarters in 2000, where he worked as Photo Desk Manager. He has been Director of Photography at NBC News since 2013. Saliba (2017) oversees five reporters on a team that is responsible for finding, verifying, and acquiring user-generated content for all NBC News brands and platforms. She has been a senior editor at NBC since

2016, where she also started as a Social Media Reporter in 2014. Before NBC News, Saliba had worked as a reporter at *Time* and CBS News.

As a traditionally-grounded visual journalist and editor, Collins says the notion of being a citizen journalist gave him some pause.

> There were those of us who are, you know, came up through traditional photo-journalism and professional journalism, who were a little bit cautious about sort of opening up the gates. There's a certain negative side of UGC, where there's assumption that basically anybody could be a photojournalist.
>
> And the ironic thing is that there is a bit of truth to that. Like anybody can be a journalist, if they're in the right place, at the right time and, you know, they're contributing to a news gathering effort. But it doesn't mean that there's any kind of expertise is automatically bestowed on people who just happen to be witnesses.
>
> So, I think that's gotten very confusing in the conversation in the last five to 10 years, where I think that there's a larger question about whether the overall sort of the perception and reputation maybe of photojournalists has been in some ways brought down a bit. Because you have basically such a flood of amateurs, contributing to news reports.
>
> But having said all of that, I've come around to the way of thinking that, in breaking news situations – and that this is how Emmanuelle operates – securing this material from witnesses on the scene in various places around the world is such a valuable contribution to our reporting, that it's hard to imagine doing without it nowadays. And, you know, there are hazards that go along with gathering this material, but we have so many standards and checks in place, and that's where Emmanuelle's expertise comes in.

Emmanuelle Saliba went on to underscore the value of citizen journalism and UGC, especially in the opportunities it offers to shed light on events where the media hasn't yet arrived. Saliba explained,

> I think we're getting information more quickly and we're getting visual information more quickly because of citizen journalists. So, for example when you think of that Dakota Pipeline protest, most of the footage we were watching and using at the beginning were live streams from the ground from protesters. So, I think in that sense that's a good example of information that's coming to us that we wouldn't get otherwise and also shedding light on an event that we maybe wouldn't have had any visuals of in the past, or at least not right away.

Saliba and Collins went on to underscore an interesting nuance that, in the end, it's not about the person making the content, it's about the content.

> It may sound like semantics – but I think there's a distinction between UGC and citizen journalism. Citizen journalist describes a person. And we are not really concerned, as a news organization, with who that person is who captured the material, whether they're amateur or professional. Our only concern is verification. The actual content is what's important. So, whether it's a photographer who is a professional who threw up a 'hail Mary' to get a lucky picture, or it's an amateur who happened to be in the right place at the right time to compose, you know, one of the best

news photographs of the year. It doesn't matter to us. We're focused on what they contribute to the report.

So, you know, in the early hours of a big breaking story, often, as you can imagine, we see the UGC first, right? It's people who were on the scene. There's no time for any photojournalists to arrive, naturally. And so, we see that material. At some point, we kind of sift through it, we use what we want, and at some point, when the wires start getting material – getting the pros in – we will switch over and look at that. But often, you know, the first on the scene still holds up as the best material. It's just what fits into our overall reporting. And that's why I'm actually very fortunate to sit in close proximity to Emmanuelle and her team. We actually sit right across from each other so in these breaking news situations, it's kind of like a complement. We're filling in the gaps of what we need, and what we don't need, regardless to where it's coming from.

A vital part of using UGC in a visual report is the verification and editing of the work. According to Saliba, the process of vetting "depends on the image." Explained Saliba,

> We have a pretty thorough set of standards. It really depends on what you're looking at. So, if you're talking about video from the ground in Syria that can take a different level of vetting than, for example, an amateur video of a big fire. So, it's a different level of vetting and reporting that needs to be done.
>
> Like for example yesterday, we do some simple things like use Google reverse image search of the news before if it's old. We talk to the person who shot the content. If someone won't get on the phone with you, that's probably a pretty good indication that it's probably not real. We go through a series of different questions that we ask ourselves to verify. But nothing gets used on our end at least we don't approve anything that hasn't been gone through the verification process.

Collins elaborated,

> We verify it and check it just like any good reporter does with any kind of news gathering. You check things out. Does it hold up? Does it stand up? You know, a reporter who is just writing a story will check quotes and verifies in a story, it's the same thing with this visual material that we're gathering.

However, for the conventional photo editing for UGC – the cropping, toning, etc. – a light-handed approach works best for Collins.

> Often I think we don't do a whole lot to UGC. I think, from my viewpoint, part of the *authenticity* is sort of leaving it the way it is. That it's coming from the phone or from, you know, somebody who's not skilled and so, sometimes, if we're going to use it in a display. It depends on its use too.
>
> So, Emmanuelle's team gathers material and clears it and contacts the user for permissions and for verification and then passes it on, or makes it known that it's available to other teams, for broadcast or for web.

That raw and authentic nature of UGC can be an important factor in driving an audience's sense of credence and trust in a news report. Says Saliba,

There are some studies that have shown that user-generated content is trusted more with Millennials [Knoblauch, 2017 and "Social influence," 2017]. I think if I'm a viewer, you're getting raw images unfiltered from someone that witnessed it so I think there's some credibility to that.

Collins agrees. "I think that there's sort of how the language of amateur imagery that's kind of become commonplace now ... and almost strengthening up and conveys an authenticity just by its rawness and it's... 'amateur-ness.'"

The sense of urgency and immediacy that is facilitated through using UGC is often seen as a valuable impression to give an audience.

I think that you see sometimes with news organizations where they Skype with a correspondent, when you know it's not necessary for them to be doing that. There are other means but it conveys the sort of newsy, hurried, 'we had to rush to air and get this out' kind of feeling and that sensibility I think is just pretty widespread.

"But at the same time, you know, compelling professionally produced imagery is still something that's valued," Collins affirmed.

But I think that the language of imagery has been greatly affected by the massive scale of ability of amateur produced images through cellphones and other things. If you look at 9/11 and what we saw in 9/11. You know, I shot film that day and we're only talking about 16 years ago. So, it's really hard to believe.

Saliba interjected, "Imagine 9/11 today."
"Right." Collins continued.

Just the amount of content that would be flooding in from an event like that. At AP we were purchasing walk-ins from people who shot slide film. It really feels like another world. But it was not that long ago and it was really just later that decade when smartphones and the technology advance that it just exploded. And now nearly every event has had some kind of UGC. And it's just amazing. It really is. It's just totally altered the landscape.

An oft-expressed anxiety among visual communicators is that the prevalence of smartphone cameras and citizen journalists have somehow devalued the work of professional and trained photojournalists. Saliba doesn't share in the concern that UGC will somehow replace or usurp the power of photojournalism.

I think it just complements it. Many times, when Jim and I work together, we've seen the first wave of information that comes through social media through user-generated content. And then, the second wave is going to be the professional photographers getting to the scene. Often those photos are going to be better and higher quality and better shot than the first wave. So, we'll often swap it out. Unless it's a piece of content like the Manchester video of the girls running out of the Manchester stadium, which is powerful on its own ["People running," 2017]. You know, in terms of photography, what we use on the cover, none of it was user-generated content.

Collins continued to elaborate,

> No – there was a professional photojournalist on the scene, pretty early on. That one picture from freelance photographer Joel Goodman (2017) of the girl with the ripped jeans was everywhere. It's possible that somebody could have taken that with their phone, but there were a lot of difficult circumstances. First of all, he's pretty far away. He's using a long lens and you have all the street lamps and stuff like that so there's challenging conditions. And so, a pro really needed to make that picture. It's possible and somebody can get a 'happy accident' with a cell phone, but that you can see the skill there.
>
> So, one of the pictures out of Manchester, was clearly a cell phone shot of people on the floor, with debris and smoke and very fuzzy and everything, but it's a very important piece in the in the individual reporting, because it gave you a sense of what actually happened right at the blast. But the next day, when more photographers arrive for vigils and things like that. You have Emilio Morenatti from AP making this extraordinary picture of a woman with her hands covering her mouth, and everybody in the newsroom can recognize that's a picture that takes a certain amount of artistry and professionalism ["Vigils across England," 2017]. Even with the best cell phone that is not going to happen. That comes from years of experience and somebody who really is talented at storytelling.
>
> These things work together. You need those witnesses who are on the ground to get the first wave just like you needed 50-years ago when there was a fire somebody arrived and a reporter just got a quote from somebody. And then, you need the professionals to put it in context and make the kind of impactful pictures that are summaries, in some ways, of the story.

Saliba also discussed the way that the initial UGC might inform newsroom editors and administrators about the nature and magnitude of a breaking story, to help them direct their coverage, logistical decisions, and resource management.

> It really informs us if it's a story or not. For example, with the Paris attacks, seeing that video immediately of someone on the ground as being able to verify that, and then you start making the decision to move people to Paris just because of that witness. And it's not just images or videos that we're gathering. We gather information from them. So, we're talking to them and it's going to inform where we put our journalists, and who we're sending. So, we're doing a lot of interviews. We interview every person that we gather content from.
>
> The Hoboken train [crash] is a good example [Varela et al., 2016]. There was one very clear photo when the Hoboken train derailed. We just saw one image and it showed the train going through the station, and immediately without having to call the police or officials, we knew to deploy people on the scene immediately. We're not waiting for officials anymore.

A number of ethical and legal considerations govern the communications between news content managers like Collins and Saliba and the citizen journalists who share their work with them. Explained Saliba,

> We're also very mindful on how we reach out to people especially during big breaking news and tragic stories. We always make sure that they are in a safe place and that they can talk. It's our policy to never ask them to shoot for us to take photos or videos. We

clear and we try to acquire that piece of content that they shot, but we never ask them to head to the scene of an explosion or fire.

Added Collins,

> That's a very key point ... We do not direct these users. We collect their material and verify it. Directing them is a whole different arrangement. That's basically commissioning somebody to work on our behalf. There are times when we've had people who we've discovered were on the scene and maybe were freelancers and then we can convert to working for us, but that's a different arrangement.
>
> We don't tell the guy who is back in his hotel room after being down in the casino floor in the Philippines, 'go back down and start getting us some more pictures' because what he sent us wasn't good enough [Johnson et al., 2017]. We never do that.

References

"Emmanuelle Saliba Twitter page." (2017). Accessed June 30, 2017 from https://twitter.com/_esaliba?lang=en.

"Jim Collins LinkedIn page." (n.d.). Accessed June 30, 2017 from https://www.linkedin.com/in/jim-collins-83885173/.

"Joel Goodman photography." (May 22, 2017). Accessed June 30, 2017 from http://joelgoodman.photoshelter.com/gallery-image/22-05-2017-Manchester-Arena-Bombing/G0000IBk11yC61sw/I0000wXH8hfL1kks.

Johnson, A., Ortiz, E., and Bratu, B. (June 2, 2017). "Casino robbery ends with dozens dead at resort in Philippines." NBC News. Accessed June 30, 2017 from http://www.nbcnews.com/news/world/resorts-world-manila-gunfire-smoke-reported-casino-philippines-n767241.

Knoblauch, M. (April 9, 2014). "Millennials trust user-generated content 50% more than other media." Mashable. Accessed June 30, 2017 from http://mashable.com/2014/04/09/millennials-user-generated-media/#sQFK_xQ0YGqq.

"People running from bomb explosion Manchester Arena." (May 22, 2017). YouTube. Accessed June 30, 2017 from https://www.youtube.com/watch?v=lFR71zca69s.

"Social influence: Marketing's new frontier." (2017). Crowdtap. Accessed June 30, 2017 from http://corp.crowdtap.com/socialinfluence.

Varela, J., Schuppe, J., Saliba, E., and Ortiz, E. (September 29, 2016). "Commuter train crashes into Hoboken, New Jersey, Station, Killing 1: Officials." NBC News. Accessed June 30, 2017 from http://www.nbcnews.com/news/us-news/commuter-train-crashes-hoboken-new-jersey-station-n656711.

"Vigils across England honor Manchester bombing victims." (May 24, 2017). NBC News. Accessed June 30, 2017 from http://www.nbcnews.com/slideshow/manchester-vigils-take-place-across-england-n763886.

Advertising and Public Relations: An Interview with Lisa Lange

As a strategic communications professional, Lisa Lange knows something about the challenges of ethical persuasion. She is the Senior Vice President of Communications at People for the Ethical Treatment of Animals (PETA) (2017). Lange's organization carries the word "ethical" in its name. PETA is also an organization that is synonymous with controversy and a counter-culture mission to persuade a society to drop its meat-consuming, fur-wearing, and circus-attending habits. It's a messaging mission where images are key.

Lange discussed PETA's approaches within the framework of the five **TARES** principles for ethical persuasion – that strategic messaging should be **truthful, authentic, respectful, equitable**, and **socially responsible**.

Truthful: Lange first spoke of truthful communications. "It is crucial that in everything we do we're truthful about it. I mean we are and we've always been very dedicated to that," Lange said.

> People have to be able to trust us. We rely on the information we get in investigations, for example, to change the way people basically carry out their lives. If we do an undercover investigation, in a slaughterhouse for example, we present that to people through social media, through the mainstream media, and through our own website.
>
> They need to know that what we say is happening. Especially when you consider that those who are hurting animals a lot are the Big Ag companies, fast food companies. Anyone across the board who profits from abusing animals and selling cut-up portions of their corpses, for example. They're not going to be particularly forthcoming in information about how animals are treated, either before they end up on your plate, or how they're treated under the big top in the circus. So, we kind of stand alone in that.
>
> PETA presents the truthful information that allows people to make kind decisions. We, in everything we do and all of our investigations, for example, where there is a law that even minimally which most of them only minimally protect animals, we file complaints. And that can be either on a city level, state level, federal level depending on the law that we think has been broken by the abuse, and with the abuse. And as you know, that those authorities are going to rely on truthful information that you can back up with documentation. And so, everything that we do, we approach that way.

Part of the truthful messaging is to generate their own images for their messaging.

> In general, we prefer to use our own [visuals] because we can go all the way back to when it was shot, or whoever created it. But we have used documentation from other groups. And we get as much information as possible on the veracity of something, Orcas in a tank at SeaWorld, for example, if someone else took the photo, we get all the documentation on where it was shot, who shot it, that kind of thing, and it's key.
>
> I mean, we are in such a visual world now but I, more than anything, we're winning campaigns by showing people what's going on behind the scenes. Video more than anything. Because video tells its own story. So, we can do an investigation that lasts eight months or four months or however long and the video that we end up presenting to the public is going to be cut down because you can't show 24 hours' worth of footage. No one's going to sit through it. But the video footage that we give over to the authorities for investigation, we make all of our footage available to authorities, because they may want to look at all of it.

Too much truth especially if it's raw, unfiltered, and graphic can risk offending, horrifying, or overloading the recipient of the message. So, there is a tension of how do you facilitate blunt truth in the messaging while still maintaining respect for the audience, which is one of the other TARES principles?

"That's the million-dollar question," said Lange. "And it kind of depends on who your audience is. So, if we were somewhere with children, we're going to show something very different than we would to adults."

> It's so interesting because I really have to hand it to people. In general, online, people have a high tolerance for graphic material. And sometimes, we'll put together a video

like the 'Meet your Meat' (2010) video. I think it's 13 minutes long. It's quite lengthy. And it is relentless. It is relentless in showing you what each animal goes through. And we go through each animal: fish, chicken, sheep, cows, pigs. And we show exactly what happened to them, from the time they're babies through the factory farming process to when they're killed. And that is an incredibly popular video. As is our China fur video that shows animals were still fully conscious and able to feel pain, being skinned. One animal is skinned all the way down her entire body and all that's left of her are eyelashes and she's still blinking which is a sign of consciousness. So, that ends up being one of our most popular videos, meaning the most viewed.

So, people have a very high tolerance for it. And maybe it's because they're popular on social media. And people can sit in the confines of their own homes or their offices when they're not working, and probably should be, watching the videos. And it's personal. And it's not necessarily on a big screen. So maybe it's easier to watch on a smaller screen [See Chapter 8].

But we're also able to track it, so we can see if someone clicks on to our China fur video. How long are they staying on? And that'll help inform how we make the next video. As far as getting too graphic, we don't ever worry about showing too much, except if there are children there or if we're having a very small, intimate fundraiser. Typically, people who are going to a sit-down dinner thing do not want to see animals being hacked apart. And we know that. And we also know that the reaction can sometimes be a little hostile. You don't want to do that in an intimate fundraising setting for example. But our belief, and what we have found has paid off for us, is that give people all of the information. They can always turn it off. But typically, what they do is they pay attention, and they read. More importantly, on social media they share it. I think in some cases we have to put warning out for our videos. I'm not exactly sure and I know Facebook does that too. They'll put warnings up. You have to be able to say you're 18 years or older, or whatever, I think.

We want people to share, share, share. And it just doesn't matter, you know, with whom they're sharing. Because honestly what is usual is they share with friends on social media. They're sharing it on Facebook or on Instagram and it goes out to all their followers. So, they conceivably know who's following them.

In her approach to visuals, Lange acknowledged that there is probably no image that would be too graphic for use especially given the tools available in social media.

You know, I can't think of anything. Again, we wouldn't use a really, really graphic photo and, you know, in every venue. But, no, I mean, we know that when we pitch an ad for example, if we do a 30-second spot on vegetarianism or something and if it shows graphic footage, we know that by and large it is going to be rejected by most television stations. So, we may pull back there, only because strategically, we don't want to waste our time putting something together that a station is going to reject anyway. But in terms of education and outreach I can't think of anything that was too graphic.

If it was bad enough that they went through it, the least we can do is be a witness to it. And it's hard. I mean trust me, and I've been with PETA for 25 years this year and it never gets easier. And, you know, I'll watch this stuff and just think I can't sit through another octopus video or I can't sit there, but you know what? Something in me clicks and then I think, 'No... no... no... This is the easy part' having to watch what they went through and they're going through it right now. And if I can watch it, and this is

true for anybody who's seeing our photos and videos online, that if I can watch it I'll be a better ambassador. I'll be able to at least describe what they went through, because certainly I don't know what it feels like. But if I can empathize, if I can watch it, and I can describe what they went through, then maybe somebody else down the line is going to decide 'You know what? It's not worth it to me to eat them, because it's too much pain!'

There are individual supporters of ours who don't send me anything graphic and we have to respect that. But no I really can't think of another example, only because you have the right to not click on something. You know, I'll be on Facebook and I'll see something come up. And boy they get you, because they have the automatic video running now. And so, someone will post something a friend of mine, who maybe works for another animal group, and it will start going, and I'm like I don't need to see that right now, you know. And sometimes I move past it. Everybody has the ability to do that. It's not like we're chaining people in a room and making them watch something. So, it's our job to get the information out there and show people what's going on behind the scenes and it's horrific and it's gruesome and it's not just what you see it's what you hear, because most animals are very vocal. Sheep are not. I mean, that's where they got the *Silence of the Lambs* thing. They would go through torture and not make a sound. A dog will. Most dogs will yell. A mother cow will bellow as her baby is literally being dragged away from her to turn it into a veal calf. And so, she can start continue to produce milk for human beings. She will run after her calf she will bellow and it's crying. Orca mothers cry when their babies are taken from them. One of the most devastating scenes in the documentary *Blackfish* is when that mother swam back and forth after a baby was taken. She cried all night long over the loss of her baby.

So, especially when it's a video, we are obligated to show that to people and they can turn it off. But typically, most don't. And as a result, they make changes. And look at SeaWorld. I mean, look what happened with SeaWorld. *Blackfish* is an incredibly devastating documentary, but it's also been years and years and years of us pounding away and showing people what goes on in video-form that has gotten people to say 'You know what? I don't want any part of that.' And now, SeaWorld is on the run.

Authentic: Lange spoke of the challenges relating to authenticity – especially with regard to attacks on PETA's character. Lange said,

You know, I think it's important to understand, too, that we are held to a bit of a different standard than a lot of advocacy organizations are, or nonprofit organizations are. And I think it's because one of the things that we do is we're challenging people to act compassionately, without any real benefit for them. Now there are definitely benefits to being vegan for your health. But that's not generally why we're asking people to stop eating meat and eggs and dairy. We're asking them to do it completely for the benefit of somebody else.

And so, people also don't like to be told what to do. You know? And we've kind of grown up in this society that values animals, basically on how you can use them. How you can wear them. How you can eat them. How they can entertain you. How we can test cosmetics on them, et cetera. So that's kind of where we come from. People view

animals that way especially in America. And we're challenging people's long-held beliefs about the use of animals.

So, they're always trying to pick us apart. They are always trying to find something that they might call inauthentic. Or they might challenge us on our sincerity on something. So, we're ready for that. Because this comes from a very sincere place. This comes from a very authentic place. It's a horror show out there for animals. And it's our job to very strategically and truthfully and authentically present 'What are the facts?' And you can do with them what you will. But people rely on us to be authentic and sincere. And we simply have to be, because there's just too much at stake.

As authenticity is so related to trust, Lange spoke on how PETA strives to develop a trustful strategic messaging. "You know, we're 37 years old now," Lange said.

So, I think, over the years, people have come to find that we are 100 percent trustworthy. And a lot of that comes from our success. So, when we come to people and say 'we need your help. We need you to write your member of Congress. We need you to only buy products that aren't tested by blinding rabbits or poisoning mice. We need you to stop wearing fur because this is what happens to those animals. We need you to write to such-and-such company to ask them to end some cruel process on animals.' We win those campaigns.

When we did an undercover investigation into Angora farming in China, when we released the footage that we got from the time that we spent on Angora farms because China is the largest export of Angora fur in the world fur, seventy companies within a couple of weeks declared that they would stop selling Angora and some of them took it off the shelves ("Cruel truth," 2017).

And these are major, major companies that were selling it. I think that speaks to the trust that people have that we dot every I, we cross every T. We have all of the information. We have all of the research done before we launch a campaign. We have been that way since day one. And, you know, with enough time behind us, people see that we are a group that can be relied on for that.

Respectful: As she moved on to discuss respect, Lange spoke of PETA's blunt messaging with regard to stewardship and deference to their target audience.

That is where people may argue with us a little bit because with some of our ad campaigns, some people believe [the campaigns] cross the line ("Controversial ads," 2017). And that's where our goal is to absolutely show respect for the audience, but to also give people credit for being able to kind of think beyond the norm and to challenge people. You know, when we talked about 'Meat is Holocaust on your plate,' we had an entire display about that (Banescu, 2003). And we drew comparisons between how Jews and others persecuted and killed by the Nazis were treated in some of the very same ways that animals are treated today. And without getting into all the details, it's pretty clear, it's pretty evident. Isaac Bashevis Singer said it well before us.

Our project was funded by a Jewish woman, who also, very clearly, saw the comparison. As you can well imagine, this inflamed many in the Jewish community. But it didn't make it less right. The comparisons were appropriate. Were they offensive? Not everybody thought so. Some people did think so. We still showed an enormous amount of respect for victims' families and for those who were still alive. But sometimes those

kinds of things, those kinds of *appropriate* comparisons where you compare the act and the actors, meaning those who are behind the cruelty, when you compare them, they are appropriate. It's the same mindset, that thinks that, because this animal can't speak out or because 'I have the power to kill this person.' It's the same mindset. It's an uncomfortable comparison for many people. You know, I completely understand that. But that's the type of thing where we have found controversy. And some might say you're not showing respect for, in this case, the Jewish community. Some of whom got upset about the Holocaust, using the word Holocaust.

Lange maintains that the target audience is not the only group of stakeholders that deserve respect. "Respect should cover other stakeholders and that's really primarily what we're all about," said Lange.

We may not be like animals in many ways, in our needs, in our desires, but in the key ways we are very much like them. They feel love. They suffer pain. They suffer fear. They hunger. They thirst. They love being well cared for. And those are the things that we need to take into consideration, everything we do that affects them.

Equitable: In the TARES paradigm, equitable speaks to a sense of fairness and lack of deception in the presentation. In this context, Lange responded to critics who attacked PETA for use of manufactured replicas of victimized animals in their campaigns (Beers, 2015).

We will use models as in demonstrations to show people what animals go through. In this case, it was the Australian wool industry. We also use costumes which are so very obviously costumes – big giant Orcas or, you know, they're like fluffy carpet anyway. So, we are tasked with trying to get the attention of as many people as we can, when everyone is being called on by social media, by all the cable stations, by all of the causes. There's just so much trying to get people's attention today, more than ever. And so, we're tasked with figuring out the most clever, creative, colorful, visual ways of making people just stop and say 'What's this all about?' So that's our task. And we will use models to do that, sometimes.

Lange stressed that the very nature of their organization's ethical mission would prohibit using real artifacts or victims of animal cruelty in the creative work.

We have shout-outs with real animals, when the circumstances are absolutely 100 percent comfortable for that animal. For example, Joaquin Phoenix just recently did an ad for us with a sheep ("Wool doesn't suit," n.d.). He went with us to a farm sanctuary, and there was one sheep on the premises who really liked to hang out with people. I mean, a number of them did. But this one actually sought out the companionship of people. And just liked standing near Joaquin. And so, he stood and he gave her treats and the photographer just kept taking pictures. And then we got that image that we wanted. That is the only circumstance where we will work with an animal to make our point, when the animals are comfortable. It's a companion animal. They're in a setting that is absolutely comfortable to them. So, you'll see in some of our ads that promote spaying and neutering or not crating your dogs or cats, that we shoot those in someone's home, it's their companion animal. Like my cats would never work because they're too skittish around people, so I would never try. My last dog: same way. But, if someone has a dog who just likes to be in the thick of it, then we'll do that. But that one it always comes down to

this: With us their concerns their desires their needs come first. And if it's not comfortable for them then we won't do it.

Socially Responsible: Lange finished the discussion of the TARES framework on how images drive the organizations focus of social responsibility. "Images are everything for us," Lange said.

> A good example would be the circus. We've done numerous investigations into how the circus treats elephants, and how they live in chains. How they are constantly beaten and threatened with the beatings by bullhooks, which are the fire-poker type rods with a sharp end, they hit the elephants on their ears, and between their toes, behind their knees, on their trunks. The most sensitive areas of an elephant's body to make them perform tricks that are confusing to them and often very uncomfortable to them, because elephants in the circus, the number one killer is arthritis in their feet because they're always living and performing on concrete. And so though, you know, showing the world exactly what goes on behind the scenes, year after year after year, ended up closing down Ringling Brothers this year. This was their last year 145 years in business, we're seeing an end to the biggest circus in the world.
>
> Our images are everything because, what we do is we present these images to people, and say it's very easy to be socially responsible when it comes to animals. You can still volunteer your time with another cause that means something to you, or you cannot. If you have a family and you've got a huge job and you've got too much to do to be able to volunteer your time elsewhere. You can still be an animal rights activist from your kitchen and from your home, just by simply not letting them end up on your plate. Not buying fur. Just checking the labels of your shampoo to make sure that it is registered as a cruelty free product.
>
> So, what we try to do is let people know how easy it is to be socially responsible for animals. And yeah, I mean that's basically it. If you don't pay attention then they suffer so drastically. But it is one of the easiest things you can do.

Lange spoke of how important PETA's ethical foundations were to their function and role in social responsibility.

> Well I mean it's all kind of in our motto that animals are not ours to eat, wear, or to experiment on, use for entertainment purposes, or to abuse in any way. And so, everything we do, we just, you know, it's a hardcore line – it's an abolitionist line.
>
> There are other animal groups out there that think that the end goal should be that animals are treated more humanely on their way to being used by human beings. We don't subscribe to that. It isn't for me to say, 'if you give a chicken a little bit more living space, a laying hen a little more living space and then it's okay to take her eggs and to eventually kill her once she is no longer able to produce.' That's not for me to say: that's her life. It's not for me to say about any other human being, and it's not for me to say about any animal so that is that. That is our tenet. That is what we stick to and we try to do it in a number of creative and incredibly visual ways.

In the end, Lange is surprised at how optimistic she currently is.

> I'm much more optimistic than I ever was really. Because of social media or just because of the change we've seen. I never thought, in my life, would I see the end of Ringling

Brothers. I mean that came and, you know, we're in for the fight. Going to probably perish under my desk, you know, and hopefully at a very, very old age. [laughs] But I mean, the growth of the vegan, I'm incredibly optimistic.

"When I started there was a lot of hostility. But we are a group that is as tenacious as anything. It comes from Ingrid Newkirk (n.d.), who founded PETA. Our biggest problems are apathy and silence."

Lange loves the business of changing minds.

You know, Tucker Carlson, he kind of hates so much of what we do, but he loves dogs. And so, when we've investigated the Chinese dog industry and what's going on there for their skins and for food that kind of thing, that riles him like nothing else. So, you do see that a lot. I've seen people change their minds. I've talked about going on Fox News and having been pounded on by Bill O'Reilly. You know, as the years went on he really mellowed out on the whole issue. Now he always came after me but he conceded that he was against bull fighting. I mean I know it seems like a no brainer [to be] against bull-fighting. He really went for that low hanging fruit there but, he did … at least he did that.

So, I mean that kind of speaks for optimism as an organization like I will never give up. But for everyone there's a door you can open. And sometimes it's their kids. It's like if they're a little older they're like, you know, 'I've always done this where I don't want to change now.' And then, they raise a lovely vegan. And they start looking at things differently.

And so … we don't give up on anybody.

References

Banescu, C. (February 28, 2003). "PETA's 'Holocaust on your plate' campaign sinks to a new low." *The Voice*. Accessed June 30, 2017 from http://orthodoxnet.com/blog/2003/02/peta-holocaust-on-your-plate-campaign-sinks-to-a-new-low/.

Beers, L. (April 20, 2015). "Farmers furious at anti-cruelty ad showing man holding up a blood-drenched lamb with the slogan 'here's the rest of your wool coat'." *Daily Mail Australia*. Accessed June 30, 2017 from http://www.dailymail.co.uk/news/article-3047244/Farmers-furious-PETA-ad-shows-man-holding-blood-drenched-lamb-slogan-s-rest-wool-coat.html.

"Controversial ads: 10 of PETA's worst brain farts." Who Approved This? Accessed June 30, 2017 from https://whoapprovedthis.com/controversial-ads-10-of-petas-worst-brain-farts/.

"Cruel truth of how angora rabbit's fur is removed." (2017). *Daily Mail*. Accessed June 30, 2017 from http://www.dailymail.co.uk/video/news/video-1074612/Cruel-truth-angora-rabbits-fur-removed.html.

"Ingrid Newkirk biography." (n.d.). PETA. Accessed June 30, 2017 from http://www.ingridnewkirk.com/.

"Meet your meat." (November 22, 2010). YouTube. Accessed June 30, 2017 from https://www.youtube.com/watch?v=32IDVdgmzKA.

"People for the Ethical Treatment of Animals website." (2017). Accessed June 30, 2017 from https://www.peta.org/.

"Wool doesn't suit Joaquin Phoenix – compassion does." PETA. Accessed June 30, 2017 from https://www.peta.org/features/joaquin-phoenix-beautifully-suited/.

Virtual Reality: An Interview with Sarah Hill

Sarah Hill, the founder and Chief Storyteller at StoryUp (2017), wants to be in your head ("How virtual reality will change us," 2016).

Hill (2017) describes herself as a "journalist with a little j". The Missouri-based immersive media entrepreneur had her professional origins well-established in more than two decades of broadcast experience. Nonetheless, the veteran journalist and lecturer self-describes as 'little j' because as a VR storytelling innovator, she is willing to push boundaries and conventions to explore the potentials of a new and rapidly evolving way of storytelling.

> The experiences we make are creating meditative experiences and mindfulness experiences in VR, combined with story. When we do stories we don't stage or tell individuals, you know, what to say or anything like that. But, we're kind of a blend of filmmaking and nonfiction storytelling. So, 'nonfiction storytelling' is probably a better way to describe what we do.
>
> All of the tenets of journalism still apply. This is just a different medium. You still need fairness, impartiality, humanity, and accountability. Nothing has changed except you are telling stories in an immersive environment. But VR is a bit like playing with fire.
>
> For instance, we had a big debate in our shop about 'should we clone-out tripods and rigging? That's considered altering the image. And ultimately, we decided, in our shop that, 'yes, we will clone' because that's a production value. We're not altering anything in the shot. We are taking an existing image and covering up a tripod. And we don't think it dramatically changes the story [However, if you drag down on the StoryUp picture on a beach, you will notice the tripod that held the camera].

Hill feels her variety of storytelling further strays from traditional journalism in the way it might affect, directly influence, or even manipulate responses from users.

> We run an immersive media company in Columbia, Missouri and we do nonfiction storytelling, specifically to affect certain brainwave patterns. Our media platform is used for areas of acute stress: blood draws, chemotherapy clinics, corporate wellness, people in nursing homes and assisted living centers, and those who aren't able to travel. We're combining story with neuroscience and measuring what these stories do to the brain. We compound media much as you would compound a drug to try to make people feel a certain way.

Hill's sense of exactly how exposure to VR storytelling affects people is better than just a guess. Partnering with Jeff Tarrant (2015), an Oregon-based psychologist, StoryUp uses the tools of brain monitoring technology and neuroimaging to see what areas of a user's brain are activated and when in order to gain insight to their cognitive and (especially) emotional reactions.

> The anterior cingulate is that emotional processing center in the brain [Decety and Jackson, 2004]. We know from measuring reactions to our stories on Zambia, in which a woman is crawling toward you on the ground because she lacks a wheelchair, the anterior cingulate lights up [is activated] in the brain. What does that say? That says that that individual is processing a sense of empathy for that person who is on the ground.
>
> Flat medium affects the brain. Immersive media really affects the brain in a powerful way. We believe that media isn't just for information and entertainment. It can actually be used as a therapeutic tool to help people. We're creating these experiences in stories, in order to increase the alpha activity in the brain.

We're also working with the gamma activity in the brain. For instance, we have a VR experience where we're using BCI [brain computer interface] to assign values to brain-wave patterns. There is something called the Muse head set. It's a meditation headset that you wear. Whenever your brainwave pattern gets to a certain level, we assign that value to an asset in a unity software game environment. A user is able to essentially control a story with brainwaves and train the brain to behave a certain way. If your alpha activity increases: the sun shines brighter and you go up the mountain on this waterfall. So, there are all kinds of different ways that you can use brainwave patterns with stories to affect them in a certain way.

With her significant journalism background, Hill talked about how she had to shift her own thinking about the dynamics of this kind of storytelling.

We had to totally shift our approach, because in a flat world, the storyteller was in control. They had the ability to control the frame. The frame was how we directed attention. But inside these immersive environments, when the user has the ability to look all the way around, the storyteller is no longer in control. So, we have to use specific storytelling inputs, if you will, in order to control that frame that is moving inside the sphere.

You can use positional audio to get someone to turn their head – a clap or something in the back of the room – and you can use color, shading, and everyone in the room is looking in one certain direction. There's also software called Liquid Cinema that allows you to reorient the sphere on the cutline so that you can make sure that they're looking at that option and direction.

But from a storytelling perspective, you've totally given up that control and you have to place it in the hands of the user and trust that they will be able to see those certain things. Story has depth. It's not necessarily linear, but you can go deeper into stories. It's not just a flat environment.

Hill describes an almost gingerly and finessed approach to how she might subtly direct a viewer's attention through a virtual environment.

It's indirect. There's a great ethical debate going on in the journalism community as well about should we even BE directing the audience's attention. Is that somehow manipulating or being disingenuous to the user if we are showing them what they should be looking at more in a frame, as opposed to them just discovering it naturally?

To me I think we should absolutely be directing the audience's attention, because ultimately people want to be led in stories. That's how we've been lead in stories for generations and generations. We have experiences now or put the headset on and they will say 'it's great but I kind of felt like I didn't know where I should be looking.' And that's an incredibly dissatisfying experience to the user. So, that's one of the things that if there are any ways that you can direct attention in that sphere and make that audience feel comfortable that they are being led to that experience, it's a greater piece of content.

Hill is excited about this nascent and rapidly evolving time in the development of the medium. Among other things, the rapid evolution has improved the quality of the product and made some parts of the production easier. "As VR becomes more democratized, the

cameras are self-stitching. We know in a year we'll be able to have an 8K self-stitching camera that comes out looking great right out of the camera with no post-production."

> We use a variety of cameras. My current camera crush is on the Z CAM S1 (2017). By far the best camera we work with has been the Jaunt camera (2017). It's 24 different cameras set up on array with stereo pairs. We would love to use that all the time, but obviously taking those rigs to the top of a volcano, or in a foreign country, or something like that is not conducive. So that's why we like the Z CAM. It's portable. It has four cameras. We also have had good luck with GoPro rigs (n.d.), although they are a little bit more difficult to use than the Z CAM. They output very beautiful video, very crisp video.

Not only did Hill adjust to the rapidly changing technological environment, but her production approaches also needed to evolve, as VR and 360 users and consumers became acclimated to the immersive medium.

> It's already changing as the novelty wears off. For instance, when we first started we shot our first experience three years ago. It was very new and the etiquette – the editing etiquette, if you will, of the time – was using very slow and controlled shots. You didn't use any quick edits, for anything.
>
> And now of course that's been turned on its head. You can do quick edits, but you do have to be careful about movement. Any kind of movement has the potential to make somebody sick in a headset, so you want to make sure that it's slow and controlled. [A solution to sea sickness among viewers when a camera is moved is to attach a gimbal that minimizes the effect.]
>
> When we show people VR for the first time, here in the Midwest, we still have to remind them that there's other real estate in other places, so it's good to look all the way around. As the user develops in their consumption of content, so too must the storyteller develop abilities to find new and unique ways to not only direct their attention, but to tap into their emotions. The whole discussion of empathy is controversial in the journalism community as well because, should we even be trying to create empathy as journalists? Shouldn't we just be telling the story and letting the audience decide whether or not that's empathetic? Hill continues,

> VR is very different than in the flat world. And we know that from research, that it creates unique memories in the brain. So that's why this platform is a valuable tool for empathy, because you can create those memories. So, after someone sees an empathetic experience, perhaps it's more engaging than if they actually saw it in the flat world. We know this anecdotally and also through research that individuals who watch immersive media longer, they share it more and they like it more on social media.
>
> It's a different kind of media. To me it is the ultimate responsibility of our non-fiction storytellers. You noticed that I didn't say journalists. They are non-fiction storytellers. In some of the content we evoke a sense of empathy. Because by trying to do that you have the potential to affect change. And that's what we are trying to do with our stories. We want people not just to watch them but to actually feel them.

Because the medium is so powerful in the way it affects people, Hill shares the ethical concerns of many, that immersive storytellers need be especially careful with regard to disturbing, violent, and graphic content used in a VR or 360-video environment.

I have a concern about that – not in the work that we do because the experiences that we offer do not place users in a war zone or not in a first-person shooter experience. However, there is research to show that trauma is passed down from generation to generation. And I guarantee you, if we were to do a brainwave assessment in the midst of some of these VR video games, you would see some traumatic experiences and ultimately, it kind of begs the question, 'What is your media diet?' and 'Should you be placing someone in a situation where they feel like they're getting shot?' Because you can really inject trauma and drum up some post-traumatic stress. You could do some damage. So, as journalists, I think the journalism community needs to be cognizant of the fact that the same rules still apply with journalism.

Because the media is different, you need to be sensitive to what you're placing on your viewers' faces. And if it's a traumatic experience, you absolutely need a warning. You need to be having [conversations] in an immersive environment because the potential to do harm could be greater because of how immersive media can make people feel.

There needs to be good quality content. I've seen some amazing killer stuff on all of these platforms. 'Good content always bubbles to the top.'

References

Decety, J. and Jackson, P.L. (2004). "The functional architecture of human empathy." *Behavior and Cognitive Neuroscience Reviews*, 3(2), 71–100.
"GoPro VR website." (n.d.). Accessed June 30, 2017 from https://shop.gopro.com/virtualreality.
"How virtual reality will change us." (May 17, 2016). TEDxCosmoPark. Accessed June 30, 2017 from https://www.youtube.com/watch?v=OO–K7z-oxE.
"Jaunt website." (2017). Accessed June 30, 2017 from https://www.jauntvr.com/jaunt-one/.
"Jeff Tarrant webpage." (2015). Accessed June 30, 2017 from http://drjefftarrant.com/.
"Sarah Hill LinkedIn page." (2017). Accessed June 30, 2017 from https://www.linkedin.com/in/sarahhill1/.
"StoryUp website." (2017). Accessed June 30, 2017 from http://www.story-up.com/.
"Z Cam S1 website." (2017). Accessed June 30, 2017 from http://www.z-cam.com/.

Editing Challenges: An Interview with Judith Walgren

Renowned photojournalist, visual artist, editor, producer, editorial director, and lecturer Judy Walgren is the editorial director at ViewFind.com ("Chronicle photography," 2011 and "ViewFind webpage," 2017). Walgren has a Master of Fine Arts (MFA) from Vermont College of Fine Art that she recently earned after she was the Director of Photography at the *San Francisco Examiner* and the SFGATE for more than five years. Before that, Walgren was behind the camera and/or editing for more than 23 years at such places as the *Denver Post, Rocky Mountain News, Dallas Morning News*, and as part of her own busy freelance business.

Walgren considers herself a "digital first" photo editor, and approaches the editing workflow from that perspective since her time at newspapers.

We were always thinking digitally first because the image can appear in a number of different ways. The image could appear in a gallery that you click through – a gallery where the captions are turned on and off. So, a lot of times the audience is confronted with an image in an online setting with text around it and a caption. It gets to be quite complicated – but more times than not, you're dealing with an audience that has a very short attention span. And the goal of photography – now more than ever, in the history of the world – is to be that element that grabs the audience in.

As a photo editor, especially now working for a start-up, and working for dying media organizations [laughs]… I would see my goal as capturing that audience. So, my initial response to an image is from aesthetics. I'm not just talking about designing graphic aesthetic qualities – I'm also looking for impact.

So, I'm an emotional editor and I'm an emotional photographer. My work is based on interaction – and moment – and expression – and in mood and impact. Okay? So, you have three kinds of photographers. One type of photographer is specifically looking for a light first … then they're looking for composition … then they're looking for moment. I'm the type of photographer traditionally who has always sought the moment and *then* thought about it in terms of the composition and the light. So, I tend to edit from that place too. First, I'm looking for impact. Is this photograph making me feel something? Whether it's joy, anger, sadness, whatever emotion that's the first thing I'm looking for in a photograph. Mood ….

And then I step back once I see the images collectively, I've got the ones that I'm really feeling. Then I step back and I consider the text. And I know this sounds backwards, but ultimately, that's when I start thinking about the text and the story that the image will be accompanying … or not. So, is the image a standalone photograph? Which I tend to do a lot as well as an editor. Then, I'm specifically looking for semiotics [the study of signs and symbols]. I'm looking for what the photograph is going to visually transmit to the audience about the specificity of time, place, culture – how that image fits into visual culture – which is what the MFA has brought to me.

Along with her mission as a visual editor and leader, Walgren feels a social mission too that she incorporates into her decision path in photo editing.

A whole new emphasis of the work that I do as a photo editor is trying to disrupt visual culture … . Or disrupt how photography has shaped visual culture for the last hundred years and to try to consider breaking down, most importantly and most critically the stereotypes that have emerged through photography. I feel very strongly that photography has been the main component that can be aligned with the construct of race and gender and bigoted stereotypes. And so, now, that is literally the first thing I consider, along with the impact of the photograph.

So, a good example is right now I'm working on a piece for students and it will translate over into the ViewFind about street photography. I'm looking for images that I can include in a PowerPoint as well as probably in a blog entry that I'm going to write and curate. And when you search street photography on the internet, you find a long line of photographers: Bruce Gilden (2017), Garry Winogrand (2014), and Scott Strazzante ("Shooting from the Hip," 2017), a great friend of mine. But they're all coming from a certain level of privilege, of race and gender, and as I start searching further, I'm finding other photographers who are amazing. Vivian Meyer, a woman who we all know. And this one photographer who I'm totally enraptured with, Zun Lee (2015), an incredible street photographer. So, for me, instead of putting in the Garry Winogrand images right away, I'm going to think about Zun Lee instead who's an Asian/African-American photographer who documents African-American fathers, et cetera. So that's a second thing I consider.

Now if that photograph is going to accompany a story, I do consider the text from this story. I consider it, but I don't edit off of the text. I am not one of those 'linear' photo editors, where the story dictates how I edit the photographs. What I tend to do is

I'll edit the photographs first and then I'll see how they work their way into the text. Now I always read the story first, okay? Scan the photos, get my rough edit, and then I also read the captions. But I take all of that content into account when I'm putting a story together. So, something I do quite often with the photo editors or the photography editing interns that I work with is I try to break that. I try to break them from editing in a linear fashion because I think that being able to step back from that and consider the document of the photograph in the same gravity, with the same amount of impact as the text, is the way that we need to be approaching everything now. I really feel strongly, now more than ever: It's an 'image first' world. And that is something that the startup that I'm working for now is supporting. Now, we're not there … At all … And I'm finding that pretty much increasingly every day there's a lot of work to do. But I think the conversation has to start right now.

As Walgren ponders the challenges in photo editing, she falls back on her own experiences as a photojournalist to guide her in what type of violent imagery can be published.

So, my background: I covered some pretty significant violent events in our world in the first part of my career, including Somalia in the war on famine in Somalia and Sudan. I was in Bosnia in the 90s and I physically cannot look at those photos anymore. For me it triggers PTSD. I never watched Saddam Hussein being executed. I can't look at that stuff. So, for me, coming from that type of background, I don't want to see it. I don't think it necessarily moves the needle forward. Okay? We are talking about graphic, violent photographs. If people are not going to look at it, then it's not going to do its job, basically. However, I completely disagree with Susan Sontag (2004) and her assertion that people are desensitized to those types of images [in her book, *Regarding the Pain of Others*].

Case in point is the photograph of the young boy who drowned and was lying on a beach – 'Aylan' was his name … . That was a situation of the *Chronicle* that was pretty powerful for me, because it happened as I was getting my MFA. And I found myself kind of caught in the middle of this discussion – the one at the newspaper and the one with the visual artist that I was working with at the time.

So, for me … A photograph has power. A photograph has power to change the world. And I know that is a very lofty thing to say, but it's the only reason why I got into this profession. I believe that because of some very significant things that happened very early in my career and I knew when I saw that photograph, even though aesthetically maybe it wasn't, you know, the most perfect image ever made or constructed. It wasn't Paolo Pellegrin (2017) style, you know, a groovy photograph that you would necessarily see in The World Press, but damn it, it just had me on the floor when I saw it. And I could look at that photograph and take it in. It was shot in a way that was maybe slightly naïve, because the photographer was not like a highly trained and highly shaped quote unquote documentary photographer, but the lack of stylization, right? Just the clear document of that image for me moved me beyond words because in a sense it was as simple as having a child on a beach with a person kind of surveying the scene in a very slightly casual way.

The child was dead on the beach and this person is there who's surveying the number of bodies that are there. Detached is the word I was looking for. I would say detached because I know that that's how that person has to be to do that job well. And so, I ran that photo. I ran it big and I ran it with very, very little text on the first day (Walgren, 2015).

I came back and wrote a piece about it, about my feeling about the photograph, and about how I felt. And I was also reading Sontag's book at the time, et cetera, et cetera ... and about how that photograph, even though it did not, I mean there's no excuse for that happening to anybody, whether it's a child or an adult or anyone. And there's no excuse for that to be happening right now. It opened doors. The doors of Europe were flung open after that image was taken. Now, is there a backlash to that. Absolutely. But at a time when people were desperately trying to get in, that photograph opened doors that day. It took less than 24 hours for things to change quite rapidly. I've seen that also on the other hand. I saw that happen with Kevin Carter's photograph ("Starving child," 1993).

A more recent example for me would be Paula Bronstein's work on the casualties of war so diligently covered for the last 30 years especially in the Middle East and in Afghanistan in particular. The body of work that she produced was extremely emotionally devastating. And bloody at some points. She has a photograph of a hand of a person on a gurney. It's spot-lit under the light from the surgeon. The blood is dripping from the fingers and I just cannot look away from it. You don't want to look at it but you can't not look at the photograph. It's work like this that I want to put out there. I don't want to have a photograph of a body blown apart lying on the ground. I don't want to have a photograph of a leg sticking out of a bucket in an operating room with no context. It's images like that that I just cannot, in my mind, ethically publish, because they don't take me anywhere. So again, when I'm looking at the photographs and I'm trying to make a decision about whether to publish a graphic photograph or not, I'm thinking about it in terms of the emotional impact that that image is going to have, and whether or not it's going to move the conversation forward. I would say but, yeah, I guess the first thing I really consider is whether or not people are going to actually take that image in because that's what we do, we publish images to be seen not images that are gratuitously going to grace the digital or the printed page.

Other editing challenges, like photographing someone in profound grief or reeling from loss, Walgren is also informed about from her own personal moral compass.

So, I think this is really important too, and it comes from my history as a photojournalist and knowing people. And understanding that, more times than not, I've been thanked for being present rather than screamed at.

That's because more often than not, the people in the places that I tended to go, and still am very passionate about, there aren't a lot of people there. There aren't a lot of journalists there. There aren't a lot of people photographing there. There are not a lot of witnesses to other people's pain, to their suffering, and to just the struggle it takes basically some days just to get water. Basically as you saw in not only Somalia that's another level or Rwanda, but in Bosnia. Having to run across an alley just to get water; you can be killed. So every day thinking: 'Water: Death. Water: Death.' Growing up in a suburb of Dallas and then finding out how people lived in most of the rest of the world, was a huge call to action.

On content of a sexual or racy nature, Walgren is informed about whether to publish by clear-mindedly thinking through the question: What is the point? Walgren explains,

So, I mean, ultimately for me there is a difference between pornography and eroticism. Right? Is a news organization an erotic platform? In my mind: No. It's not. So again I

have to think about the photograph from an ethical standpoint. It's not about the sexuality or the erotic intention of the image or the subject matter. It's about the ethics around creating the photograph. I am sick of looking at photo essays of people having sex on heroin. I'm sick of it. So, you're with a heroin addict, doing your thing as a photojournalist, you're documenting their lives. They're high. They don't know. They're wacked. Are they hitting on all cylinders? No. More times than not, when I'm confronted with the image of people having sex, it's coming from a situation of addiction or marginalization.

But, if it's interesting and erotic… . Would I run Robert Mapplethorpe photographs? I would. Some of them. Would they be accepted by the paper? If I made an argument for it. So, that's the thing. If I made an argument to run a photograph, nine times out of ten, they will run it. For example, San Francisco traditionally has been a place where people could walk around naked, no problem. We have this huge story about the new gentrification. There was a law going into the books about making nudity illegal. And the nudists went nuts. So, a lot of photos of full frontal nudity. A lot of protests. Lot of guys walking around with things hanging out, piercings here and there. I mean, ultimately, I'm not running penises. I don't really feel like running women's breasts, unless they're somehow essential to the story. But it's not coming out of any type of conservative feeling or by showing someone's breasts it's a sexual photo. It's just, ultimately, is the photograph good enough without the breast in it to even be published? Nine times out of ten, it's not. Nine times out of ten, the only thing about the photograph is that you got a bit or a part in there. And I don't really see a need to publish sexually explicit photographs in the newspaper or magazine. I don't think it's that interesting. I think it ends up being pornography and there's a whole legion of places to publish that.

Again, like what I am always trying to do is to consider the audience. And I think that, for the audience, they want to see a balance. Right? So, if you're doing a story… let's go back to Paula Bronstein's (2016) book [*Afghanistan: Between Hope and Fear*]. Her photographs have the amazing spectrum of imagery. Horrible photographs of people cut up in pieces on the gurney in Cabo, and then incredible photographs of women, even though they've been disfigured, in painful situations, experiencing a sense of joy. And I thought about Paula's work and was trying to decide whether or not I wanted to look at the photographs or even publish them. I started to consider the way the audience would see it and the way I would want to see it.

Walgren admits that being a mother has guided her photo editing and consideration of the audience as well as being informed by her own experiences in the field.

I've had a lot of trauma in 30 years. I've seen too much. And I'm the first one that will acknowledge that. And I wish I could un-see years of my life, actually. But in the end, it also gives me a greater sensitivity when I am considering the audience that has never seen or experienced trauma like this.

I am also a mother of a 10-year-old. I think a lot about my son when I'm editing, and about how I want to introduce him to the trauma and the pain and suffering that is in the rest of the world. But how can I do that in a way that doesn't leave him damaged? Did he see the photograph of the child dead on the beach? Absolutely. I made sure he saw it and I talked to him about it. Did he see the photographs that John Moore (2007) took of the assassination of Bhutto? No. Because it's not going to do him any good. The context for him is just not there. So why is he even having to look at a leg lying

detached on an asphalt street? It's not going to help him. Has he seen the photograph of the man standing with the carnage around him, you know, looking to the sky? Yeah. He's seen that. The way I've been operating the last few years is how would a 10-year-old receive this? I think ultimately, especially in this country, with this audience, even though digital can be worldwide, that's probably the mentality of most of the people who are engaging with the work in America. They're probably coming at it from the eyes of a 10-year-old. They haven't gone through their visual adolescence yet.

Being able to thoughtfully discuss an image's visual meaning is key to a photo editor's skills.

Other than a visual literacy that a photo editor brings to the table, an expert eye in visuality and how that image fits into this idea of an archive and visual culture, being able to articulate why that photograph does those things is half the job. I think more often than not photo editors are not trained correctly in the ability to articulate.

For me, I'm passionate about photographs, about the power of visual communication, and the importance of visual storytelling. I very rarely am unable to passionately move the person who I am trying to advocate to. There have been a couple of times when that has happened. But in the end, I would say it didn't work out well for the person that didn't follow my recommendation, for the sole reason that I don't pull that out of the hat unless it is important.

So, there is also this understanding of when do you do that and when do you just kind of go, 'Okay, how important is this?' I think really supporting photo editors and photographers to be able to understand within themselves the right to survey themselves and to feel confident that their intuition and then their expertise is going to guide them in the right direction when you pull that trigger. When I decide: 'this is really important,' I'm not going to lose that argument. It's critical. You have to be able to know how to pull that handle when you need to.

As Walgren talks about how and when to make arguments on behalf of images, she advocates an "egoless photo editing" approach.

I mean, it's always the greater good for me [a utilitarianism approach]. Would I be a great photo editor for *Vogue*? No. I would be a massive failure at *Vogue* for lots of reasons. For me, it's the greater good and always has been. Pulling your ego down and really approaching your work from this idea of the greater good. What is going to impact a greater good? Now this is a different way of thinking than what I was taught. I was taught that the photos follow the words. I pushed that envelope literally since I was still in school, to be quite honest. I never really believed that. I've always believed that photos should lead the words. And actually, that's how I worked best with writers. I worked with some of the most vividly eloquent writers in the world, including Chris Hedges, for many years. In any event, I really feel strongly that it's not only the greater good for the subject, but it's the greater good of the audience. How do I serve the audience the best way possible? Giving them a photograph that's going to get them out of their chairs? Giving them a cool little video that's going to make their day because some kid got to be Bat-kid for a day?

I'm always kind of thinking about the audience, the people, the world and how that content is going to be integrated into their life, and then into their visual history.

References

Bronstein, P. (2016). *Afghanistan Between Hope and Fear.* Austin, TX: University of Texas Press.
"Bruce Gilden webpage." (2017). Accessed June 30, 2017 from http://www.brucegilden.com/.
"Chronicle photography: Judy Walgren, director of photography." (March 4, 2011). SFGate. Accessed June 30, 2017 from http://www.sfgate.com/news/article/Chronicle-Photography-Judy-Walgren-director-of-2379895.php.
"Garry Winogrand." (2014). Metropolitan Museum of Art. Accessed June 30, 2017 from http://www.metmuseum.org/exhibitions/listings/2014/garry-winogrand.
"John Moore." (2007). World Press Photo. Accessed June 30, 2017 from https://www.worldpressphoto.org/collection/photo/2008/spot-news/john-moore.
"Paolo Pellegrin." (2017). Magnum Photos. Accessed June 30, 2017 from https://www.magnumphotos.com/photographer/paolo-pellegrin/.
"Shooting from the hip." (2017). Scott Strazzante. Accessed June 30, 2017 from http://www.shootingfromthehipbook.com/gallery.php.
Sontag, S. (2004). *Regarding the pain of others.* New York: Picador.
"Starving child and vulture 1993 Photograph by Kevin Carter." (1993). *Time.* Accessed June 30, 2017 from http://100photos.time.com/photos/kevin-carter-starving-child-vulture.
"ViewFind webpage." (2017). Accessed June 30, 2017 from https://viewfind.com/frontpage.
Walgren, J. (September 3, 2015). "Can image of drowned Syrian refugee child save lives?" *San Francisco Chronicle.* Accessed June 30, 2017 from http://www.sfchronicle.com/thetake/article/Can-image-of-drowned-Syrian-refugee-child-save-6484122.php.
"Zun Lee photography." (2015). Accessed June 30, 2017 from http://www.zunlee.com/streetportraits.

Let Empathy Be Your Guide: An Interview with Kenny Irby

The notion that journalists should embrace empathy as a core professional value is nothing new to Reverend Kenny Irby (2010). He is a nationally known veteran journalist, editor, and newsroom leader, as well as a consultant and an affiliate at the Poynter Institute on topics including diversity, ethics, and visual journalism. From contributing to Pulitzer projects in the newsroom of *Newsday*, to being a juror on a Pulitzer committee in 2007, Irby in 2016 was appointed by the mayor of St. Petersburg to be a Community Intervention Director. From journalism to a police department, he creates solutions for young people who are at risk of ending up in jail, or worse.

Irby appreciates that the concept of empathy has gained some traction in recent times in the dialogue among journalists.

> I think that a conversation about empathy has become a richer conversation and a more relevant conversation in contemporary times – particularly in journalism circles and social services circles. I think for journalists, the idea of empathy helps us get closer to truth-telling by way of accuracy.

Irby feels that there "has been a major disconnect between the journalists who are covering the news and transmitting that news with the audiences, and many of the communities that they are covering."

Irby wholly rejects the notion that journalists can go too far or get carried away with empathy.

> I don't think we talk about it enough. I think you know the Zeitgeist that is being acknowledged here and the 'buzzword' is one that still is very much inside journalism, and maybe inside some halls of academia. Where we really need to expand that

conversation is amongst the masses. And you do that through media, through social media, through traditional journalistic media, and the like.

According to Irby, the reluctance to engage in empathy has led to "great vulnerability in terms of its accuracy and its authenticity." Irby elaborates:

> There has been the lack of empathy, a lack of appreciation of diversity. So, there's a direct corollary that I've taught through all my career and experience that when we are talking about finding truthfulness and reporting greater accuracy and validity to our coverage, it moves us in that place where it's not just about a racial conversation in terms of black and white, or black and Hispanic, or Asian and Hispanic or whatever. It is about perspective worldview and ability to appreciate that 'your opinion is no match with somebody else's experience.'

Irby coined the quality of understanding in a journalist as an "empathy quotient," and this should be considered key to any journalist's success. "To be able to appreciate that because you have not experienced something," Irby explains,

> it doesn't devalue the authenticity of that of the other person's point of view, or life experience to be more intelligent about and more receptive to empathic engagement. It allows the journalist, the reporter, and the reader/viewer to have a better appreciation and understanding of really what that experience that you're reporting about is. You know I think that the realities of empathic connections and sincere understanding of otherness is a good thing, and it helps us build bridges, gain perspective, and insight and to report factual information across disciplines, about complex subject matter and topics.

In his work in the municipal sector, Irby has embraced restorative practices, which is a social science movement that seeks to develop healthy communities and address social problems through use of increased social capital and pro-social action. He finds it refreshing that some journalists have discovered ways to do the same.

> So, there's a 'restorative narrative' push within journalism, writing circles, and communication circles. In order to move from penalty and punishment, we need to move to ideas about restoration and reconstruction and rejuvenation. And you can't move in that direction without empathy. Sympathy is not enough. To be on the outside and just kind of looking in and having a cursory appreciation for someone's sorrow, pain, or misfortune is not enough. It's only when you move to the level of empathy where there's more of a psychological appreciation for that pain, that harm, that disconnect or disrupting in one's life, that you are really moved to conscious action.

Irby wants to see more of a conversation about restorative practices among journalists and in journalism schools.

> I think it offers a practical framework that moves from the analytical side of journalism, where we're observing issues and reporting on what we see to a restorative practice approach through the prism of empathy that moves us to a more conscious and a more effective form of solution-oriented coverage and journalism. And we need more solutions. It's easy to identify the dilemma. It's a much more difficult proposition to dive deep and

to offer solutions and corrective practices to our many, many challenges in society. You won't hear me argue against a solution-based approach.

Irby feels that this conversation about journalistic core values should be revolutionary in nature.

I think we're long overdue for a change. There is a balance to everything. There's a season and there's a time and place and the need for analysis. I was in a breakfast conversation today with some senior editors discussing the value of editorials and commentaries in the realm of traditional journalism. And I think the whole idea of watchdog journalism holding the powerful accountable and then the examination of solutions is what has been lacking. That's why so many in this society have disconnected I think from journalism because mainstream media, for the most part, have disconnected from what the problem is. The problem is when people who are in need feel that the role of journalism needs to be more involved within a democratic society. 'Democracy dies in the darkness.' If we don't shine a light on the issues that need to drive that day and what the solutions are, then democracy dies. And as democracy goes, so goes the American culture and what it's about. So, yes, I think journalists should be more actively celebrating the solutions.

Irby outlines the challenges which include business models, political polarization, and a general reluctance to be led by empirical knowledge.

Our challenge is the traditional model of journalism that a financial or an economic underpinning does not really allow that anymore. We've had so many people cut out of the process. The demands for clicks and responses on digital devices have had an adverse effect on the ability to do what I would just simply call a higher quality. Higher quality journalism is where we need to have investments. The big challenge for media leaders is the question, how do you find that balance? How do you cover the basic nuts and bolts of the day?

And you also have a higher quality of doing that now with *The New York Times* and its coverage of major issues. For some reason, there seems to be an attitude in America that only the 'liberal media' covers the pressing issues of the masses. It's so politicized, instead of just evaluating responsiveness, and the primary issues of the day.

I look at coverage that the *Washington Post* has done – not only on the political front, but some of the coverage that has been done on global warming. Coverage that the *Tampa Bay Times* has done on education and the education gap and their 'Failure Factory' series in this place [the Gulf Coast of Florida] where I engage and live. I've seen a lot more impact on the infrastructure – whether it's education or local government – and on dialogue. The *Times* just did a series called "Hot Wheels" and it's an exploration of auto theft in west central Florida. It took about a year to do that report and investigation. They presented it as a way to explore what is one of the central issues that involves teens involved in illegal activity. It's a level of new nuisance crime to have your car stolen. It's a pain to have your car broken into. I've had my car broken into on our driveway. So those kinds of things are real and relevant to people. At the end of the day, it's also a personal responsibility, because in upwards of 87 percent of the auto thefts in our county it's been because the cars are left unlocked and many times the keys are in the ignition. This is a call to action for personal responsibility by citizens in the community, so we all

examine what the solutions are to a growing problem. I say we look at that kind of coverage at a local level. Then more citizens will be more inclined to support and to have greater appreciation or regard for local media. It's purely through that empathic prism that we're talking about.

Irby thinks that the road to a higher empathy quotient starts with a strong effort in reflective thought, self-examination, and an effort to burst out of one's protective bubble.

You know, I think the biggest impediment to empathy is a lack of relationship and a lack of connectedness. We don't know our neighbors anymore. We don't recognize that America is a nation founded on – and not to politicize this in anyway – it's just a truism that we are a nation of immigrants. We are a nation where people are valued because of who they were, not from where they came from. Now we've become so disconnected in our relationships. We drive into our communities. We go into our homes. We spend time in those homes and rarely discuss with our neighbors or people who have any level of difference from us. Because of digitization, we go online and we're more inclined to seek affirmation to our point of view, as opposed to being open to this great serendipity of learning from other perspectives, other worldviews, and other intellectual articulations about the issues.

And so, we need to find for ourselves an appreciation for us all being, as Dr. Martin Luther King, Jr. said, 'inextricably connected by a single garment of destiny,' so that destiny that we pursue is not pursued in isolation. We have neighbors. We have family members. We have colleagues that we should seek to be open to human relationships. That's what makes us special in the cosmos, many of us believe. But I think moving beyond isolation is the only way that we really turn the corner on this. I think we have the capacity and the potential. The real issue is: Do we have the will? Or another way of saying: Do we have the desire to move beyond our comfort zone?

Ultimately, Irby maintains that the road to empathy begins with a look inward – an "examination of self." Then, he adds, look at "the manifestations of one's self or one's occupation of one's heart and then, in that examination, have an honest willingness to evaluate." To that point, Irby sees a key component to this kind of self-examination is to examine our own words and language within journalism. Visual communication professionals should think about the jargon they use every day to talk about what they do. Irby has long exhorted photojournalists to think about what it means when they say they "shoot" pictures, subjects, or assignments.

I've been engaged in this dialogue around the vernacular, etymology and nomenclature in journalism for 35 years or more. I became responsive to this as a freshman in 1979 at Boston University when I had Professor Harris Smith who sent me out to go 'shoot some photos.' And that was not a term that I was accustomed to hearing because my first photojournalism teacher in junior high school, when I first got the bug, always talked about 'making pictures,' and 'let's go make some pictures.' And so, it was a place where I intellectually had to start an engagement with myself about how I'd describe what it was that I did. You know, I made photographs ... I didn't just take photographs, because – and maybe it was because of my spiritual upbringing – I thought to take something was synonymous with stealing something, that you didn't have a right to do.

But nonetheless, as I pursued through the photojournalism track at Boston University, I was always engaged in this. Even at a very young age, as an African-American, I was sensitive. And this was just me, personally. So, this is an unpacking of my own experience, which is fairly impacting for me to have this conversation with my adversity towards 'shooting.' And I completely own it.

Because – just a slight digression in the conversation – yesterday my aunt sent me a series of photographs from November 1968 when my first real non-family mentor was murdered. He was her boyfriend, a police officer, who I had grown very attached to, who was working an undercover assignment, and was mistakenly killed on a drug raid. And I remember all the conversation about him being shot. So, I've had a negative association with 'shooting.' And so of course as a city boy I hadn't been around a lot of guns without a negative association. And so, when it came to journalism, and me developing in my early career as a journalist I couldn't quite understand why so many photographers were referred to as 'shooters' and talked about what they did as 'shooting.'

And then the second layer on that was an appreciation for war photography and what David Hume Kennerly (2017) and others were engaging in Vietnam. And they were seeing themselves as 'shooters.' There was a book (1979) that was published around that time, in the 1970s about shooting. It glorified these photographers who were alongside soldiers who were shooting with bullets to take lives and these photographers who were in the same proximity and had the same attentiveness and passion about what they were doing. But they were then associated as 'shooting' photographs that would inform the world about what would happen.

So, in Pontiac Michigan and Wilkes-Barre Pennsylvania, and Philadelphia at the *Philadelphia Daily News*, at the newspapers where I started out, I would always engage the professionals and senior photographers and for the reasoning for this dialogue. And it was always almost not a thoughtful response: 'That's just always the way it's been.'

I always saw a negative association with my writing colleagues around that – that it was fairly mindless activity. As we grew into the 80s, and we saw lots of gang activity and violence, where it was in association with the negative things that were happening in the community, and what the photographers on the staff did. The photojournalists did 'drive-bys.' They did 'quick shoots …' and it never had a really positive impact on the thinking about colleagues and the relationships that were trying to be developed, by some of the legendary newsroom leaders like Bob Lynn (2016) and J. Bruce Baughman (2011), and all the folks who in that era were like the iconic picture editors and leaders. But it was Jim Dooley ("Q&A," 2014) who was really receptive to my ideas as a young photographer and my pushback. In 1988, this really started for me: I showed up and I was not a shooter. I kind of ceremoniously declared, that, you know, 'I'm a photo-journalist.' So here I am, the youngest new guy on the staff, espousing a different attitude and outlook about what I did. And it caused some tension in some places. However, in more cases than that, it created an opportunity for dialogue, where folks said, 'Tell me more about that. Why do you feel so passionately about that?'

Fast forward to 1995 when I got to Poynter and I was challenged with the responsibility of creating a new tradition for photojournalists in this historically writer's retreat and oasis. It allowed me to sit with some major voices in journalism like Roy Peter Clark (2017), great writing coaches like Don Fry (2010) and Mario García (2017), and to begin to have a new dialogue about what photojournalists did, and how they did it, and why they did it and where the similarities were and where the differences were. I

initially made a decree that I was representing a group of individuals who, in the world of both broadcast and print reporting, were equal members of the news gathering teams. They were equal reporters – yet they were reporters with cameras. And I committed to obliterating the language around 'shooting' and redirecting the view about what was done in concert with, and in similarity, and maybe even empathically with what journalism was all about, and those journalists who were doing that work.

And so, with heartfelt intentionality, I have pursued a language that was more relevant of the news gathering experience, as reporters/photojournalists are capturing and documenting and even more directly photographing – instead of a shorthand language – that within journalism circles, built greater credibility and connectedness with what the broader newsroom was all about.

That's internally. Externally, that argument has been an easy sell. Because within broader society we begin to live in a much more violent world in America, which was not just only in Vietnam where there was conflict but these conflict zones where people were always shooting and attacking and taking the lives of each other whether that's in Africa or in the Middle East or in Yugoslavia, in South America in Colombia. Places where crime was happening and crime is always associated with gun violence, and therefore were great discussions about shooting at home here in America. The idea of shooting and gun violence became a much bigger issue. And again, there was a need to differentiate and disconnect from that violence. And then, by extension, to celebrate the noble and honorable works that these individual photojournalists that were always rushing towards the epicenter of the drama and trauma of life with the great honorable intent of being the eyes of a community not to take light or to shoot or to harm.

Irby's hope is that, among other things, the road to empathy might lead to a greater understanding and appreciation of diversity and its value in solving social problems. He shared his thoughts after a recent visit to the United States Holocaust Memorial Museum in Washington (2017).

A real struggle is for us to grow beyond this stalemate we seem to find ourselves, where there's more of a 'divide and conquer' mentality …

I think this is really important for us to understand that diversity is a rich asset – not a liability – in the pursuit of solutions. We need to understand that every human being has the capacity to contribute and what we need to do is be a part of a culture and a society and a world that celebrates those differences as we move to higher levels of efficiency in our country and a higher level of acceptance in our world. Because we all have the capacity to contribute. It's just a matter of creating a climate where we all are allowed to continue. And we're all able to be educated, to be valued in diverse opinions and views and that only happens through two positive relationships and through dialogue.

It's through dialogue that you build relationships not diatribe.

References

"Bob Lynn website." (2016). Accessed June 30, 2017 from http://boblynnvisioncourageandheart.com/.

"David Hume Kennerly." (2017). Accessed June 30, 2017 from http://kennerly.com/.

"Donald Fry." (2010). Poynter. Accessed June 30, 2017 from http://about.poynter.org/about-us/our-people/donald-fry.

"J. Bruce Baughman." (2011). Indiana Journalism Hall of Fame. Accessed June 30, 2017 from http://mediaschool.indiana.edu/ijhf/j-bruce-baumann.

Kennerly, D.H. (1979). *Shooter*. New York: Newsweek Books.

"Kenny Irby." (2010). Poynter. Accessed June 30, 2017 from http://about.poynter.org/about-us/our-people/kenny-irby.

"Mario García website." (2017). Garcíamedia. Accessed June 30, 2017 from http://garciamedia.com/.

"Posts by Roy Peter Clark." (2017). Poynter. Accessed June 30, 2017 from http://www.poynter.org/author/rclark/.

"Q&A with James Dooley, The Alexia Foundation." (June 23, 2014). The Brownbill Effect. Accessed June 30, 2017 from https://www.thebrownbilleffect.com/blog/qa-with-james-dooley-the-alexia-foundation/.

"United States Holocaust Memorial Museum." (2017). Accessed June 30, 2017 from https://www.ushmm.org/.

APPENDIX B: THE 10-STEP SYSTEMATIC ETHICAL ANALYSIS

1. What are the three most significant facts of the case?

2. What are three facts you would like to know about the case?

3. What is the ethical dilemma related to the case?

4. Who are the moral agents and what is each person's specific role-related responsibilities?

5. Who are the stakeholders and what is each person's specific role-related responsibilities?

6. What are the possible positive and negative values of all the moral agents and stakeholders named in Steps 4 and 5 and the two most opposite values from all the lists?

 Most opposite values:

7. What are the loyalties of the moral agents and stakeholders named in Steps 4 and 5 and the two most opposite loyalties from all the lists?

 Most opposite loyalties:

8. For each of the six moral philosophies used in this book describe either a justification or a criticism that can be applied to a moral agent or a stakeholder named in Steps 4 and 5 in the case study.

 Golden rule:

 Golden mean:

 Hedonism:

 Categorical imperative:

 Utilitarianism:

 Veil of ignorance:

9. What creative and/or credible alternatives could resolve the issue?

 Creative:

 Credible:

10. What would you do as a member of the media?

APPENDIX C: CASE STUDIES USING THE TEN-STEP SEA

Case Study One

On October 3, 2016 news broke that Kim Kardashian West had been held at gunpoint in Paris, France. According to several media outlets, five masked men dressed up as police officers broke into Mrs. Kardashian West's Paris residence and tied her up to lock her in a bathroom. After being gagged and tied up, the robbers managed to steal several of her expensive valuables. Hours after the robbery had occurred, MediaTakeOut.com reported that Mrs. Kardashian West had faked and lied about the whole robbery. Days after the robbery, she decided to sue MediaTakeOut for libel as they had published three articles which had attacked her character, as they had suggested that her robbery was a publicity stunt. Mrs. Kardashian West and the media outlet ultimately reached a settlement in which they published a retraction claiming that she was actually robbed.

Case study written by Genisse Aguilar

Weaver, H. (October 25, 2016). "Kim Kardashian settles lawsuit." *Vanity Fair*. Accessed June 30, 2017 from http://www.vanityfair.com/style/2016/10/kim-kardashian-settles-lawsuit-with-mediatakeout.

SEA Analysis

1. What are the three most significant facts of the case?

 Kim Kardashian West reported a robbery.
 The MediaTakeOut website wrote that West lied about the burglary.
 West sued the media outlet.

2. What are three facts you would like to know about the case?

 Did a burglary actually take place?
 What is the credibility of the reporter for MediaTakeOut?
 What were the terms of the settlement?

3. What is the ethical dilemma related to the case?

 Economic influences.

4. Who are the moral agents and what is each person's specific role-related responsibilities?

 MediaTakeOut: Report and publish news stories.

5. Who are the stakeholders and what is each person's specific role-related responsibilities?

 Kim Kardashian West: Maintain celebrity status and business and be a wife and a mother.

6. What are the possible positive and negative values of all the moral agents and stakeholders named in Steps 4 and 5 and the two most opposite values from all the lists?

 MediaTakeOut: Haste, indiscretion, creativity.
 Kim Kardashian West: Vanity, ambition, honesty.
 Most opposite: Haste vs. honesty.

7. What are the loyalties of the moral agents and stakeholders named in Steps 4 and 5 and the two most opposite loyalties from all the lists?

 MediaTakeOut: Website.
 Kim Kardashian West: Herself, her family, her business.
 Most opposite: Website vs. West.

8. For each of the six moral philosophies used in this book describe either a justification or a criticism that can be applied to a moral agent or a stakeholder named in Steps 4 and 5 in the case study.

 Golden rule: MediaTakeOut agreed to a settlement in order to prevent further grief from the story.
 Golden mean: Other media entities should have made sure the reporting from Media-TakeOut was accurate before including the story in their daily coverage.
 Hedonism: MediaTakeOut clearly wanted to generate publicity for its own website.
 Categorical imperative: When threatened, Kim Kardashian West must defend herself.
 Utilitarianism: Kim Kardashian West used the lawsuit to educate journalists to report the truth.
 Veil of ignorance: MediaTakeOut managed to accomplish an astounding feat – for the general public to feel empathy for Kim Kardashian West.

9. What creative and/or credible alternatives could resolve the issue?

 Creative: Use a time machine to warn Kim Kardashian West of an impending burglary.
 Credible: Make sure the facts are correct before publishing a story.

10. What would you do as a member of the media?

 If pressured by an editor at MediaTakeOut to write a sensational, false story, I would pass on the assignment and start looking for another job.

Case Study Two

Journalists often claim that their calling is to shine light into dark places and to give voice to those who have none. But some stories are especially hard to tell, and some voices need to speak for themselves. This is especially true of refugees, many of whom have lost almost everything: their homes, their countries, their professions, sometimes their families. They are starting their lives all over, often in transit, with nowhere to call home.

In response to this dilemma, British photographer Beatrice-Lily Lorigan and the NGO "The Refugee Info Bus" handed out 40 disposable cameras to refugees (mostly Sudanese) in Calais, France, and asked them to document their experience. They hoped the photographs would help outsiders to understand their experience, the terrible conditions they had to endure, and the shared nature of human experience. Among the collected photographs include a lost teddy bear, refugees lined up for food, and a painted sign that read, "Mother, Father, I hope I see you again."

Case study written by Stephanie A. Martin

"Refugees in Calais tell their stories through photography." (February 8, 2016). Observers. Accessed June 30, 2017 from http://observers.france24.com/en/20160802-calais-refugees-tell-stories-through-photography.

SEA Analysis

1. What are the three most significant facts of the case?

 A mission of journalism is to give voice to the voiceless.
 Still cameras were given to refugees.
 The amateur photographers mostly made pictures of personal objects.

2. What are three facts you would like to know about the case?

 How were the refugees chosen?
 Were the refugees offered any photographic training?
 How were the images displayed?

3. What is the ethical dilemma related to the case?

 Privacy. Did the photographers give consent on how their images would be used?

4. Who are the moral agents and what is each person's specific role-related responsibilities?

 Beatrice-Lily Lorigan: Create and run the project, process images.
 "The Refugee Info Bus": Fund the project, arrange for publicity, arrange for a display.

5. Who are the stakeholders and what is each person's specific role-related responsibilities?

 The refugees: Accept cameras, take pictures, give images to organizers.

6. What are the possible positive and negative values of all the moral agents and stakeholders named in Steps 4 and 5 and the two most opposite values from all the lists?

 Beatrice-Lily Lorigan: Understanding, education, reputation.
 "The Refugee Info Bus": Understanding, education, awareness.
 The refugees: Curiosity, communication, trust, naivety.
 Most opposite: Education vs. naivety.

7. What are the loyalties of the moral agents and stakeholders named in Steps 4 and 5 and the two most opposite loyalties from all the lists?

 Beatrice-Lily Lorigan: Refugees, project, herself.
 "The Refugee Info Bus": Project, itself.
 The refugees: Project, themselves, family members.
 Most opposite: Beatrice-Lily Lorigan vs. refugees.

8. For each of the six moral philosophies used in this book describe either a justification or a criticism that can be applied to a moral agent or a stakeholder named in Steps 4 and 5 in the case study.

> Golden rule: Allowing the refugees to communicate their world through images might have helped them to overcome their adversity.
>
> Golden mean: Rather than take pictures, Beatrice-Lily Lorigan gave the refugees a voice through their pictures.
>
> Hedonism: If donations were given, did any of the proceeds go directly to the refugees and their families?
>
> Categorical imperative: An NGO is charged to help groups of people when government agencies are slow to offer assistance.
>
> Utilitarianism: By showing the world the images taken by the refugees a better understanding of their plight is communicated.
>
> Veil of ignorance: Others may look at the subject matter of the images taken and see familiar objects (teddy bear) that communicates empathy for the refugees.

9. What creative and/or credible alternatives could resolve the issue?

> Creative: Give each refugee $1,000 for participating in the project regardless of whether their pictures are used.
>
> Credible: Make sure each photographer knows how and why an image is used.

10. What would you do as a member of the media?

> I would make sure the refugee photographers could keep their cameras and offer long-term photographic training to those who wish to pursue a career in the profession. I would also make sure that those taking pictures are known individually and not as the collective term, "refugees" so that those viewing the images would think of each person's exclusive journey toward safety. In addition, text accompanying each image should include the photographer's story.

Case Study Three

One of the downsides of the digital age are declining newsroom budgets. There simply isn't as much money for good journalism as there used to be. One of the things that has been cut is money for photography. Especially hard hit has been money for in-depth photography and photo essays of ongoing stories – pictures of things like the ongoing effects of famine, war, or disease, for example. In response, some photographers have begun to partner with non-governmental organizations (NGOs) who are often also working in these same spaces – groups like Doctors Without Borders – who will sometimes sponsor individuals to take pictures of what's happening. While this is helpful and makes it possible to get and share the story, it also violates journalist norms and creates a conflict of interest.

"The problem is that we say we will not work for Shell Oil because we don't like their policies, but in the same breath, we have become the spokesperson for NGOs," explains Stanley Greene, a photographer who Doctors Without Borders sponsored to take pictures of a hospital they were operating in Dhaka, Bangladesh. "But let's be real – there's only two kinds of people that go to conflict zones and places in crisis and that's the NGOs and the

journalists. We're in bed with each other. You can't operate without them. Any conflict, any crisis, you're going to have to deal with an NGO. That's just fact."

Case study written by Stephanie A. Martin

Estrin, J. (November 19, 2012). "Photography, video and visual journalism." Accessed June 30, 2017 from https://lens.blogs.nytimes.com/2012/11/19/when-interest-creates-a-conflict/.

SEA Analysis

1. What are the three most significant facts of the case?

 Declining newsroom budgets.
 Little coverage of traditional, documentary-style stories.
 NGO funding for coverage of various crises around the world.

2. What are three facts you would like to know about the case?

 What is the overall effect of the decline of newsroom budgets?
 Has there actually been a decline in photojournalism stories?
 Are NGOs the only source for visual reporters?

3. What is the ethical dilemma related to the case?

 Credibility: Do those who control the funding also control the message?

4. Who are the moral agents and what is each person's specific role-related responsibilities?

 Visual reporters: Find stories, report in words and pictures, process accounts, arrange for presentation venues.
 NGOs: Provide aid to those in dire situations, hire visual reporters, clearly specify missions and goals of the project.

5. Who are the stakeholders and what is each person's specific role-related responsibilities?

 Sources of the stories by photojournalists: Let photographers conduct interviews and take pictures.
 Readers, viewers, and users: Take the time to review thoroughly the work provided by the visual journalists.

6. What are the possible positive and negative values of all the moral agents and stakeholders named in Steps 4 and 5 and the two most opposite values from all the lists?

 Visual reporters: Altruism, communication, self-aggrandizement.
 NGOs: Truth-telling, awareness, fund-raising.
 Sources of the stories by photojournalists: Honesty, truth-telling.
 Readers, viewers, and users: Attentiveness, thoroughness, consideration.
 Most opposite: Truth-telling vs. self-aggrandizement.

7. What are the loyalties of the moral agents and stakeholders named in Steps 4 and 5 and the two most opposite loyalties from all the lists?

 Visual reporters: Themselves, sources of stories, NGOs, profession.
 NGOs: Itself, those they help, journalists, donors.
 Sources of the stories by photojournalists: Themselves, their families.

Readers, viewers, and users: The publication.

Most opposite: Sources of the stories by photojournalists vs. donors.

8. For each of the six moral philosophies used in this book describe either a justification or a criticism that can be applied to a moral agent or a stakeholder named in Steps 4 and 5 in the case study.

Golden rule: Showing others in dire situations may be unsettling for many.

Golden mean: Concentrating photographic coverage on the success stories is better than words alone or the worst cases.

Hedonism: Are visual reporters working for themselves, their pictorial sources, or the NGOs.

Categorical imperative: NGOs should show the good work they are going in order to secure a constant revenue stream.

Utilitarianism: Journalists educate the public with their stories.

Veil of ignorance: If the pictures show universal moments in peoples' lives, readers, viewers, and users will see themselves and be emotionally moved to care.

9. What creative and/or credible alternatives could resolve the issue?

Creative: Sponsor a concert by U2 within a refugee camp and get Bono to give food to those in need.

Credible: Make sure the journalists hired are not aware of the sources of funding.

10. What would you do as a member of the media?

Allow the journalists to cover any aspect of a story in order to improve the level of credibility with the general public.

INDEX

Taylor & Francis eBooks

Helping you to choose the right eBooks for your Library

Add Routledge titles to your library's digital collection today. Taylor and Francis ebooks contains over 50,000 titles in the Humanities, Social Sciences, Behavioural Sciences, Built Environment and Law.

Choose from a range of subject packages or create your own!

Benefits for you

>> Free MARC records
>> COUNTER-compliant usage statistics
>> Flexible purchase and pricing options
>> All titles DRM-free.

Benefits for your user

>> Off-site, anytime access via Athens or referring URL
>> Print or copy pages or chapters
>> Full content search
>> Bookmark, highlight and annotate text
>> Access to thousands of pages of quality research at the click of a button.

REQUEST YOUR FREE INSTITUTIONAL TRIAL TODAY

Free Trials Available
We offer free trials to qualifying academic, corporate and government customers.

eCollections – Choose from over 30 subject eCollections, including:

Archaeology	Language Learning
Architecture	Law
Asian Studies	Literature
Business & Management	Media & Communication
Classical Studies	Middle East Studies
Construction	Music
Creative & Media Arts	Philosophy
Criminology & Criminal Justice	Planning
Economics	Politics
Education	Psychology & Mental Health
Energy	Religion
Engineering	Security
English Language & Linguistics	Social Work
Environment & Sustainability	Sociology
Geography	Sport
Health Studies	Theatre & Performance
History	Tourism, Hospitality & Events

For more information, pricing enquiries or to order a free trial, please contact your local sales team:
www.tandfebooks.com/page/sales

 Routledge
Taylor & Francis Group

The home of
Routledge books

www.tandfebooks.com